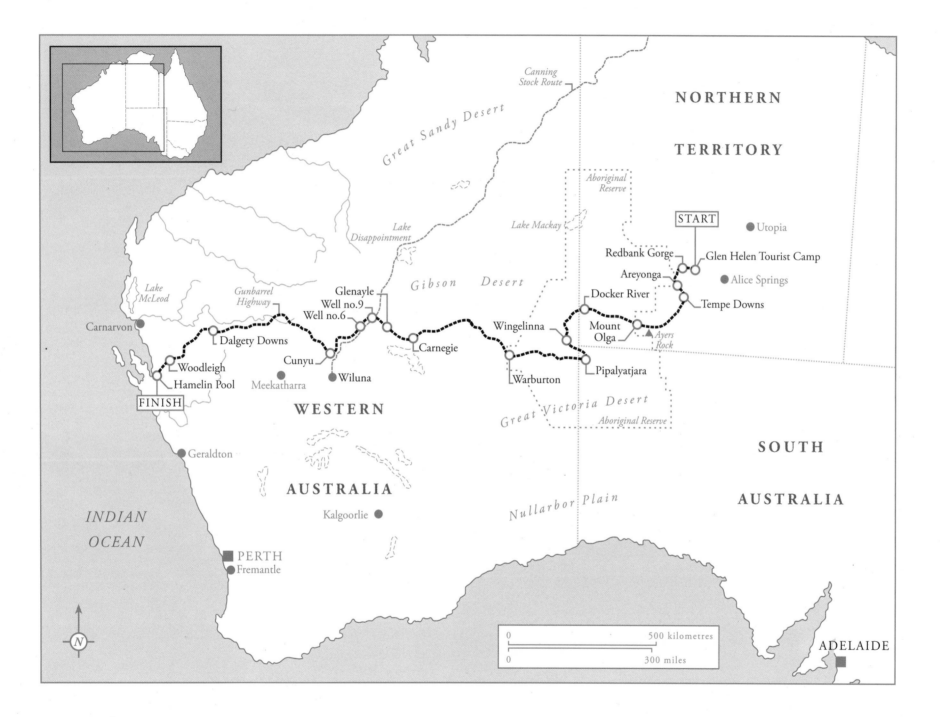

ROBYN DAVIDSON WENT TO THE DEAD HEART
OF AUSTRALIA IN PURSUIT OF A DREAM:
TO CROSS THE DESERT ALONE.

The journey would take her 2700 kilometres
across an ancient, secret land.

The outback would work its magic on her life
in strange and subtle ways.

From an Aboriginal tribal elder she learnt desert sense,
and from an Afghan camel herder she learnt to master,
ride, outwit and care for the camels that became her
pack animals and adored companions.

The voyage led to the discovery of self
as well as to the profound beauty and nobility
of a threatened land and its indigenous people.

Published in 2014 by
Against All Odds Productions II

Against All Odds Productions II
PO Box 1189, Sausalito, CA 94966
415-331-6300
www.InsideTracksBook.com

The compilation of materials in this book ©2014 Against All Odds Productions II
Pull quotes from *Tracks*, courtesy of Robyn Davidson and Bloomsbury Publishing

Inside Tracks ISBN 978-1-4549-1294-1

Color reproduction by iocolor, llp
Printed in China by 1010 Printing International Limited

Readers should be aware that if members of some Aboriginal communities see the
names or images of the deceased, particularly their relatives, they may be distressed.
Before using this book in such communities, the wishes of senior members should be
established and their advice taken on appropriate procedures and safeguards.

CREATED BY RICK SMOLAN

AGAINST ALL ODDS
PRODUCTIONS

INSIDE TRACKS

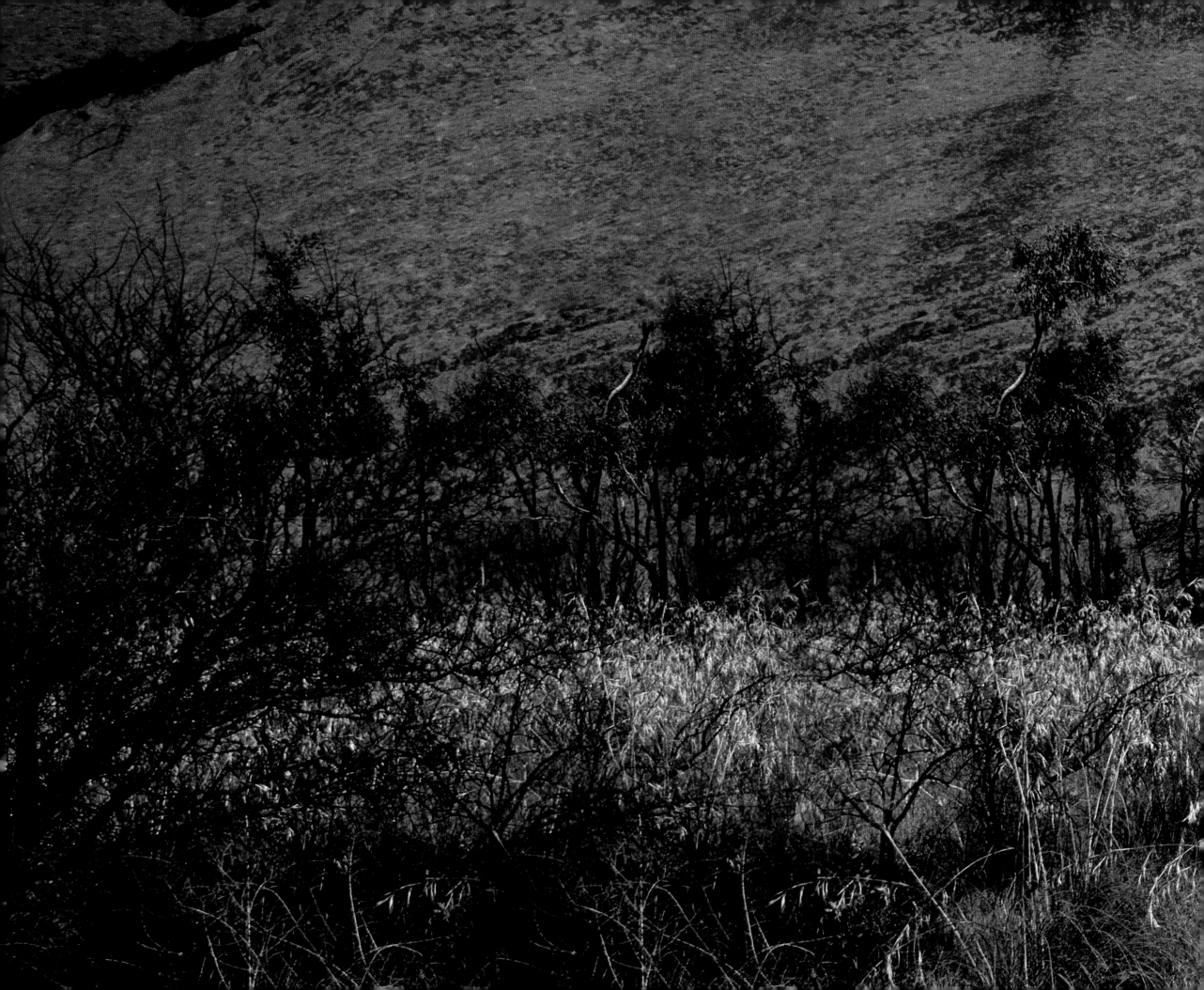

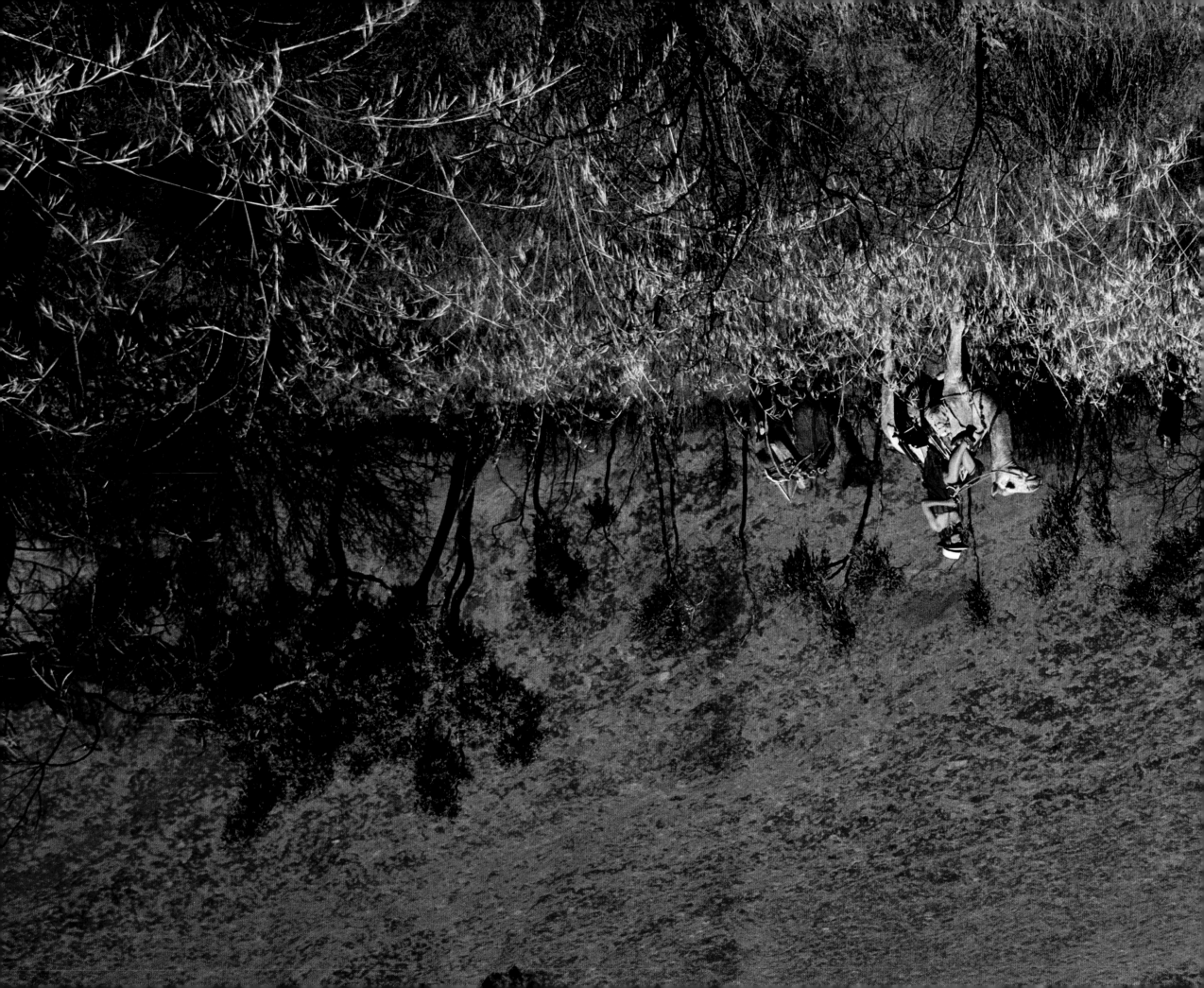

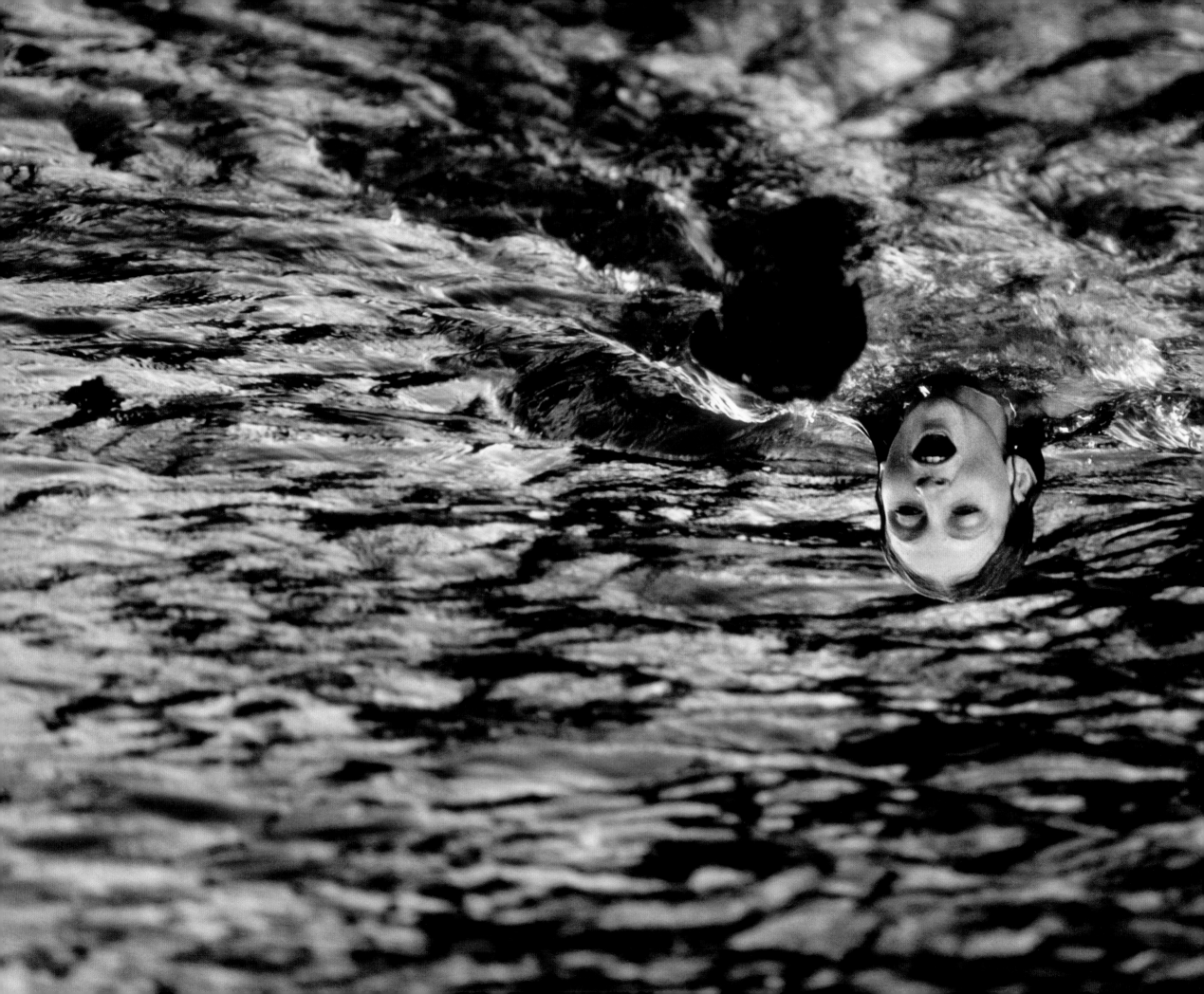

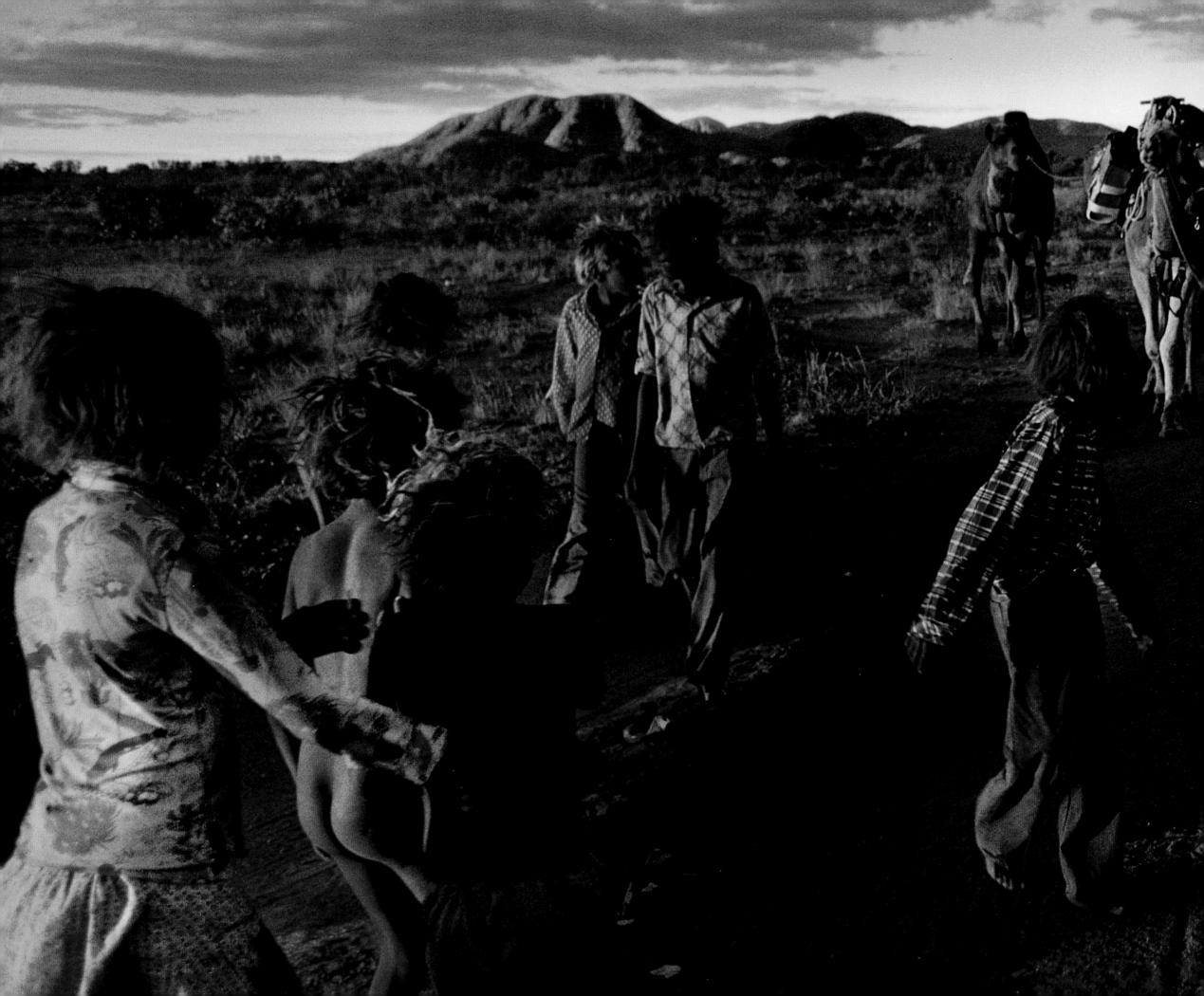

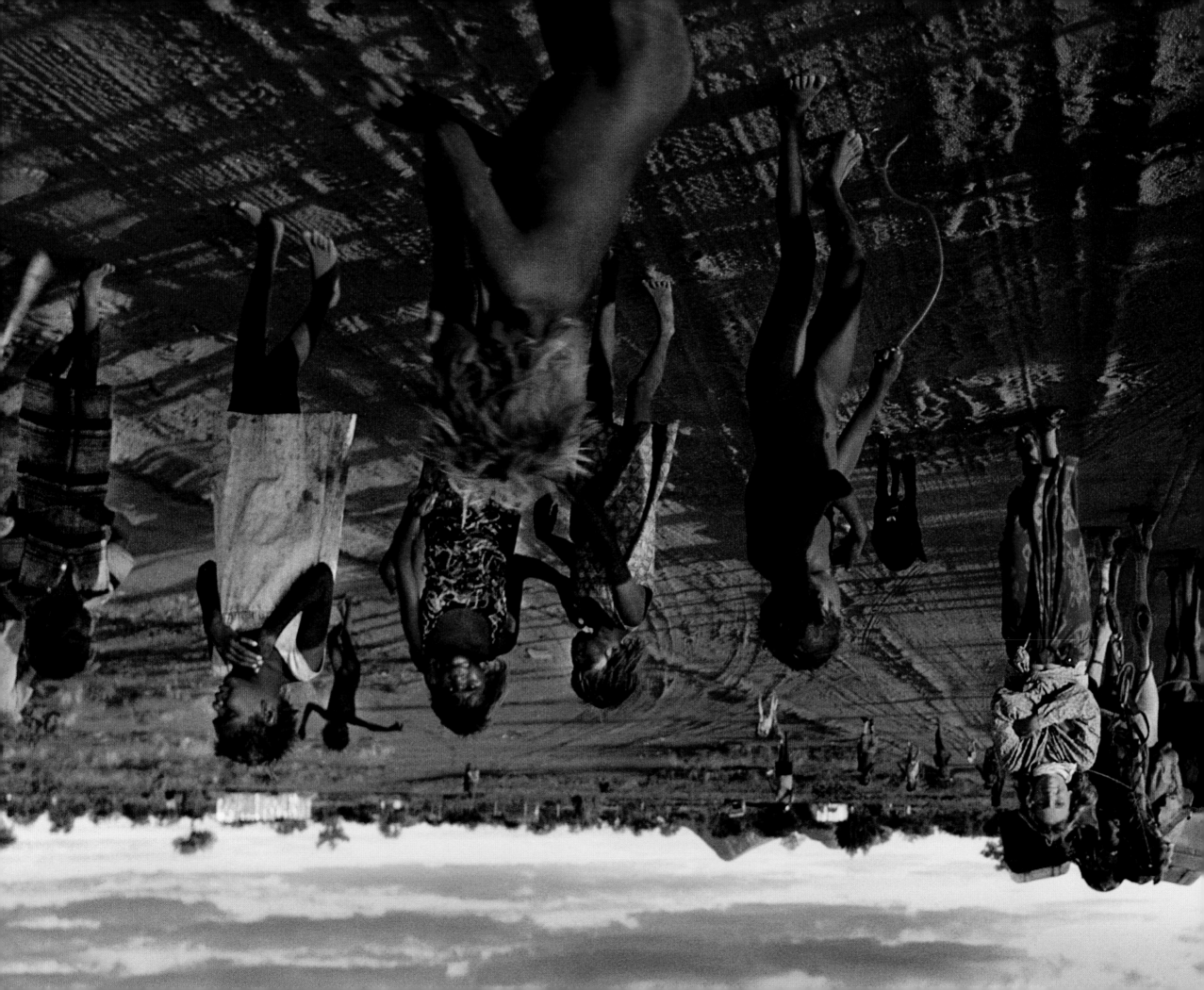

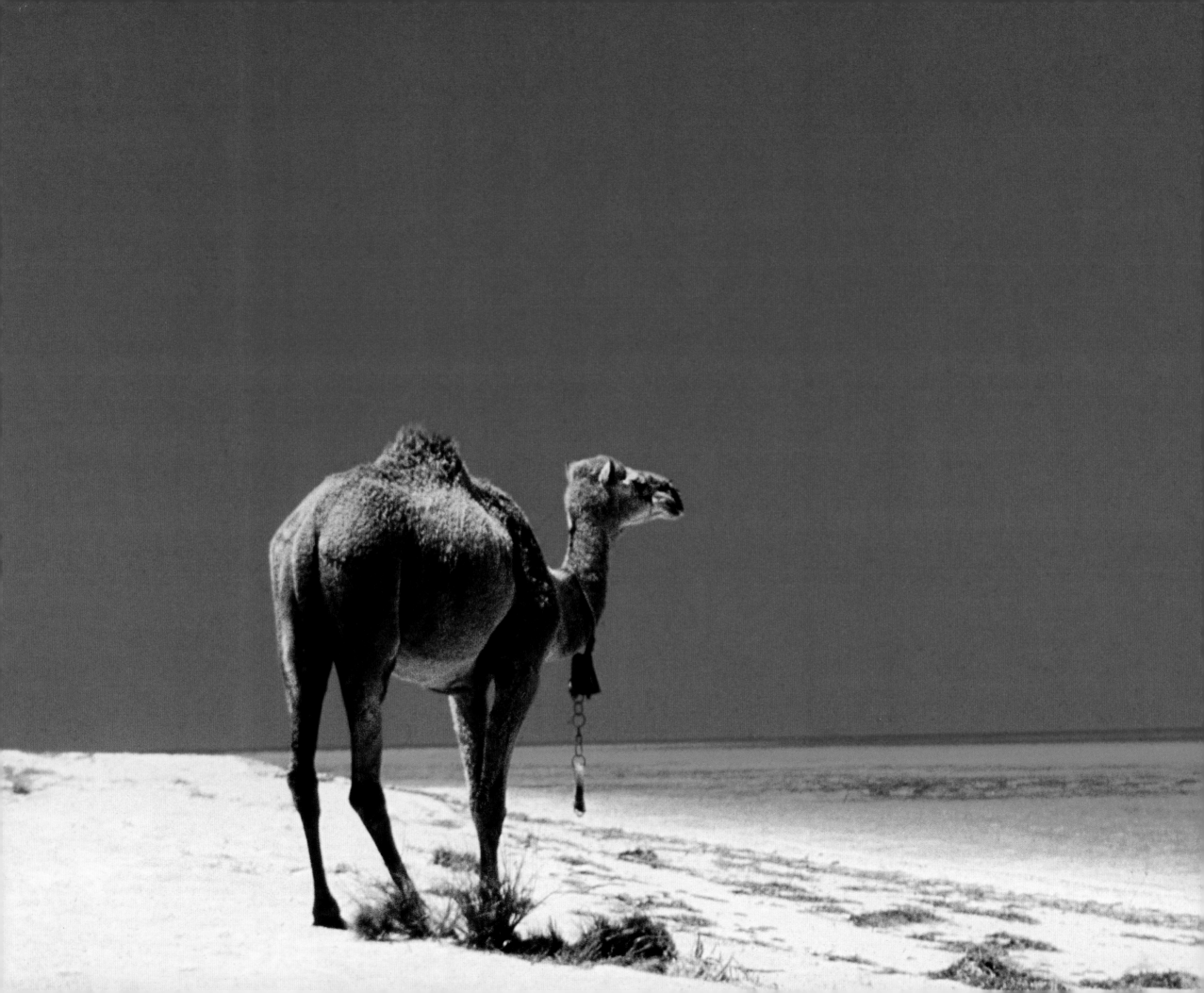

CONTENTS

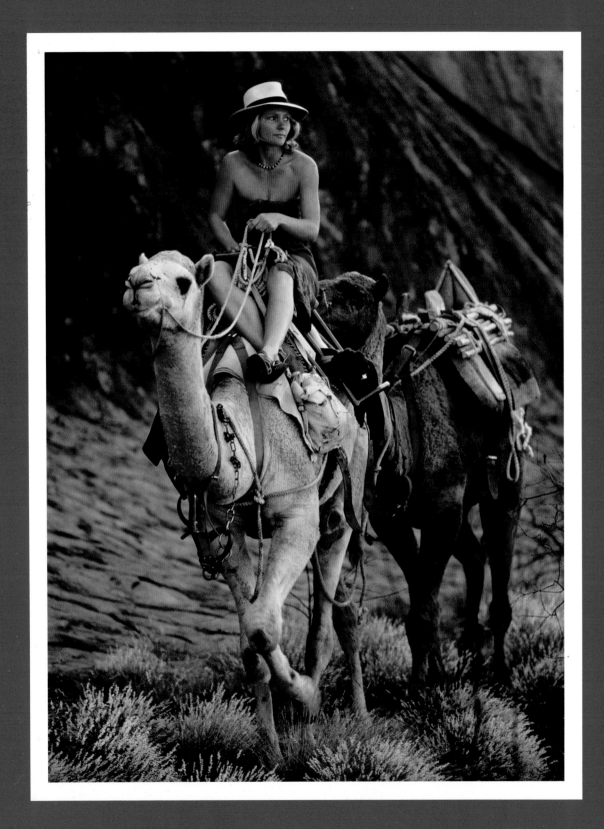

INSIDE TRACKS

THE ORIGINAL TREK

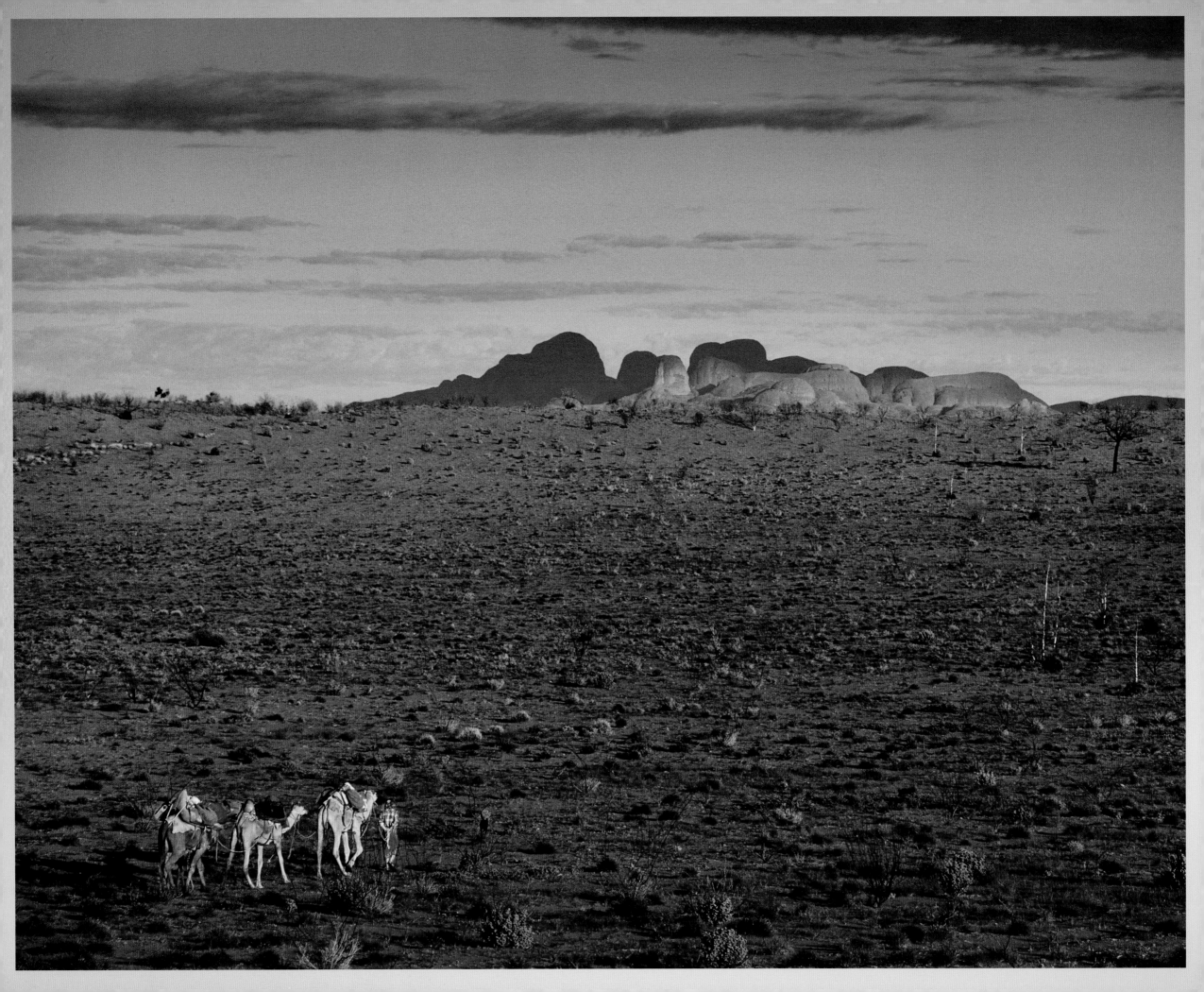

A JOURNEY IN PHOTOGRAPHS

BY RICK SMOLAN

This book is deceptive. It might appear to be the adventure story of a young woman's 2700-kilometre solo trek alone across Australia's outback, but it is, in fact, about a completely different kind of journey.

Inside Tracks is the story of what happens when you discover that the most dangerous terrain is not external but internal.

This book is also the story of how I came to know a young woman whom I admired more than anyone I'd ever met. Unlike most people, whose instincts tell them to run when frightened, this woman's inner voice urged her to challenge and confront her fears head on. She was willing to risk her life (not to mention her sanity) for something she felt compelled to do.

When I first met Robyn Davidson she was living in the desert town of Alice Springs and preparing to cross the outback alone with only four camels and Diggity, her beloved Kelpie. She didn't feel she owed the world an explanation, but she did need money to fund her trip. *National Geographic* was the perfect solution: the magazine agreed to provide her with the resources she needed. But their funding came with one big catch: me.

Robyn never planned on sharing her trip, especially not with a fledgling photojournalist. Then again, she certainly never intended to write a book about it, never suspected she would become one of Australia's best-loved authors or imagined in her wildest dreams that her story would, so many years later, attract the attention of See-Saw Films, the Oscar® winning team behind *The King's Speech*. And, when she set out on her journey, she would have been speechless to know that one day in the distant future, Mia Wasikowska, a chameleon-like Australian actress who wasn't even born when Robyn crossed the outback, would bring her story to life on the silver screen.

And, for me, what began as a dream assignment for a 28-year-old photographer turned into a much more profound and life-changing experience.

Robyn loved the outback, thought it was magically beautiful. As a big city kid from New York I couldn't understand what she saw: to me it was dry and ugly, simply an exotic background for my photos of her. But, as I tracked her down numerous times during the journey, my photos began to change and I started to see the desert through her eyes. The intensity and colour of the light in the outback was unlike anything I had ever experienced, and it was as if I'd been wearing sun glasses my entire life and then suddenly taken them off.

Robyn was the most direct human being I had ever met and she constantly challenged me, as she did herself. One conversation that still resonates was her observation one day that Americans treat friendship like Valium. I asked, a little defensively, what that was supposed to mean and she said that every time she saw Americans together they were comforting each other. 'Don't worry, it will be alright. Everything will be fine.' I asked what could possibly be wrong with that. She said that in Australia if someone is your mate, your friend, if you really care about them, then you risk your friendship by being brutally honest and hitting them over the head with a piece of two-by-four if they are doing something stupid. You don't allow your friends to keep making the same mistake, marrying the wrong person, sticking with an abusive boss, and so on. Even when I disagreed with her, I found her thought processes and bluntness unlike anything I had ever encountered.

We had another thought-provoking conversation on my third visit. Robyn hadn't seen anyone for several weeks and as we sat by the campfire she suddenly demanded: 'When are you going to get here?' I remember wondering if she was losing her mind and said: 'Robyn, I'm sitting here right across from you.' She stared at me and said: 'No, you're not. You are worrying about the film from your Taiwan assignment and where you are going to drop your car in two weeks when you leave me, and whether your photo is going to be on the cover of *Time* next week. You show up out here and then you are everywhere else but here. If you're going to come, then be *here* with me and not lost in your head the whole time!'

One of my biggest fears was that something terrible would happen to Robyn and that she would die during her journey. Being attacked by wild bull camels, getting lost and running out of water, sunstroke, poisonous snakes and insects, being thrown from a camel and hurt, her camels running away with all her supplies, crazy humans... the list of dangers seemed endless.

One day between outback trips, I was on assignment in Hong Kong and had arranged to meet *Time* magazine's bureau chief Richard Bernstein, at the Hilton Hotel for breakfast. Richard knew that I was joining Robyn intermittently during her journey and when I got to his table he looked very pale and told me I better sit down.

He handed me the *South China Morning Post*, Hong Kong's daily English newspaper, and there, on the front page, was the headline: 'Mysterious Camel Lady Missing in Gibson Desert: Desperate Search Underway'. My heart sank and I have no memory of how I got to the airport but the next thing I recall is waking up while the plane refuelled in Darwin enroute to Perth. Flight attendants distributed morning newspapers from around Australia and there, on the front page of every paper in the country, were my photographs of Robyn. I immediately assumed *National Geographic* would never have given out my photos unless she was confirmed missing.

Robyn Davidson (left), Mia Wasikowska (right), photographed by Rick Smolan

What I didn't know at the time was that two weeks earlier a racing car driver looking to set a new world record for crossing Australia had spotted Robyn's campfire and screeched up to her in the middle of the night. He stayed a few minutes and then blazed off in a cloud of dust. She later told me that she was so exhausted she was never sure if he was real. His effect on her trip was certainly real.

I later learnt that when the racing driver reached Sydney and held a press conference to celebrate his accomplishment, one of the reporters asked him what had been the most memorable part of his journey. He told them about the romantic evening he'd spent with 'a mysterious camel lady'. That remark led to a completely fabricated story about the 'missing camel lady' and to more than 80 paparazzi from around the globe descending on Western Australia. Like the rest of the world, I had believed Robyn was truly missing and probably dead, perhaps never to be found.

I was desperate to find her but, by the time I did, there were dozens of reporters and camera crews following me. These parasites, with their fabricated stories, descended on Robyn like flies. For a few days it looked as if they were never going to leave, forcing her to consider abandoning her trip. One night, while everyone was asleep, I hid her in my Toyota LandCruiser and drove to a cattle station 32km away where we waited a week until their news budgets ran out and she could return to continue her trip.

Robyn's most trusted companion on her journey was Diggity, a loyal Kelpie who was her protector, sleeping-bag partner and confidante. One night by the camp fire Robyn told me how Diggity had become such an important part of her life. Two years before the camel trip Robyn had taken a job at a hospital, only to learn that in the basement were animals being used as test subjects. Seeing these animals in such distress and unable to bear the horror, Robyn had sneaked back in one evening and set them all free. One small dog, a mere puppy, refused to leave and thus Diggity became part of Robyn's life. In a cosmic sense of payback she saved Robyn's life several times during the journey.

Throughout the trip I kept encouraging Robyn to keep a journal so that she could one day write a book about it. Her response was predictable: 'Why do you have to turn everything into a product that can be packaged and marketed and sold? Why can't you just experience something for its own sake and not be constantly thinking of how you are going tell your friends all about it?'

Three years after she finished her journey Robyn called to tell me she had written a book about the trip. I was stunned and asked if she wanted a copy of my journals. She politely declined but sent me a draft to read.

I remember two things about my initial reading of *Tracks*. The first was being stunned at what a powerful writer Robyn was; how I was hypnotised by the story, sucked completely into her world. The second was that while most of us have memories like sedimentary layers, with the most recent memories on top and fresh while older memories are faded and compressed, Robyn had an extraordinary ability to remember every day of the trip as if it were happening in real time.

Without any journal or notes she had conjured up and brought to life the tiniest details, sounds, smells, emotions, verbatim conversations, reflective observations, even the patterns small insects had made in the sand. I called her at her home in London and asked how on earth she had been able to recreate the trip with such verisimilitude. She chided me: 'Because I was *there*. While you were snapping away and thinking about f-stops and underexposing half a stop to increase the saturation of your film and scribbling away in your journals, I was letting myself experience every moment.'

She was right. While I was always filtering the experience, she allowed herself to actually experience every moment of the trip, the pain and the wonder.

Before *Tracks* was released in movie theatres around the world, producer Emile Sherman and director John Curran graciously set up a private screening for me in Los Angeles. As I walked into the small screening room on Sunset Boulevard I was excited and looking forward to a trip down memory lane.

Instead, a few minutes into the film I found myself gripping the arms of my seat, breaking out into a sweat, my heart pounding, experiencing a full-blown anxiety attack. Sitting alone in that darkened theatre I was flooded with a sense of dread, suddenly remembering that every time I drove away from Robyn during her journey I would look in my rear view mirror and wonder if that would be my last memory of her; if she would die out there.

That rush of forgotten memories made it impossible for me to enjoy my first viewing of *Tracks*. It wasn't until I saw the film again at the Toronto Film Festival with 800 other moviegoers, heard them hold their breath when Robyn was attacked by wild camels, heard them laugh in unison at Adam Driver (who amusingly captured the social awkwardness and fish-out-of-water aspects of 'Rick' when he shows up with a raft he'd been conned into purchasing "in case of flash floods") and cry when Robyn lost her best friend, that I was able to properly experience *Tracks* for the first time.

Robyn and I have been asked many times since *Tracks* debuted how accurate the film is to what actually happened. Obviously the Robyn and Rick in the film are fictionalised versions of us and many of the events have been tailored and altered to fit into the movie's 90-minute narrative arc. And, in many ways, even Robyn and I were on different journeys and we each remember parts of the trip very differently. Ironically, the thing we both fear now is that the movie version of events (larger than life, powerfully directed by John Curran, stunningly filmed by Mandy Walker, with a mesmerising music score by Garth Stevenson) may begin to replace our memories of the real events.

One big question has always loomed over Robyn's trek. When tens of millions of *National Geographic* readers first experienced Robyn's story, when more than a million people in 18 languages read *Tracks* and now when hundreds of millions of movie-goers watch the film *Tracks*, the first question people always ask is, 'Why did Robyn make this trip?'

It's the one question that Robyn has never felt the need to answer. Perhaps allowing each person to reach their own conclusion is what makes Robyn's unlikely journey so compelling. To me, what matters is that Robyn permitted herself to listen to the little voice inside that so many of us ignore.

As you turn the pages of this book and experience Robyn's original journey and then join the actors as they recreate her adventure on the silver screen, I commend you to reflect on a quote from *Tracks*, 'You are as powerful and as strong as you allow yourself to be and the most difficult part of any endeavour is taking the first step.' My deepest hope is that Robyn's journey will inspire you to look inside and find your own journey, your own personal 'camel trip'.

Rick Smolan, CEO of Against All Odds Productions, is a *New York Times* best-selling author with more than five million copies of his books in print. A former *Time, Life,* and *National Geographic* photographer, Smolan is best known as the co-creator of the *Day in the Life* book series. His global photography projects, which feature the work of hundreds of the worlds leading photographers and combine creative storytelling with state-of-the-art technology, are regularly featured on the covers of prestigious publications around the globe including *Fortune, Time,* and *GEO*. His most recent project *The Human Face of Big Data* captures how our planet is developing a nervous system. The 'Human Face' iPad app won the 2013 WEBBY for best educational app and the companion TV documentary won the 2014 award for Best Cinematography at the Boston Film Festival. More than a million people have watched Smolan's 'Natasha's Story' on TED.com (www.NatashaStory.com). *Fortune* magazine describes Against All Odds as 'One of the 25 Coolest Companies in America'. Smolan lives in New York City with his wife and business partner, Jennifer Erwitt, and their children, Phoebe and Jesse.

"I arrived in the Alice at five a.m. with a dog, six dollars and a small suitcase full of inappropriate clothes."

After a two-day, 800km train journey from Adelaide, Robyn and her dog, Diggity, arrived at dawn in Alice Springs, where she would live for the next two years.

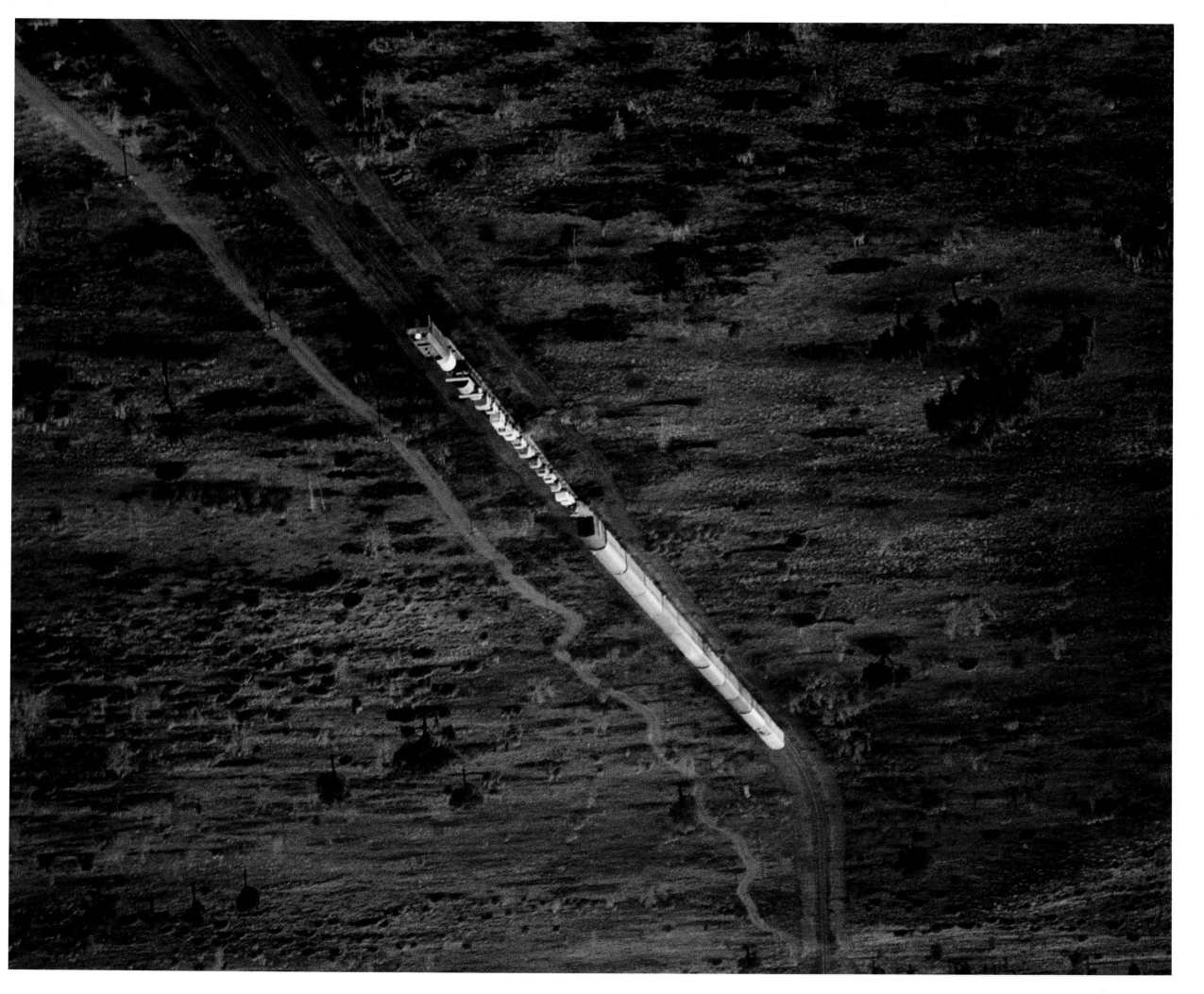

Robyn Davidson,
c/o The Post Office,
Alice Springs, N.T. 5750
Australia

Joe Judge (Senior Assistant Editor)
National Geographic Magazine,
17th & M Streets, N.W.,
Washington D.C.,
U.S.A. 20036

Dear Sir,

I wrote to you almost a year ago now in the hope that you would consider publishing a story on my proposed camel trip across Western Australia. You weren't interested at the time, but since then I have gone through two years preparation and when I discussed it with David Lewis he seemed to think you may yet be.

I have my three camels (and one small calf) trained and ready to go and have been working with them solidly for the past eighteen months. They are perfectly reliable beasts. Most of the equipment is already bought and I have done a few test runs into the semi-desert surrounding Alice Springs.

Living with the Aborigines has taught me a lot about survival — tracking, bush, food gathering etc. I would like to be able to take Aboriginal guides with me occasionally along the route to learn something of their methods of navigation.

The general plan at present, is to leave Alice Springs in late April and take a leisurely ride to Ayers Rock via some of the more beautiful gorges along the McDonnell Ranges and Finke River. From the Rock I shall push on to Docker River and Giles Meteorological Station just west of the border, following the track known as the "Gunbarrel Highway". The real Western Desert then has to be crossed and I shall probably take the track to Wilune. The dangerous leg of the journey then being over, I shall decide whether to go straight to the West coast or down to Perth.

The trip will take me through some of the most beautiful and some of the most barren country the Western Desert can show. I will be travelling alone, save the dog and camels, and the trip should take six to eight months.

As I shall be following roads and four-wheel-drive tracks most of the way, there will be ample opportunities and facilities en route for filming, photographing, talking or whatever else National Geographic journalists have to do. I shall have a Nikkonos camera with me as well. I have some photos of me, my animals and the surrounding countryside, along with a map of the intended route, taken by a Time photographer, which I shall send you if you are interested.

I have written to you because I feel that National Geographic, a magazine of international repute, would be the most suitable to cover the story. I look forward to hearing from you in the near future.

Yours faithfully,

Robyn Davidson

National Geographic turned Robyn down the first time she wrote asking them for support. But Rick urged her to try again. Her persuasive letter convinced the magazine to provide the $4000 she needed to fund her trek.

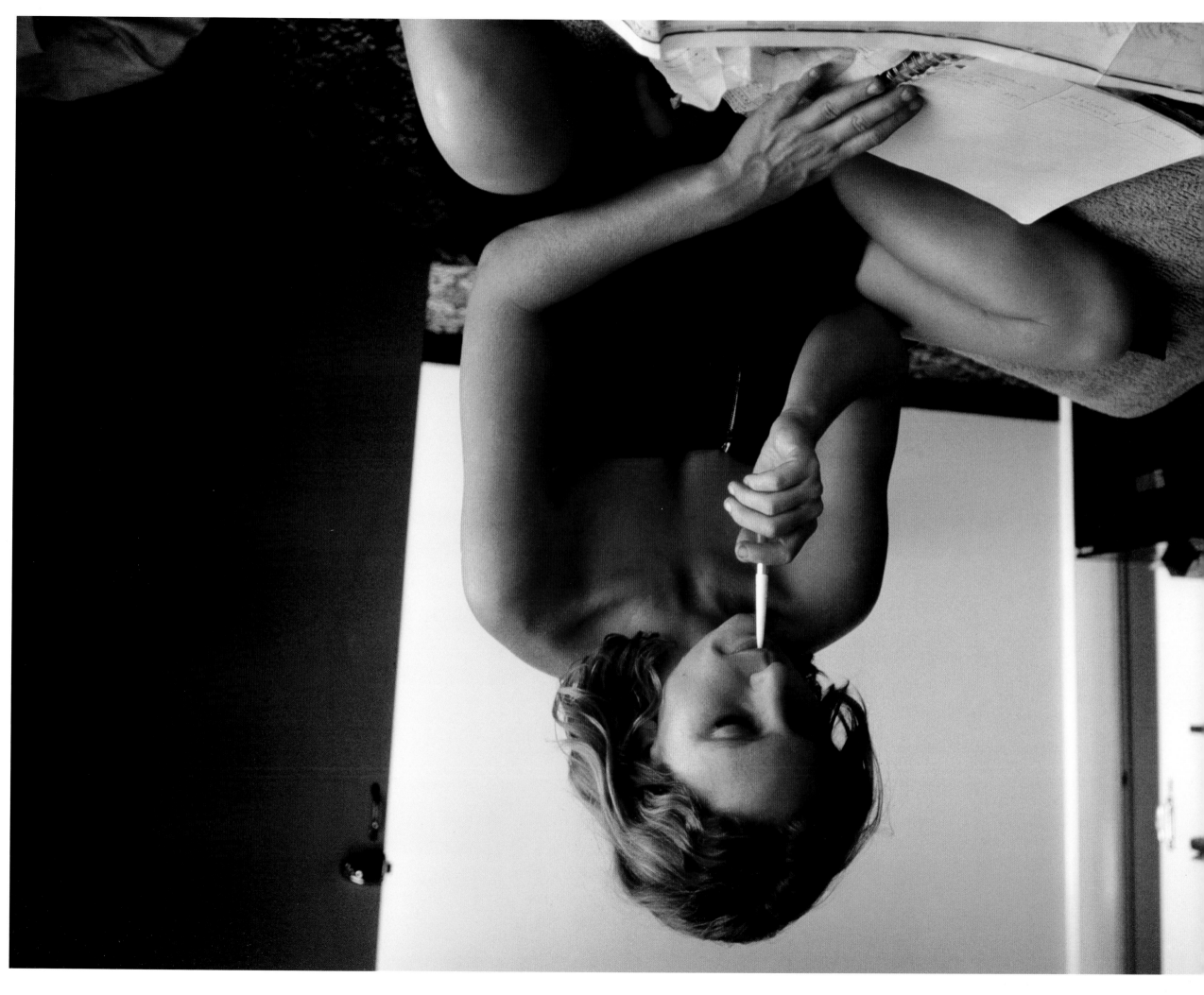

Like the other camel men in Alice, Sallay Mahomet, an Australian-born Afghan camel handler, was initially dubious about Robyn's ability to carry out her plan. Sallay, whose business was exporting wild Australian camels back to Arabia, eventually agreed to trade Robyn two animals in return for a few months' work.

The line-up: baby Goliath; his mother, Zeleika; Bub, a gelded male; and big Dookie, an older gelding.

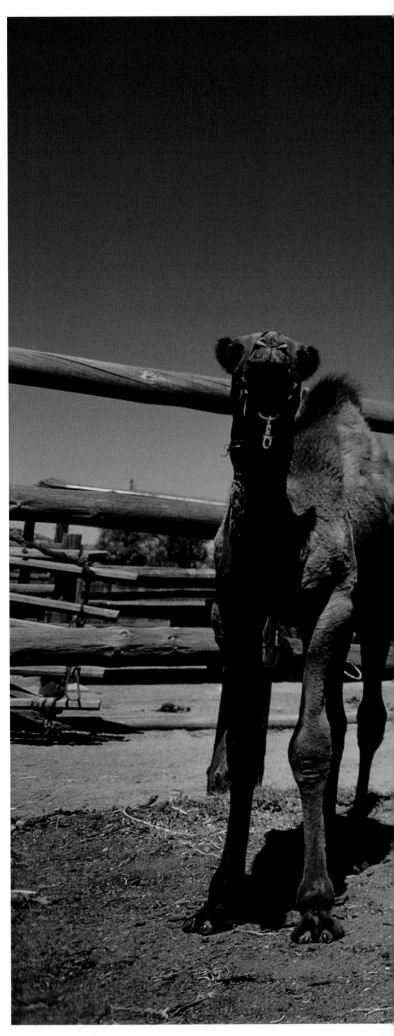

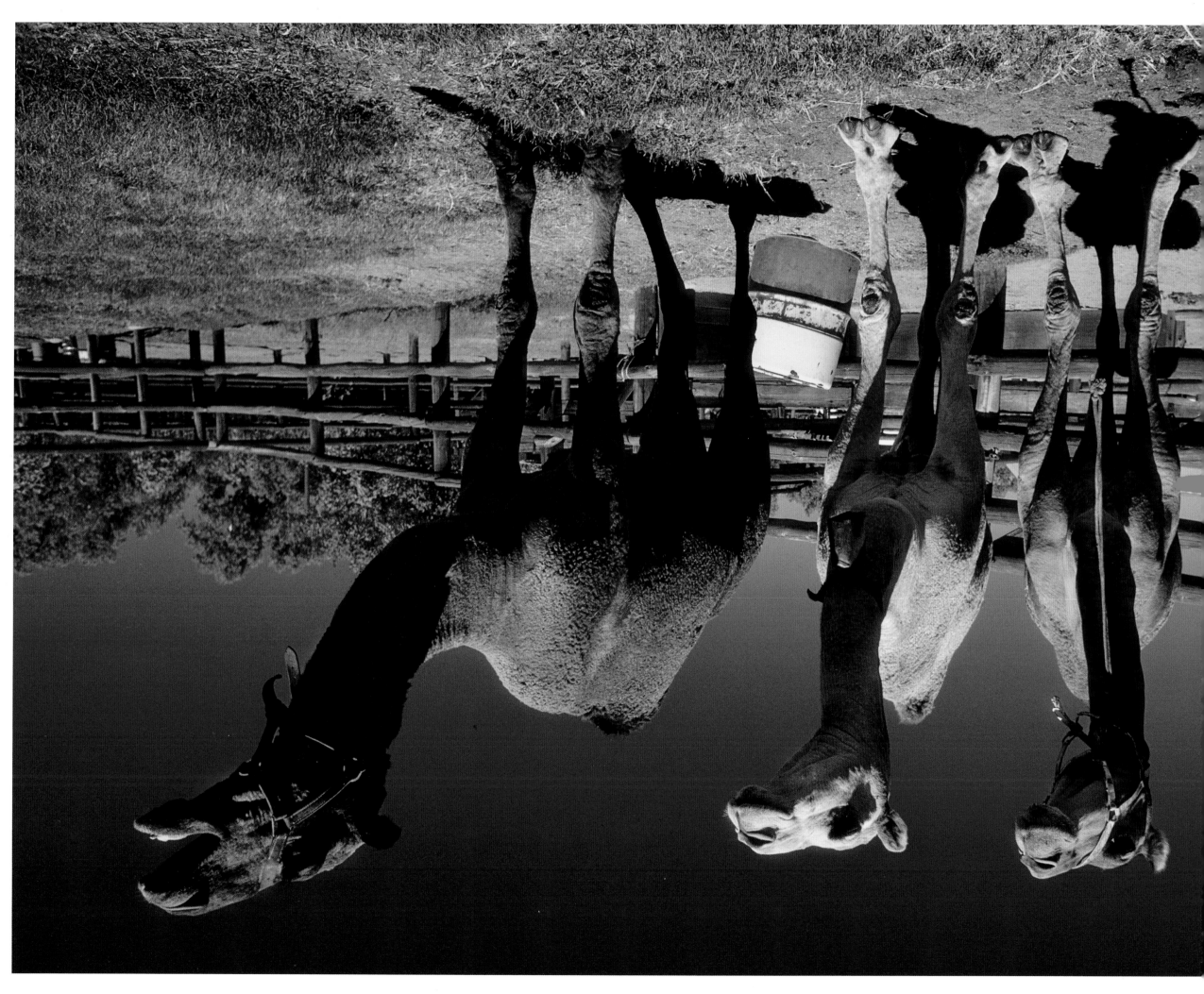

"Before I went to Alice Springs, I had never held a hammer, changed a lightbulb, mended a sock, or used a screwdriver. I had never done anything which required manual dexterity, patience, or a sense of functional design."

Zeleika, Robyn's first camel, had been caught in the wild and tamed, as well as any wild camel could be. Zelly never lost her 'desert smarts' and instinctively knew which plants were safe to eat and which were deadly. Because she had lived in the wild, she took being hobbled as an insult and in the beginning often asserted her independence by kicking.

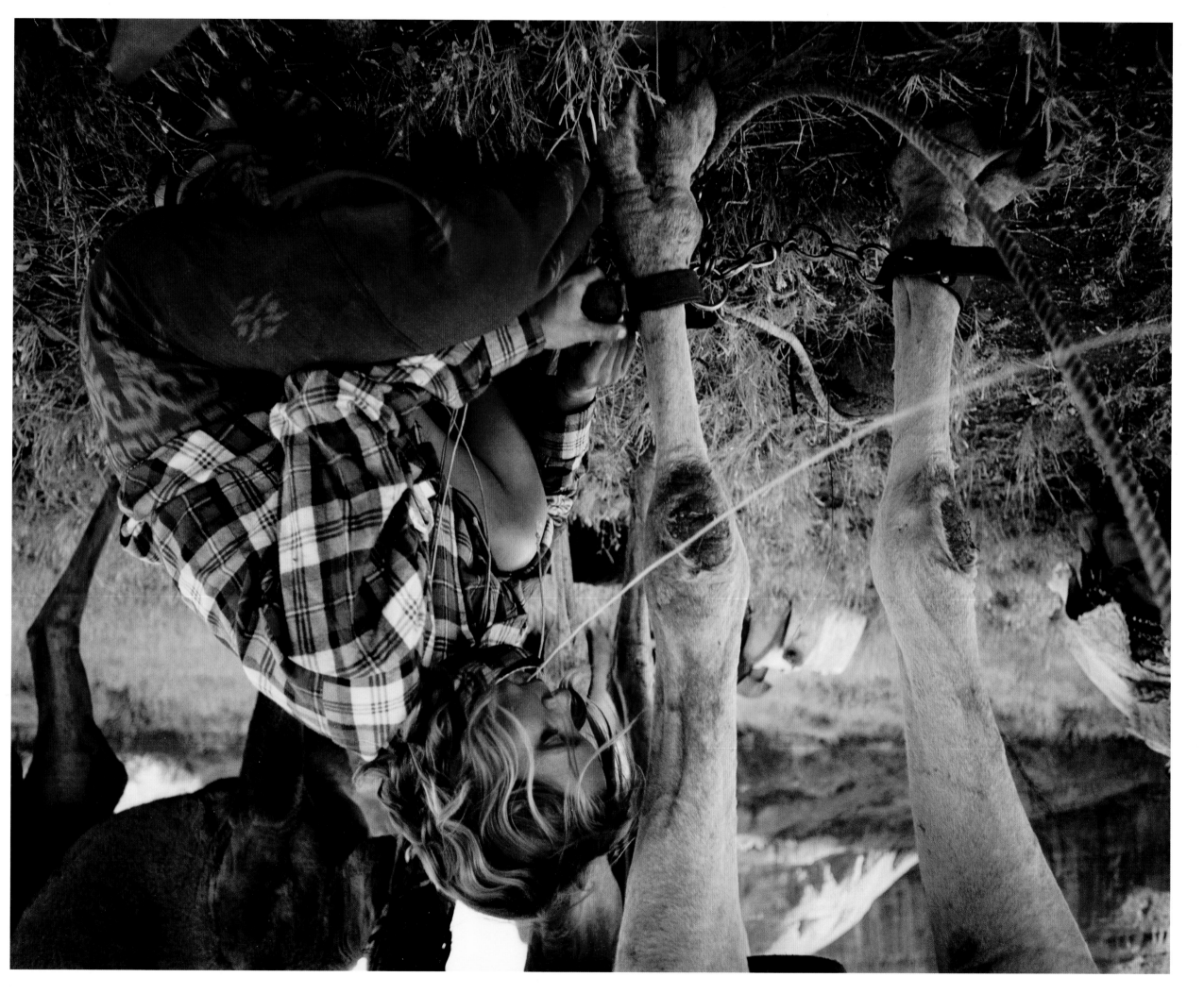

As the time for her departure neared, Robyn's friends were concerned that she had started to identify too closely with her camels. As her band of camels grew, so did her affection for them. Under her growing expertise they began to develop distinct personalities. 'They are the most intelligent creatures I know except for dogs and I would give them an I.Q. rating roughly equivalent to eight-year-old children.'

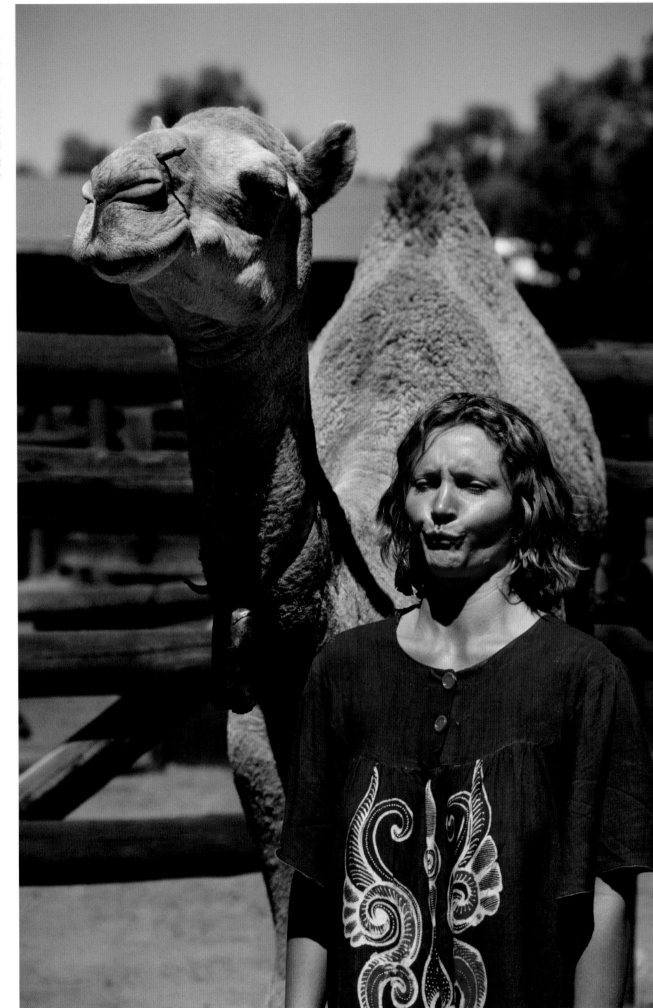

Bub, Robyn's cheeky young male camel, was a natural clown, a creature driven in one direction by unbridled curiosity and in the other by a cowardly fear of his own shadow. Of Robyn's camels, Bub was the most easily spooked.

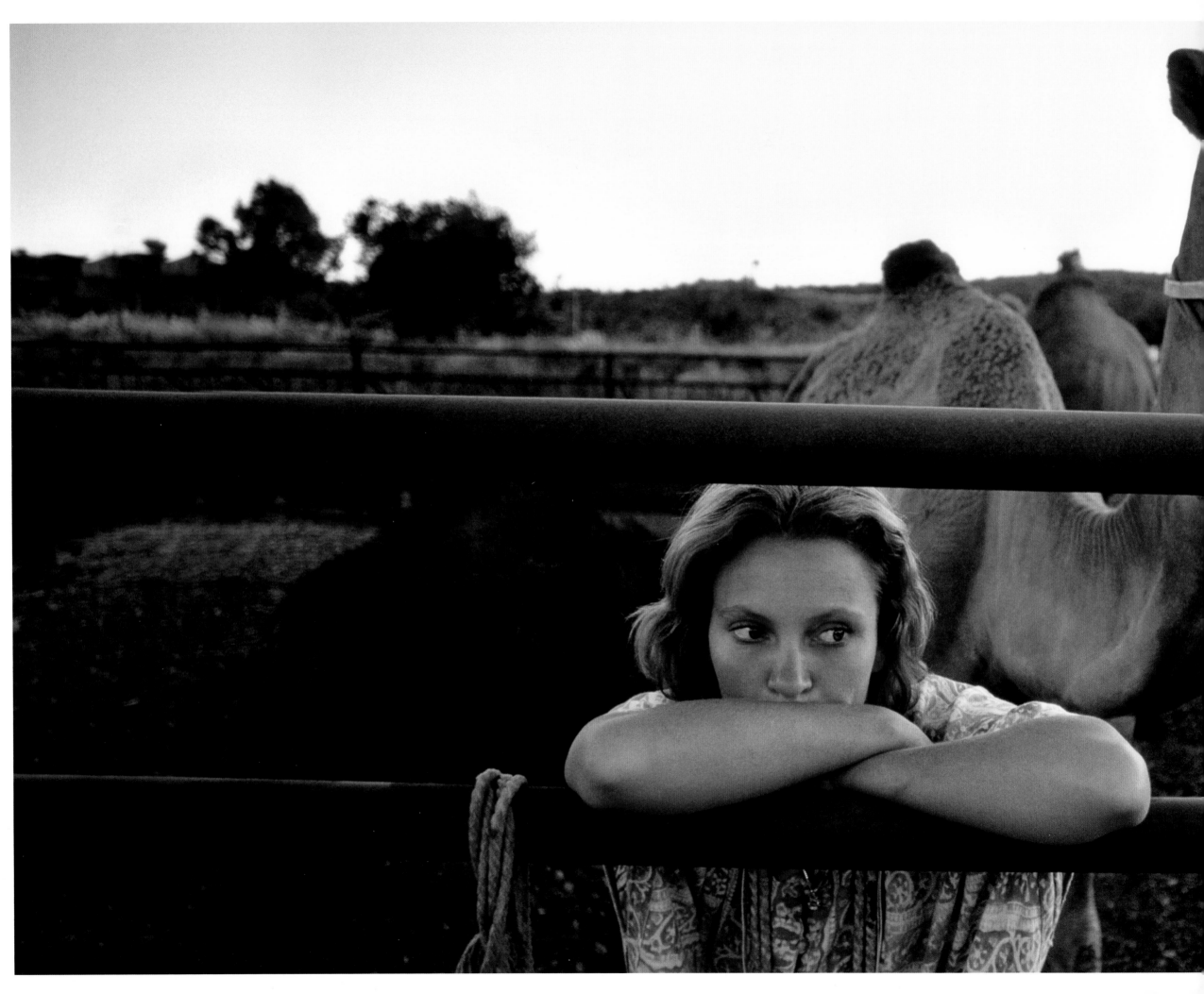

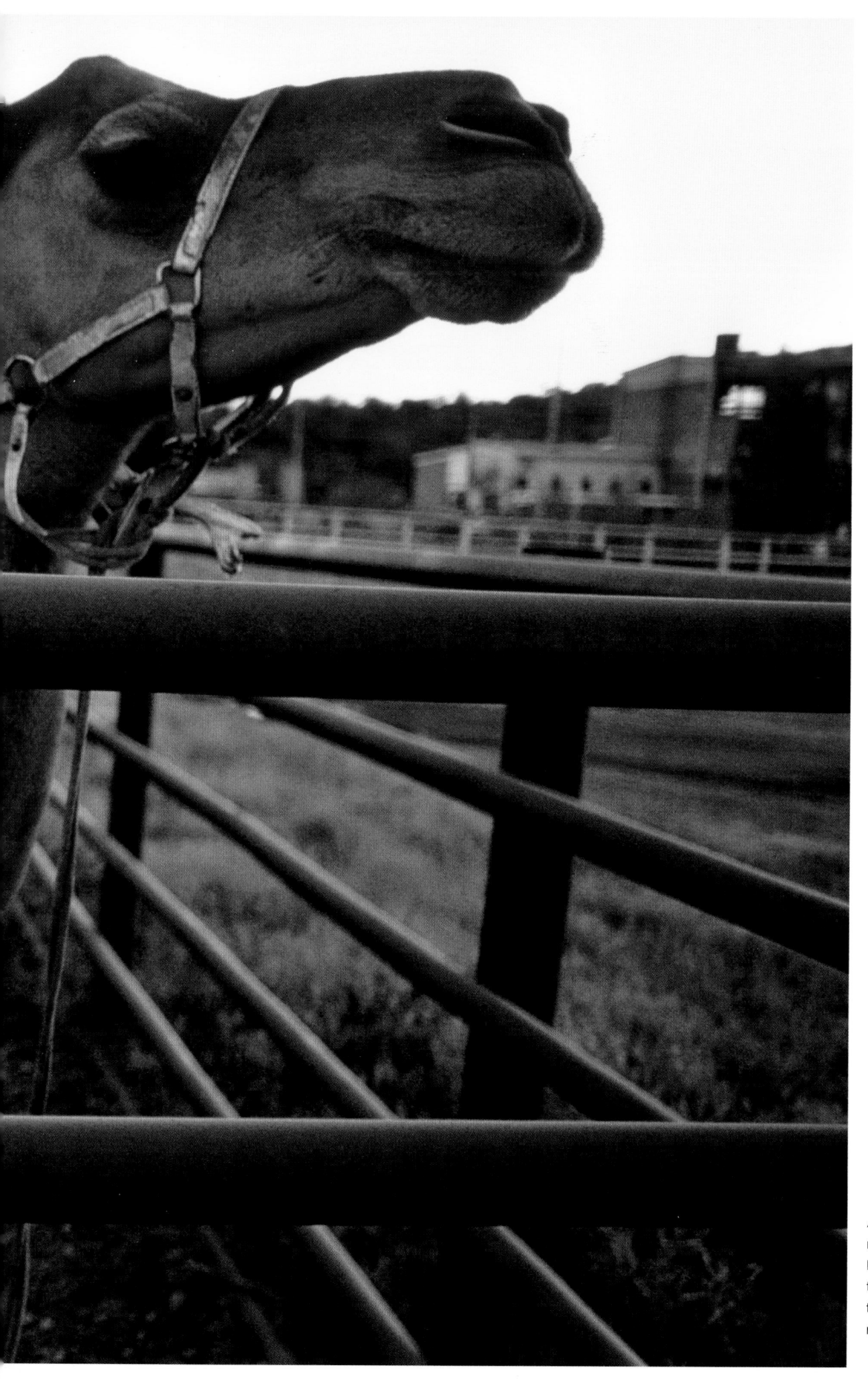

As dawn broke on the morning the trip began, Robyn feared, even after two years of preparation, that she still wasn't truly ready for what lay ahead.

"When you are truly stuck, when you have stood still in the same spot for too long, you throw a grenade in exactly the spot you were standing, and jump and pray. It's the momentum of last resort."

–Renata Adler, *Speedboat*

> "From the day the thought came into my head, 'I am going to enter the desert with camels,' to the day I felt the preparations to be complete, I had built something intangible but magical for myself which had rubbed off a little onto other people."

DAY 1 Words spoken when people think they might never see each other again are often stripped of pretence. Robyn and her father shared the sunrise the day her trip began.

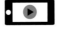

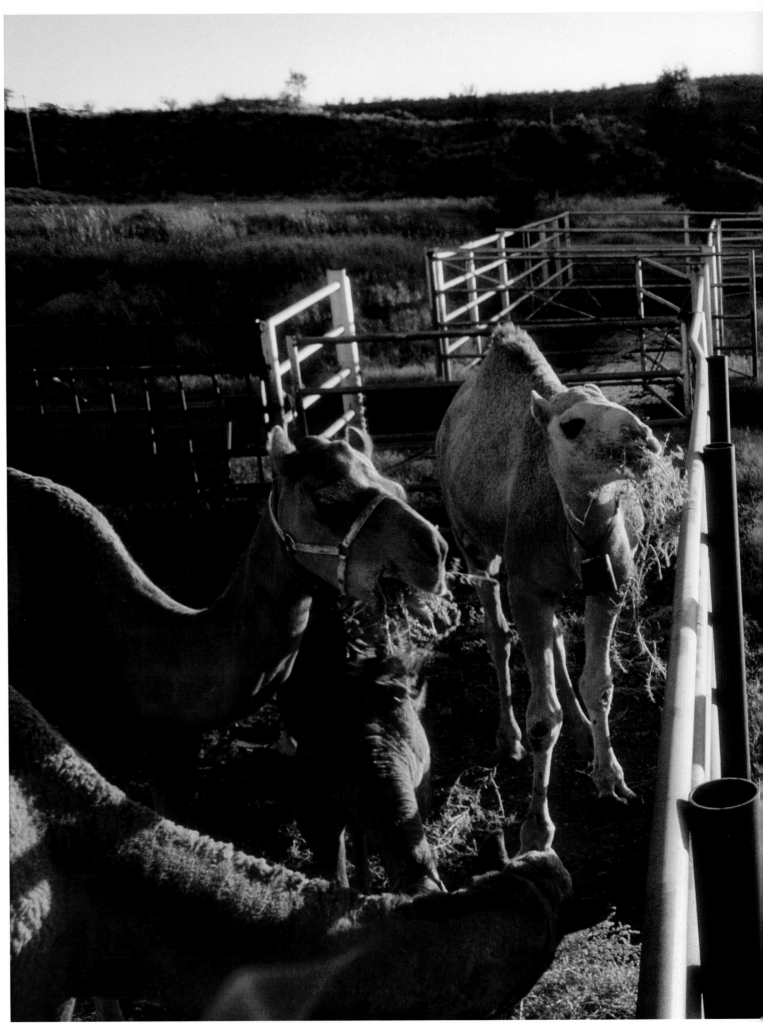

"I am quite sure Diggity was more than a dog. She combined all the best qualities of dog and human and was a great listener. There are very few humans with whom I could associate the word love as easily as I did with that wonderful little dog. "

DAY 12 One of Robyn's hopes was that Diggity would learn to track the camels if they disappeared during the night. But things didn't quite work out that way. "Diggity's desire to hunt everything except camels was a bone of contention between us. I had been trying to train her to help me track them but she was not remotely interested. Her all-consuming passions were kangaroos and rabbits and these she would chase for hours on end, bounding over clumps of spinifex, head turning this way and that in mid-air like Nureyev. She was beautiful to watch but never actually caught anything."

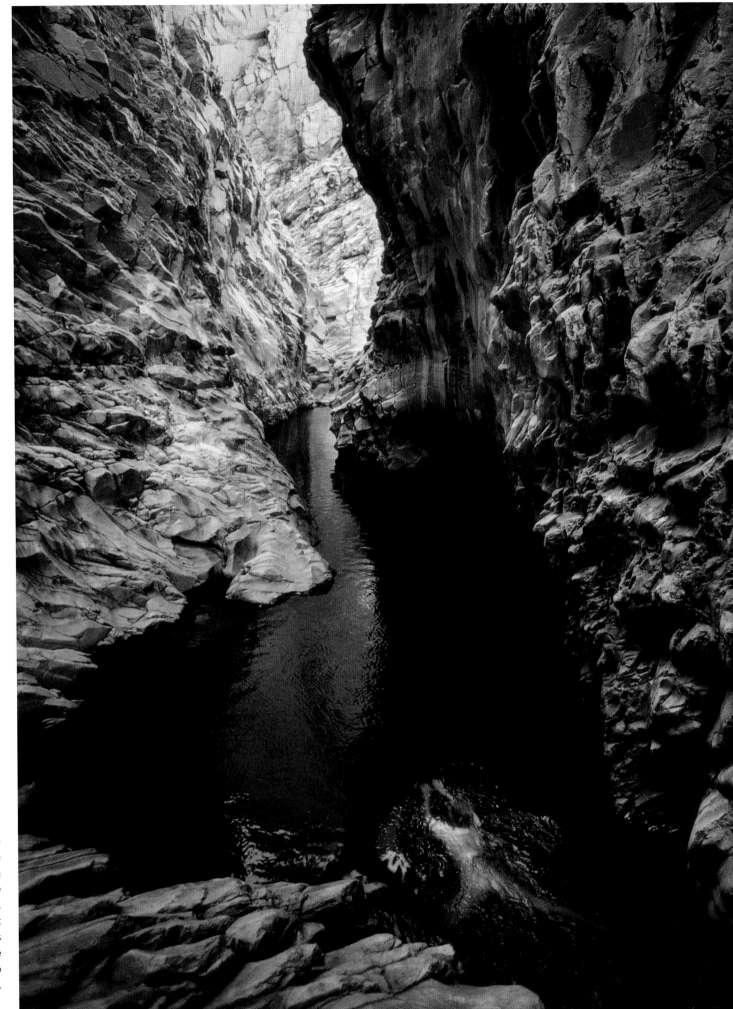

DAY 15 Robyn gave herself a day off to explore Redbank Gorge, 156km west of Alice Springs in the West MacDonnell Ranges. The gorge is so narrow that the only way to enter it is by swimming in along the ice-cold stream, which is too narrow for a canoe or boat.

Robyn had rescued her Kelpie, Diggity, as a puppy from certain death in a medical research laboratory. Diggity returned the favour by alerting her to human intruders, poisonous snakes and other dangers.

" I had simply not allowed myself to think of the consequences, but had closed my eyes, jumped in and, before I knew where I was, it was impossible to renege. "

Redbank Gorge is made up of 13 pools, which fill higher or lower depending on the time of year and the annual creek floods. The gorge is a sacred site for Western Arrernte Aboriginal people and its Dreaming Story is connected to the Euro, a small kangaroo seen throughout this area.

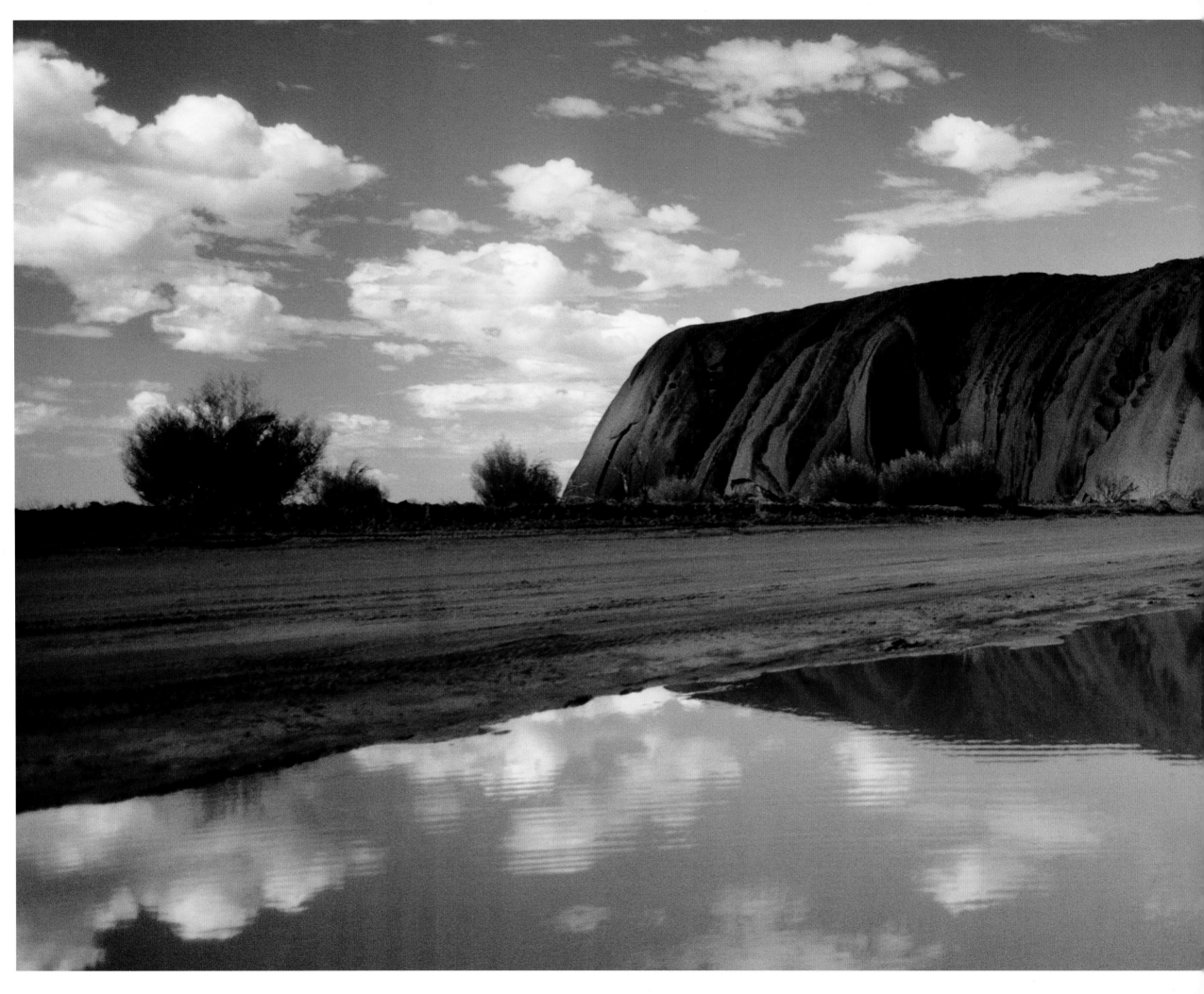

The indecipherable power of that rock had my heart racing. I had not expected anything quite so weirdly, primevally beautiful.

DAY 32 Uluru, at 348m high and 9.4km in circumference, is the world's largest single rock and has a history that goes back hundreds of millions of years. Shield shrimp, 150-million-year old desert crustaceans, have survived for eons by hatching their eggs in small pools that form on top of the rock after infrequent desert rainstorms. A sacred site for the Pitjantjatjara and Lowitja tribes for over 10,000 years, Uluru today attracts many Australians who regard a trip to the Rock as a pilgrimage. The painted white line (following page) is designed to keep tourists from falling off the edge.

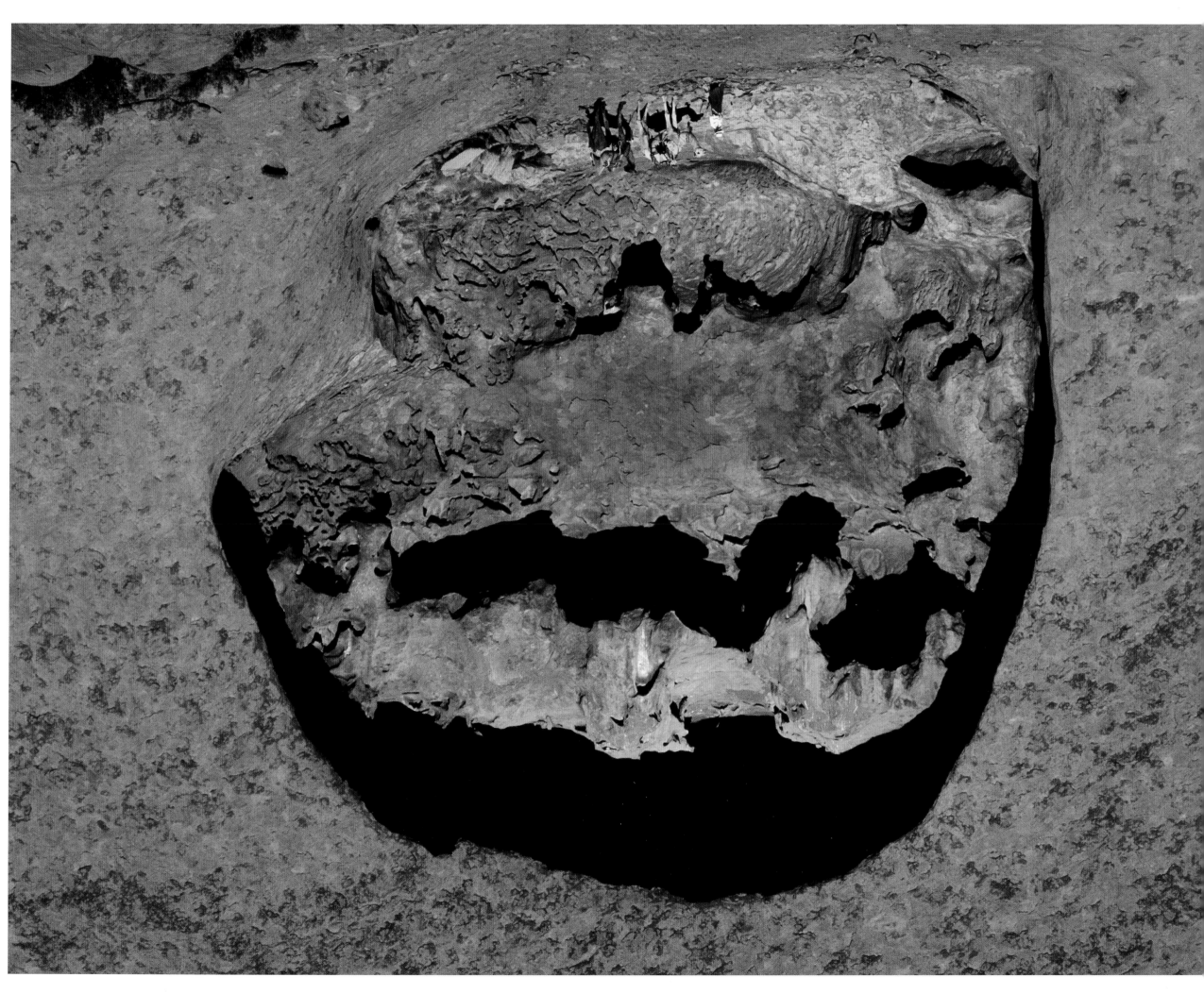

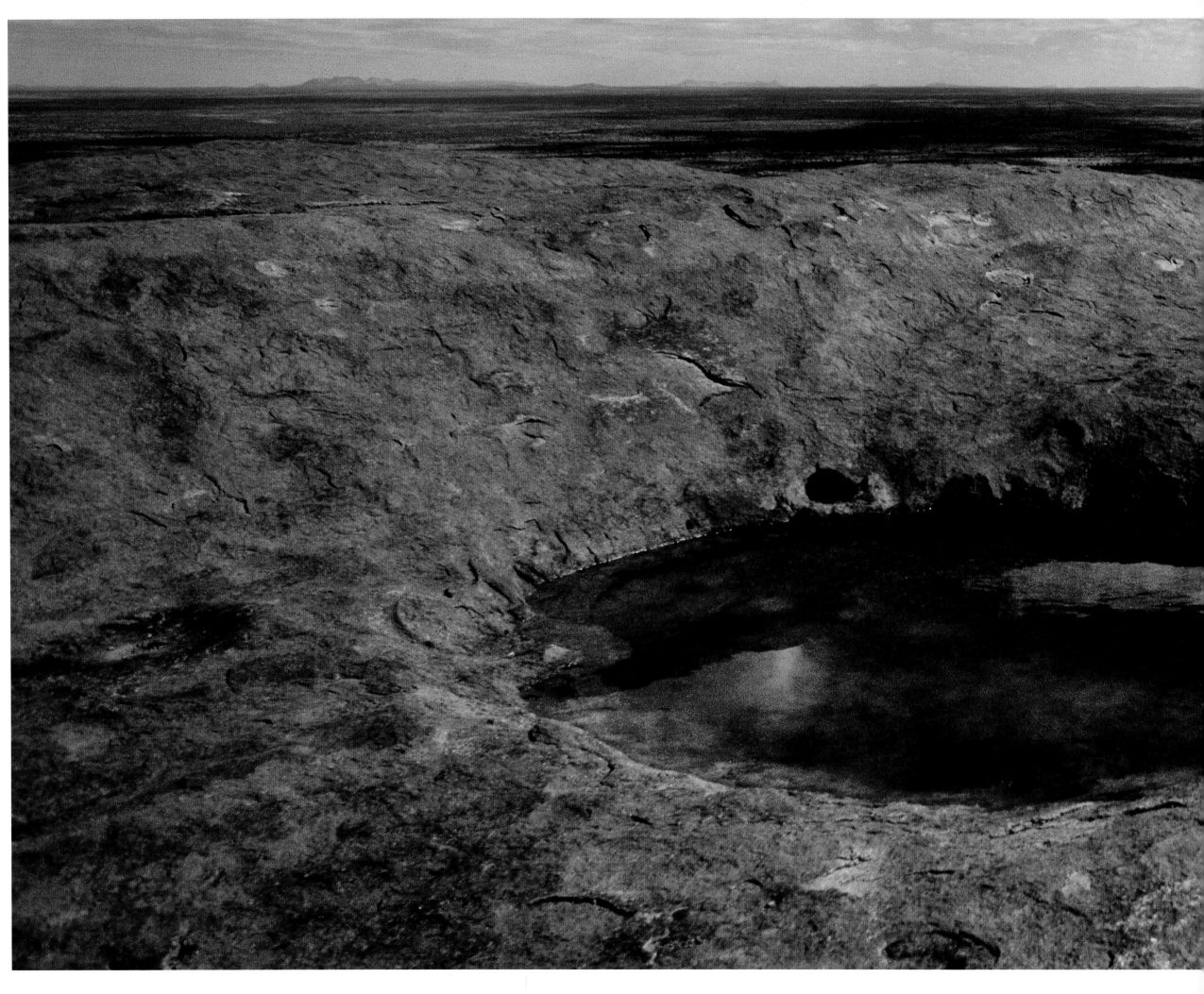

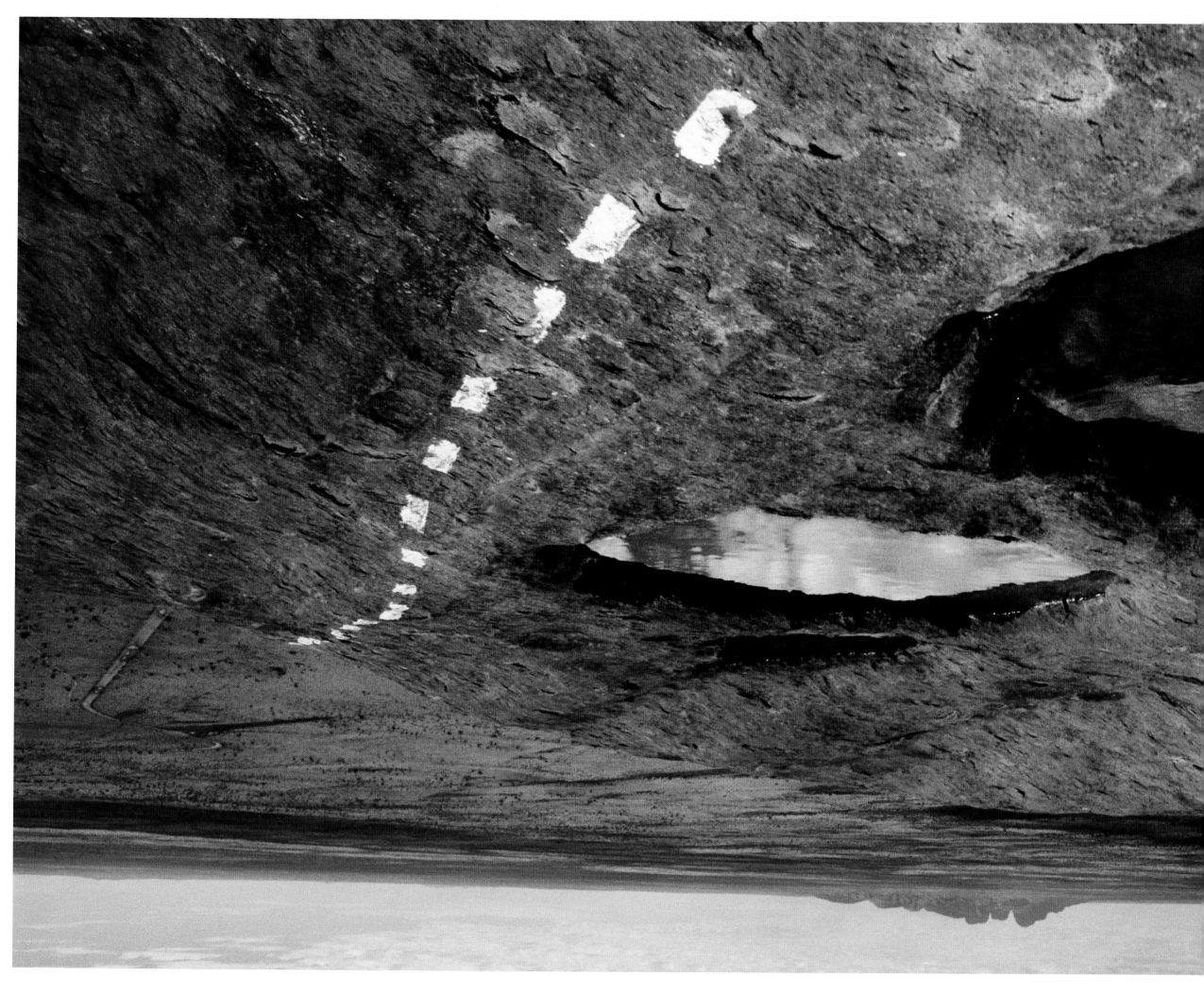

> " I wondered what powerful fate had channelled me into this moment of inspired lunacy. The last burning bridge to my old self collapsed. I was on my own. "

Central Australia's infamous red dust owes its powers of penetration to its incredibly fine texture. Prevailing winds have not only carried it across the continent, but traces of the dust have been found thousands of kilometres away in New Zealand as well.

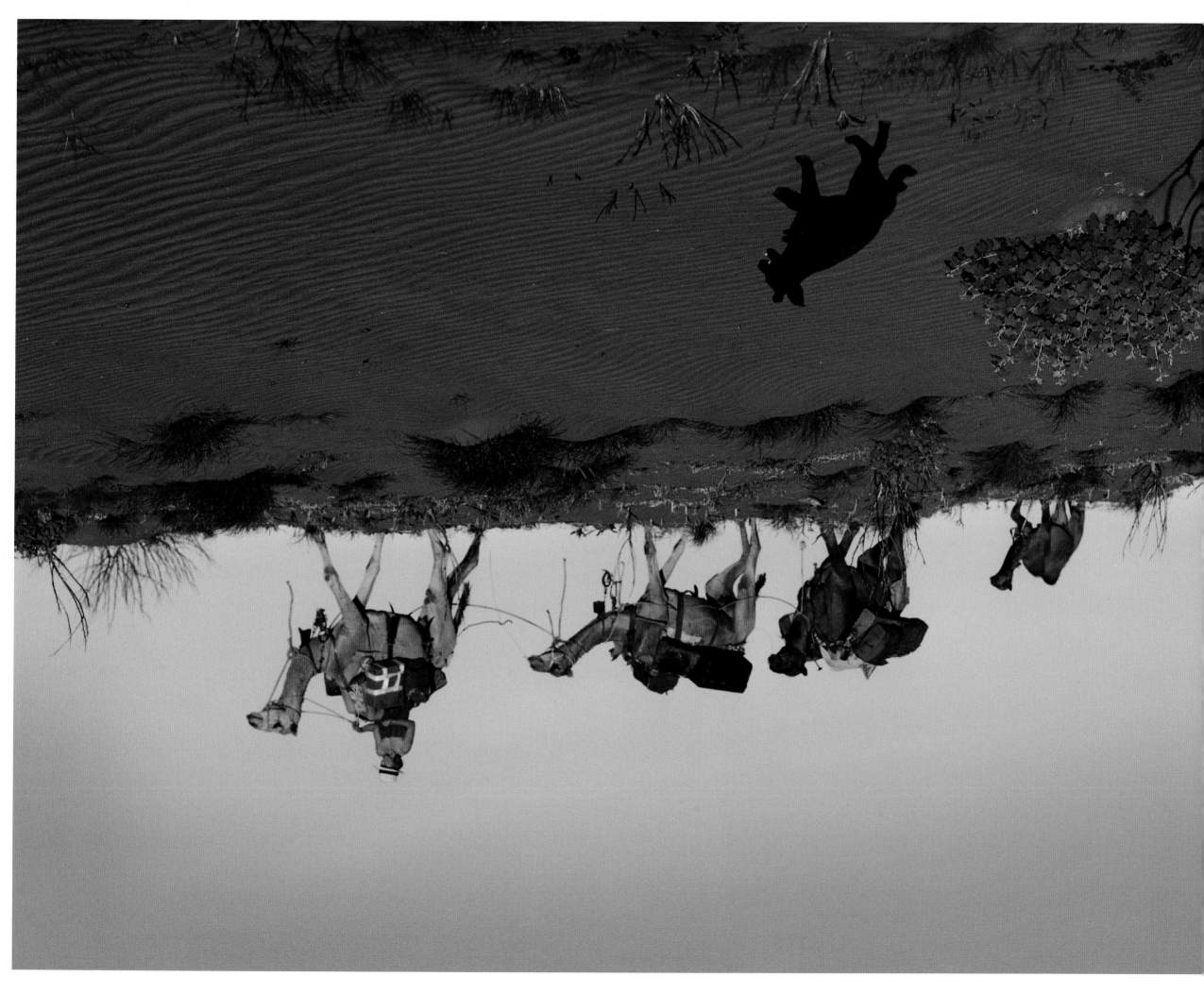

"Mountains pulled and pushed; wind roared down chasms. I followed eagles suspended from cloud horizons. I wanted to fly in the unlimited blue of the morning."

DAY 37 It took Robyn an entire day to make the 35km trek from Uluru to the Olgas. Known to the Aborigines as Kata Tjuta, meaning 'many heads', the Olgas is a formation of 36 rounded rock domes.

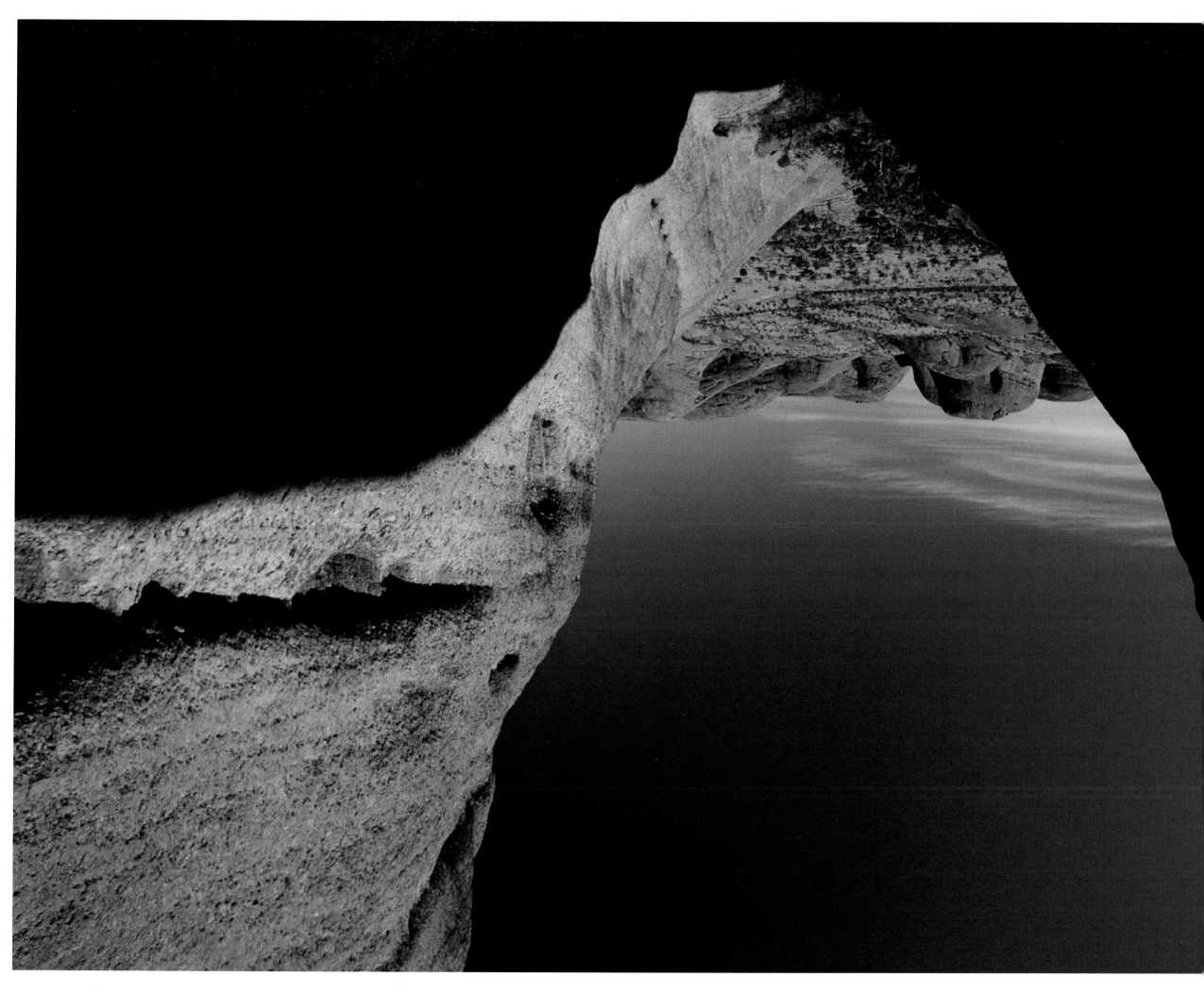

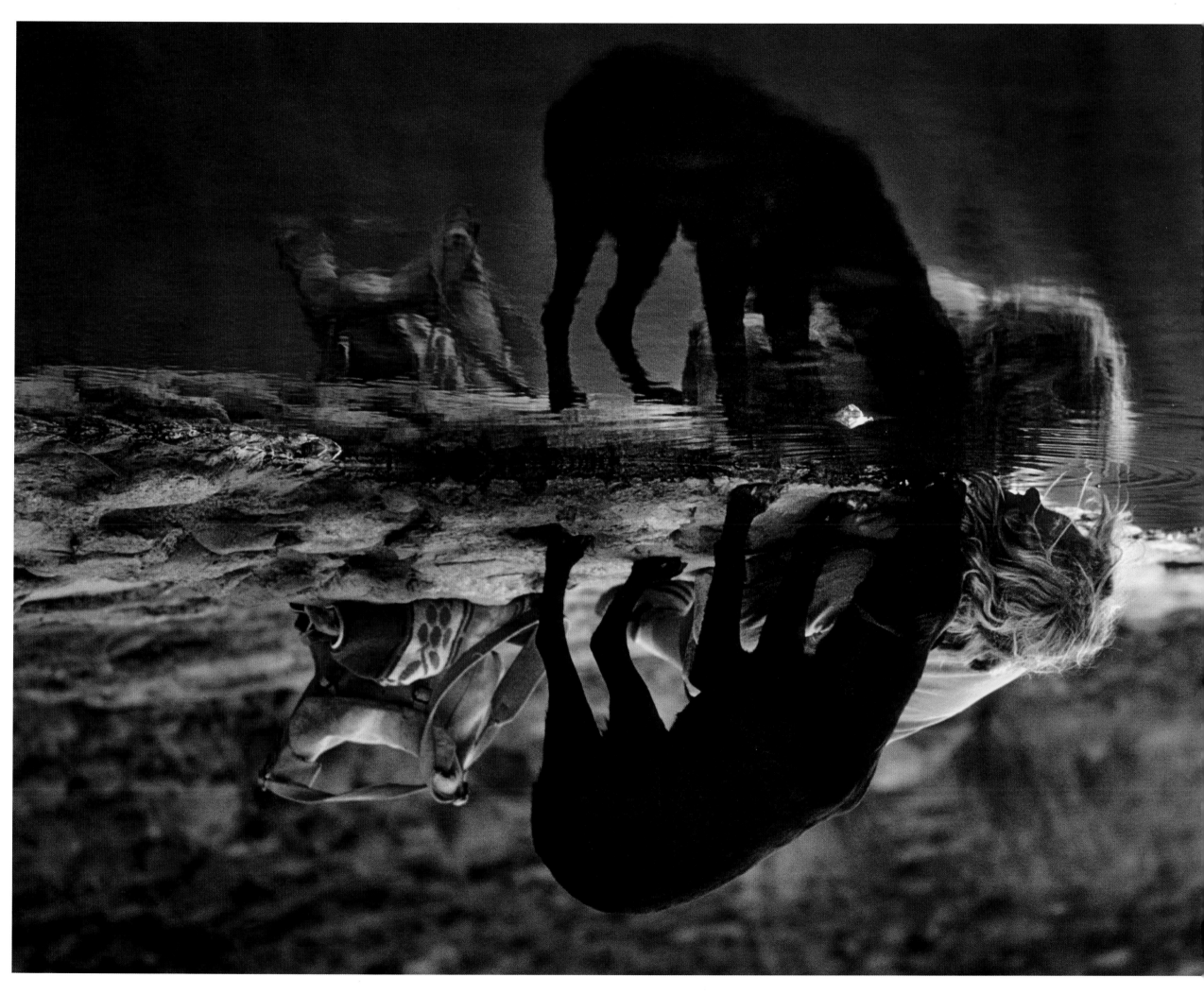

"I sat up on the first sandhill watching the gathering evening change the bold harsh daylight colours to luminous pastels, then deeper to the blues and purples of peacock feathers. The light, which has a crystalline quality I've not seen in any other place, lingers for hours."

The delicate branches of a
young ghost gum glow orange
in the fading desert light.

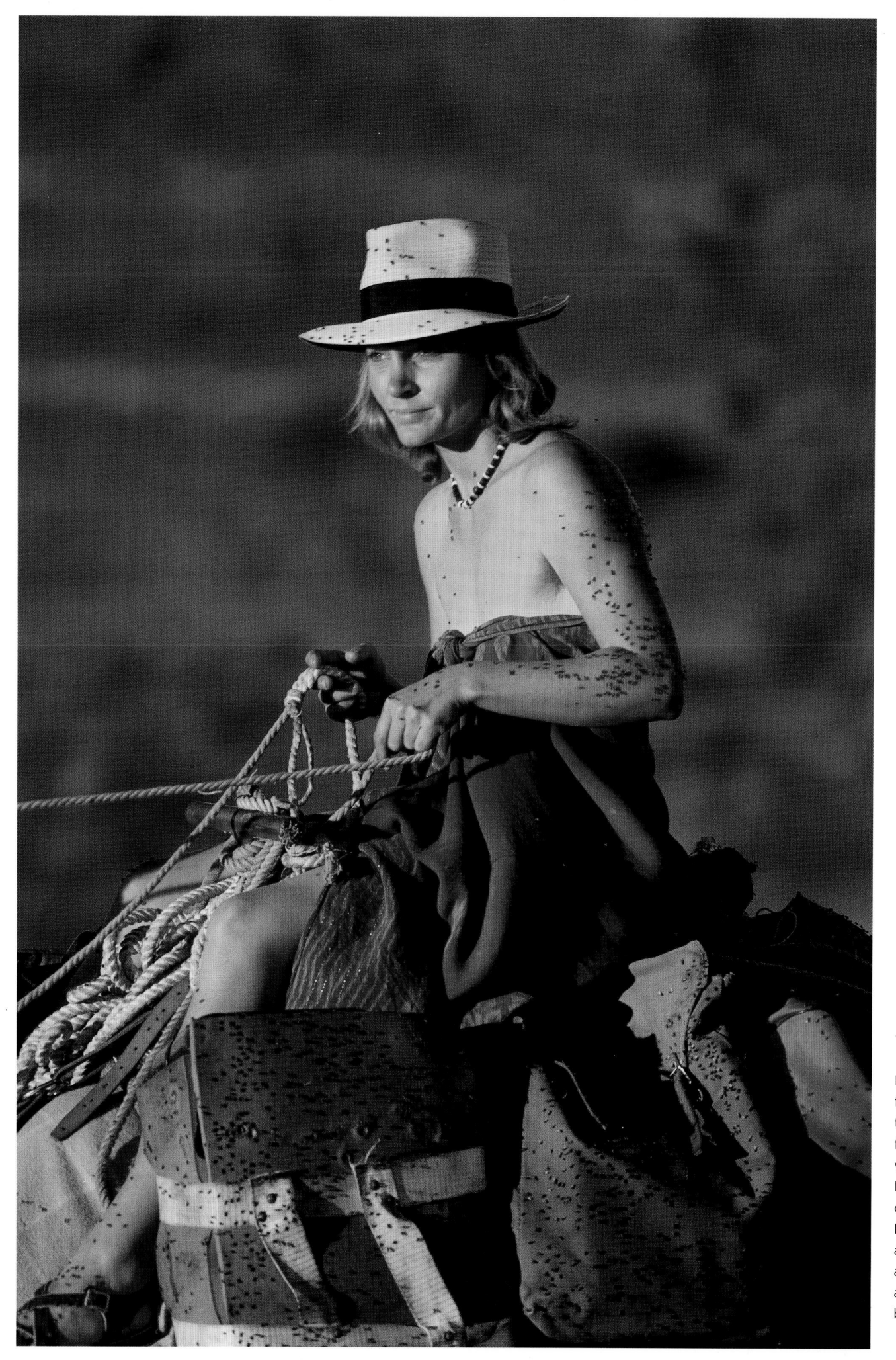

Even before her trip there was a fierceness, intensity and loneliness to Robyn that both attracted and frightened people. 'I was a changed woman. It seemed that anything I may have been before was a dream belonging to someone else. I was self-protective, suspicious and defensive and I was also aggressively ready to pounce on anyone who looked like they might be going to give me a hard time.'

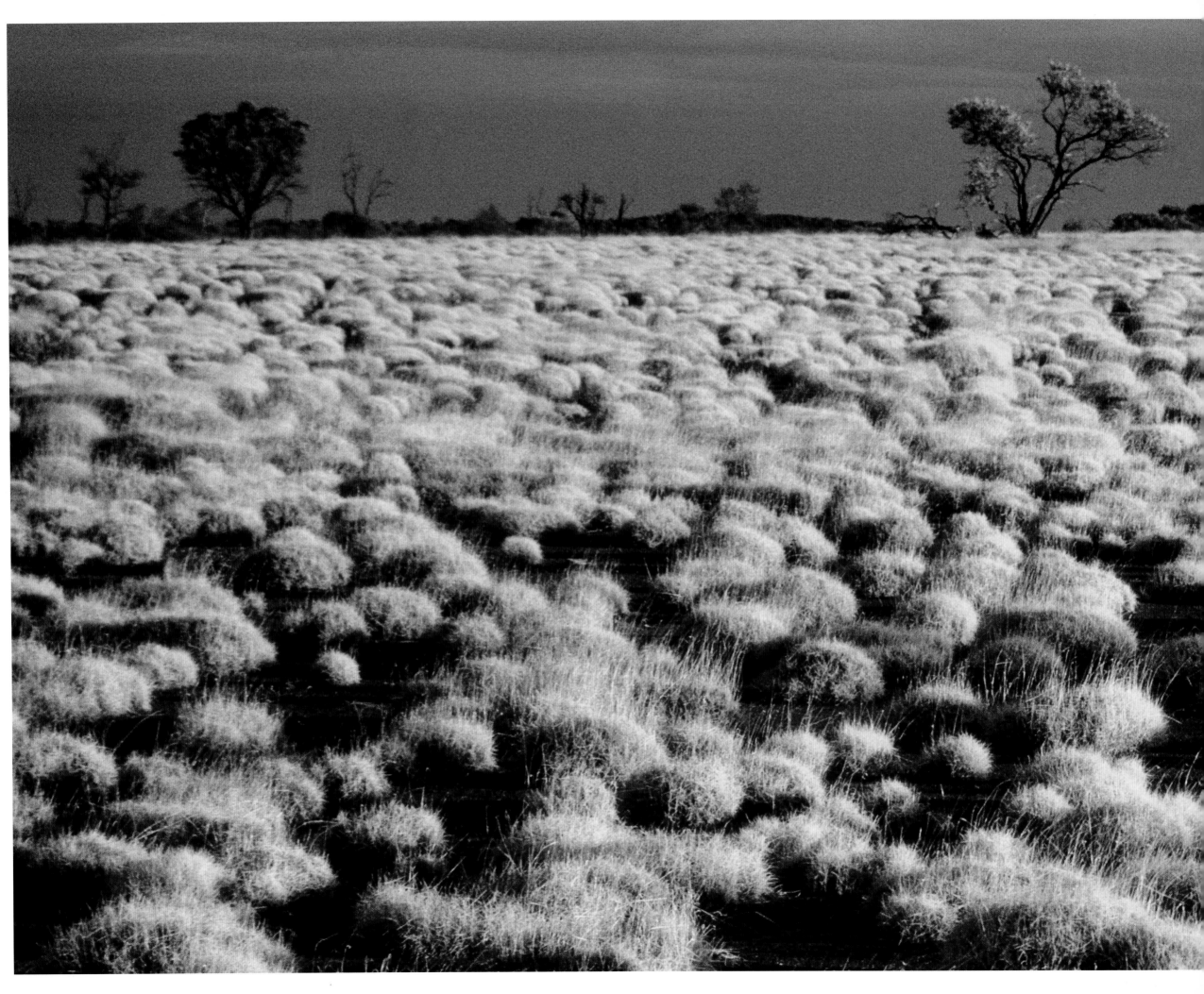

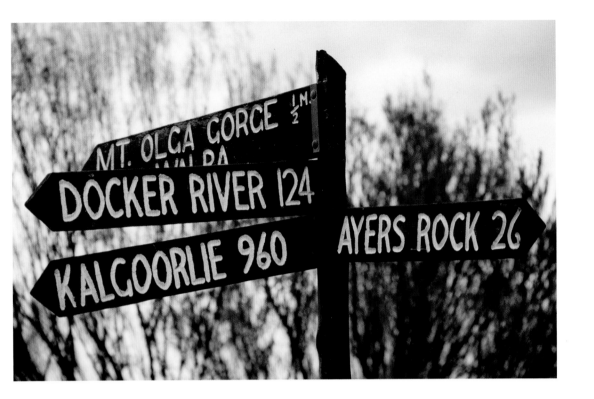

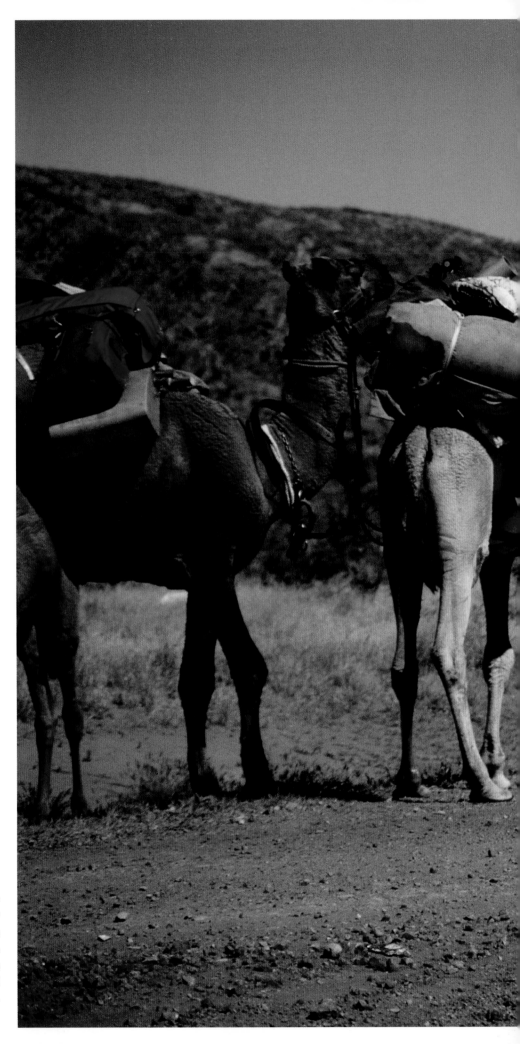

Although there are thought to be over 30,000 wild camels in Australia, the sight of Robyn and her team of four attracted more than a little attention. The Aborigines, who used camels in this area until the 1960s, were now much more attached to mechanical forms of transportation.

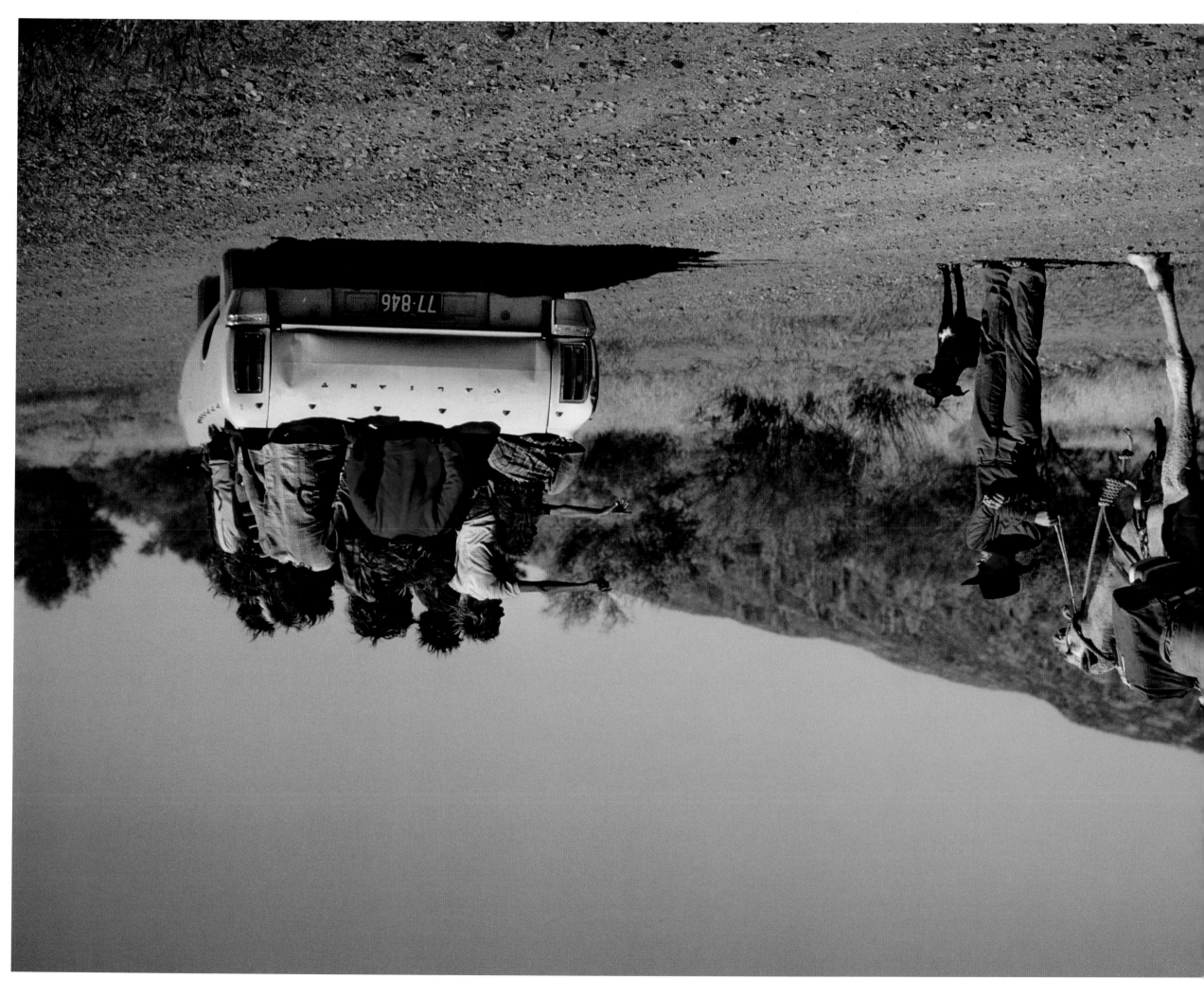

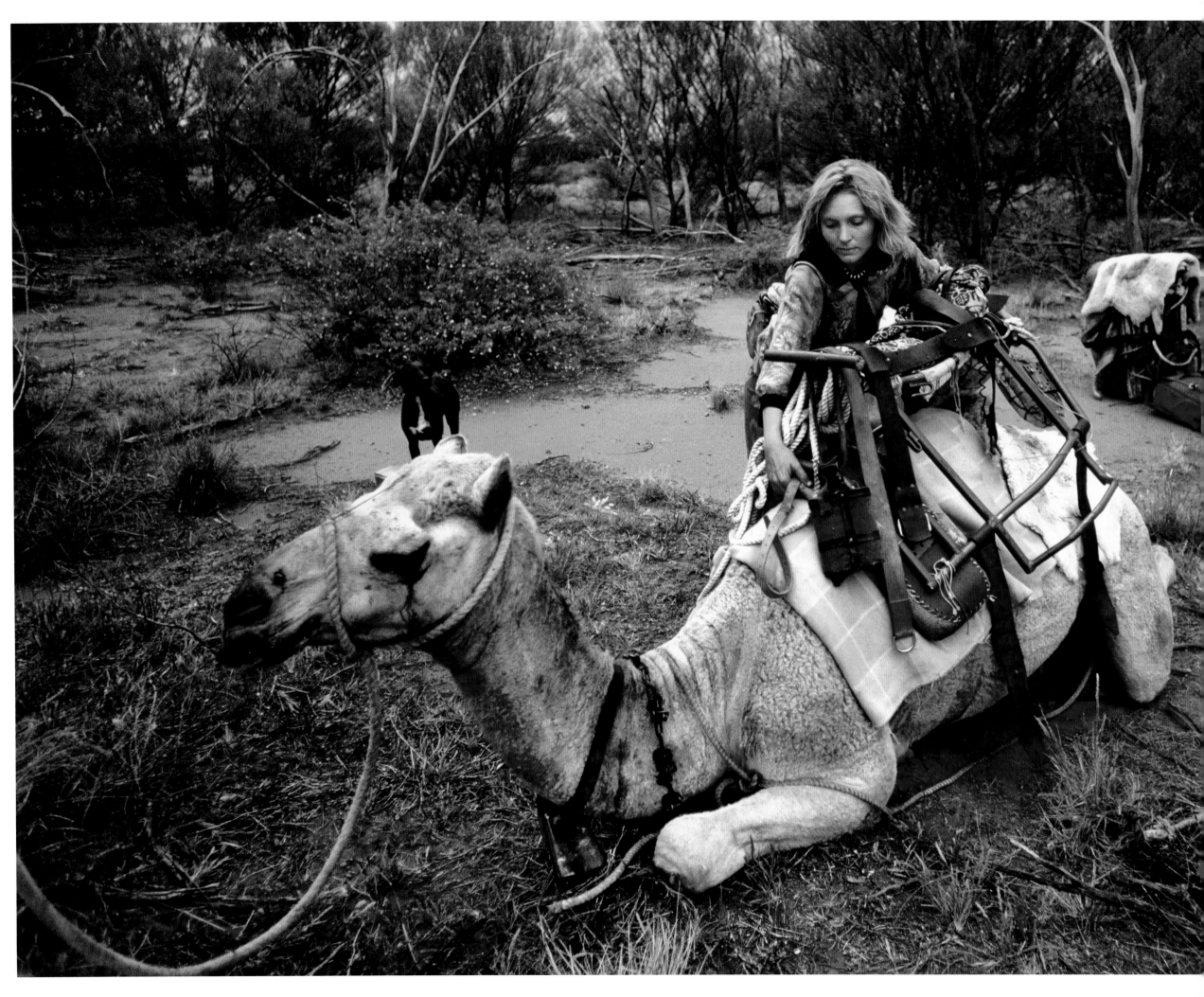

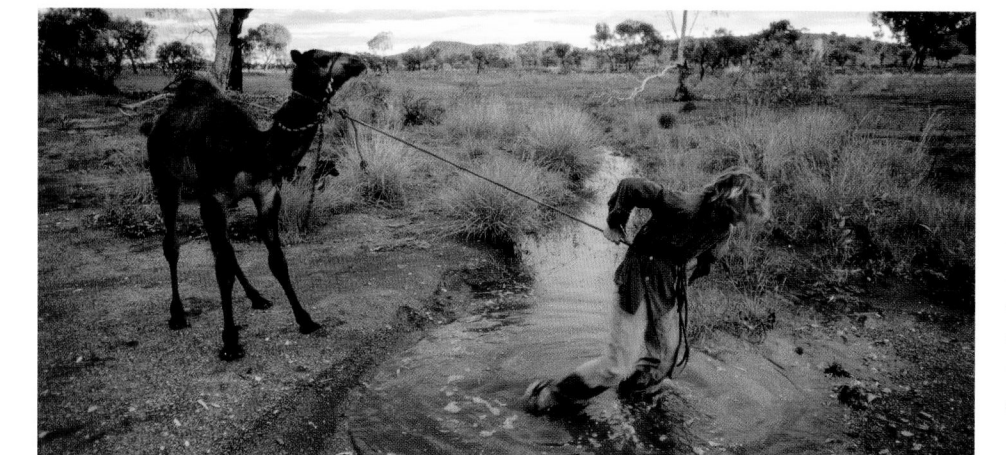

By tying up Goliath every night, Robyn ensured that Zelly (and, therefore, the 'boys' who always followed her lead) would still be around in the morning. The key was catching the calf when it was time to make camp. One evening Goliath, who now weighed over 90kg, suddenly decided he no longer liked being caught or tied up.

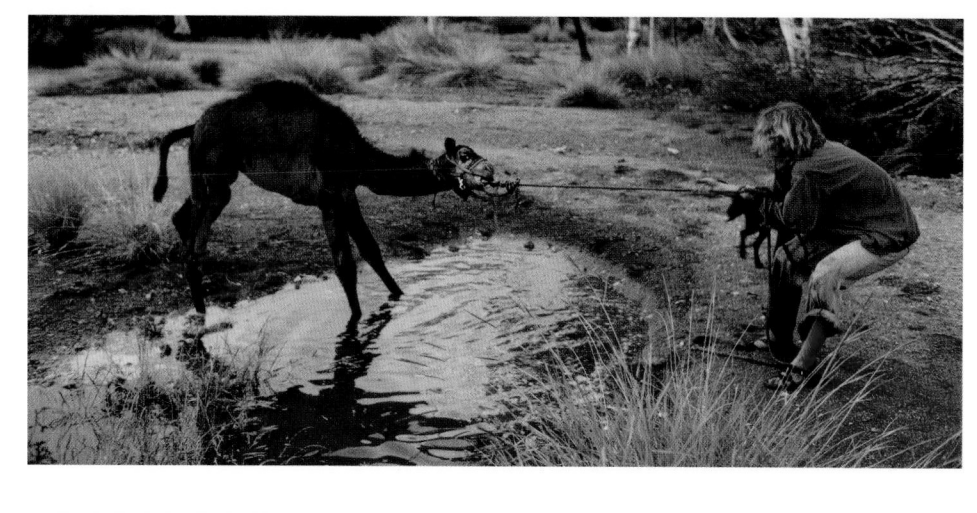

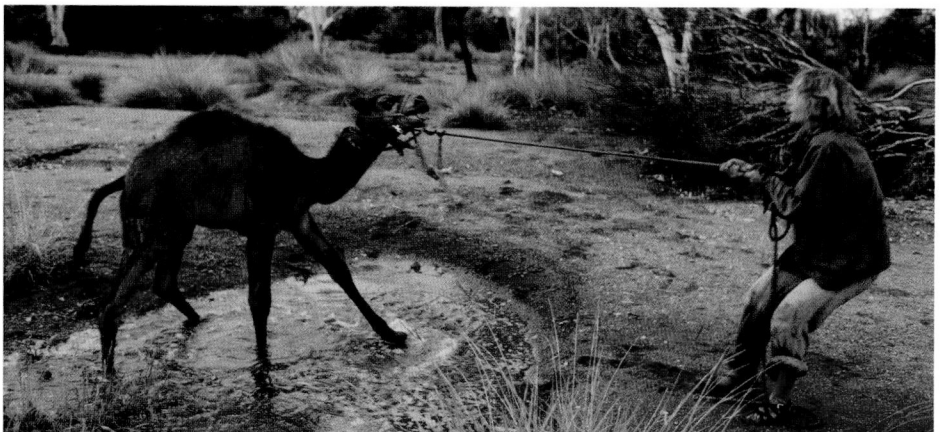

Robyn's three adult camels carried the supplies necessary for her, and their, survival. Each morning she loaded 230kg of gear onto the animals, including hand-made water drums, tin trunks of food, clothes, tools, her swag and dog biscuits for Diggity. In the early days of the trip it took her over two hours to load the camels.

" The whole texture of what I wanted to do was to be alone, to test, to push, to unclog my brain of all its extraneous debris, not to be protected, to be stripped of all the social crutches, not to be hampered by any outside interference whatsoever. "

Robyn felt the trip beginning to work its magic on her in strange and unexpected ways. 'When there is no one to remind you what society's rules are, and there is nothing to keep you linked to that society, you had better be prepared for some startling changes.'

"And as I walked through that country, the motions and patterns and connections of things became apparent on a gut level. I didn't just see the animal tracks, I knew them. I didn't just see the bird, I knew it in relationship to its actions and effects. My environment began to teach me about itself without my full awareness of the process."

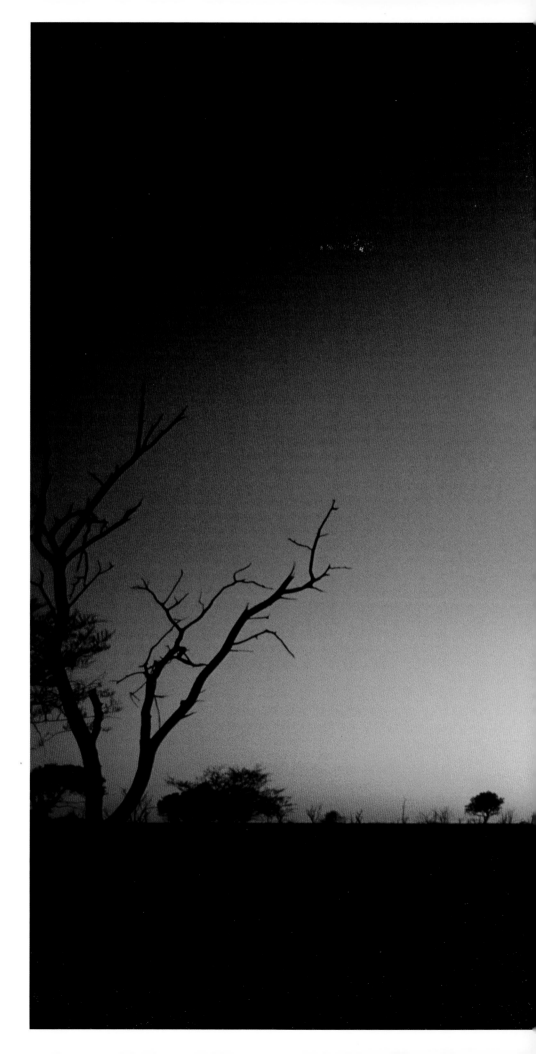

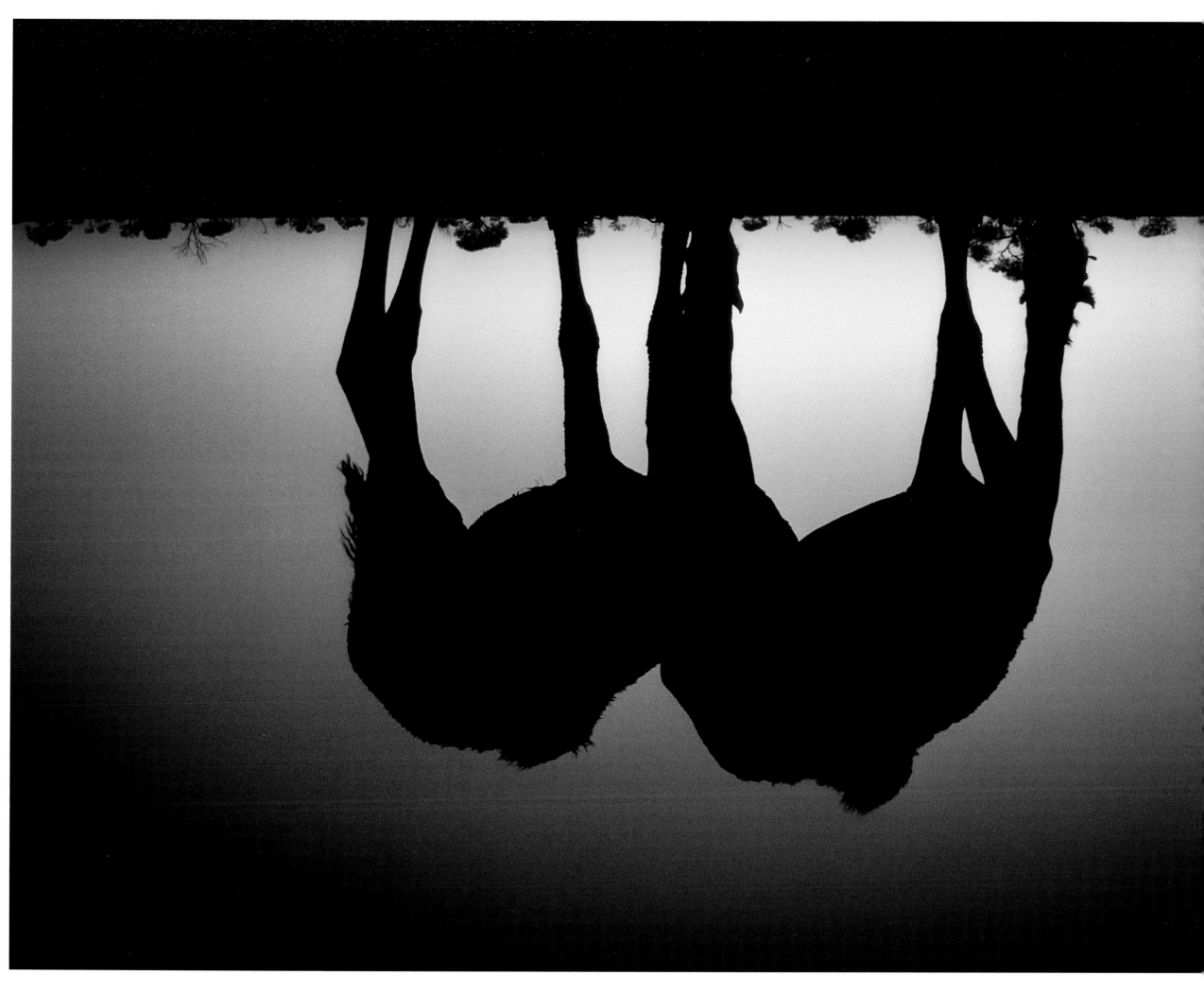

> **Some camps on those nights were so desolate they stole into my soul, and I longed for a safe nook out of that chill empty wind. I felt vulnerable.**

Evening temperatures in the desert often dropped below freezing so a warm fire was a welcome way to end a hard day's work. After making camp, Robyn would cook dinner and then listen to tapes that taught her to speak Pitjantjatjara, the local Aboriginal dialect.

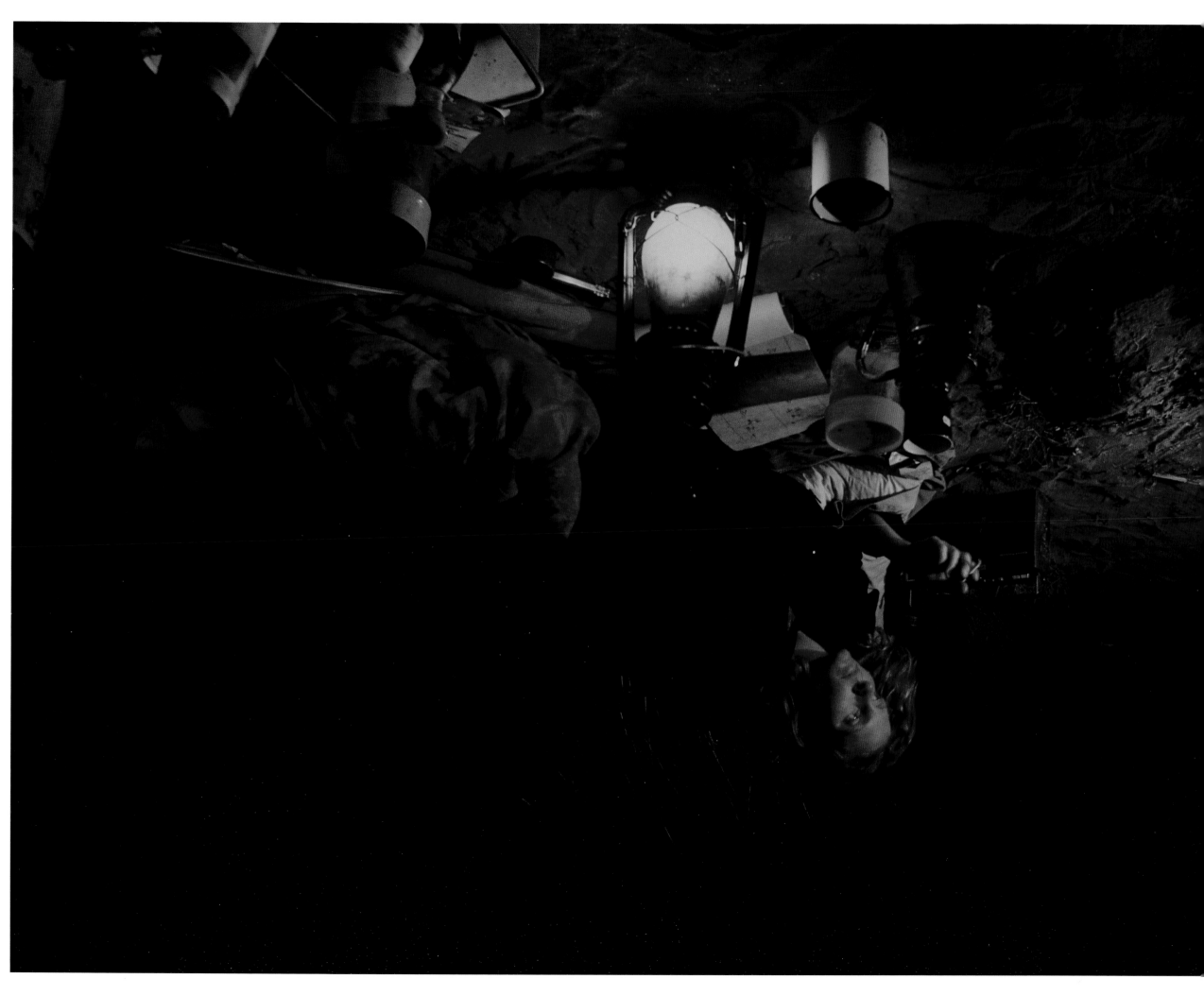

> **"** One continues to learn things in life, then promptly forget them. I should have known that pride comes before a fall. I was beginning to feel cocky, in control of events, self-congratulatory, complacent. Life was good. Nothing could go wrong. **"**

The camels took to travel and seemed to enjoy the sense of mission that Robyn imparted to the journey. They all grew accustomed to the daily 32km rhythm. It was usually safer to walk than ride, but if Robyn did ride any camel it was Bub. When he got through an entire day without being spooked, she rewarded him with tasty plant snacks.

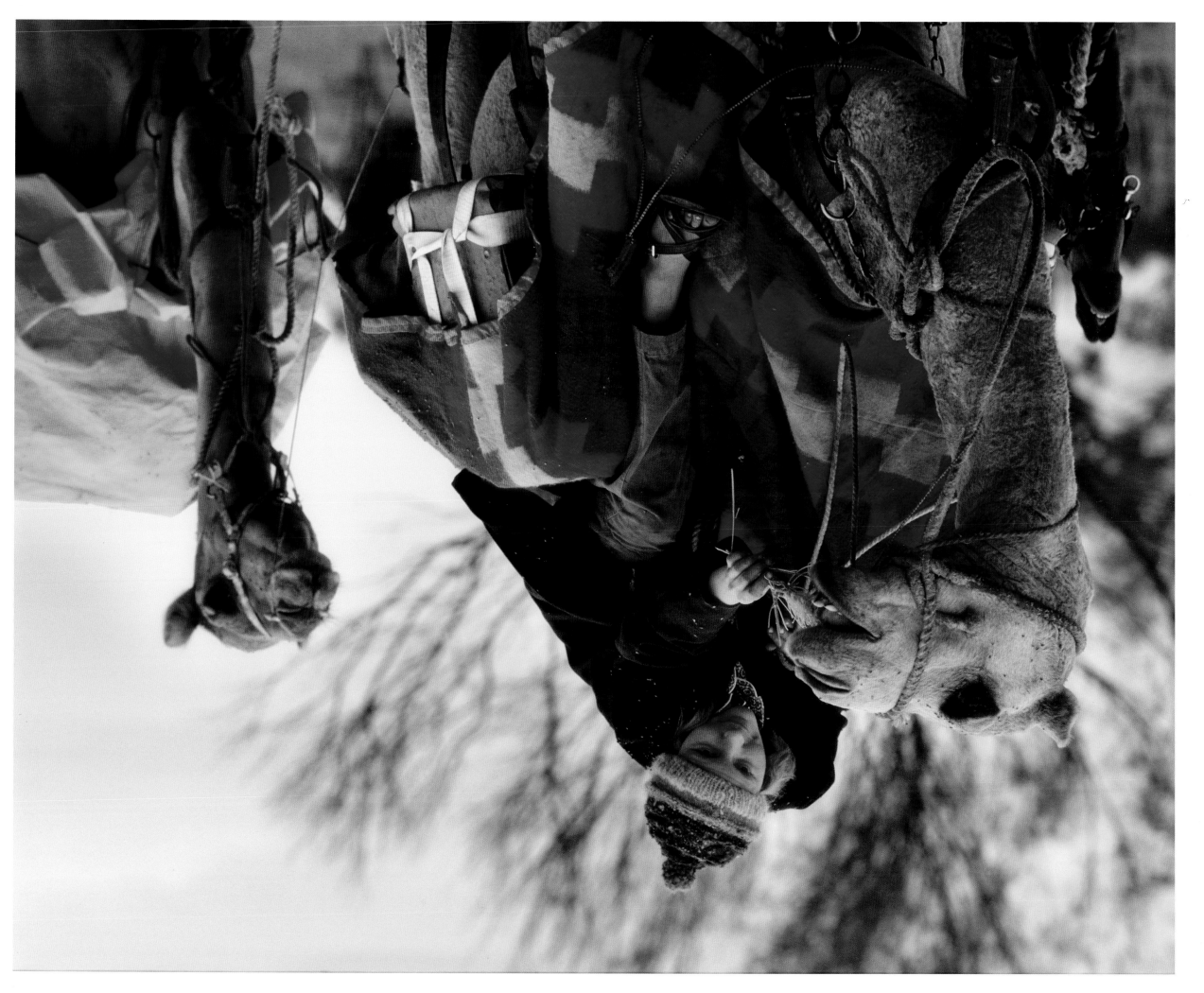

"Then the rain came. Great angry thundering clouds swarmed and bustled out of nowhere and it poured a deluge. It rained cats and dogs, elephants and whales."

The bottom of a camel's foot is covered with a smooth pad like a bald tyre. The pad contains a squishy, elastic sort of bladder that allows the camel to glide effortlessly over and through the sand. On treacherous surfaces such as a rain-soaked creek bed these pads become very slippery. Walking to Docker River through this rainstorm, Dookie slipped and crashed to the ground.

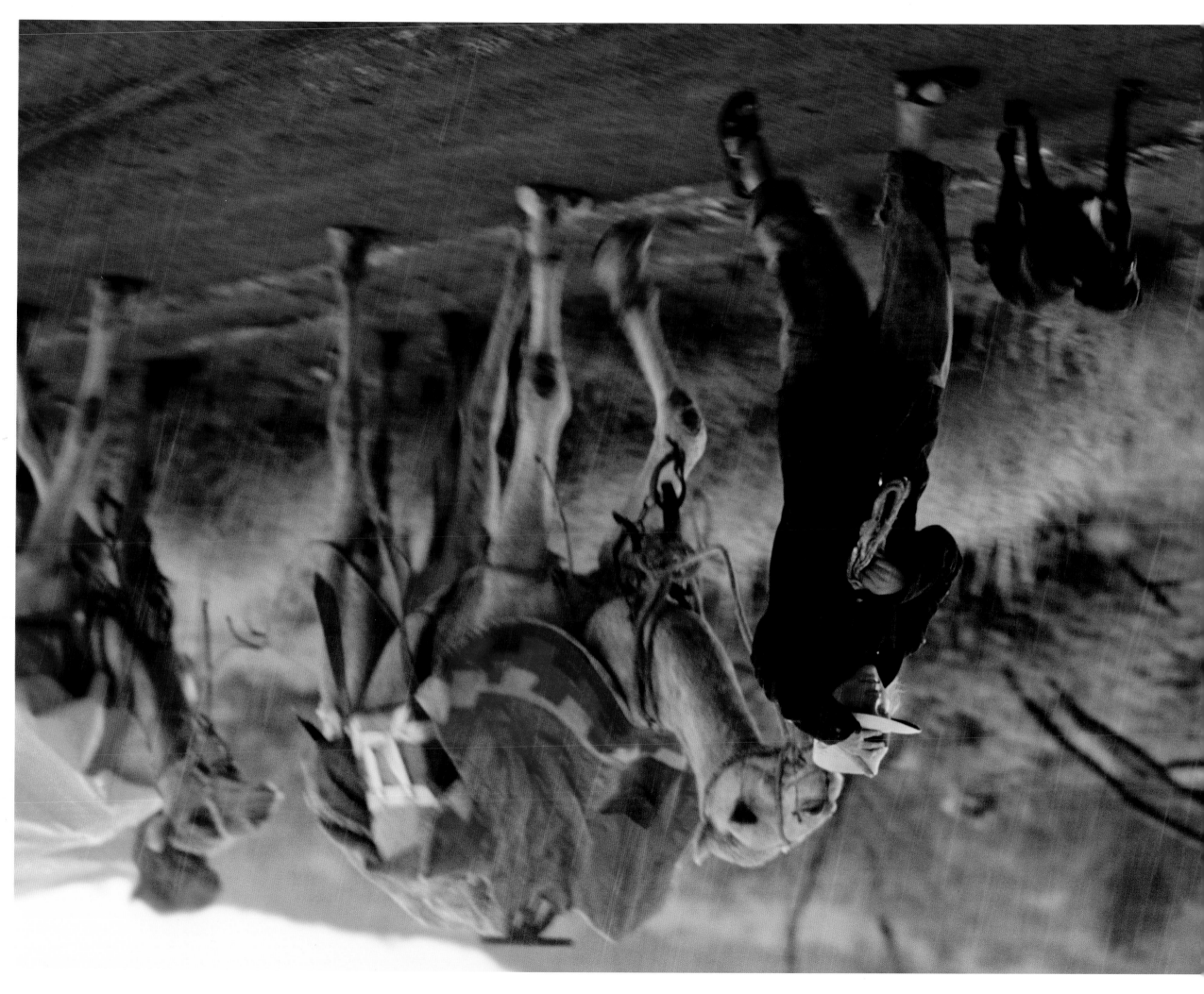

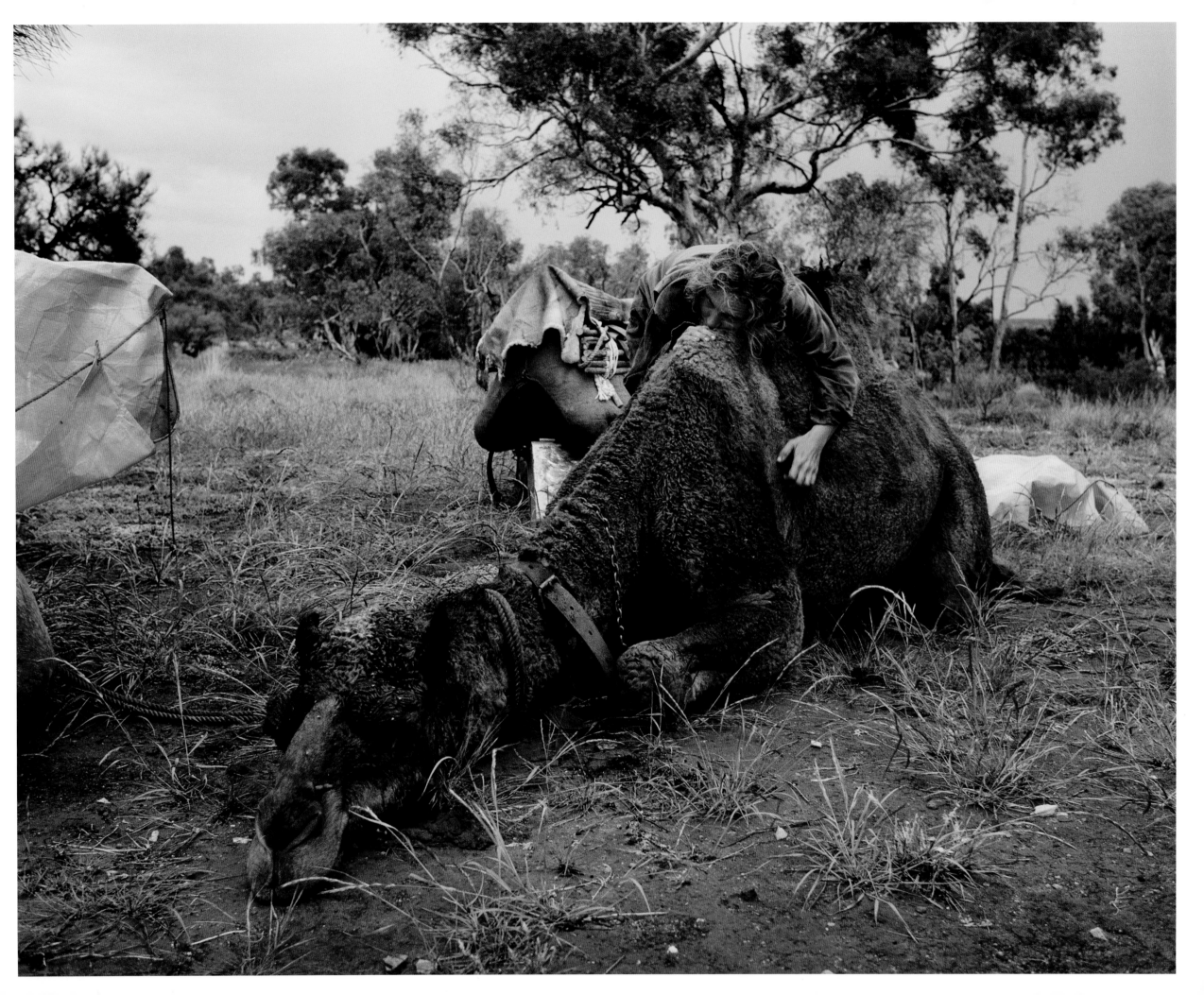

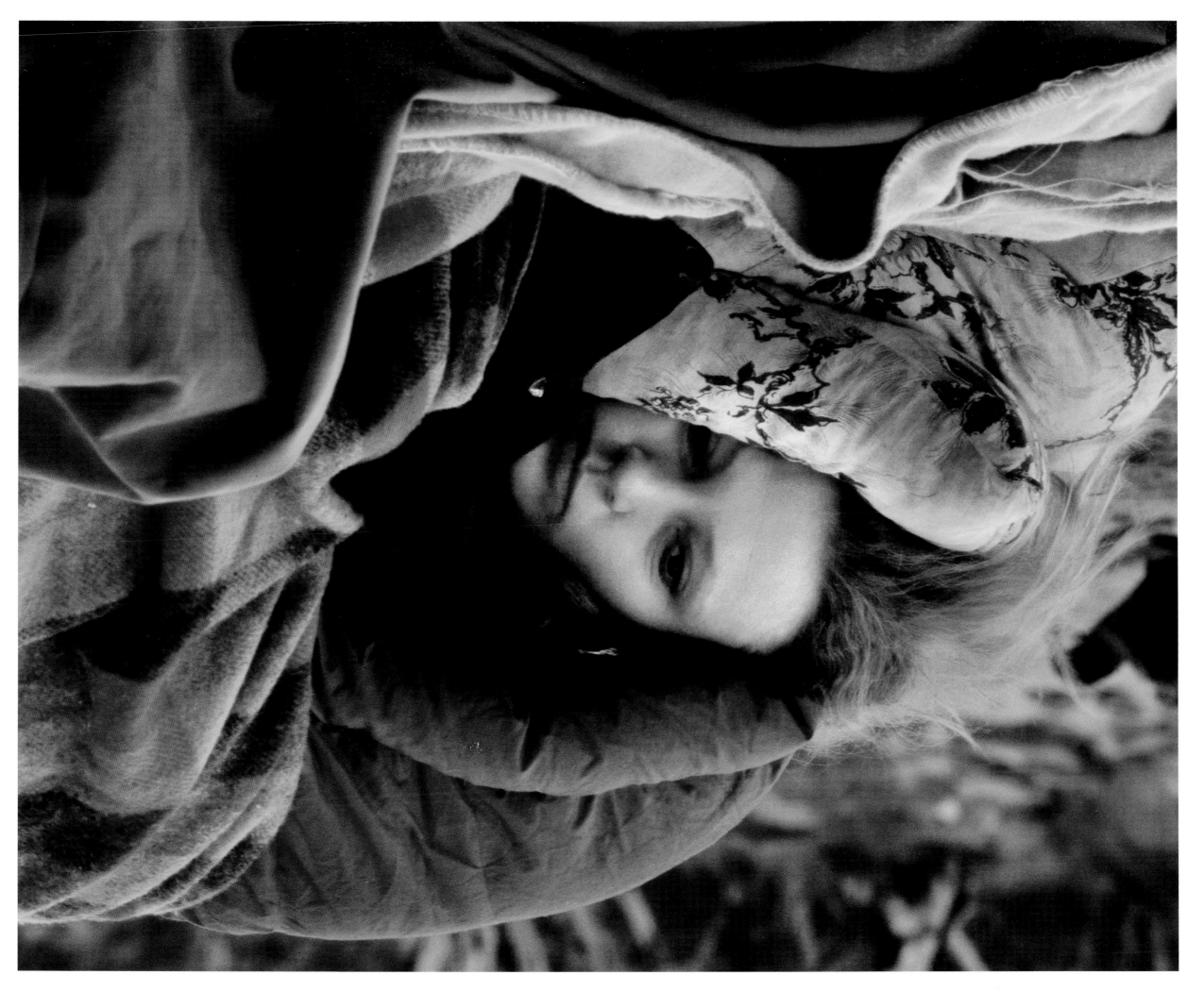

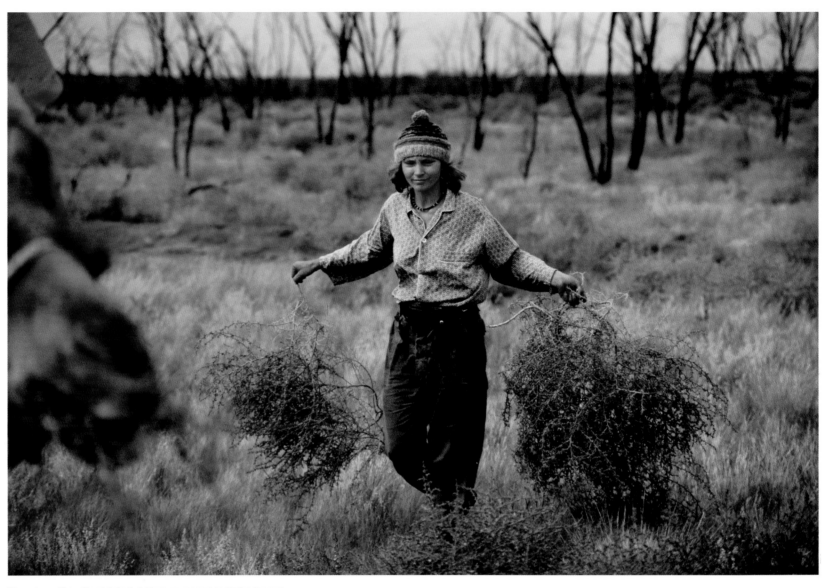

The day after Dookie's fall Robyn spent painful hours picking a desert plant that the camels loved to eat. Like many prickly plants, it has a high water content. The prickles didn't bother Dookie's leathery tongue, but Robyn's hands were torn and bloody.

Even though Robyn had a compass and detailed maps, tracks could head off in five different directions. There was no way to know which might be a 15km dead end and which was the one marked on the map.

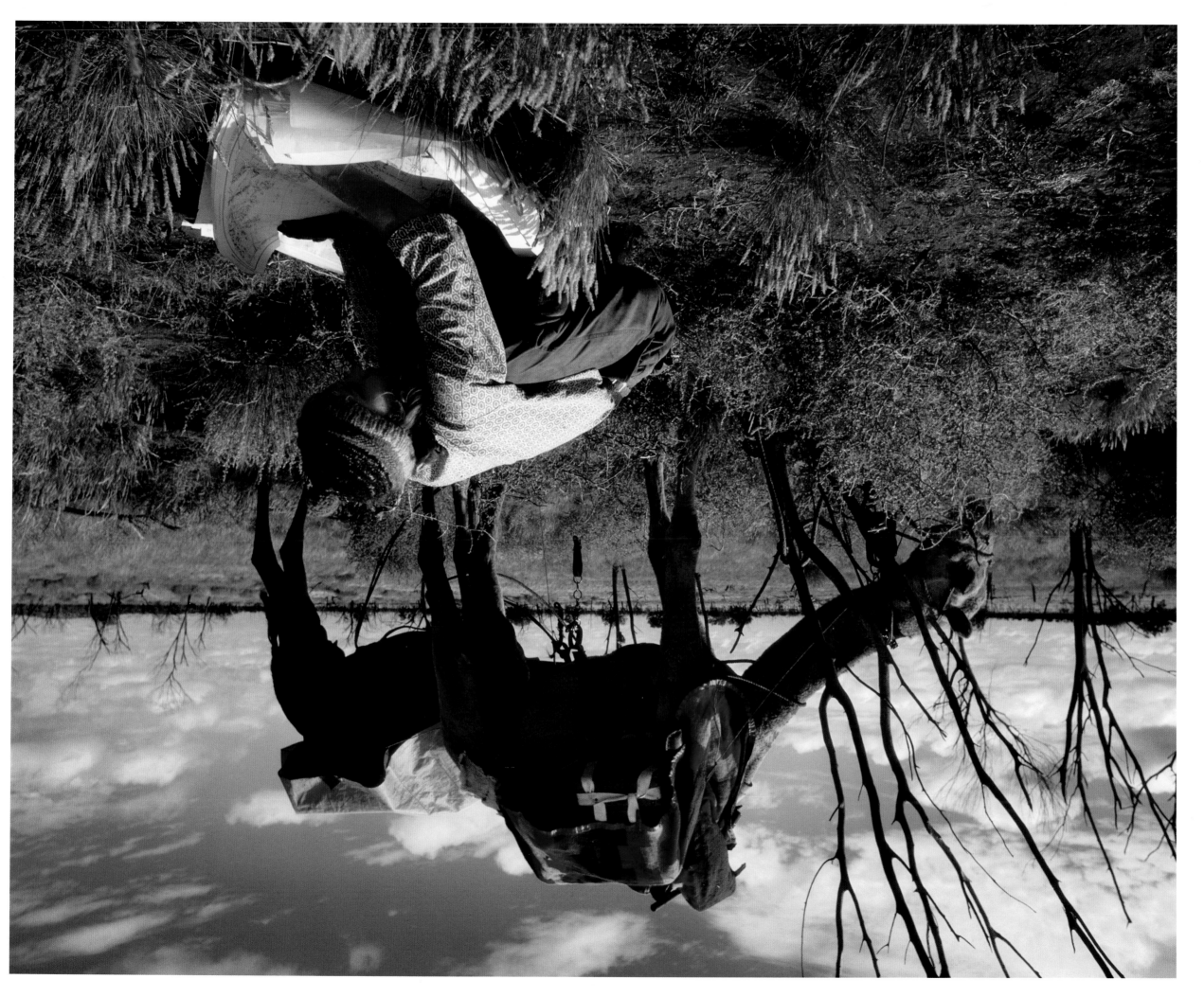

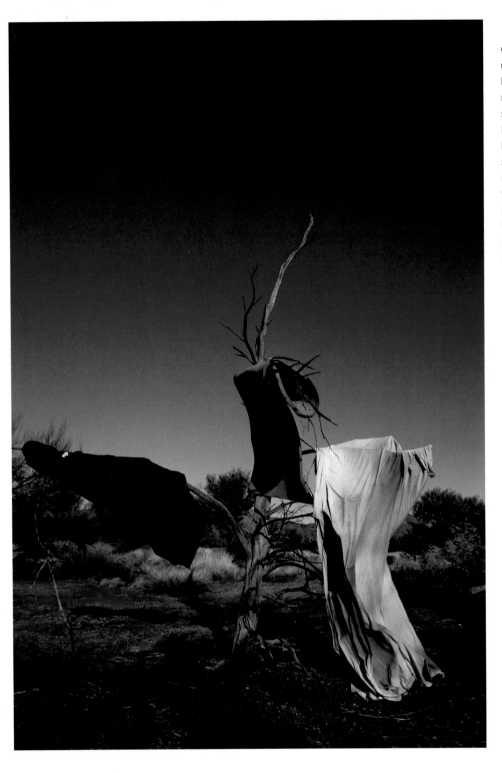

One day, after hanging up some sheets and blankets to air in the morning breeze, Robyn saw something wraith-like at the corner of her field of vision. She swung around with a rush of adrenaline. It was the first time she realised how easy it was for the camels to see spooky ghosts behind every bush.

Long before the Europeans arrived, Aborigines knew about the many medicinal uses of fever trees (ghost gum eucalypts like the one reflected in a rock pool, right). Considered to have an almost magical ability to cure dysentery, life-threatening fevers and other illnesses, these trees were later exported and planted all over Europe.

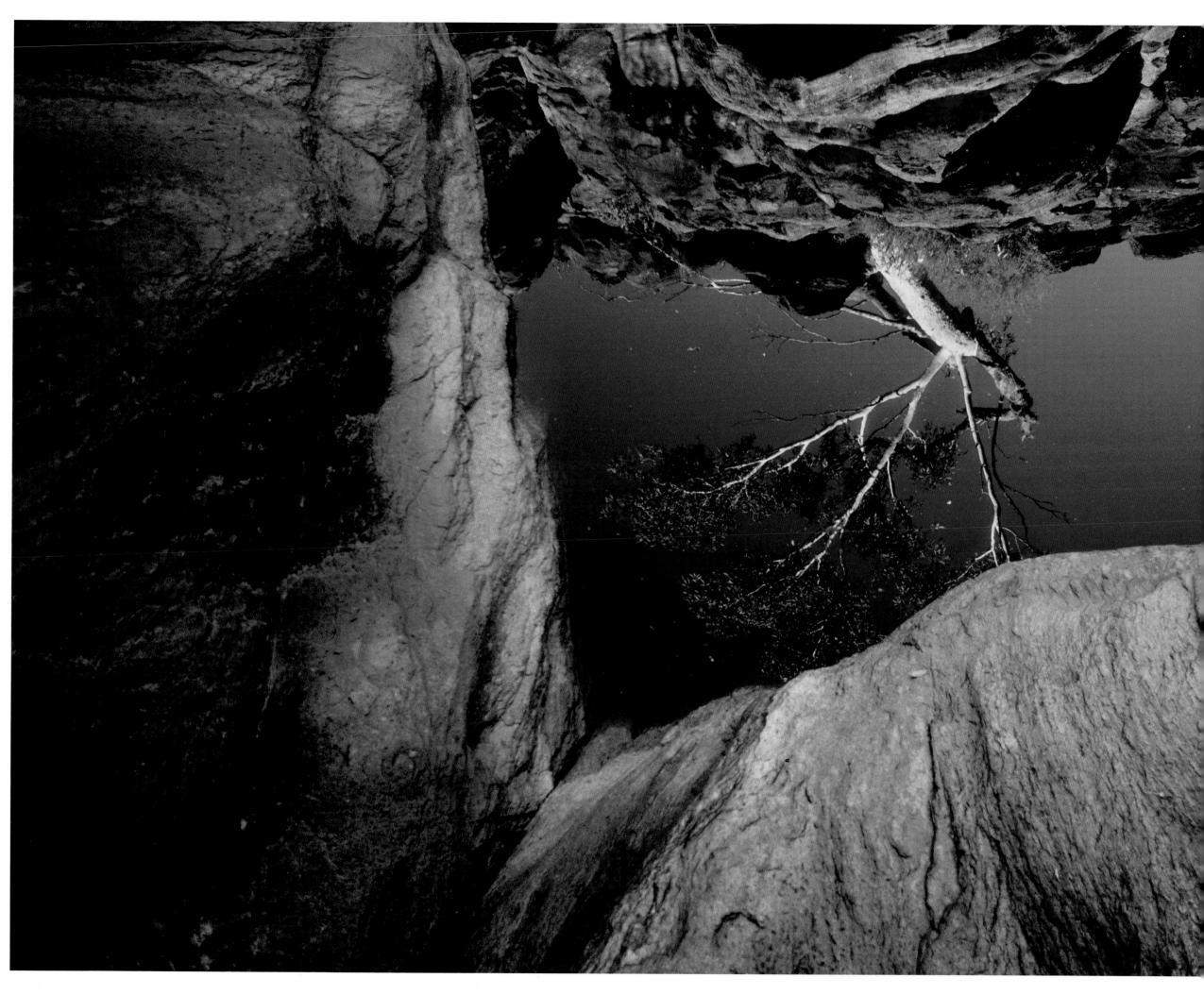

> **"** It's amazing how well one can communicate with a fellow being when there are no words to get in the way. Our greatest joy lay in the sound of birds which he taught me to mimic, the laughter at the antics of the camels, the discovery of things to eat. **"**

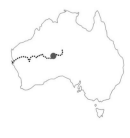

DAY 105 One night at the beginning of the trip Robyn dreamt of an old Aboriginal man who became her friend and shared the secrets of Dreamtime with her. Months later, just as she was beginning to feel the trip was empty and meaningless, Mr Eddie appeared and travelled with her for the next 300 kilometres.

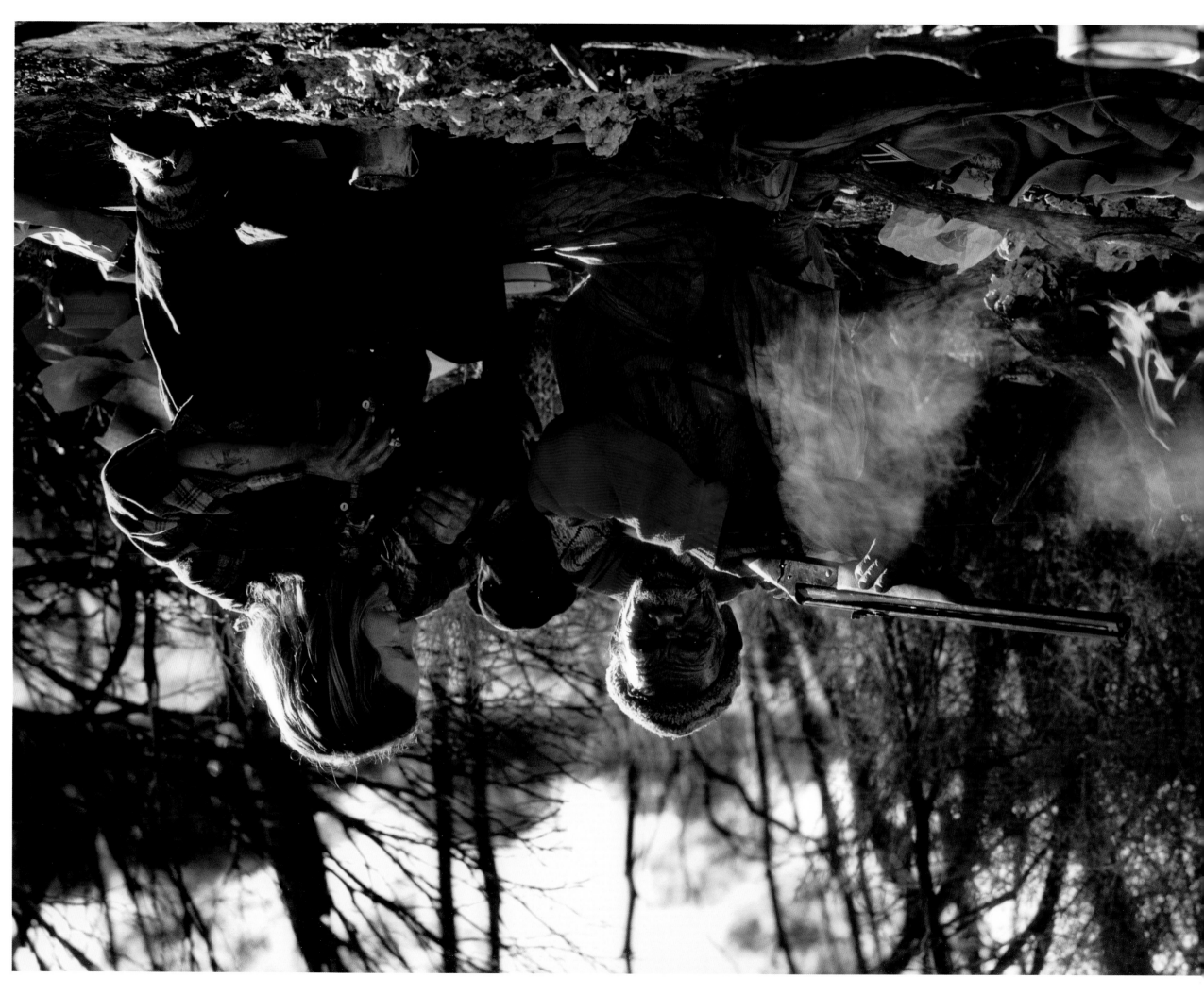

" He was sheer pleasure to be with, exuding all those qualities typical of old Aboriginal people—strength, warmth, self-possession, wit, and a kind of rootedness, a substantiality that immediately commanded respect. "

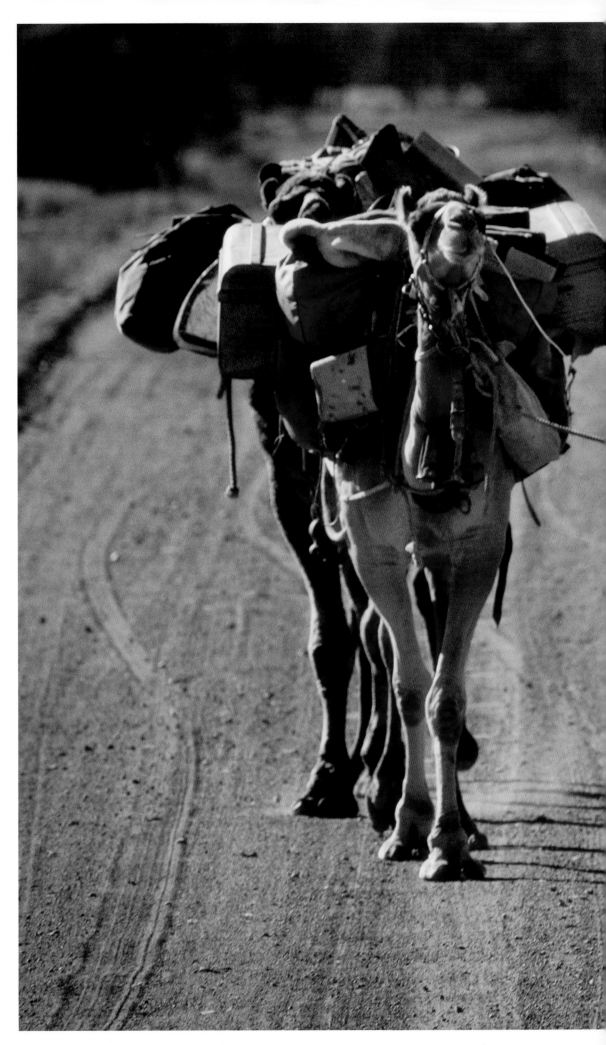

Mr Eddie's companionship opened Robyn up to aspects of the desert she hadn't earlier noticed. He not only taught Robyn the names of birds and plants, but he changed the way she experienced the passage of time. Robyn and Mr Eddie walked the last stretch of road leading into Warburton. This was where they would part.

The tourists Robyn encountered along the way were a constant source of irritation. They would snap pictures, pester her with questions or treat her like an outback sideshow. Their behaviour reminded her that Aborigines wisely divide people into two groups: tourists and travellers.

Tourists frightened the camels by zooming up alongside and many were downright rude to Robyn as well, gawking at her without even offering a drink of water.

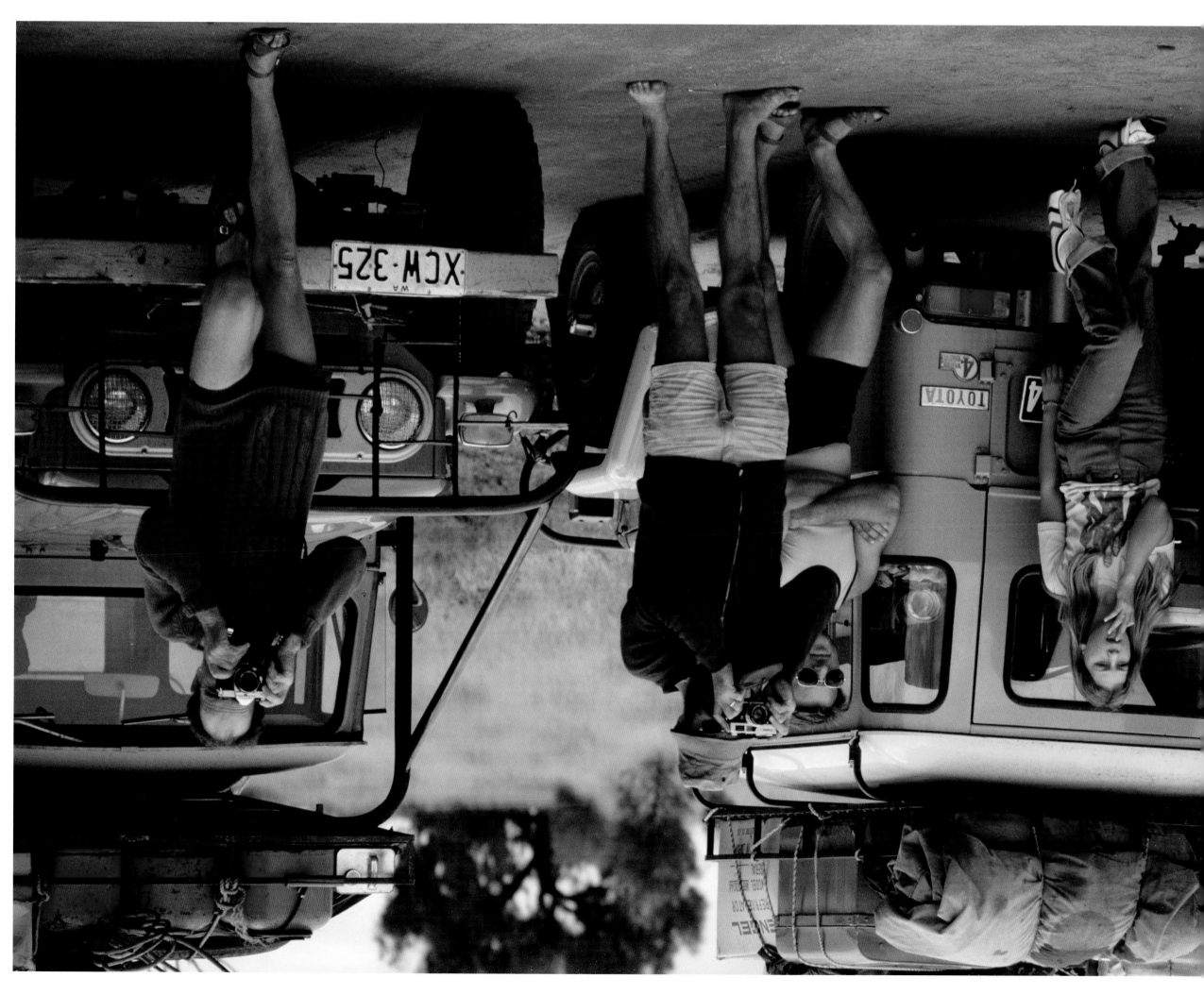

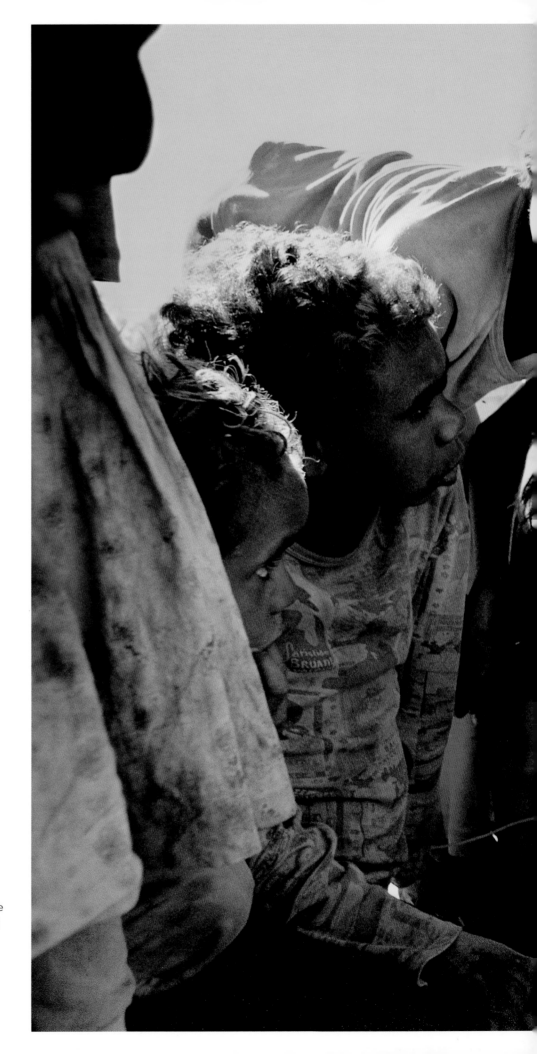

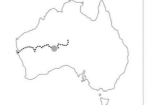

The Aboriginal school children of Warburton
reported on Robyn's arrival in their daybook,
complete with a drawing of Mr Eddie riding on Bub.

> Monday 11ᵗʰ July.
> We went to see Robin at Snake Well. She was walking with four camels. Mr Eddie from Wingellina was with her. She started from Alice Springs and is going to Carnarvon. She has a dog named Diggetty.
> Rhoda and Roelien have been camping south of here. Everyday they saw a Jumbo Jet flying overhead. (Going from Melbourne to Singapore.)

DAY 142 Robyn finally got some use
out of her Flying Doctor radio to call
a friend to take Mr Eddie home.

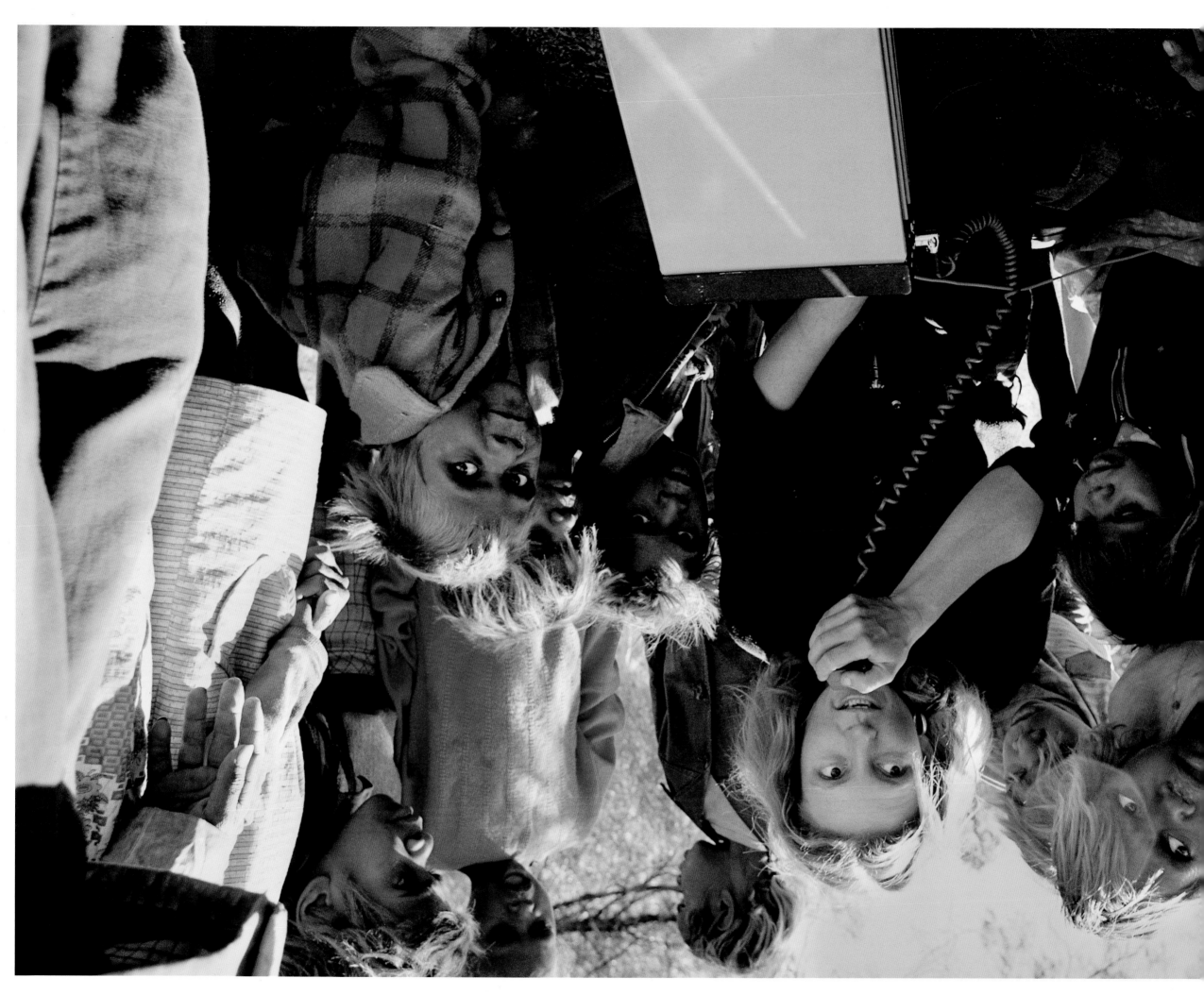

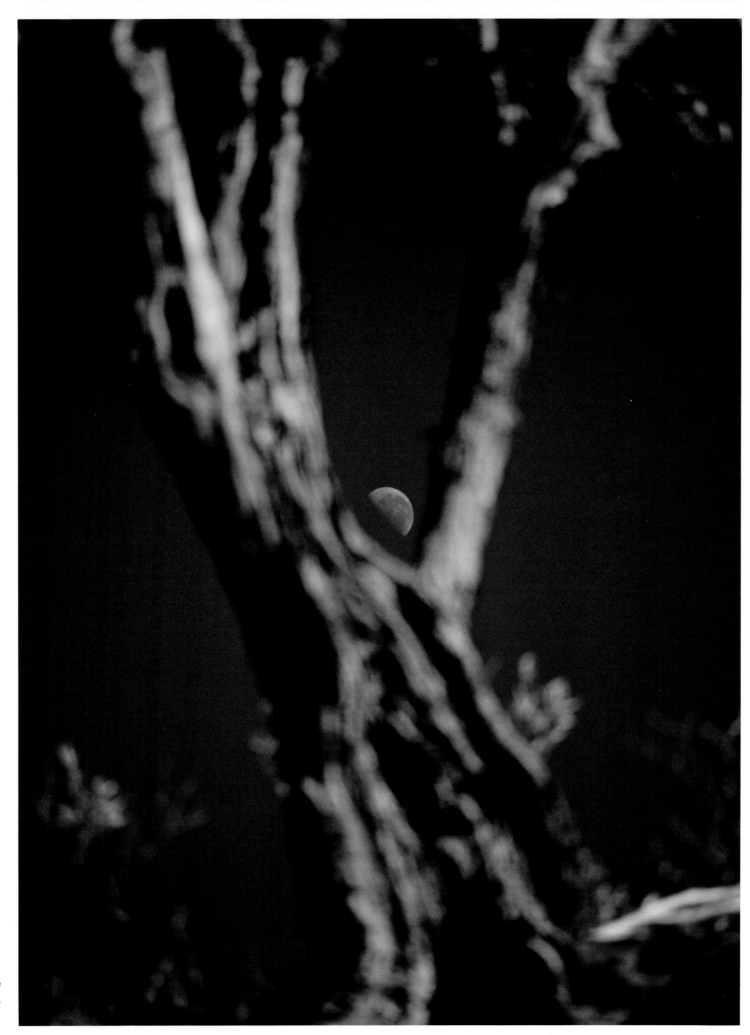

A ghostly moon rises behind the
trunk of a tree in the Gibson Desert.

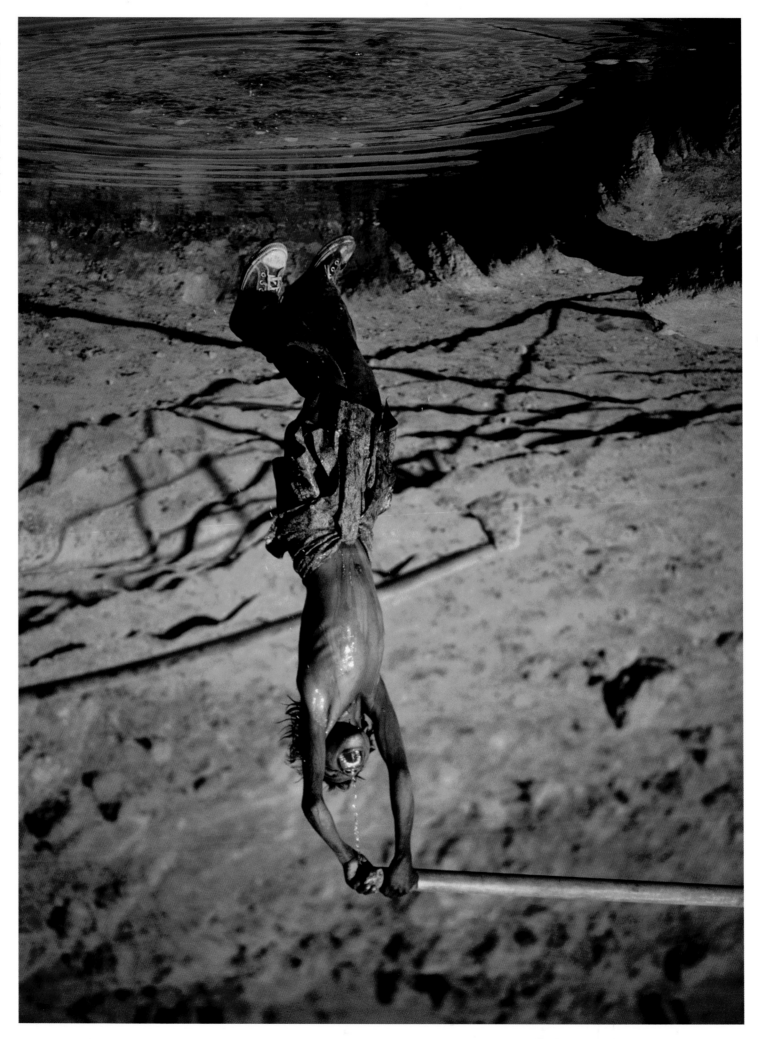

When it's 43 degrees in the shade in Warburton, the dripping end of a pipe is the best place to hang out. The only danger is falling into the cattle watering hole below (which might not be so bad under the circumstances).

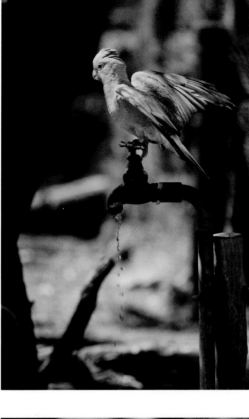

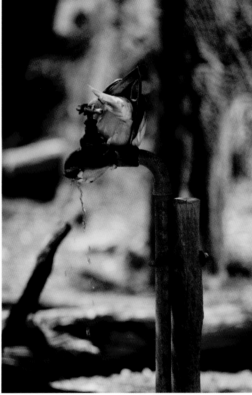

The desert is home to huge flocks of wild galahs — cockatoos that pair-bond for life. In the outback necessity is truly the mother of invention. This enterprising galah has taught itself to turn the water tap on (the station owners are still trying to teach him how to turn it off).

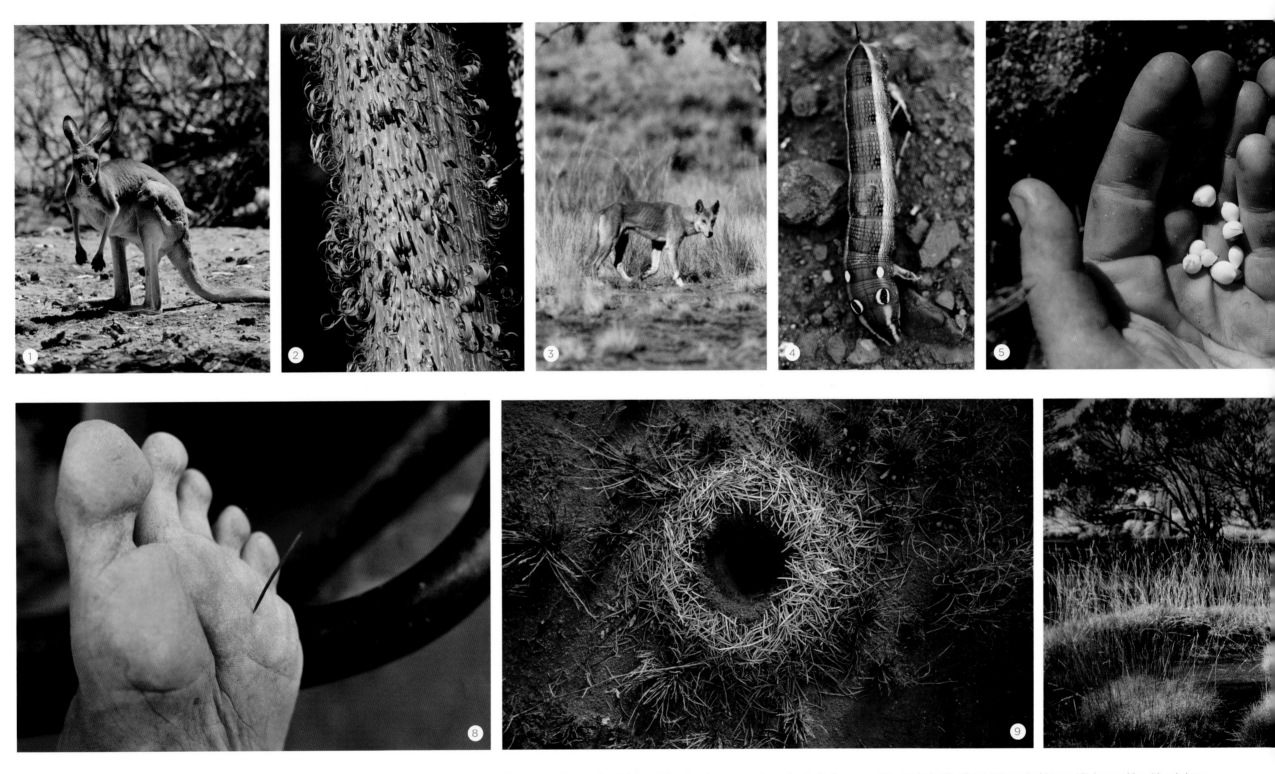

The Australian outback is anything but barren and empty, in fact it's home to an astounding variety of life, much of it found nowhere else on earth. Nearly two-thirds of Western Australia's wildflowers exist only there. *Hippotion celerio* (4) is a caterpillar which, when threatened, tucks its head under its thorax, curls into the shape of a letter 'C' and expands its eyespots to distract and deter possible predators. Termites also thrive in the predominantly dry conditions of the outback, building mounds (10) that resemble tombstones.

The curly bark of the Minnaritchi tree (2) is used by Aborigines to start fires. Dingoes (3) are hated by ranchers who believe they attack their sheep. Although Robyn began the trip eating dehydrated food, later she began to appreciate native bush foods relished by the Aborigines, such as kangaroo (1) and witchetty grubs (12), fat gooey moth larvae that taste like almonds. Another outback delicacy is yelka (5), a bush onion that can be eaten raw or cooked. Glass-like flowers (6) emerged from the shell beaches

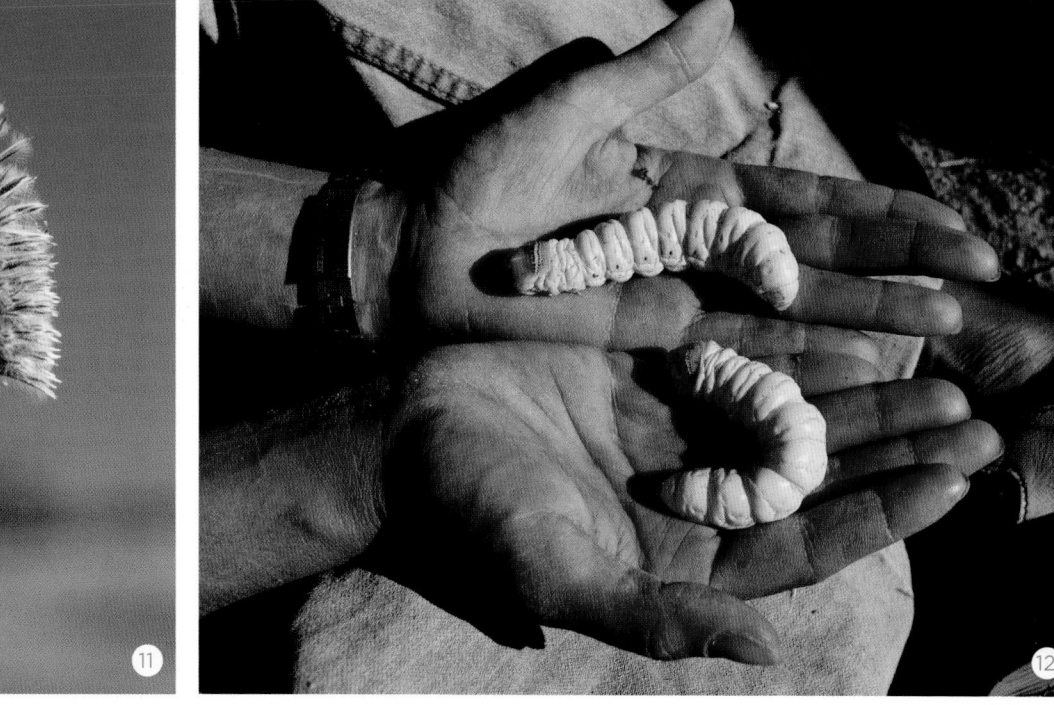

facing Hamelin Pool where Robyn finished her journey. Walking, often barefoot, 32 km a day, had toughened the soles of Robyn's feet, but even the thick calluses didn't prevent the occasional painful splinter. Many desert plants, when they first shoot up out of the ground looking so deliciously edible, protect themselves with toxins to prevent their being eaten (11). Central Australia's mulga ants (9) surround their nests with a distinctive circular 'fence' of mulga phyllodes. One theory is that these are miniature levees to prevent the nests being flooded during arid Australia's infrequent heavy rains. Robyn's favourite outback animal was the ostrich-like emu (7), an inquisitive creature. She would often glance up from her campfire and see dozens of curious eyes staring back at her from the darkness. When frightened, rather than stick their heads in the ground, emus run away at a remarkable 50 km per hour. They have good reason to run: Aborigines once hunted them for their delicate flesh and huge green eyes.

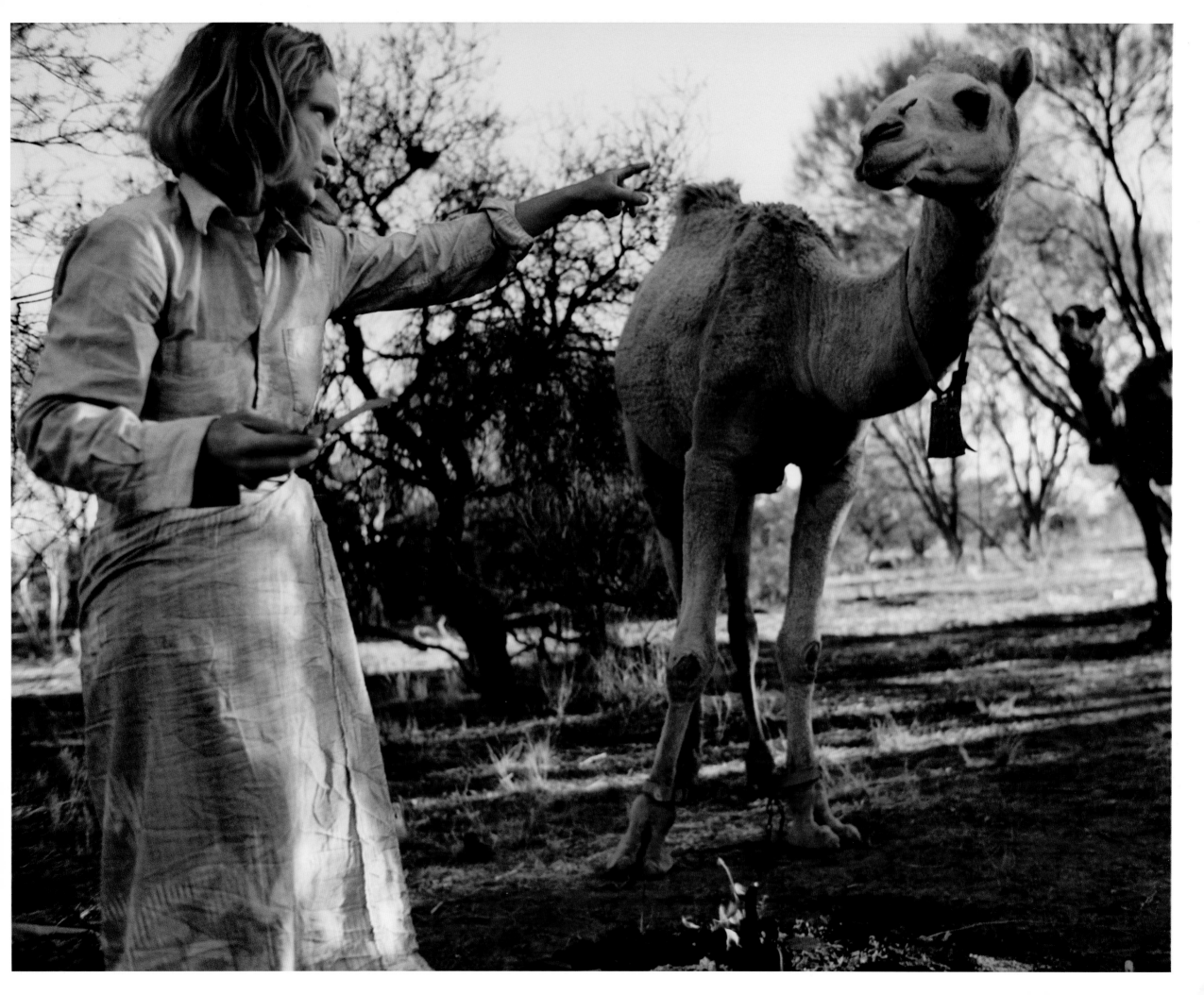

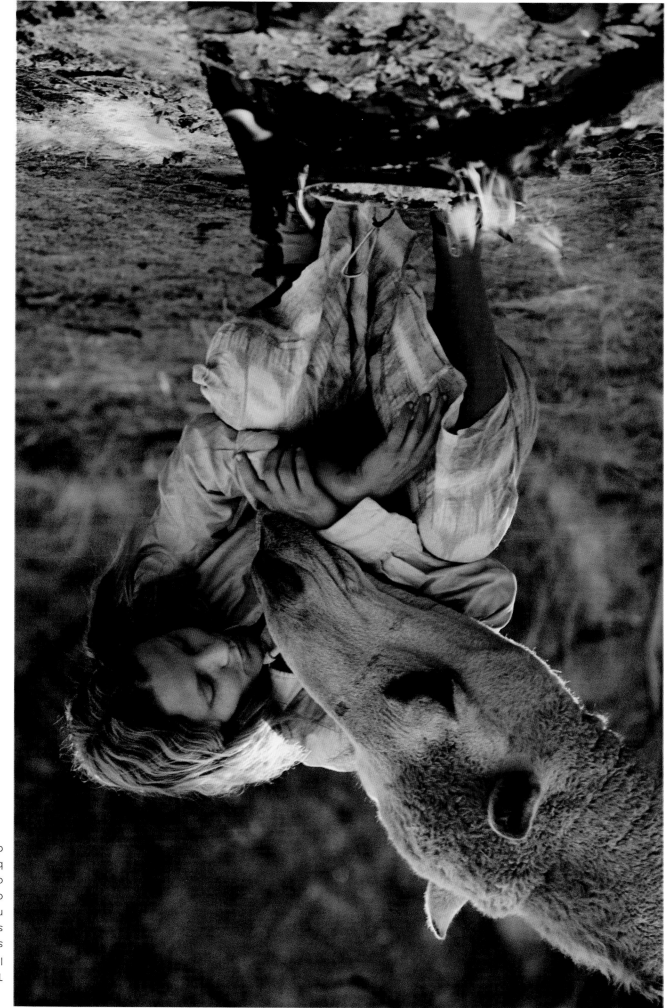

One morning cheeky
Bub decided to sample
Robyn's breakfast and
she scolded him for his
impertinence. Simply
pointing a finger to his
nose peg had the same
effect as actually pulling
on his string.

The camels treated Robyn as the
leader of their herd and, while
she appreciated their affection,
sometimes it felt like being
nuzzled by a 650kg dog. Bub, the
clown of the group, would come,
ostensibly to give Robyn a cuddle
but, the minute she let her guard
down, he'd try to steal her food.

> "Suddenly, dramatically, as soon as I hit the boundary fence, the country was broken. Eaten out by cattle. Destroyed. How could they do this? How could they overstock the country and then, with that great Australian get-rich-quick drive, lay it bare? I thought I had come through the worst part, only to find the true desert, man's desert, beginning."

DAY 185 Crossing into station country, Robyn was appalled by the scarred and desolate landscape left by drought and overstocking. She was worried that there would be nothing for her camels to eat.

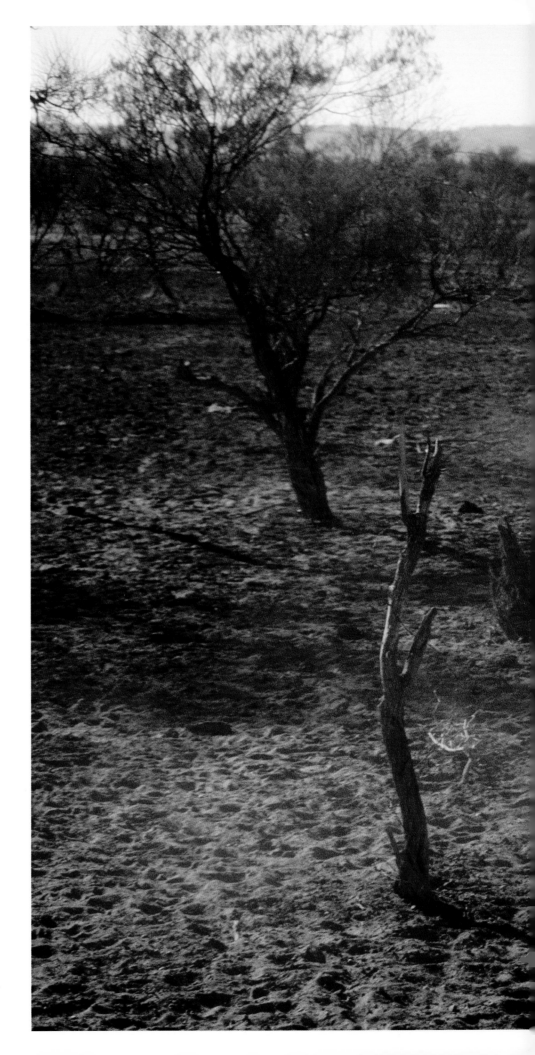

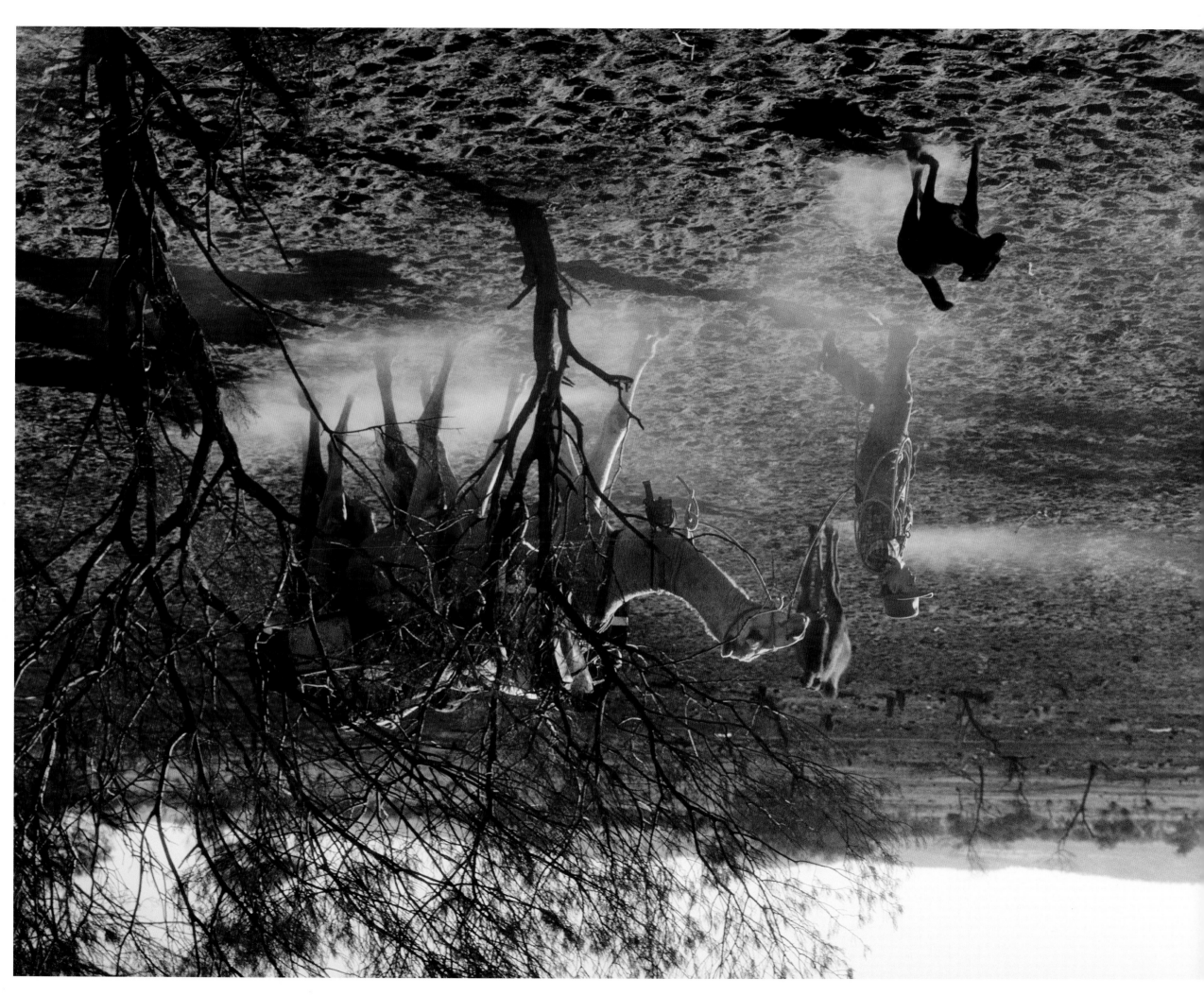

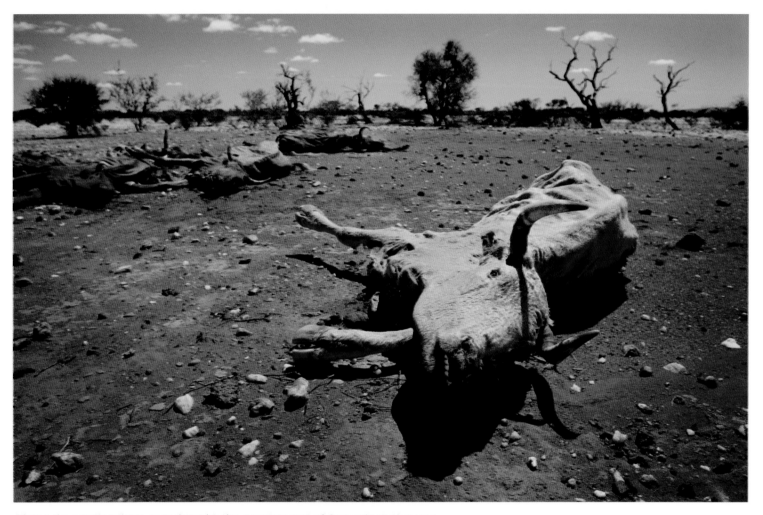

After a devastating three-year drought, the country west of Carnegie station was littered with carcasses, and those animals still living were down to skin and bones. Having survived the Gunbarrel Highway, Robyn had been hoping that cattle country would be more hospitable to her and the camels, but that wasn't the case.

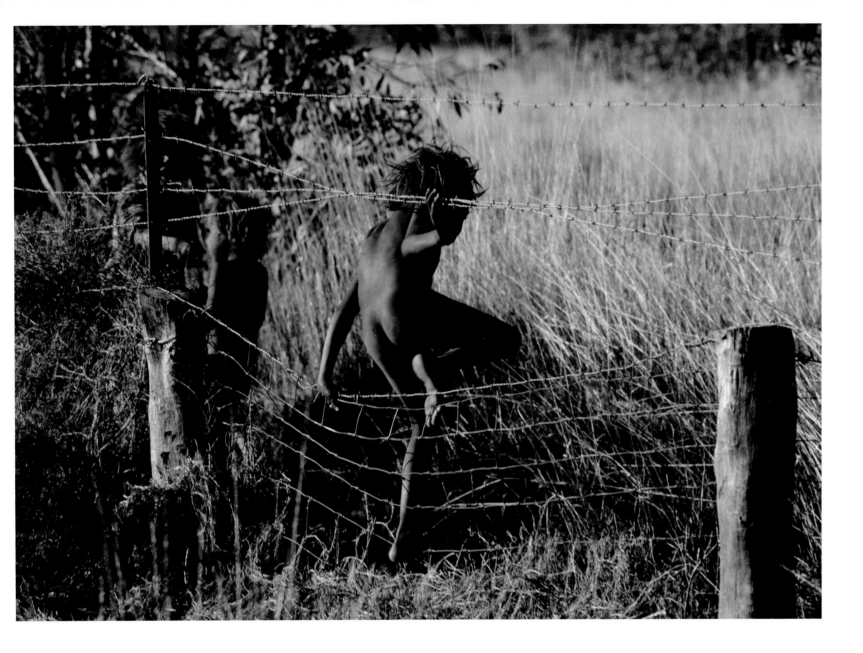

After the magnificence of the country Robyn had passed through, Warburton came as an unpleasant shock. Every tree for miles had been knocked down for firewood. Cattle had eaten out the country around the waterhole and dust rose in suffocating billowing clouds.

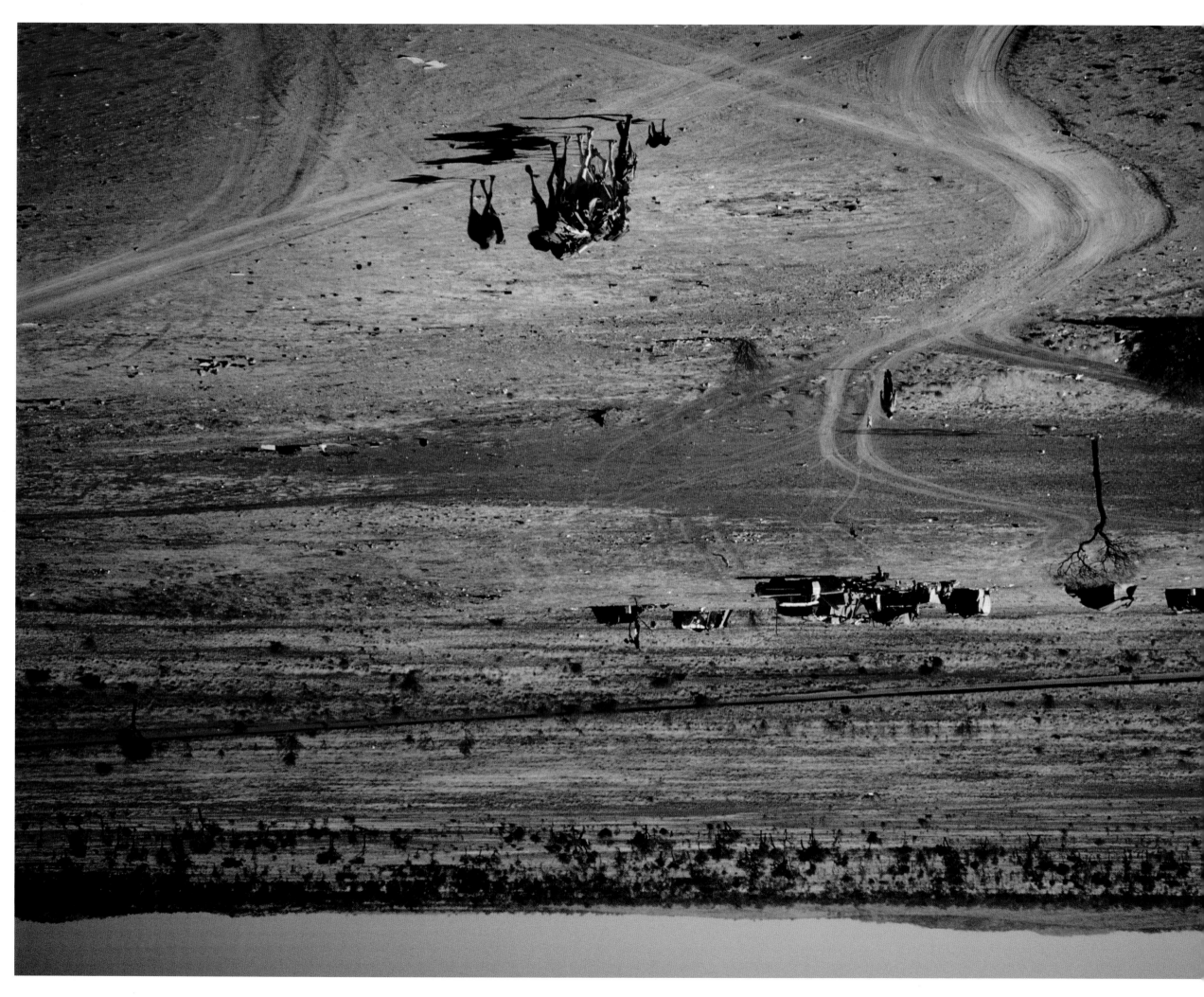

"I had been hot, irritable and tired when I arrived, but now these delightful children lifted my spirits with their cacophony of laughter. Aboriginal kids were so direct, loving and giving with one another that they melted me immediately."

DAY 210 Aboriginal children playing on a makeshift landing strip before the weekly mail plane arrives.

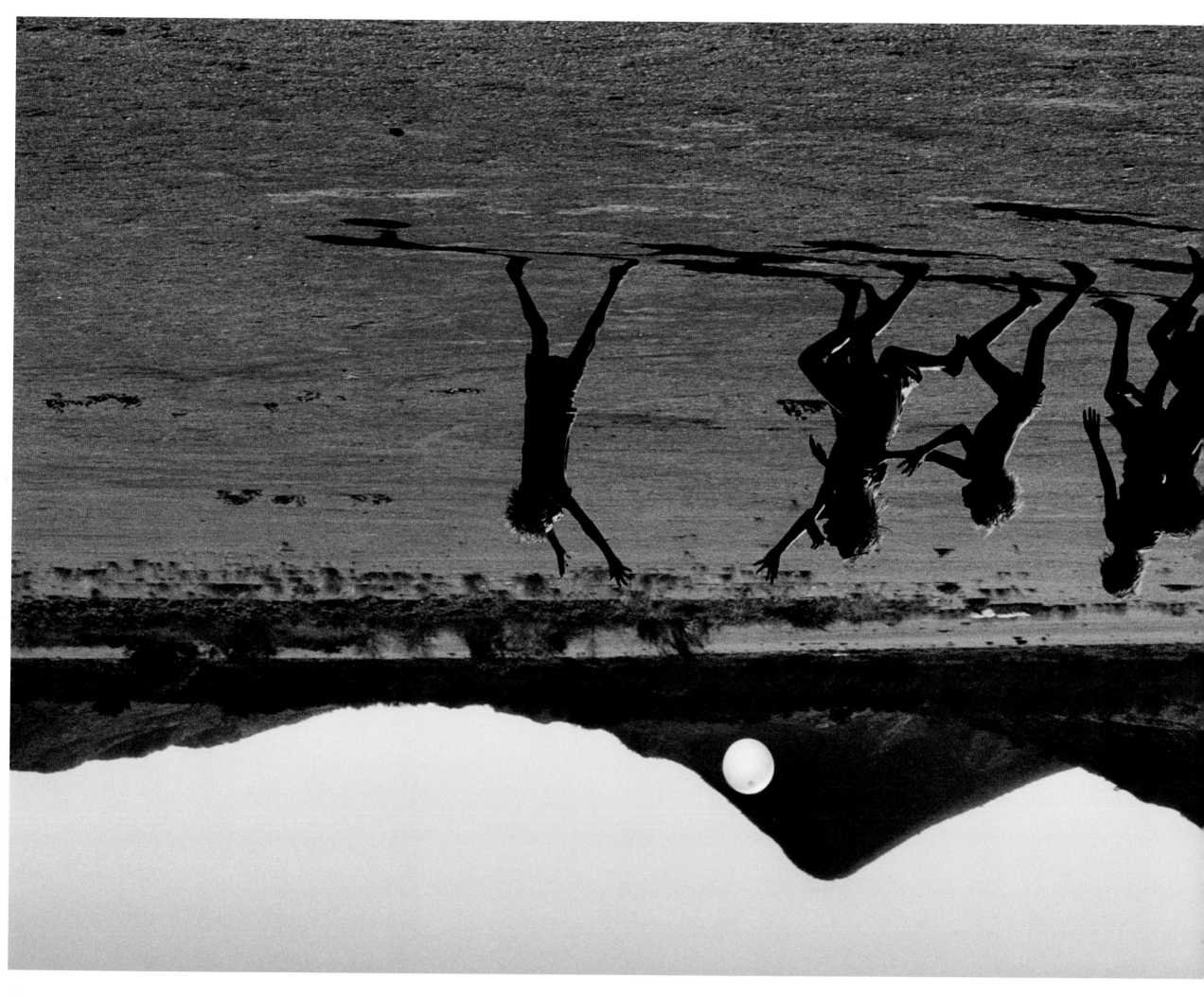

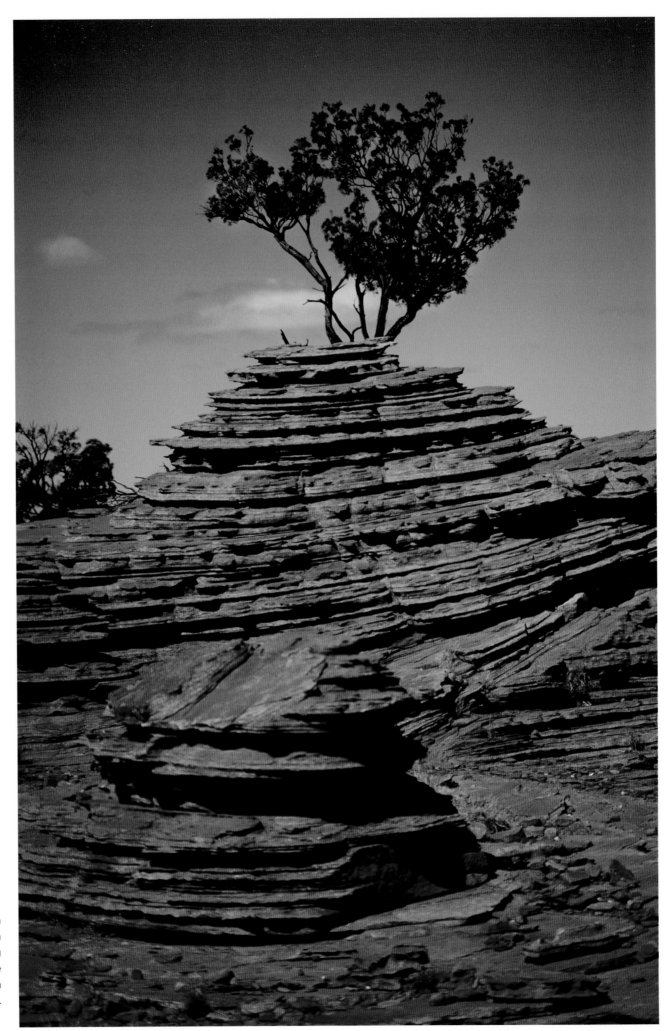

After days of endless flat horizons Robyn suddenly came across this rock formation at Pine Ridge. The ridge is located along the Canning Stock Route, a former cattle trail that crosses the bleak stretch from Halls Creek to Wiluna.

On Carnegie Station Robyn came across a patchwork aluminium hut used for overnight stays by station hands inspecting the fence lines. Some stations are over 20,000 square kilometres in area and repairing fences damaged by cattle or camels can be a never-ending task.

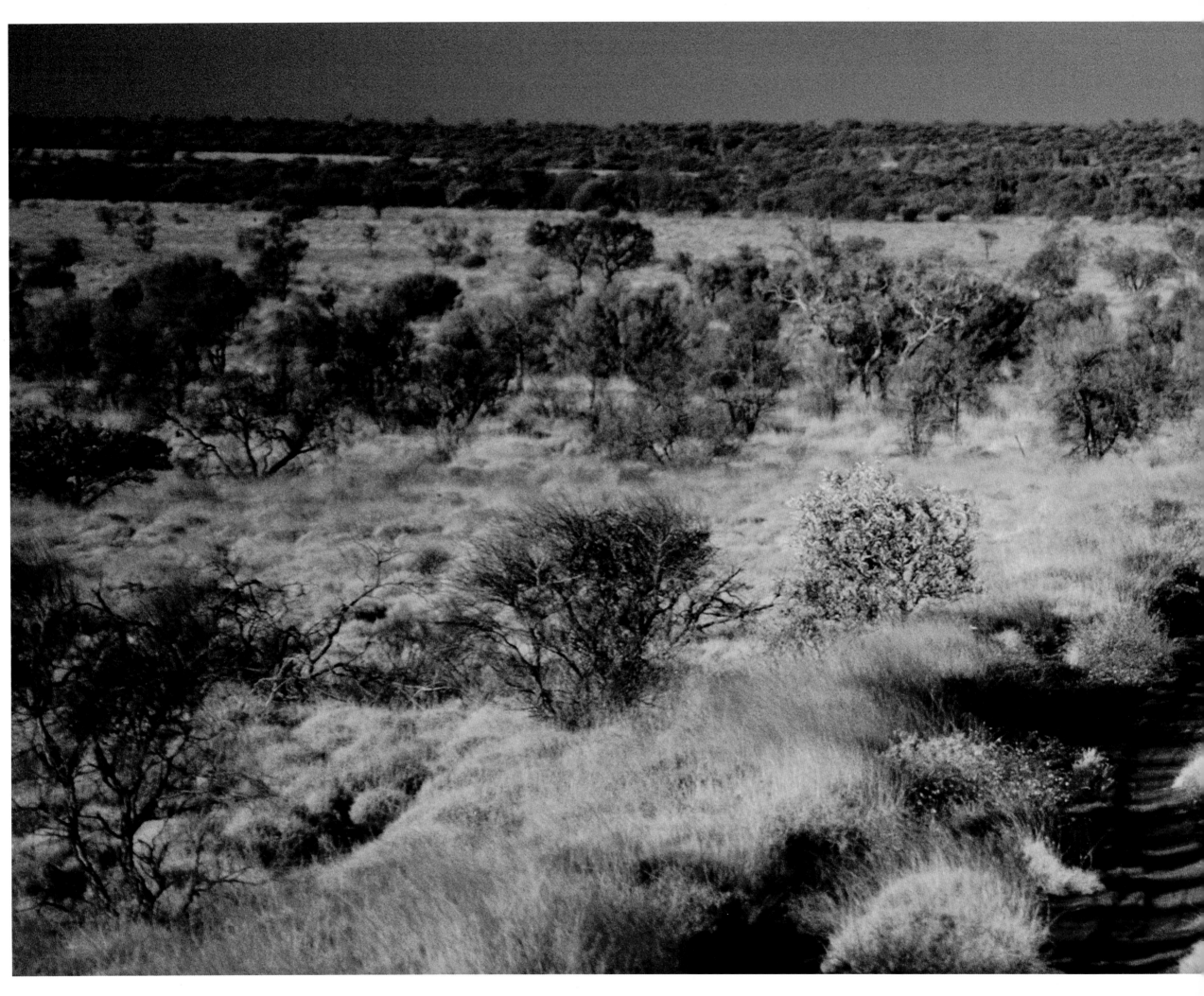

"In my own eyes, I was becoming sane, normal, healthy, yet to anyone else's I must have appeared, if not certifiably mad, then at least irretrievably weird, eccentric, sun-struck and bush-happy."

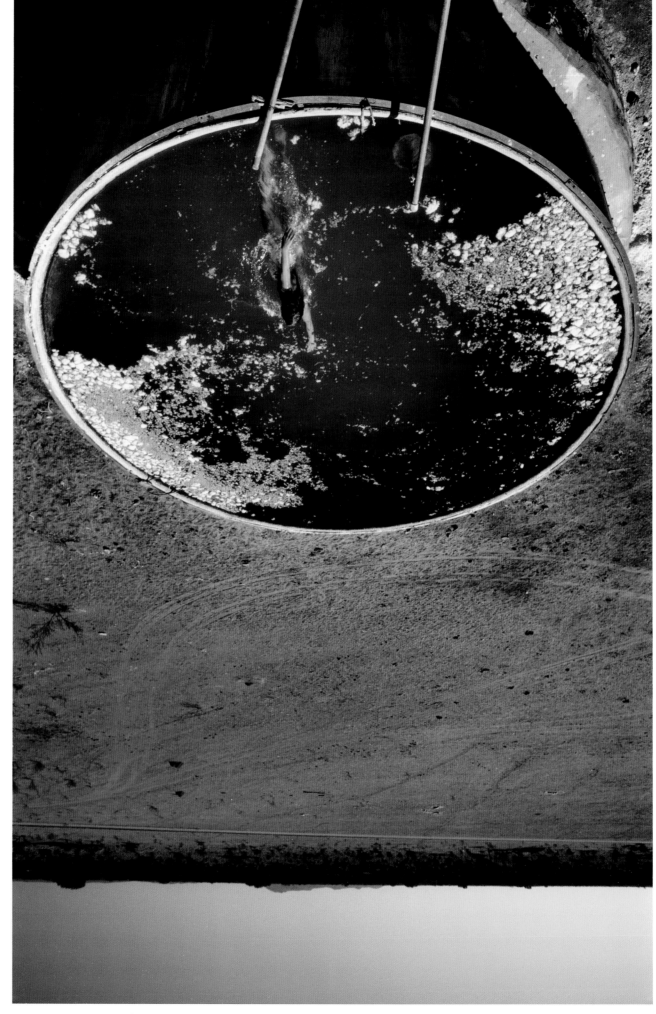

Even with mould and fungus covering its surface, this salty old cattle-watering bore was a welcome oasis.

"That night I received the most profound and cruel lesson of all. That death is sudden and comes from nowhere. It had waited for my moment of supreme complacency and then it had struck.**"**

To exterminate dingoes ranchers dropped poisonous Strychnine baits from light aircraft. Robyn had put a leather muzzle on Diggity to prevent her eating the poison but Diggity hated it and whined and scratched. She was such a picture of misery that Robyn eventually took it off.

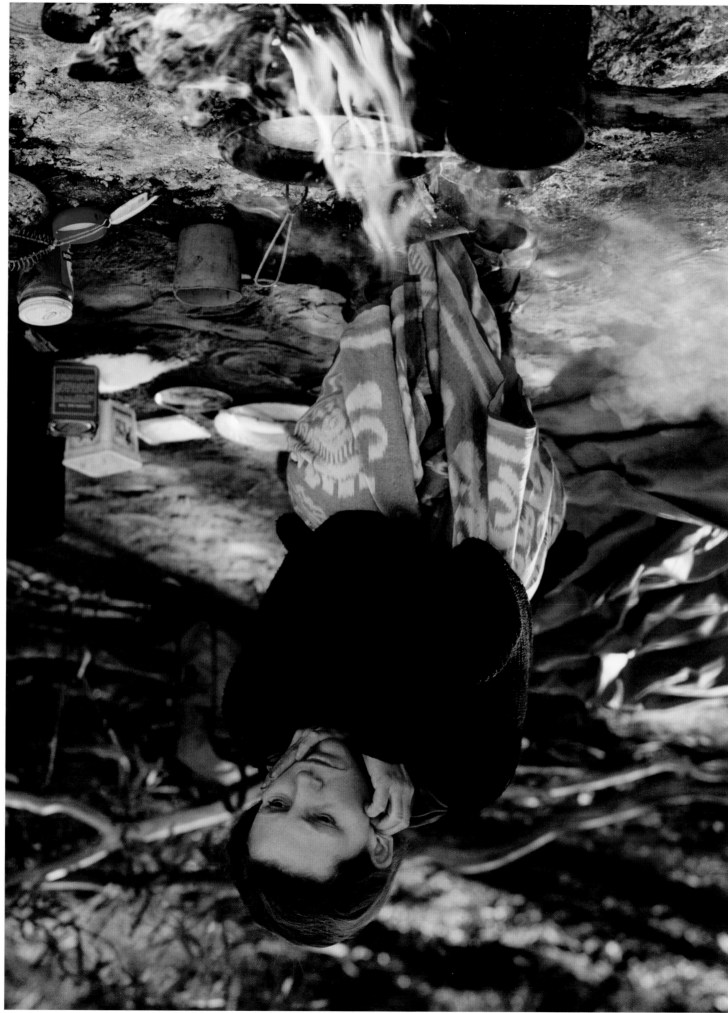

In Robyn's book, *Tracks*, she describes the most painful night of her life. "I walked back to Diggity's body, stared at it, and tried to make all of myself face what was there. I said goodbye to a creature I had loved unconditionally, without question. I said my goodbyes and my thank yous and I wept for the first time and covered the body with a handful of fallen leaves. I walked out into the morning and felt nothing. I was numb, empty. All I knew was I mustn't stop walking."

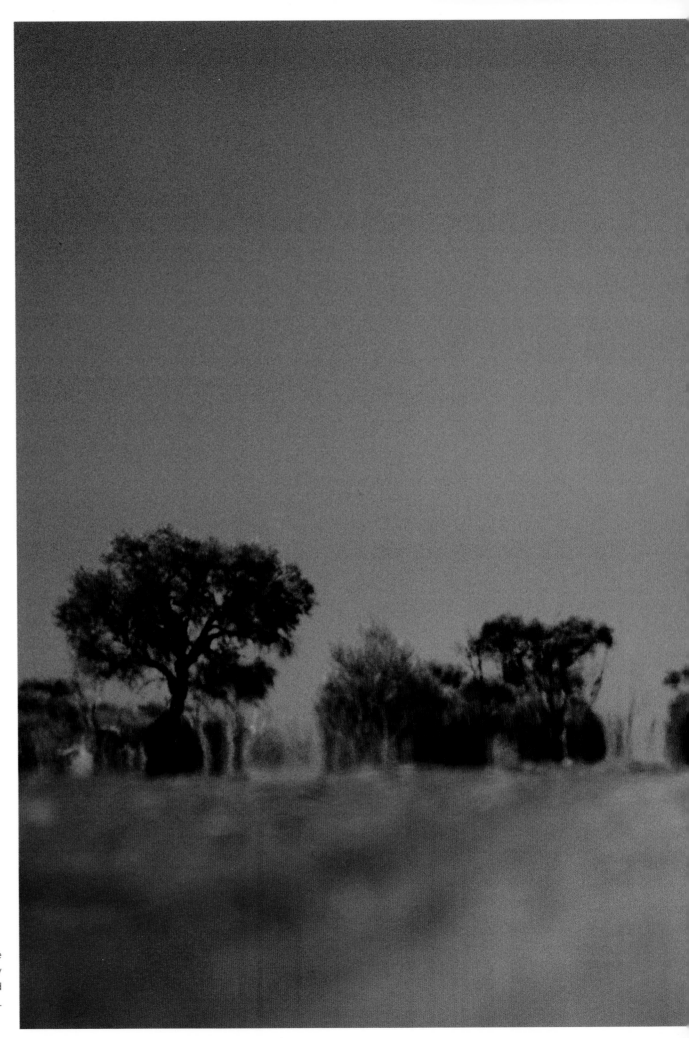

"I kept getting the odd sensation that I was in fact perfectly stationary, and that I was pushing the world around under my feet."

Sometimes Robyn's moods were internal reflections of the dry, dusty and hopeless landscape which seemed to have no beginning and no end.

" Wiluna was being invaded by reporters offering money to anyone who could find me — a kind of siege; the police were receiving international calls all through the night and were, understandably, ready to wring my neck; and the Flying Doctor radio was clogged with calls to the point where real emergencies were not getting through. "

When the first wave of press descended on Robyn near Wiluna, she felt invaded and was dismayed to find that she was on front pages around the world. Newspapers, magazines and TV networks had sent teams of reporters to track down 'The Mysterious Camel Lady'. The reporters refused to leave her alone and their stories grew more and more exaggerated. When she refused to give interviews, they simply made up stories out of thin air, writing that she was a British model on vacation, that she ate bananas and that she shot wild camels for pleasure.

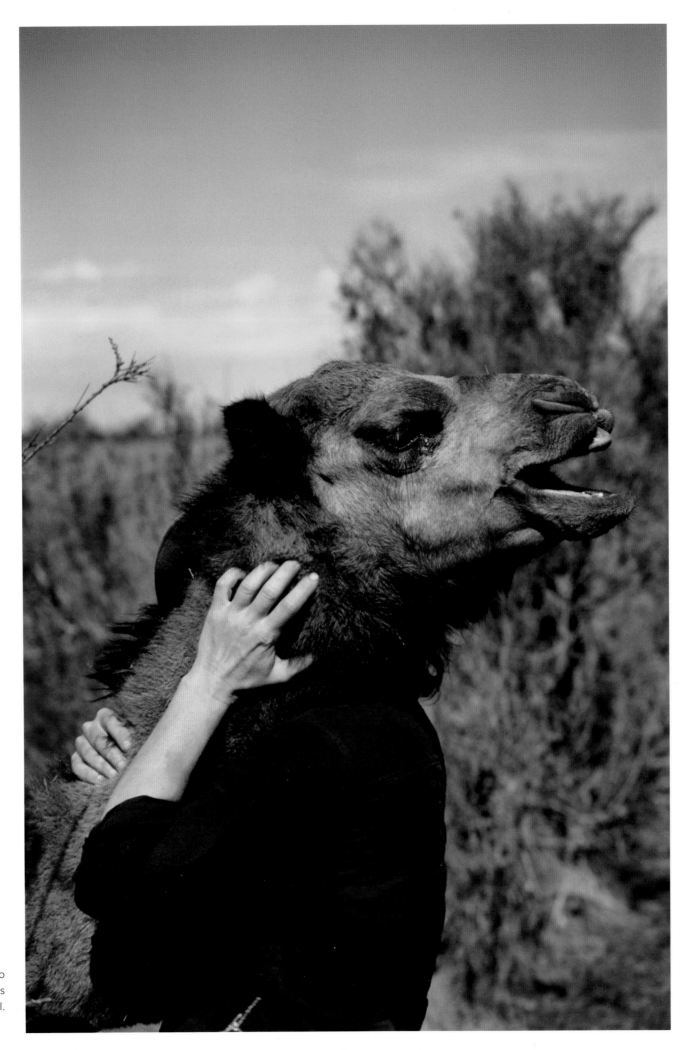

Rumours of the 'Camel Lady' started to spread, suggesting a creature that was half-woman and half-camel.

A beer and a breather for the Camel Lady

From RICHARD SHEARS in Pr ()

'I NEED a beer and my camela need a rest.'

Almost the classic Western line of the stranger riding into town.

But this was Western Australia, and the stranger with the odd taste in transport was a lady —the Camel Lady.

Robyn Davidson, a 28-year-old Tommy, got her cooling beer when she traipsed into an Aborigine settlement at Docker River on the edge of the fearsome Gibson Desert.

She had come more than 300 miles from a camel farm at Alice springs. But the worst was still to come—more than 600 miles across the blazing desert down a trail known as the Gunbarrel Highway to the equally tiny settlement of Wiluna.

The horror stretch

Today, she, her four camels and her dog are just a few days away from their goal.

Robyn, who came to Australia from England years ago, is making the trip mainly to study the Aborigines, their way of life and their language. She plans to write about the journey for the American National Geographic magazine.

She told the magazine: 'I want to see something of our native Aborigine culture before it is diluted or suffocated.'

She has given this description of her daily routine : She gets up at dawn, corrals her camels and then spends two hours loading them up with the 1,500lb. of equipment she is carrying. She starts travelling at 10 a.m. and makes camp at 5 p.m.

She has shot some kangaroos to eat and has also joined Aborigine women in digging up grubs for

'She is so determined'

CAMELS have a special fascination for Robyn Davidson.

She first visited the Fullertons' farm at Alice Springs four years ago, with a group of friends.

'Camels obviously appealed to her because she came back this year asking for work,' said Mrs Fullerton. 'She used to exercise them along the creek. You couldn't part her from them.

'She's a very attractive girl and she got on well with everyone at the farm. But at the same time she was the kind of person who kept her thoughts to herself and now I try to think about it I can't say that I really know what made her tick.

supper — but they don't taste very nice.

She wrote: 'Wild bull camels pose some threat, but I have an excellent rifle which will also come in handy for game for me and my dog.'

The part of the journey from Docker River she described as the 'horror' stretch. Even the track she was hoping to follow was lost in the sand for much of the way, and she said she would never have made it without the Aborigines' help.

At one point an elderly Aborigine man journeyed with her for several days to show her the way. Then, when she awoke one morning, he had disappeared.

The trek began in June at the farm of Noel and Isabel Fullerton, where she worked for several months. She bought four camels—one bull and three cows—from the farm for around £400 and loaded down with dried food and maps, set off eastwards into the desert.

After spending two weeks at Docker River, helping one camel to recover from a leg injury, she headed on through the wilderness.

She has spoken to very few people in recent weeks, but one Perth woman, Pat van Ouwerkerk, did see her.

She was tired and had blisters on her feet, but otherwise she was happy and confident of completing the trip, she said.

'And she was looking forward to seeing civilisation again.'

Many explorers have disappeared trying to cross the Gibson Desert. The arid wilderness is very hot by day and freezing cold at night.

Over the hump—into a legend

ABOUT the only things that survive in the dead Australian wilderness called Gibson Desert — named after one of its victims—are legends.

There's one about "Lasseter's Reef," a mountain of gold found, but never rediscovered, by explorer H. B. Lasseter whom the desert claimed more than half a century ago.

Another concerns the mysterious death there of Friedrich Leichardt, Australia's greatest explorer who disappeared attempting an east-west crossing of the continent back in 1848.

Now another legend is in the making.

The Camel Lady of Never - Never Land as Aussies call the area, bigger than the British Isles, where no rain has fallen within living memory and where the ground is so hard that heavy vehicles leave no tracks.

Like all good legends the news of 27-year-old Robyn Davidson's epic journey reached the outside world in tantalising fragments

AMAZED

A half-believed report from an outback rancher who radioed to anyone listening that he had seen a "beautiful, beautiful camel lady," came first.

A police report followed and then a traveller on the edge of the Gibson Desert—now an area mined for the minreia riches old Lasseter predicted were there — brought in a blurred photograph.

Finally a report to the Flying Doctor base at Meekathara came in about the mysterious lady.

The radio operator there, Eric Catchpole who emigrated from Ipswich seven years ago, reported :—

"Everyone is amazed that this girl should be attempting such a journey. In the old days farmers did drive their cattle through the desert to market in Wiluna. It took three or four months and they didn't all make it.

"Nobody knows much about Miss Davidson. She is keeping her movements very quiet and is deliberately avoiding publicity."

At the tiny township of Wiluna on the Western edge of the Gibson Desert, locals are waiting for Robyn's arrival.

The last report was from a ranch 150 miles away.

Said Wiluna policeman Robert Priddis : "She told the people at the ranch she was English, but that was all.

"Planes have already been up looking for her, but in that wilderness it is almost impossible. Even if they did locate her they wouldn't be able to land."

Last night a few more facts came to light.

Robyn, apparently raised in the harsh Australian outback near Alice Springs, had long dreamed of crossing the dead regions of desert and living on fat white widgety grubs which friendly aboriginals helped her to find.

She also has thanks for

the aborigines who helped her find her way across the trackless wastes.

The American magazine National Geographic backed her ambition and, with four camels, set off on the thousand mile trek to the Indian Ocean with her pet dog for company.

Since then she has had two meetings with the magazine's photographer who has flown in to meet her at pre-arranged spots and she has sent word by letter.

DANGER

"I'm relying on bush tucker," she wrote, "and I must say I don't like it very much."

She was shooting kangaroo before entering the desert and living on the white widgety grubs which friendly aboriginals helped her to find.

Latest report of Robyn came from the magazine last night, "She has sent us word that she is over the worst of the journey—and is enjoying it."

'The worst of the journey is done . . . now I'm looking forward to a hot bath and an iced drink'

MYSTERY GIRL ROBIN CROSSES 'KILLER' DESERT BY CAMEL

Amazing journey

The mystery of the English Camel Girl should be solved in about a week.

For Robin Davidson, 28, who is crossing the Gibson Desert by camel, is only 80km from the small West Australian township of Wiluna.

And when she arrives there she may tell why she is making the trip — accompanied by four camels and a dog — through some of Australia's most inhospitable country.

So far she has only a few people about which began at Alice Springs two months ago.

She has met station owners along the way and also chatted through a midnight camp-fire marathon car-crossing.

By FRANK CROOK

The driver, I cannot tell, told how he covered a record-breaking section of the desert.

'Roman...

"As two adventurers felt we had some common," he said.

...was very with the tinkling camel bells."

Bartell said Davidson's only concern for the journey... "she just wanted...

Miss Davidson covered more than 1300km since leaving Alice Springs.

But after crossing the desert she faced a journey of almost Carnarvon, on the Australian coast.

Miss Davidson's already passed folklore because an epic journey as the first woman to cross the Gibson by camel.

Senior Constable Robert Priddis, in charge of the Wiluna police station said today he expected the Camel Lady within a week.

"It's pretty well sorted out there," he said.

Constable P...

he had no plans to meet up with the Camel Lady.

worst part of her trip will be over.

"It's still a long haul to Carnarvon, but the

Camel lady looked great by moonlight

By PAUL HEINRICHS

There's movement at Wiluna, 940 kilometres north-east of Perth — for the word has got around that the Camel Lady of the Gibson Desert is coming to town.

The mysterious Camel Lady, reported to be about 25 and beautiful under desert moonlight, has humped her bluey nearly 1000 kilometres west from Ayers Rock with four camels and a dog.

No one in inland Western Australia quite knows who she is, where she comes from or why she's doing it — but that hasn't stopped them speculating.

But in Melbourne yesterday, an Adelaide adventurer who spent "a glorious hour and a bit" with the Camel Lady by a campfire in the desert wasn't giving much away.

"I said to her that I wasn't going to ask why she was doing it — we both knew why we were doing what we were," said Dennis Bartell, Adelaide farmer and company director.

Yesterday's latest came from Constable Mick Leverence, of Wiluna, who said she was now only about 250 kilometres north-east of the town.

Constable Leverence said she arrived at Henry Ward's million-acre Glenayle station "a short while ago" — by which he meant a week or so.

By now, he reckoned, the Camel Lady would be pretty near Well 10 on the Canning

stock route, and about to to turn south towards Wiluna.

The track goes under the misnomer of the Gunbarrel Highway — which Constable Leverence says is "a hell of a rough track". Its landmarks are the Giles Weather Station near the WA-South Australian border and the Carnegie Station—separated by hundreds of kilometres.

By radio telephone from Ayers Rock, one of the ranger staff, Mr. Peter Fannin, said the Camel Lady was there "some couple of months ago.

"The last report that I heard was that she had trouble with wild camels. She had to shoot two wild bulls who were attracted by her females," he said.

Mr. Bartell, 44, smelt the Camel Lady's campfire smoke and stopped while on the west-east section of what is believed to be the first lone vehicle two-way crossing of Australia at its widest point.

"When I saw the fire, I jammed on the brakes and called out 'I'm the Overlander, is that the Camel Lady?'. A little voice came back saying 'yes'. So I called out again 'The Overlander requests permission to enter camps.'

"She was beautiful. The moon was out, the camel pack was standing at the edge of the mulga with their bells tinkling.

"I remember I was freezing, and I was huddling round the fire. She was in her swag, and she could have been as ugly as ugly, but she was a beautiful thing for me."

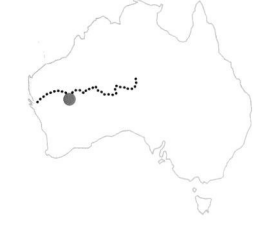

DAY 237 With each passing day more stories about the 'Camel Lady' appeared in the media. More reporters, eager for a first-hand story, poured into Wiluna. Robyn considered abandoning her trip, fearing that journalists would follow her the rest of the way.

> **"The more I got to know these people, the more impressed I was by their stoic, irrepressible good humour. They had every reason to be wringing their hands, weeping and bemoaning their fate."**

After losing the reporters by sending them off on a wild goose chase, Robyn continued her trek. Station owners she met along the way invited her to pass through their properties during branding season, and often welcomed her with a meal and a shower. These outback veterans were experiencing a terrible drought with cattle dropping dead, horses reduced to bags of bones and not a cloud anywhere in sight. It was equally tough on Robyn and her camels.

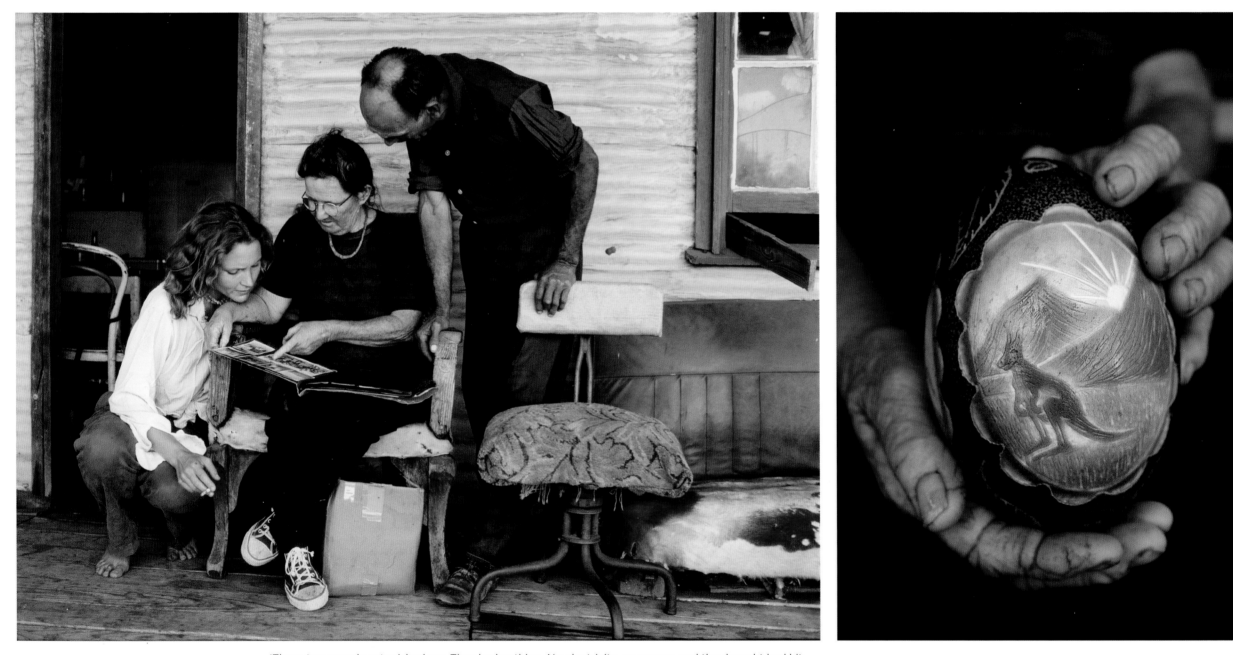

'These two people astonished me. They had nothing. No electricity, no money, and the drought had hit them so badly. And somehow they clung on, remained kind, generous, warm and uncomplaining. Of all the outback people I met on the trip, I think George and Lorna personified battling bush spirit the best. They were extraordinary people. They shared with me everything they had.' The couple's hobby was carving extraordinary delicate and intricate tableaux on the fragile surface of emu eggs.

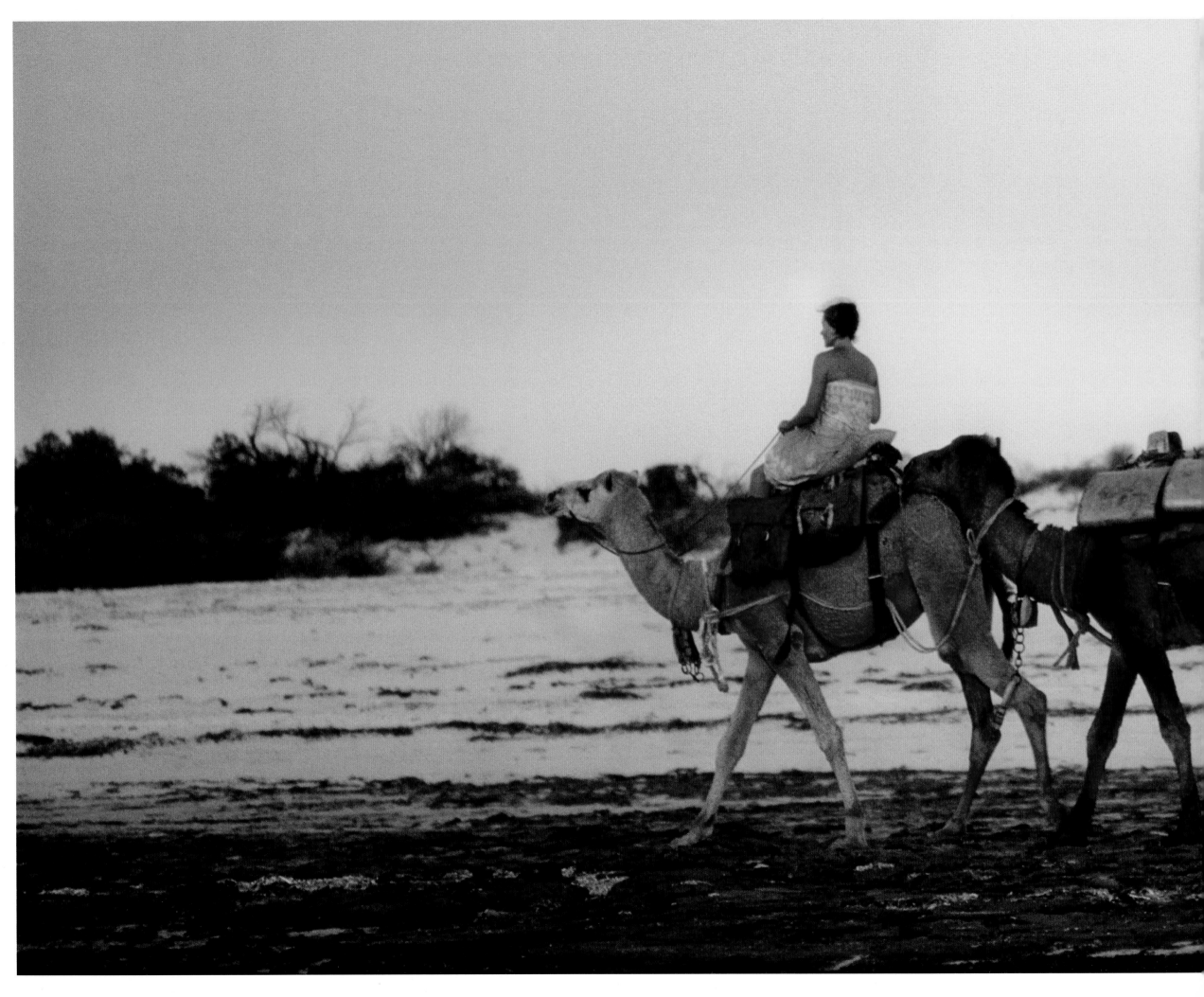

> "There was an unpronounceable joy and an aching sadness to it. It had all happened too suddenly. I didn't believe this was the end at all."

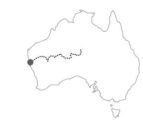

DAY 273 After nine months and 2700 arduous kilometres, it was late afternoon on a perfect day when Robyn and the camels had their first glimpse of the Indian Ocean. The camels had never seen any body of water bigger than a puddle and their eyes bulged at the infinite expanse in front of them. Their arrival marked the end of an extraordinary odyssey.

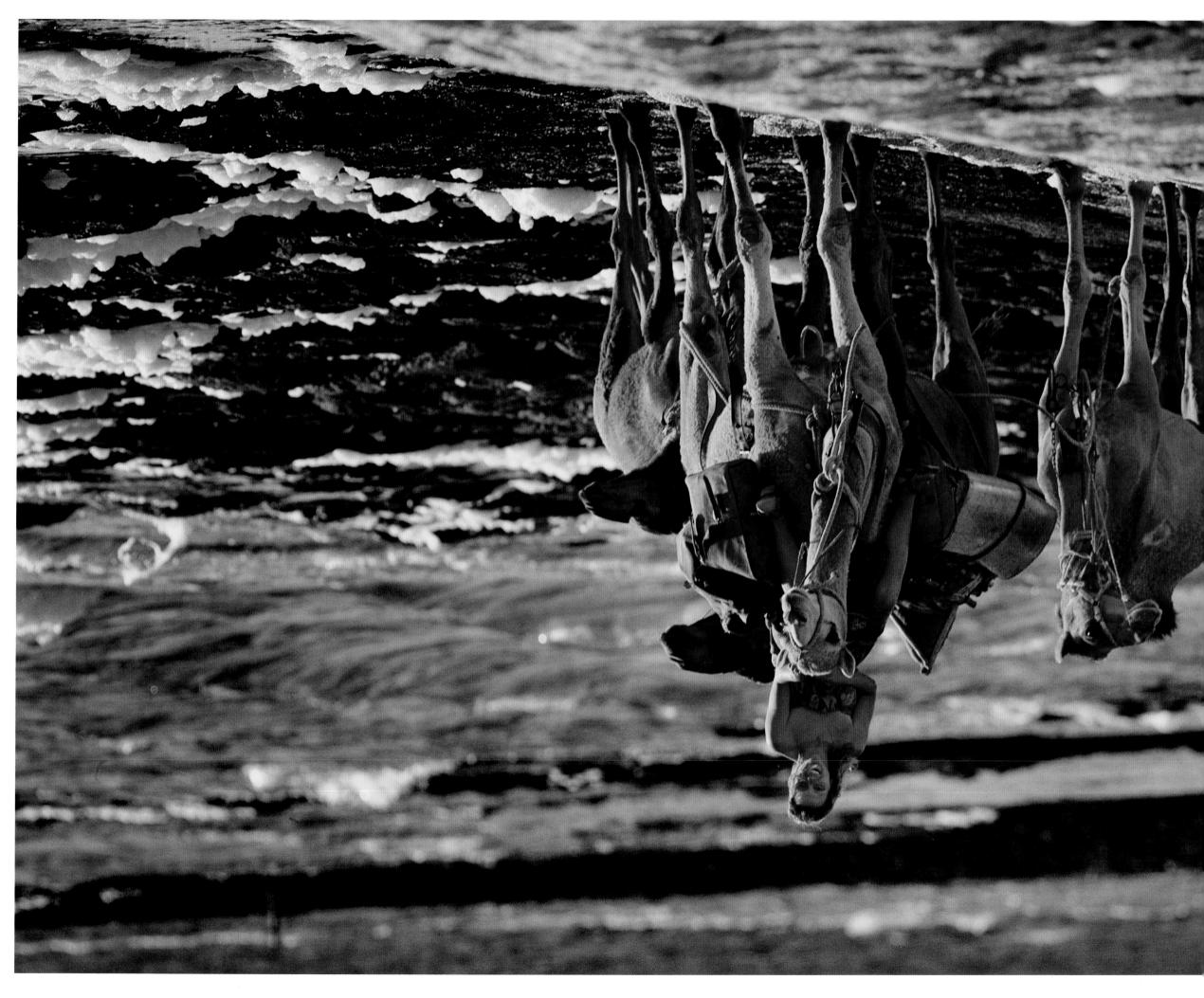

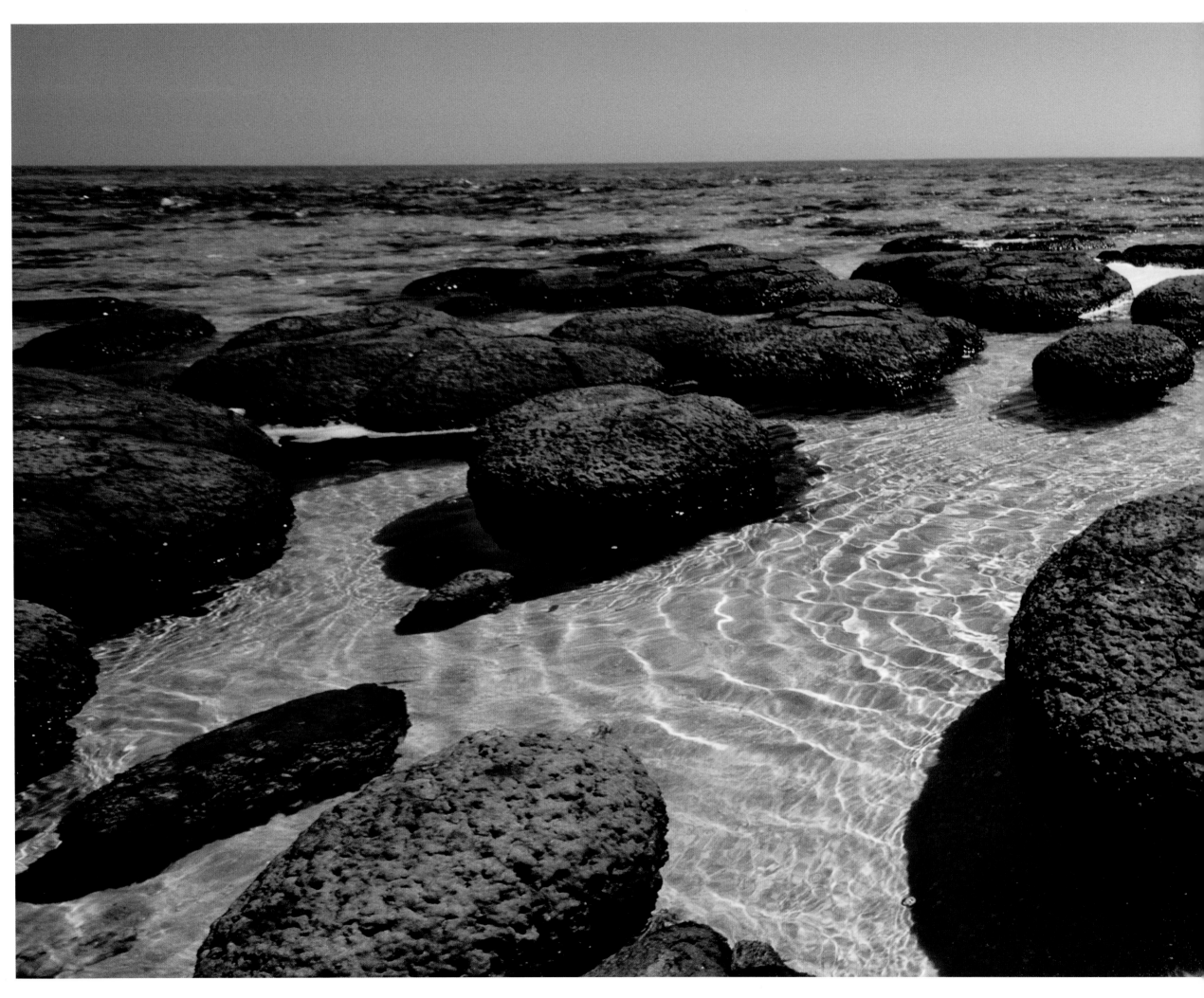

"The two important things that I learned from the trip were that you are as powerful and strong as you allow yourself to be, and that the most difficult part of any endeavour is taking the first step, making the first decision."

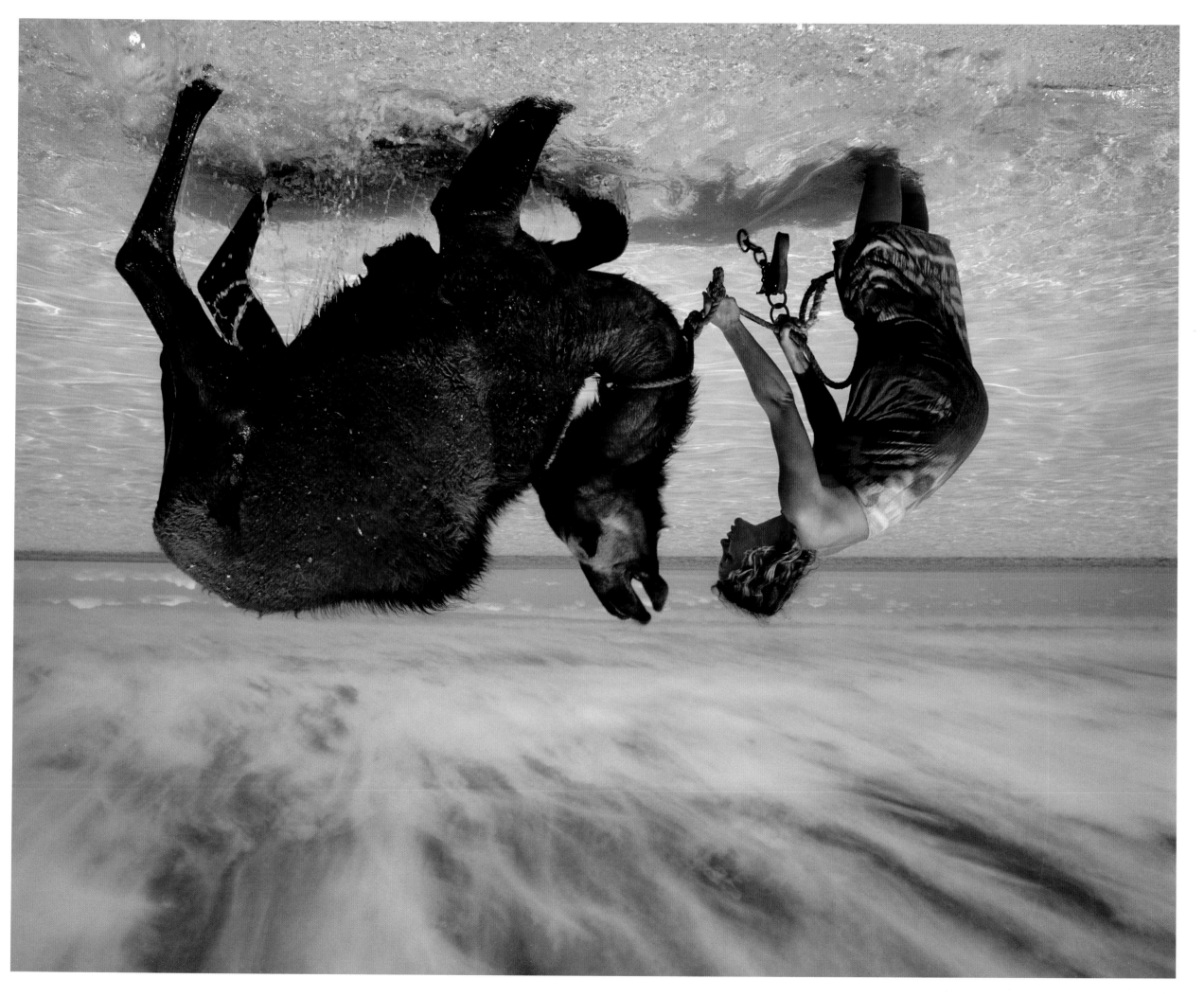

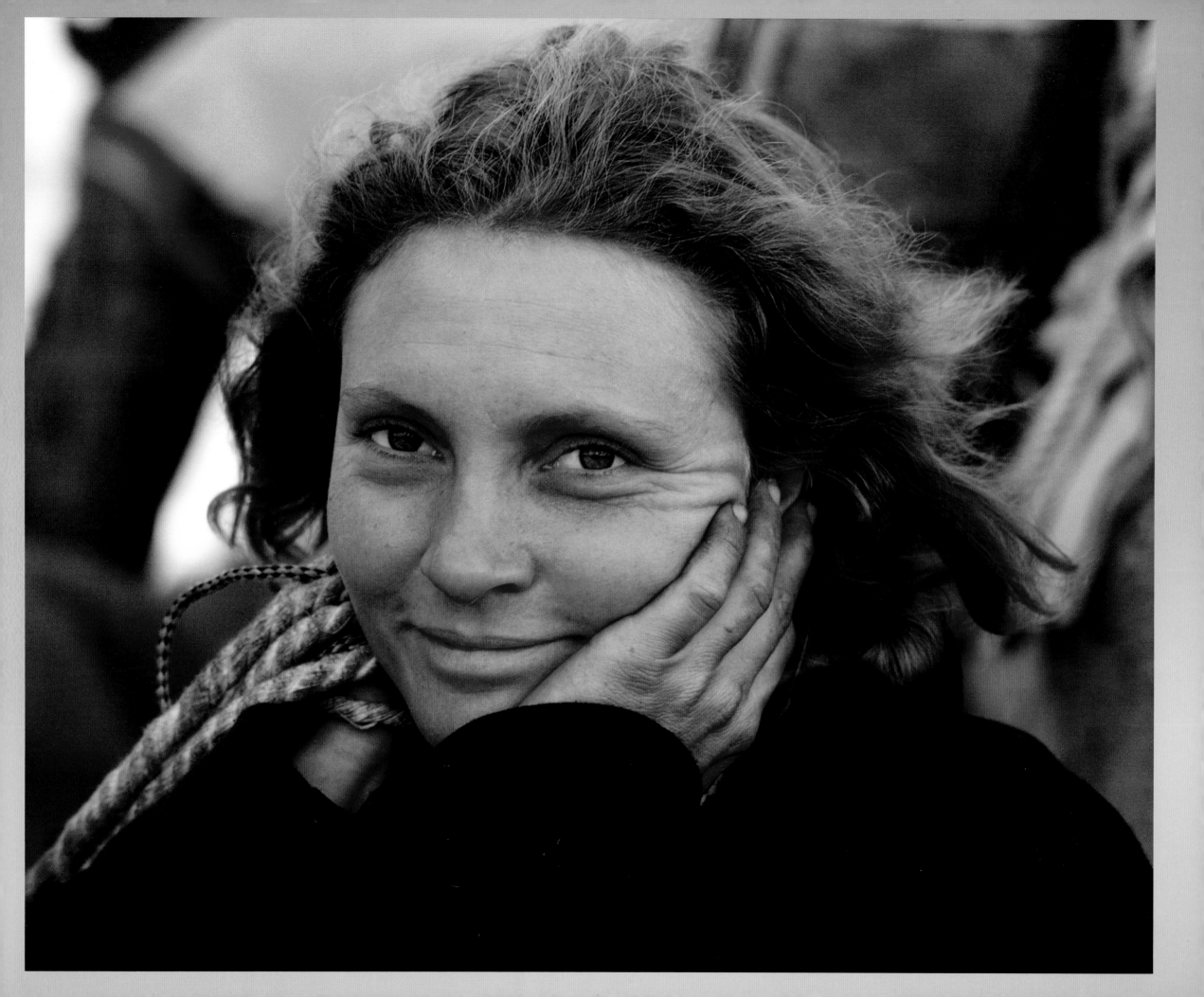

POSTSCRIPT

BY ROBYN DAVIDSON

The past caves away and dissolves behind us, leaving a few clues with which we try to reconstruct it. Hopeless task. History lives in the present.

It is over 30 years since I walked across half of Australia with my dear camels and dog. If I concentrate, I can retrieve flashes of a particular place, the affection I had for my animals, the happiness of walking into that transcendent landscape, the klutziness of fear when its indifference was brought home to me by some small, potentially lethal mistake. But they vanish quickly.

I wrote *Tracks*, my account of the journey, two years after I reached the Indian Ocean — journey's end. In a mean little flat on the other side of the earth, an extraordinary feat of remembering took place, making the entire nine months, every single campsite of the 2700-kilometre walk, limpid. (Or so it seemed to me then.) But, once the book was published, the memories began to fade, as if the book had stolen them. The real journey, who I was when I made it, all of it caved away, leaving behind a similitude called *Tracks*, and some photographs of a young woman I already had difficulty identifying with.

Those photographs were stunning, but from the moment I saw them they made me uneasy. I understood, in an inchoate way, that they represented a loss of subjective agency and that the journey, MY journey, would eventually be subsumed by its reconstructions. And I was right. First it was hijacked by my own book, then by Rick's photographs, and now by a film that is an even further abstraction from 'what really happened'. I do not mean that the film is not an honourable attempt to recapitulate the essence of the book: it is, and that is one reason I like it so much. Nevertheless, it is an abstraction of an abstraction, and must inevitably be someone else's vision, just as Rick's photos are a record of his journey, not of mine.

For years I felt uncomfortable looking at Rick's photos, and seldom did. But I love them unreservedly now. They may have supplanted true memory, but

aren't they wonderful? And perhaps the journey was never mine, could never have been mine. From the get-go, it belonged to other people, just as an author's text will have as many versions as there are readers.

So... the film? *Tracks* was optioned almost from the moment it was published. But no producer could quite get the script right, or quite raise the money... the common fate of optioned books. I always wanted the film to be an independent rather than a Hollywood version, mainly because I felt protective of and responsible for the Aboriginal content. So I turned down a great deal of money, even from people I admired — Sydney Pollack, for example. But the rights ended up in Hollywood anyway, via a circuitous route of co-production, at which point I lost interest in the whole thing. I thought: a) The film will never be made, and b) If it is, it will have nothing to do with me or the book or the journey.

My dear agent, Stephen Durbridge, did not, however, lose interest. And when, after yet another production failure, an offer came in from Emile Sherman in Australia, he talked me into granting the rights to his company, See-Saw Films.

I think it must be quite unusual for a writer to become so fond of the people proposing to document her life. But so it was. And, because decades had passed since writing the book, I was more detached from it than I might have been previously. In any case, I trusted them — Emile, John Curran, and then, the actress I had wished for, Mia.

Is the film a 'real' depiction? Is it the truth? Well, yes, sort of. And, of course not. How could it be? Take your pick: both are true.

I enjoyed being marginally involved in the making of the film — taking Mia out to teach her camel smooching; spending time on the set, twice. The first time was in the sand dunes by the sea. I saw this little figure come up over

white sand, wearing my clothes, leading camels, a black dog beside her, and tears came to my eyes. I am not sure why: I think it was the surrealism of it, or perhaps it stirred old, deep sensations, buried away for years.

And I enjoyed spending time, again, with Rick. Naturally, he remembers things quite differently to the way I remember them. He remembers things I said to him that I am quite certain I would never say to anyone. We are still as different as it is possible to be, but that friendship, forged in adversity, founded in tolerance, will last us until our deaths.

So what can I add to this cuckoo of a story? *Tracks* was a book that was never intended, that I wrote long before I considered myself a writer at all, yet has never been out of print since its publication. I have had several chances during those three decades to grind off some of its raw edges, but have always decided against it. Whatever its inelegance of style, it was written with verve, confidence and a passion for truth, for getting behind my own act: let it stand. And, whatever its flaws, it is still closest to 'what really happened'.

The question I'm most commonly asked is 'Why?' A more pertinent question might be, why is it that more people don't attempt to escape the limitations imposed upon them? If *Tracks* has any message, it is that one can be awake to the demand for obedience that seems natural, simply because it is familiar. Wherever there is pressure to conform (and one person's conformity is often in the interests of another person's power), there is a requirement to resist. Of course I did not mean that people should drop what they were doing and head for the wilder places, certainly not that they should copy what I did. I meant that one could choose adventure in the most ordinary of circumstances. Adventure of the mind or, to use an old-fashioned word, the spirit.

From my point of view, there is either no answer at all to that question, or the answer is so complex and manifold that it's pointless to go there. I hope that the action speaks for itself. Who would not want to be in that exquisite desert? And camels are the most sensible way to travel through it. (I couldn't afford a truck.) But, even if I were to attempt a simple response, I am in any case no longer the person who made that decision with her life. I have an affinity with her, occasionally even feel proud of her, but she isn't me.

So who was she? To answer that one has to understand something of her

era — the late sixties, early seventies, when anything and everything seemed possible and the status quo of the developed world was under radical scrutiny by its youth.

We were lucky to have experienced only post-war prosperity. We were not anxious about money. (We were afraid for our future in other ways: nuclear bombs, the Cold War and its various hot spots, ecological collapse.) We shared houses, learnt to live flexibly and on very little. We formed intense friendships that seemed to have the tenacity of the biological ties they were meant to replicate. We could choose not to participate in politics, but we could not *avoid* politics. It was in the air we breathed. And politics was about justice. It was high minded, and nothing to do with the low-life power struggles of career politicians.

We reacted against the closing in of the post-war nuclear family, its concern with safety and security, in particular its assumption that women should remain inside the domestic realm. We wanted to understand the political forces that shaped society, the injustices that allowed us material well-being while vast swathes of the world starved, the imbalance of power and opportunity between classes, races, sexes. But, perhaps most importantly for someone like me, nothing was as important as freedom: the freedom to make up your own mind, to make yourself. And such aspirations inevitably involved risk, unleashing opportunities for learning, discovering and becoming.

I am describing a cliché, of course, and the reality was far more variable and complicated (we were also spoilt and selfish). But no one can live too far outside the clichés of their time. I arrived in Alice Springs carried, at least in part, by the momentum of that era's sense of promise, quest and justice.

Aboriginal Land Rights had recently been legislated. Young, tertiary-educated idealists came from the cities to Alice Springs to administer that legislation, or to set up organisations designed to empower Aboriginal people. I was not directly involved in this social movement (I was too busy training camels and building saddles), but I was certainly a fellow traveller, inclined to left-wing ideas, more because I disliked the other side than fervently identified with this one. Although I was not a writer then, I nevertheless had a writer's sensibility. A writer's task is to look at the world from an independent viewpoint and to tell the truth as you see it. And that was not an easy thing to do at the time in Alice

Springs. (It is never an easy thing to do.) There was a 'correct' political view and if you did not back that view 100 per cent you were accused of providing fuel to the opposing side. The discomfort I felt under that moral pressure has stayed with me all my life and made me eternally wary of ideological certainty.

Since then, from within the Aboriginal community itself, several conflicting political perspectives have arisen and that can only be a good thing. Meanwhile, the Australian government has officially apologised to Aboriginal people. Whether that will do them a tremendous amount of good, who can say?

Could such a journey be made in the same way now? No, absolutely not. There would be many more people out there with many more ways to keep tabs on you, more red tape to hold you back, more no-go areas, more fences, more vehicles, more control. New communications technology would make it impossible to get lost, no matter how hard you tried. When I set out it was still just possible to travel through that country as a free agent, to stay beneath any kind of radar, to take full responsibility for your own life.

The notion of privacy has also changed — the desire for it being almost a cause for suspicion these days. The motivation behind my decision was intensely personal and private, such that accepting money from a magazine felt like self-betrayal. I suspect that would be thought eccentric now.

The early seventies saw the beginning of group tourism and the fashion for buying four-wheel-drive vehicles to 'go bush'. It struck me even then that the people in those vehicles, for the most part, were sealed against their environment, which they sped through without really seeing, without really connecting. Their cars bristled with two-way radios, were packed with sun creams, air conditioners, special bush clothes, refrigerators... They seemed burdened with 'stuff' and the stuff cut them off from the place they were in. For, when you understand that country, it is the easiest thing imaginable to wander through it with minimal equipment.

I wanted to shed burdens. To pare away what was unnecessary. The process was literal, in the sense of constantly leaving behind anything extraneous to my needs, and metaphorical, or perhaps metaphysical, in the sense of ridding myself of mental baggage.

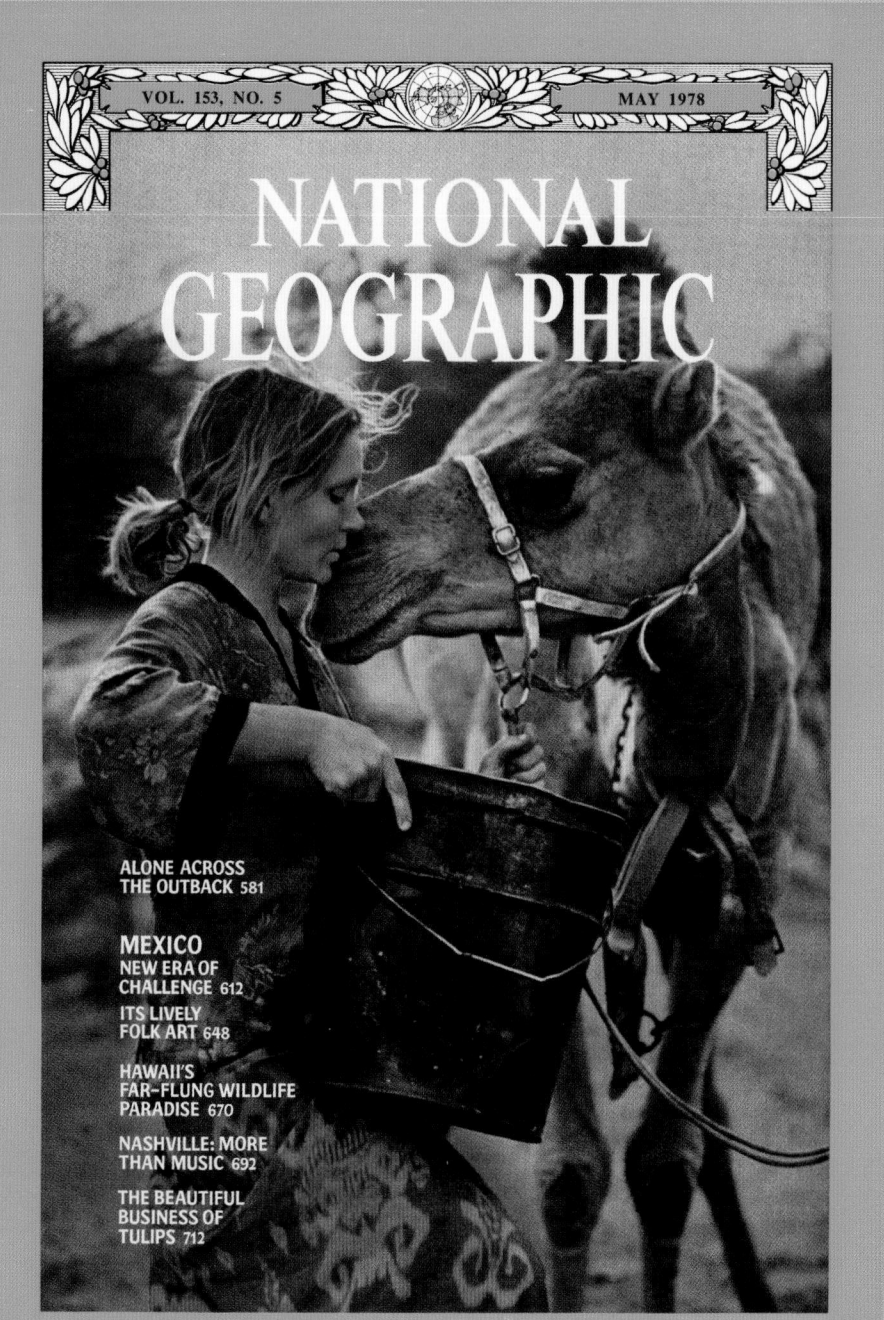

When *National Geographic*'s cover story about Robyn's camel trek was published, it became one of the most popular in the magazine's history.

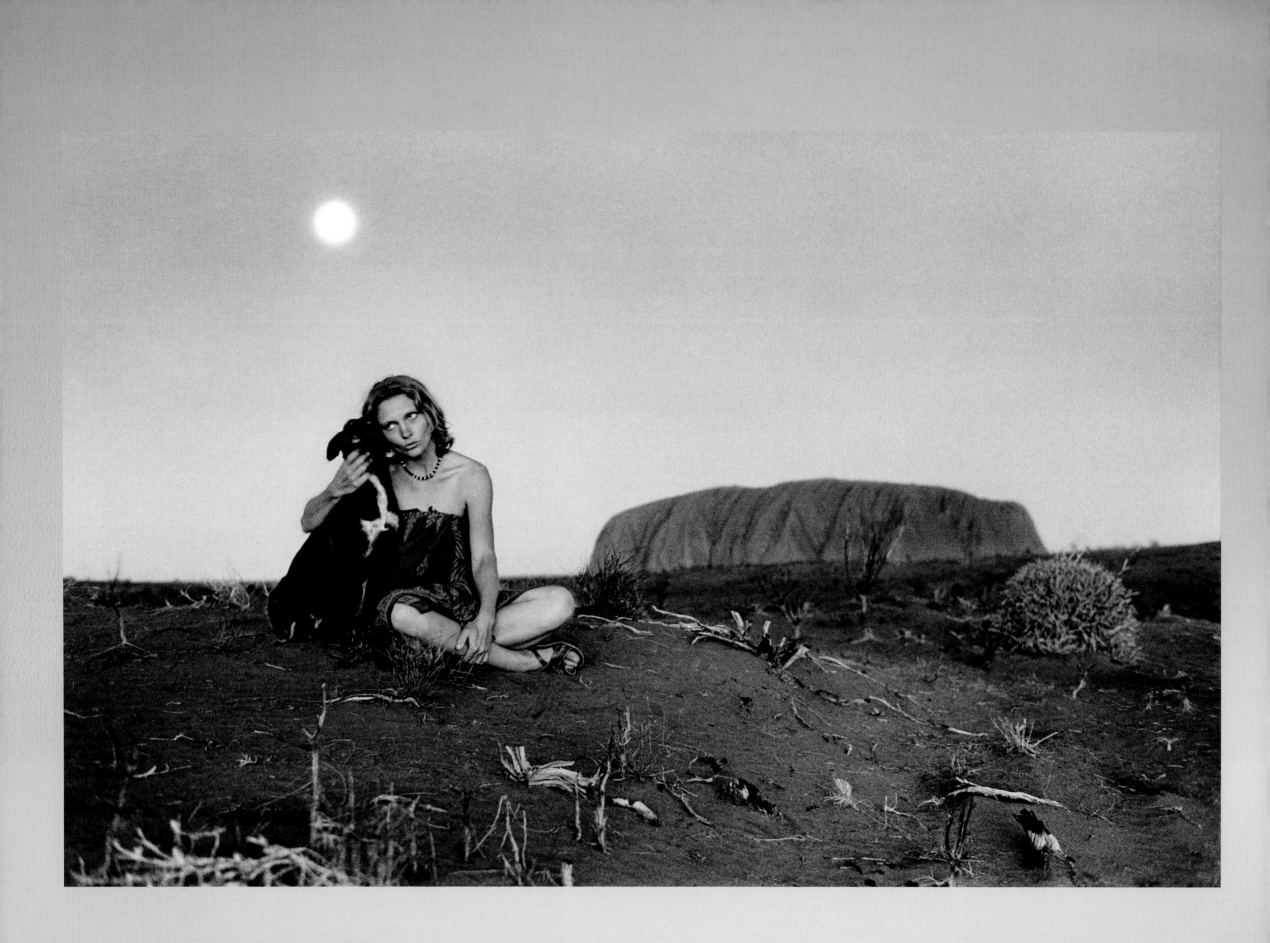

The heart of the book, I think, is the moment at which that paring away allows for a different kind of consciousness to emerge. In some ways I suspect I have never recovered from it. It was something to do with letting go of boundaries (very frightening at first), and a sensation of connection with everything around me. I tried to describe the phenomenon dispassionately, avoiding the language of mysticism.

Certainly I was intensely tuned in to my environment, aware of the interconnection of things — that net, or web, of which we are a part. Travelling with an old Aboriginal man, Mr Eddie, set me up for that change and I hope it was not presumptuous of me to imagine that this new state of mind might be something similar to the way traditional Aboriginal people related to place. It is one of history's ironies that such profound knowledge is becoming rare just as the rest of the world begins to understand its value. European Australia has existed for only 200 years, but in that time tremendous damage has been done to our country.

The desert systems, pristine to the untrained eye, have been flogged by cattle and whacked out of kilter by introduced species. Waves of extinctions have occurred and that process is speeding up. I experienced this myself and wrote about it: of travelling through the Gibson Desert during a drought, but finding it rich with life, with plenty of tucker for my animals. Then, a month later, reaching the first pastoral fence to find the real desert beginning — a dust bowl full of dead or dying bullocks, with no ground cover except poisonous turpentine bush. That boundary fence marked the most depressing transition in the whole journey.

But I could not foresee that in just 30 years the landscape I knew so well would be refashioned to such an extent that I would find it difficult and painful to return there.

Up in the sand hills, where I would sometimes sit to watch a sunset, were delicate little scrawls of tracks in the sand, made by lizards, marsupial mice, particular insects. There would be the drag marks of perenties, the pretty scallops of a snake, the long indentations of roos' hind feet, the triple prongs of emus. In the evenings those silly curious birds would come into my camp, dingoes would howl close by and I could hear the thump of wallabies and the rustle and hop of little native creatures. Now, many of those animals are rare or gone. Their tracks have been replaced by camel pads and pussycat trails and fox prints and rabbit holes. Wherever you look, these new patterns and marks spread over the earth like mycelial webs.

In other areas, dark green buffel grass has taken over. Introduced from Africa, it is suffocating everything beneath it and changing the unique palette of the Australian interior.

Sometimes I find these changes so upsetting that I never want to go to the desert again. At other times I think that my homesickness is for an experience that can never be repeated and for people and ways of thought whose rightful place is in the past. This desert belongs to another 'now' and it's foolish to compare them.

Just as it is foolish to compare the 'truthfulness' of the book *Tracks*, Rick's pictures of the journey, and the film. Each has its own artistic integrity; each is in dialogue with the others in the realm of imagination.

And that earlier Robyn Davidson? My feelings for her are somewhat similar to my feelings for Mia Wasikowska: admiration and a curiously deep connection and affection.

As she so wisely wrote in the last sentence of *Tracks*: 'Camel trips do not begin or end, they merely change form.'

Robyn Davidson was born on a cattle property in Queensland. She lived in Sydney for several years, then returned to Queensland to study Japanese and Philosophy before going to Alice Springs, where the events of this book begin. Davidson's first book, *Tracks*, an account of her journey alone, with camels, across Australia, has sold more than a million copies in 18 languages and won many awards, including the prestigious Thomas Cook Travel Book Award. She has travelled extensively, spending most of her time in London, New York and India (where she lived for a year with migrating nomads in the northwest). Davidson is currently based in Melbourne but spends several months a year at her house in the Indian Himalayas. Her books include *Tracks, Ancestors, Desert Places, The Picador Book of Journeys, Travelling Light* and *No Fixed Address*. The introductory chapter of her upcoming memoir (to be published by Bloomsbury) won the Peter Blazey Fellowship Award for Best Writing.

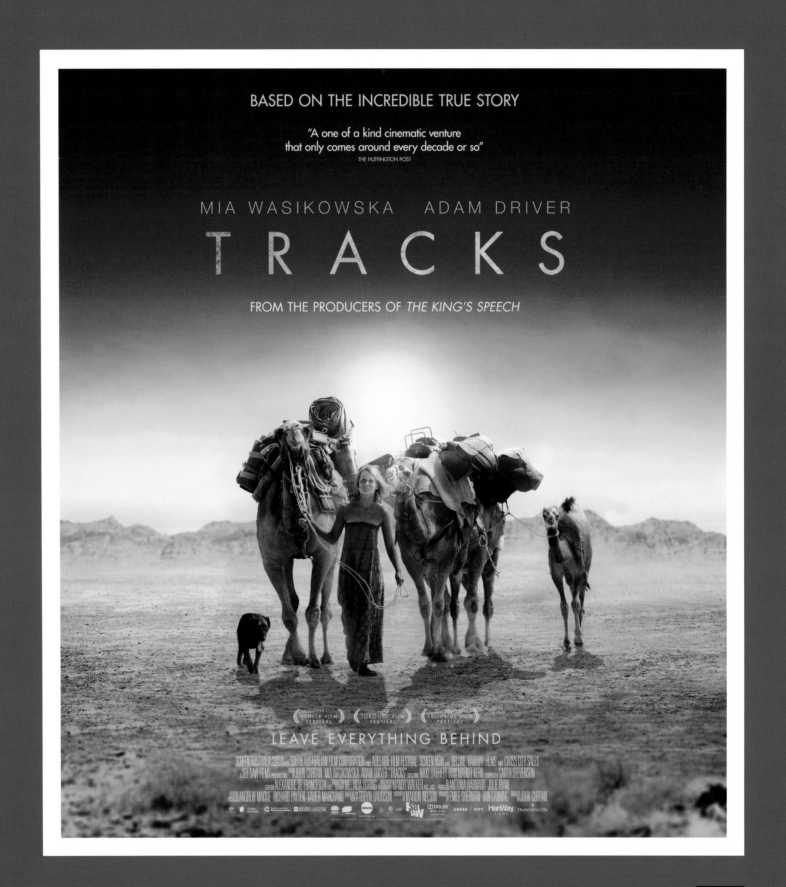

INSIDE TRACKS

THE MOVIE

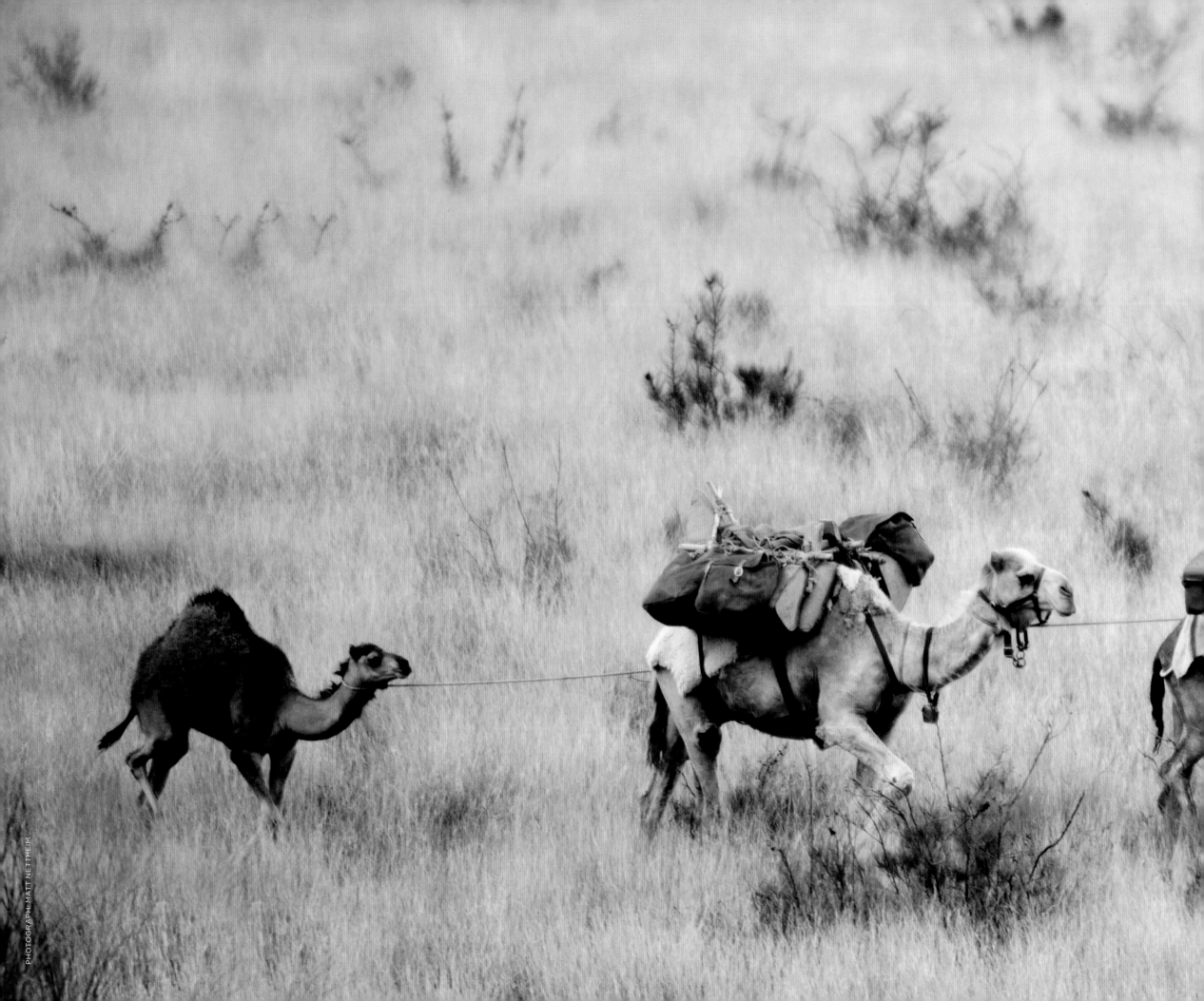

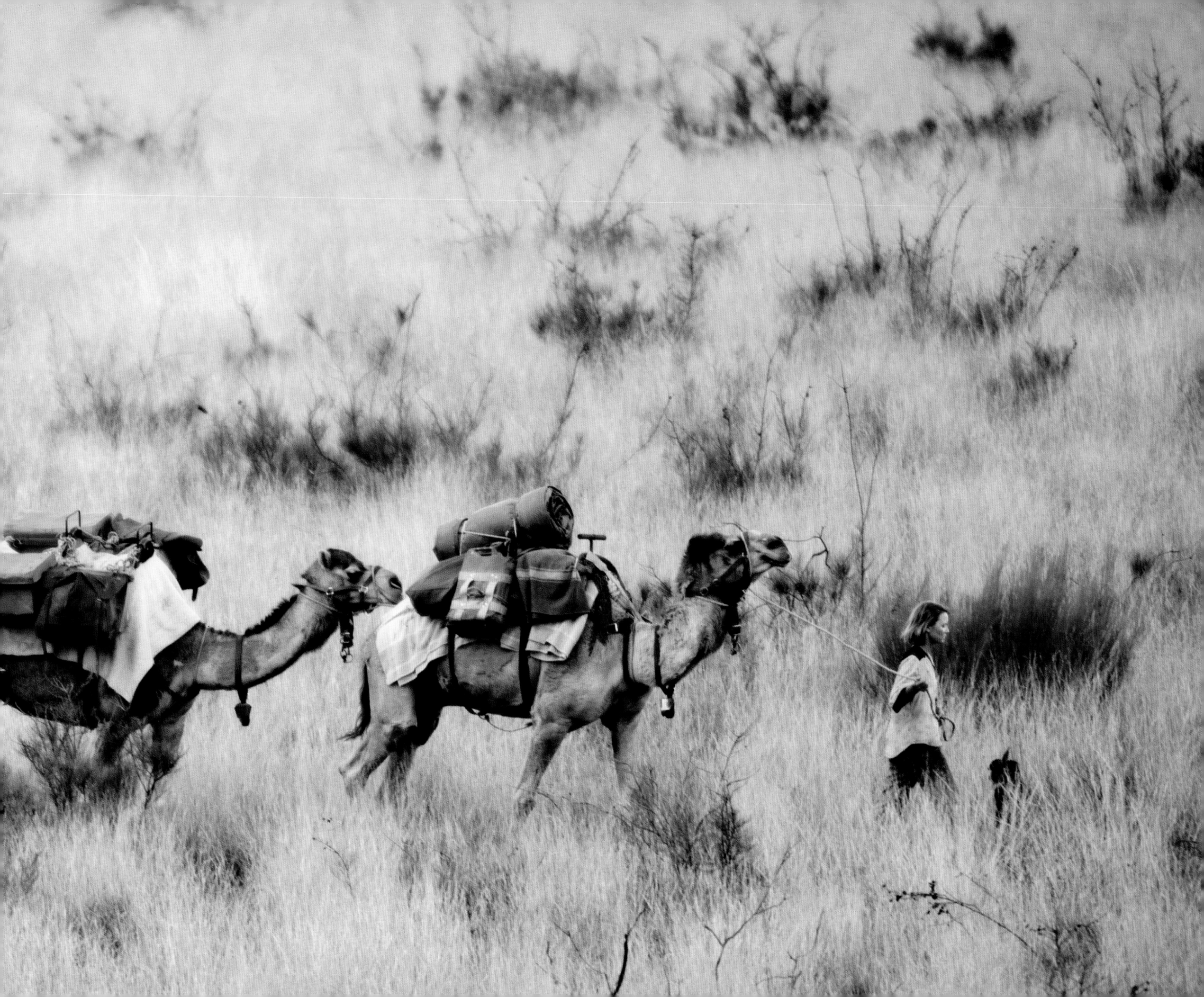

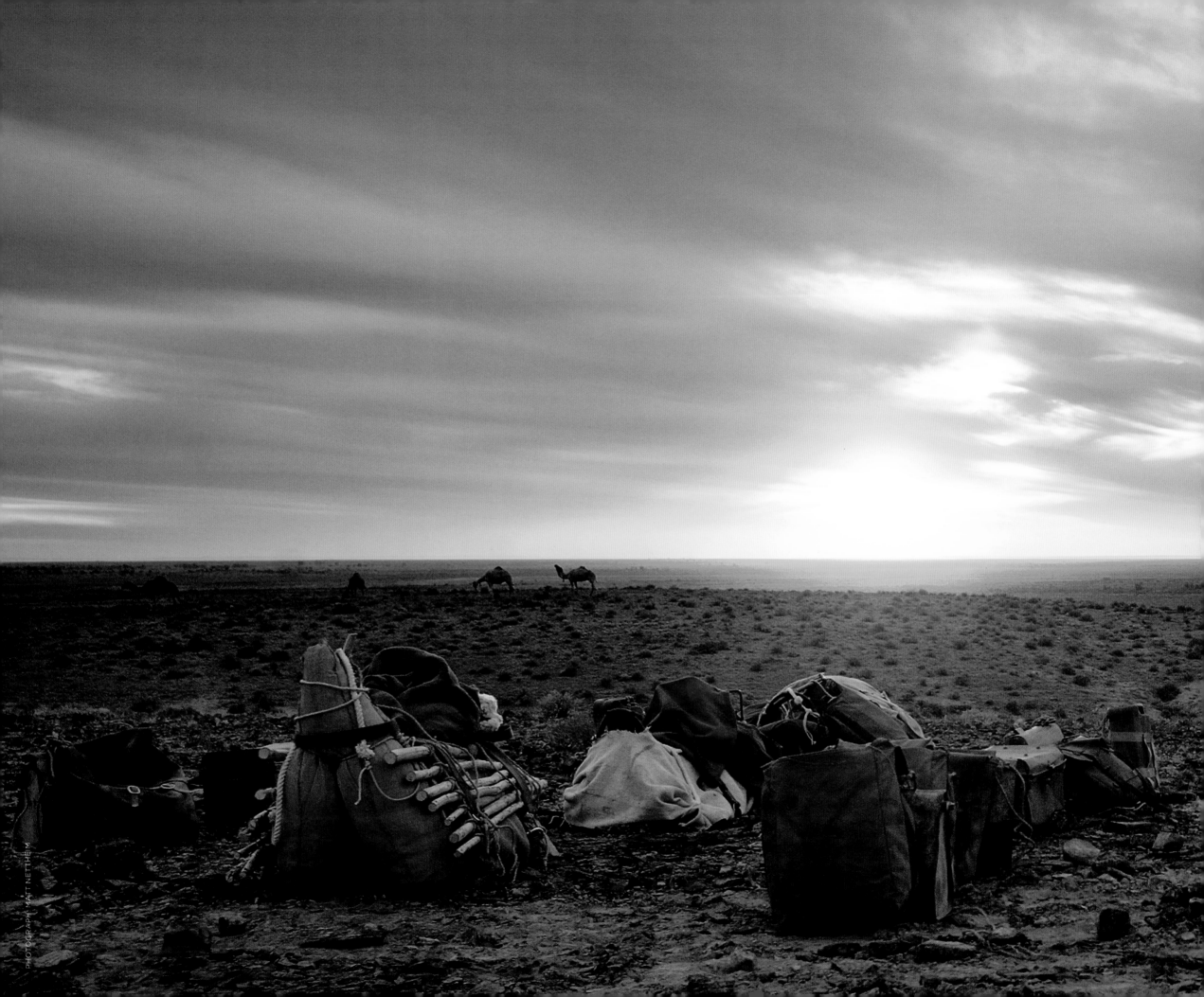

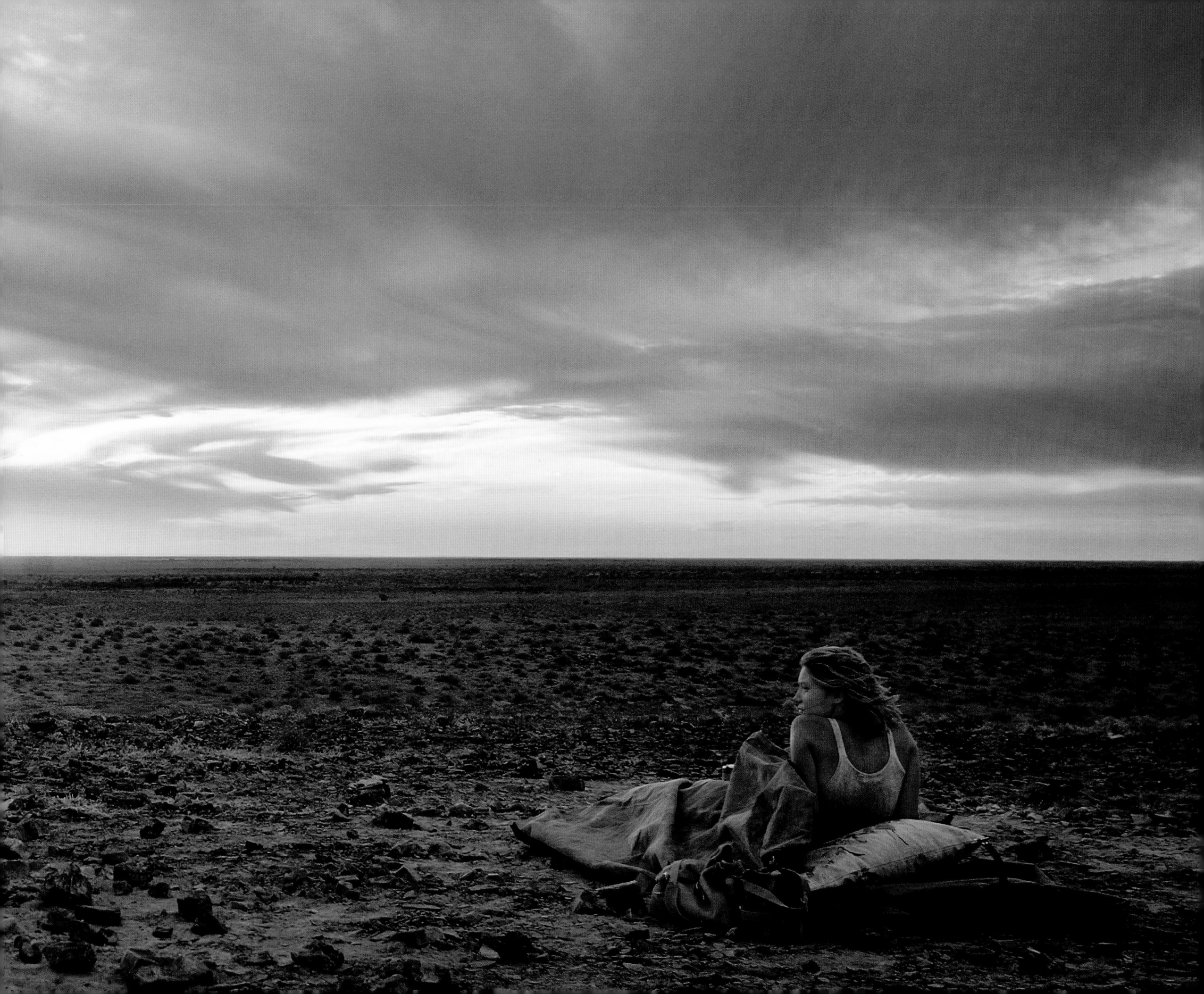

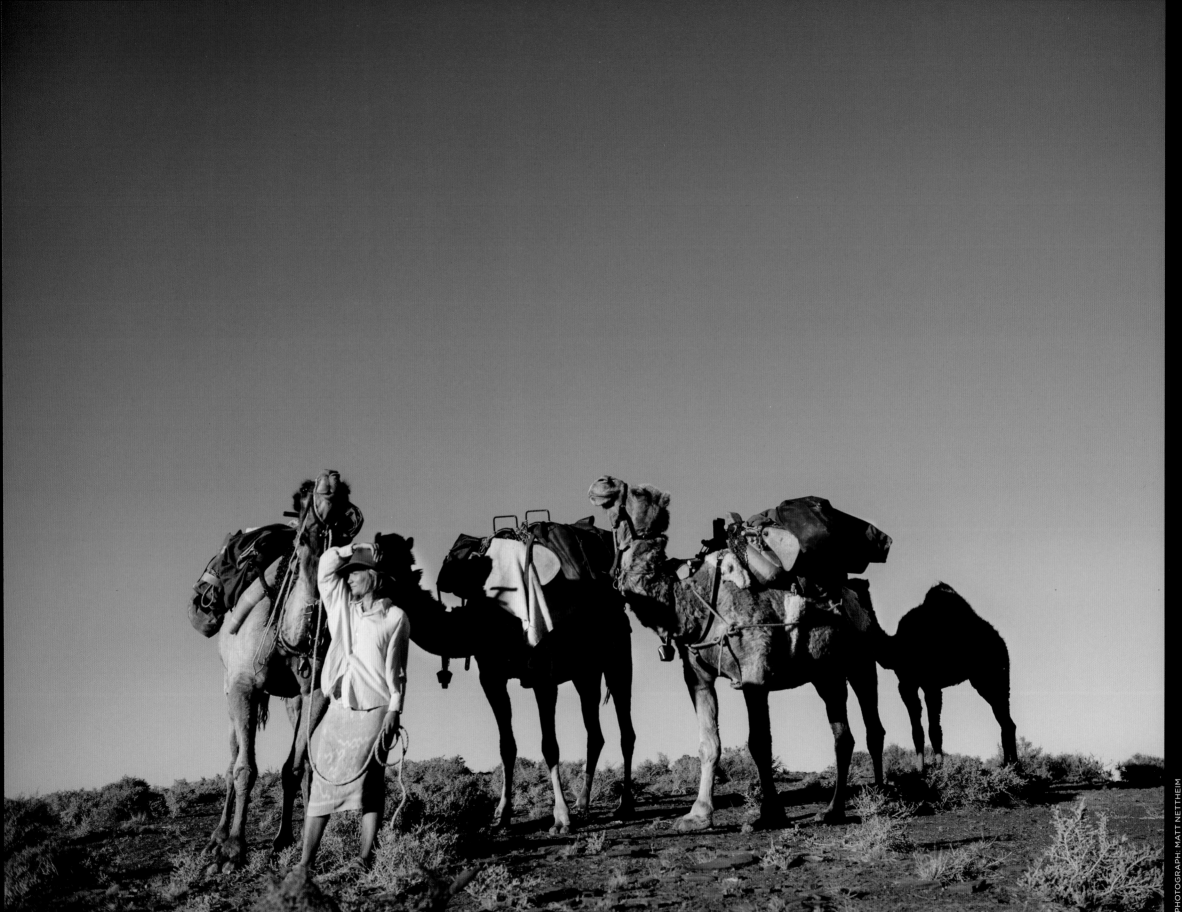

" I'D LIKE TO THINK
AN ORDINARY PERSON
IS CAPABLE OF ANYTHING "

I am planning to walk across the Australian desert from Alice Springs
to the Indian Ocean, a distance of 2700 kilometres.

The trip wasn't conceived as an adventure in the sense of something to be proved or
conquered. And, when people ask me why I am doing it, my usual answer is, why not?

I've always been drawn to the purity of the desert, its hot wind and wide-open spaces.
But mainly I am bored of life in the city, with its repetition, my half-finished, half-hearted
attempts at jobs and various studies. And I am sick of carrying around this self-
indulgent negativity that is so much the malaise of my generation, my sex and my class.

The decision to act was in itself the beginning of the journey. I believe when you've
been stuck too long in one spot, it's best to throw a grenade where you're standing
and jump and pray.

I am well aware of the hardship I will be facing and I am the first to admit I am
remarkably under qualified for such a hazardous undertaking. But this is precisely the
point of my journey; I'd like to think an ordinary person is capable of anything.

—Robyn Davidson (Mia Wasikowska)
from the opening voice-over narration in the movie, *Tracks*

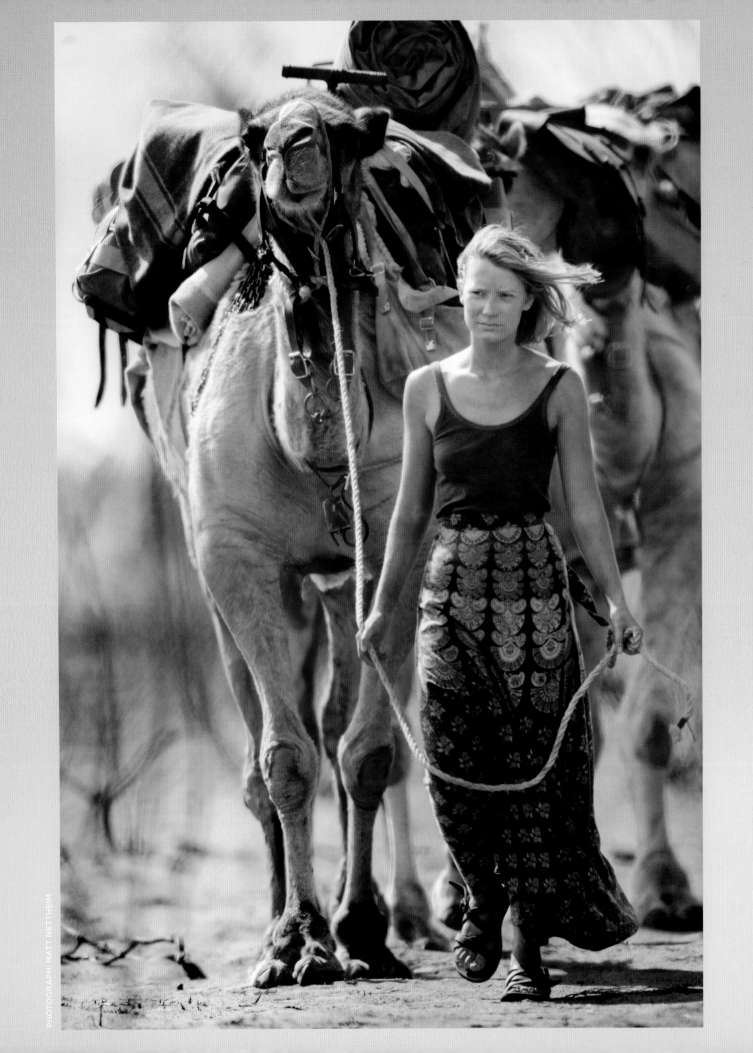

JOURNEY TO THE SCREEN

BY JOHN CURRAN

In 1984 I was working as a graphic designer and illustrator in New York and wanted a sea change in my life. For no obvious reason that I can remember — I knew nothing about it or anyone there — I decided to move to Sydney.

Along with some clothes and whatever money I had saved, I brought with me just two possessions: a 35mm camera and a parting gift from a friend — a large photography book called *A Day in the Life of Australia.* That book contains my earliest visual impressions of the country I would call home for the next 18 years.

After my arrival in Sydney I travelled up the coast for a few months, staying at youth hostels and camping whenever I could. It was during this trip that I came across the book *Tracks*. It was very popular among the foreign backpackers and gypsy surfers — particularly women — and required reading for travellers venturing into the 'outback', a destination that seemed to defy any geographical specificity other than as a place 'beyond the bush'.

Ironically, I never got around to reading *Tracks*.

Jumping forward a few decades, film producer Emile Sherman contacted me about directing a film based on Robyn's book. By that point *Tracks* had reached iconic status as a seminal Australian tale of individual fortitude and feminine empowerment. Within the film industry it was equally famous for the numerous failed attempts to bring it to the screen.

When I finally read it I understood why. The strength of the book lies in Robyn's distinct voice and first person narrative, a woman alone in the desert with animals — which doesn't easily translate into film. On the other hand, the book immediately threw me back 20 years to my arrival in Australia and my vague reasons for moving here: what I couldn't shake was my fascination with Robyn's inability to offer up some pithy explanation for embarking on her extraordinary journey. Who knows why we do the things we do?

I did a little research into the photographer in the story and was surprised to discover he was the same Rick Smolan who had produced *A Day in the Life of Australia*. A small coincidence perhaps, but one that convinced me there are larger forces at play in the universe, and that somehow Robyn, Rick, Emile and I were entwined in a pre-written destiny together.

Or maybe I couldn't decide about committing to the film and was looking for a sign? I can't remember.

Whatever my real reasons for making the film, meeting Robyn and Rick, immersing myself in their journey and re-creating it in the Australian desert was one of the best creative experiences of my life.

And I'm thankful and proud to have played a part in their ongoing story.

John Curran worked as an illustrator and graphic designer in New York before moving to Sydney, Australia in 1986. His debut film, the 1998 drama, *Praise,* won the Film Critics Circle of Australia Award for Best Director and the International Critics' Award at the Toronto International Film Festival. Other films include *The Painted Veil, Stone* and *We Don't Live Here Anymore*. He is currently developing a mini-series for HBO about Lewis and Clark.

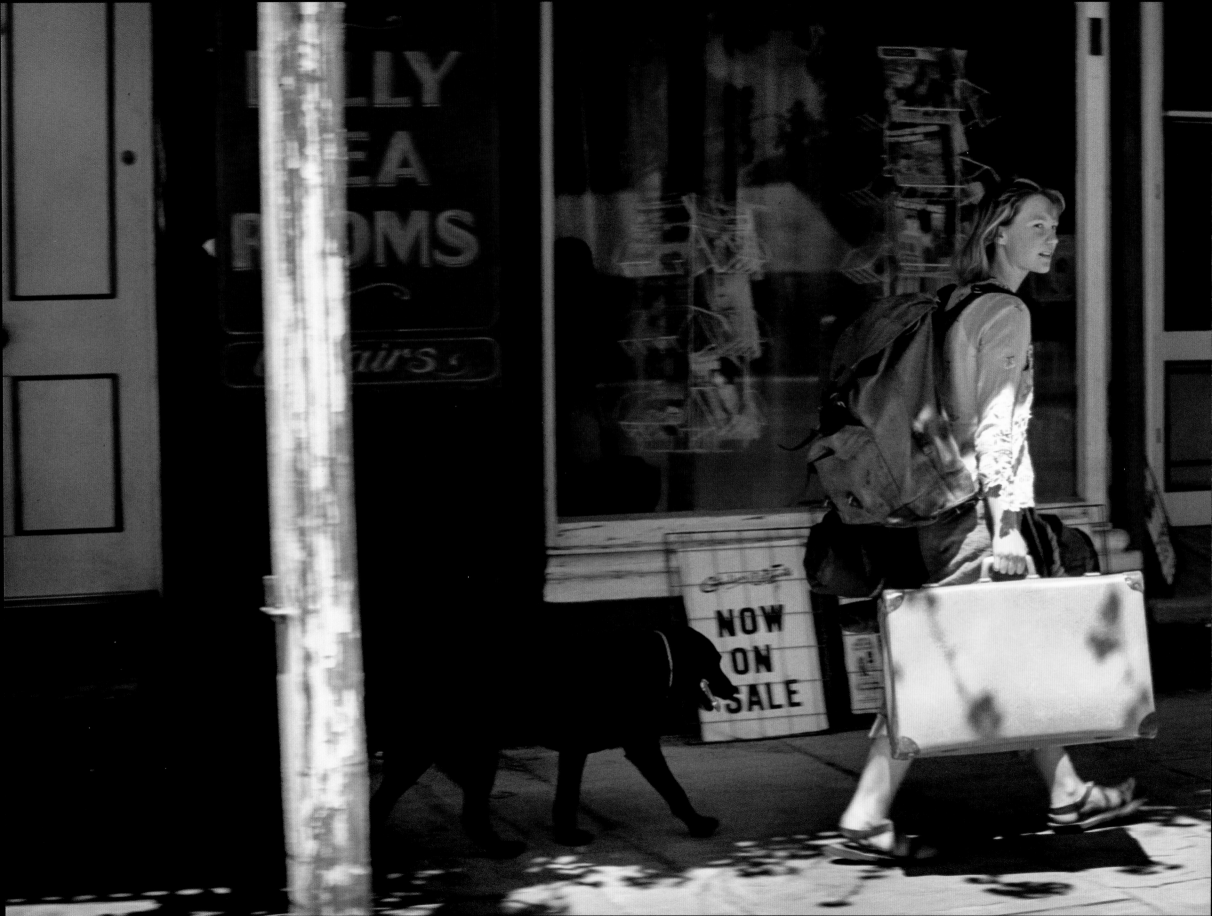

ROBYN ARRIVES IN ALICE SPRINGS LOOKING FOR WORK

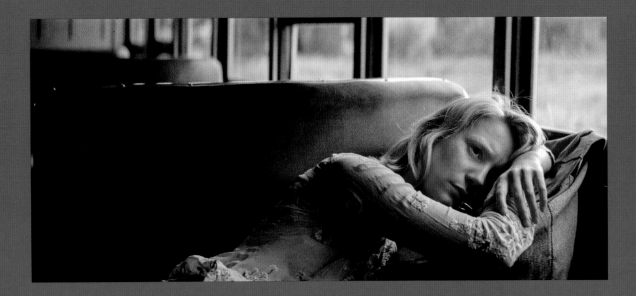

INT. TRAIN - EARLY MORNING

Robyn is curled up on the seat asleep. Her dog Diggity sits on the seat opposite watching her. Diggity whines softly. Robyn opens her eyes and realises the train has stopped.

We get our first real look at her: A careless beauty dressed indifferently, but with just enough flair to scream outsider in this country town.

She takes stock of her surroundings. Robyn shivers against the cold morning wind, a look of regret on her face. Hefts up a small suitcase and bedroll and moves off.

> ROBYN
> *C'mon Diggity.*

Robyn crosses to a row of shops, walks along the footpath and enters a PUB.

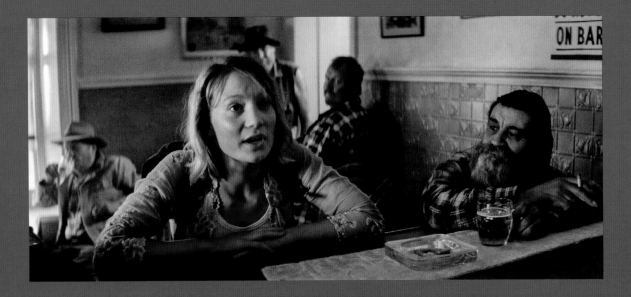

INT. PUB - SALOON BAR - MORNING

Robyn approaches the bar with a friendly smile. It is already crowded with PUNTERS - TRUCKIES, STATION HANDS, a few old men. All of them stare at her. An unfriendly PUBLICAN is restocking the till. He's not especially pleased to see her.

> ROBYN
> *I was wondering if you had any work?*

He looks her up and down.

> PUBLICAN
> *(double-edged)*
> *What kind of work?*

> ROBYN
> *Behind the bar. Anything.*

> PUBLICAN
> *Ask the Missus. She's out the back.*

He gestures toward a hard looking woman sweeping in the rear of the pub - a woman with years of tough life experience.

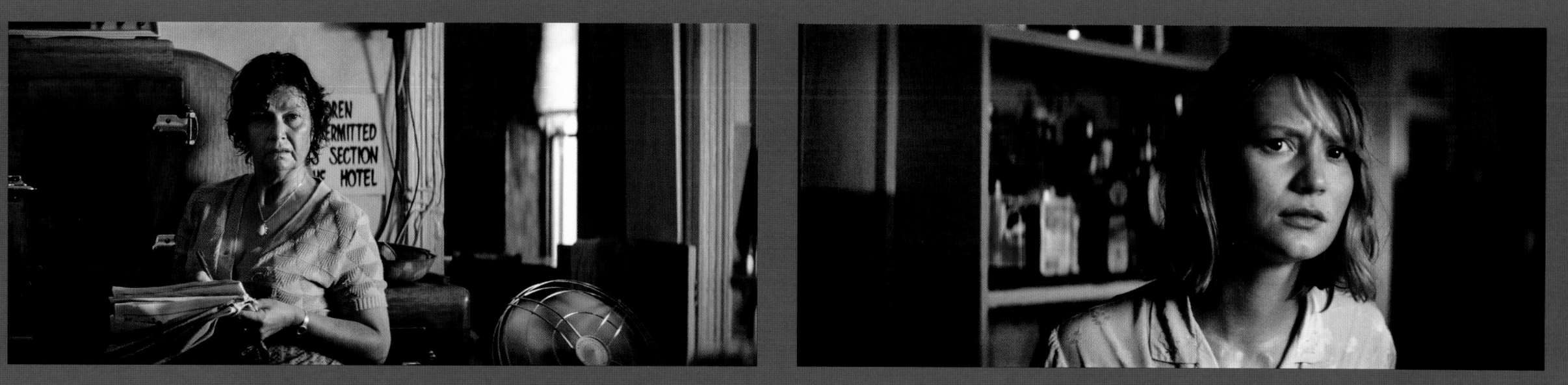

INT. PUB - AFTERNOON
The wife pauses from wiping a table.

 WIFE
 Come again, luv?

Robyn stops sweeping. It's hard for her to repeat herself, but she overcomes her
shy self-consciousness.

INT. PUB - ANOTHER DAY
Word travels fast. Robyn notices a few men snickering as she passes carrying a tray
of empties. She moves behind the bar, unloads the glasses into the sink. An angry
middle-aged Aboriginal woman, barrels into the inner bar: a breach of unspoken
protocol. She berates an OFF DUTY POLICEMAN in Pitjantjatara dialect.

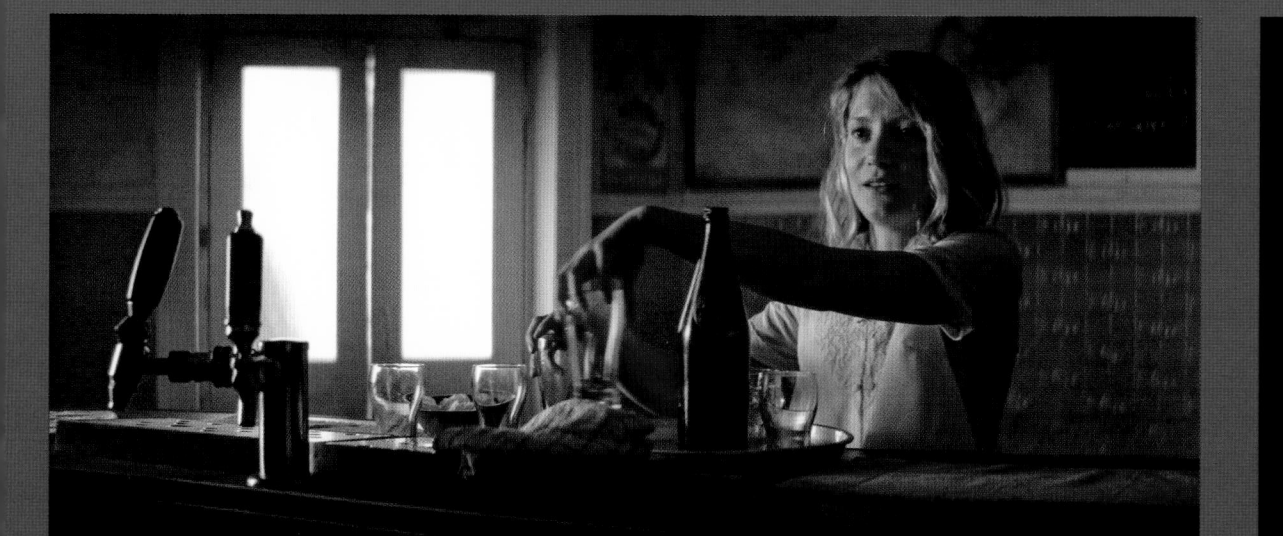

 ROBYN
 I'm going to walk across the desert. From Alice to the ocean.

The wife thinks this new girl is deluded and coddles her:

 WIFE (condescendingly)
 You go right ahead, luv, you go right ahead...

The cop ignores her. THE PUBLICAN yells for her to get out, and she begins shouting.
The publican rushes over and grabs her violently, dragging and pushing her towards
the door. He shoves her hard through the door and we see his hand come up striking
her (off camera). The other patrons barely notice. Robyn is paralysed, horrified.
Her eyes smart with tears of shame. She turns and sees the publican's WIFE watching
silently from the doorway. The wife catches Robyn's look and glances away.

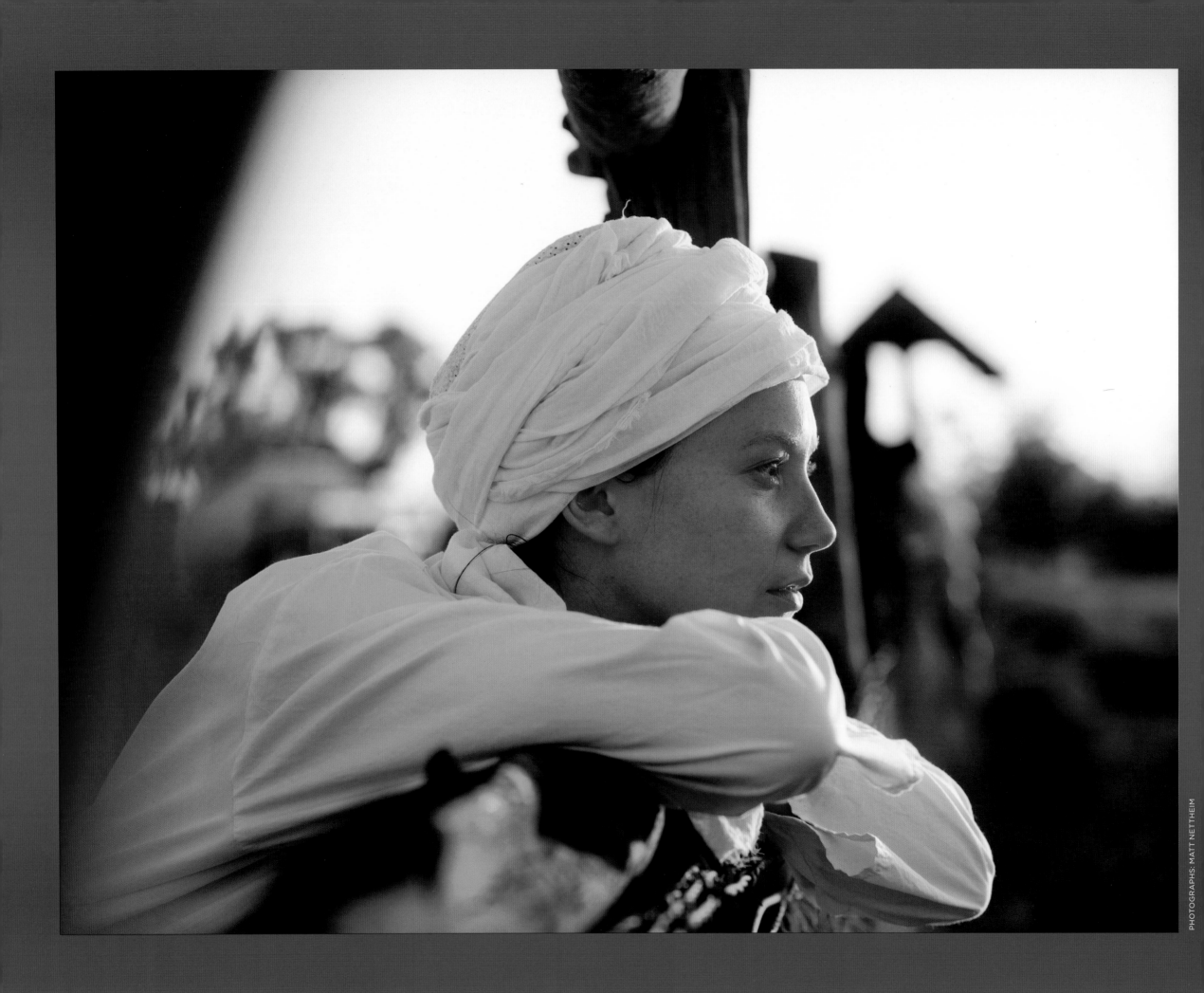

ROBYN AGREES TO WORK FOR KURT POSEL IN EXCHANGE FOR CAMELS

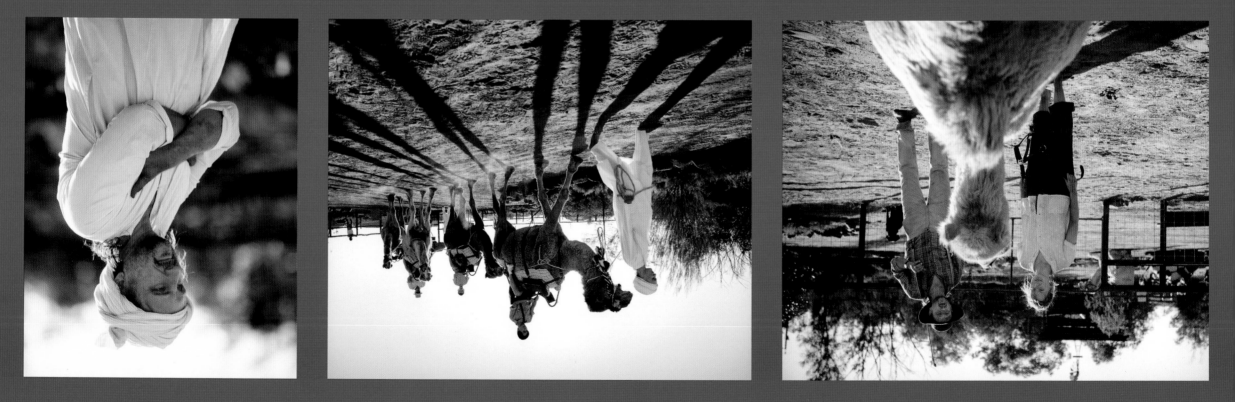

EXT. POSEL RANCH - DAY

Robyn, dressed in a ridiculous white Arabian outfit, complete with turban, is stoically leading tourists on a camel ride. She has bare feet. To a procession of tourists perched high on the camels she delivers a rehearsed speech in an embarrassed and barely audible voice:

ROBYN
There are two species of camel, neither is native to Australia. Some of the first camels brought into the country were for the Bourke and Wills expedition in 1860...

Kurt, working nearby, overhears her desultory commentary.

KURT
(yells angrily)
Louder! More effort!

Robyn is humiliated, and not amused.

ROBYN
Today there are over fifty thousand feral camels in Australia...

EXT. POSEL RANCH - DAY

Robyn and Diggity walk down a rural dirt track outside of town, past a few old run down houses. She stops outside a gate with a sign: CAMEL RIDES. Beyond it is a sad looking house trumped up for tourists with faux Alpine trimmings. Robyn turns to see

KURT POSEL, an imposing wiry man with faux beard, long hair and a thick Austrian accent.

KURT
Your plan - is ridiculous.

ROBYN
My father crossed the Kalahari in 1935 - that wasn't so ridiculous.

ROBYN
I'm a hard worker.
(She puts on her most winning smile)

He considers this. Senses an angle.

KURT
You come work for me for 8 months - for free. I will teach you to train them. After that I give you (pause) two wild camels. And that will be that.

ROBYN
So - do we sign a contract?

KURT
(not making eye contact)
Hey, I'm good to my word.

KURT REFUSES TO HONOUR HIS PROMISE AND FIRES ROBYN

EXT. POSEL RANCH - MORNING

Robyn leads the camels into the pen. Kurt is fixing a saddle, clearly in a dark mood.

> KURT
> *Yeah?*

> ROBYN
> *Can we talk about my trip? My camels?*

> KURT (sarcastically)
> *Your camels?*

> ROBYN
> *Yeah, our deal. I've tried to talk to you about it already, twice.*

> KURT
> *I need you to get up early tomorrow. I want the camels in by five.*

> ROBYN
> *I've been here for over eight months now. I don't have to do shit for you.*

Kurt looks up.

KURT
You're fired.

ROBYN
I'm going to talk to your wife about this.

KURT
Gladdy's gone! And I want you gone, too.

She stares at him, speechless. Eight months down the drain.

KURT (looking down)
I want all bitches gone from my sight.

Robyn storms away, slamming the gate as she goes.

ROBYN FINDS AN ABANDONED HOUSE TO CALL HOME

EXT. DIRT TRACK - DAY

Seething with anger, Robyn pushes an
old rusty bike loaded with luggage and
accumulated gear along a dirt track.
Diggity trails far behind, sensing her
dark mood. An OLD TRUCK drives past,
kicking dust up as Robyn leaves the
Posel Ranch.

<center>ROBYN (V/O)</center>

'The early settlers needed beasts of
burden better suited to the harsh
climate of the outback, so they
imported camels. When trains and cars
came along and there was no longer
any use for them, the camels were set
free. But instead of perishing, they
flourished. Now Australia has the
largest feral camel population in the
world. I just needed three of them.'

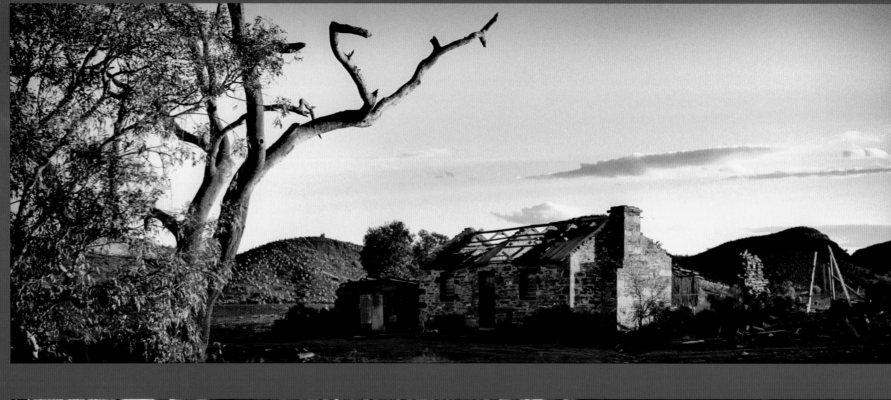

EXT/INT. OLD STONE COTTAGE - CONTINUOUS

Robyn drops her bike and gear and
wanders around the dilapidated cottage,
or what remains of it. The stone walls
are falling in. The roof is gone, only
a few beams and rusted sections of tin
remain. She enters and pokes around the
empty rooms, kicking at the remains
of broken furniture and dust-covered
evidence of former inhabitants. She
peers into a room, empty except for
the frame and slats of an old bed. She
steps outside. Through nearby trees she
sees an old WINDMILL spinning lazily.
Sitting on the floor, Robyn rummages
in her suitcase and pulls out and
unrolls an old worn MAP of Australia.
A scrap of RED YARN is taped to the
map, stretching from Alice to the west
coast. Robyn stares at it for a
long moment.

<center>ROBYN</center>
<center>*What do you think, Dig?*</center>
<center>*Home sweet home, eh?*</center>

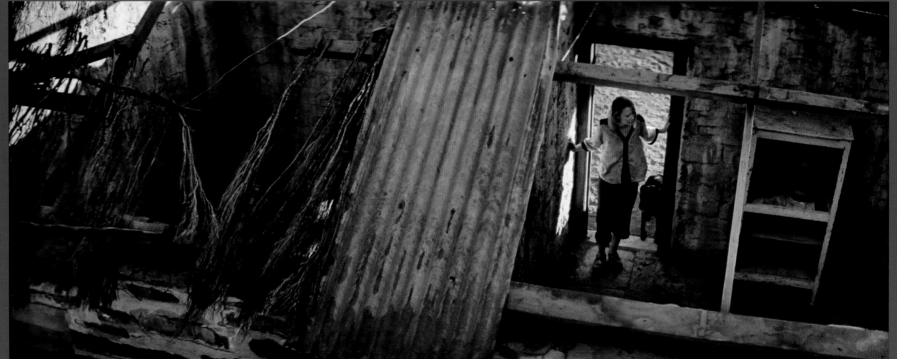

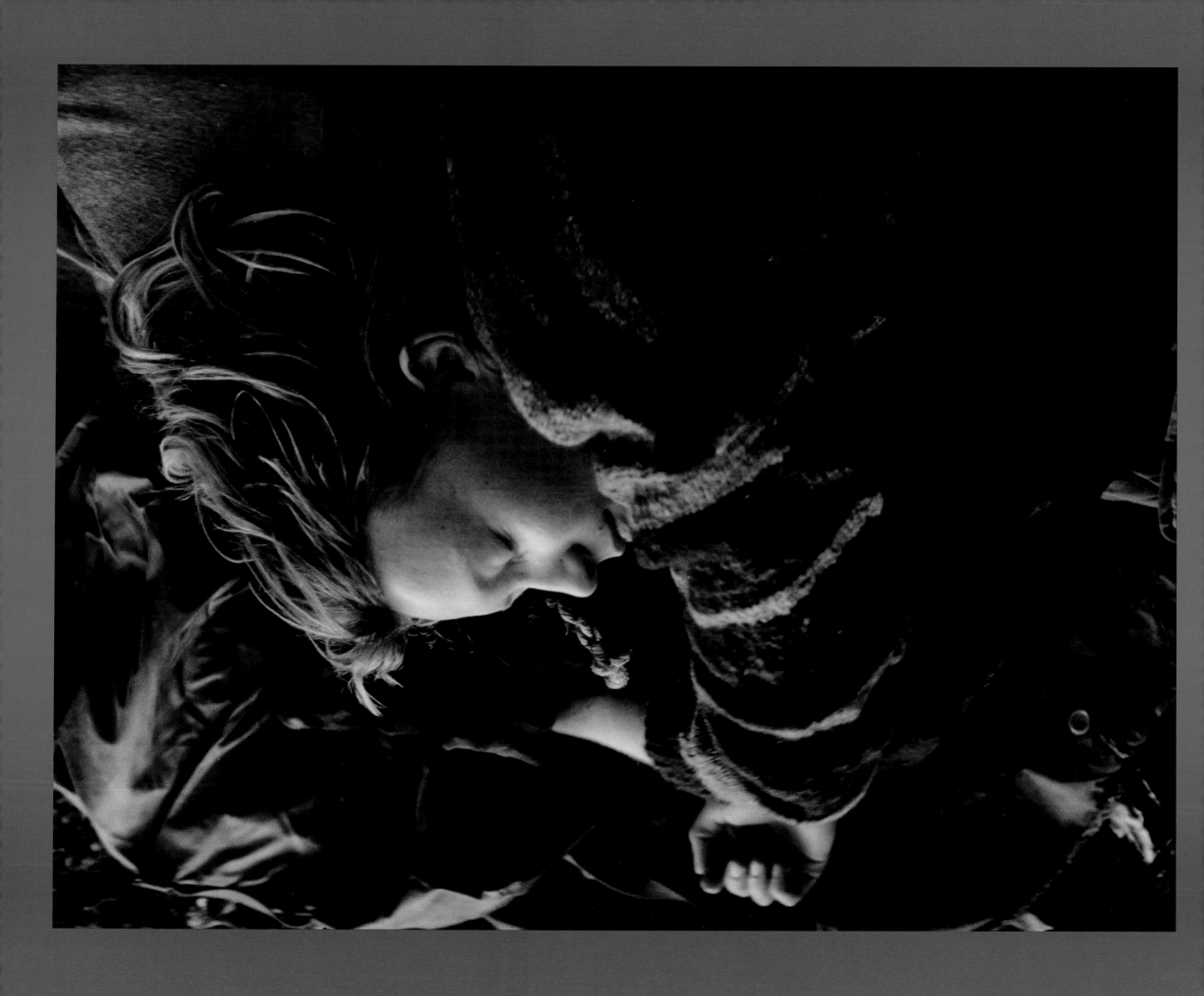

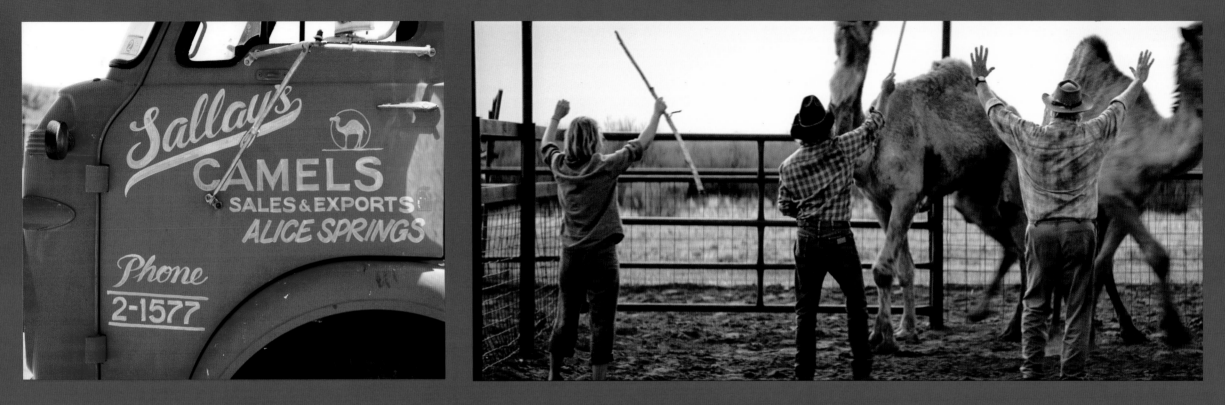

EXT. SALLAY MAHOMET CAMEL PEN

> ROBYN (V/O)

'I went to work for a 65-year-old camel wrangler named Sallay Mahomet. He came from a long line of Afghan cameleers.'

...A reluctant, groaning CAMEL is dragged off the rear trailer of Sallay'S TRUCK by two ranch hands. SALLAY is fixing leather halters near a large dusty yard filled with WILD CAMELS.

> SALLAY
> *You know that's about 2000 miles?*

Robyn stands next to her bike. Diggity sits panting nearby.

> ROBYN
> *Yes.*

> SALLAY
> *That's six months of hard walking, tougher still if you get injured. Easy enough*
> *to get lost, run out of water... food... He looks up, fixes Robyn with a stare.*

> SALLAY (CONT'D)
> *Don't have to be unlucky to die out there.*

Robyn tries to be as honest as she can - in her direct steady gaze and manner. She awkwardly tries to find the right words.

> ROBYN
> *I want to be by myself.*

A mutual assessment/communion.

> SALLAY
> *Anyone who can survive Kurt Posel for eight months deserves a chance.* (kindly)
> *Come back tomorrow. Let's see how you go.*

On ROBYN'S FACE, astonishment and relief...

> ROBYN (V/O)

'He offered me one wild camel for a month's work at half pay.'

EXT. SALLAY MAHOMET CAMEL PEN, NEXT DAY

Sallay and Robyn watch the camels from the side of the pen. Robyn is ecstatic and says thanks. Sallay is embarrassed by emotion.

> SALLAY (affectionately)
> *You're a strange girl Robyn Davidson.*

They watch the camels together in silence.

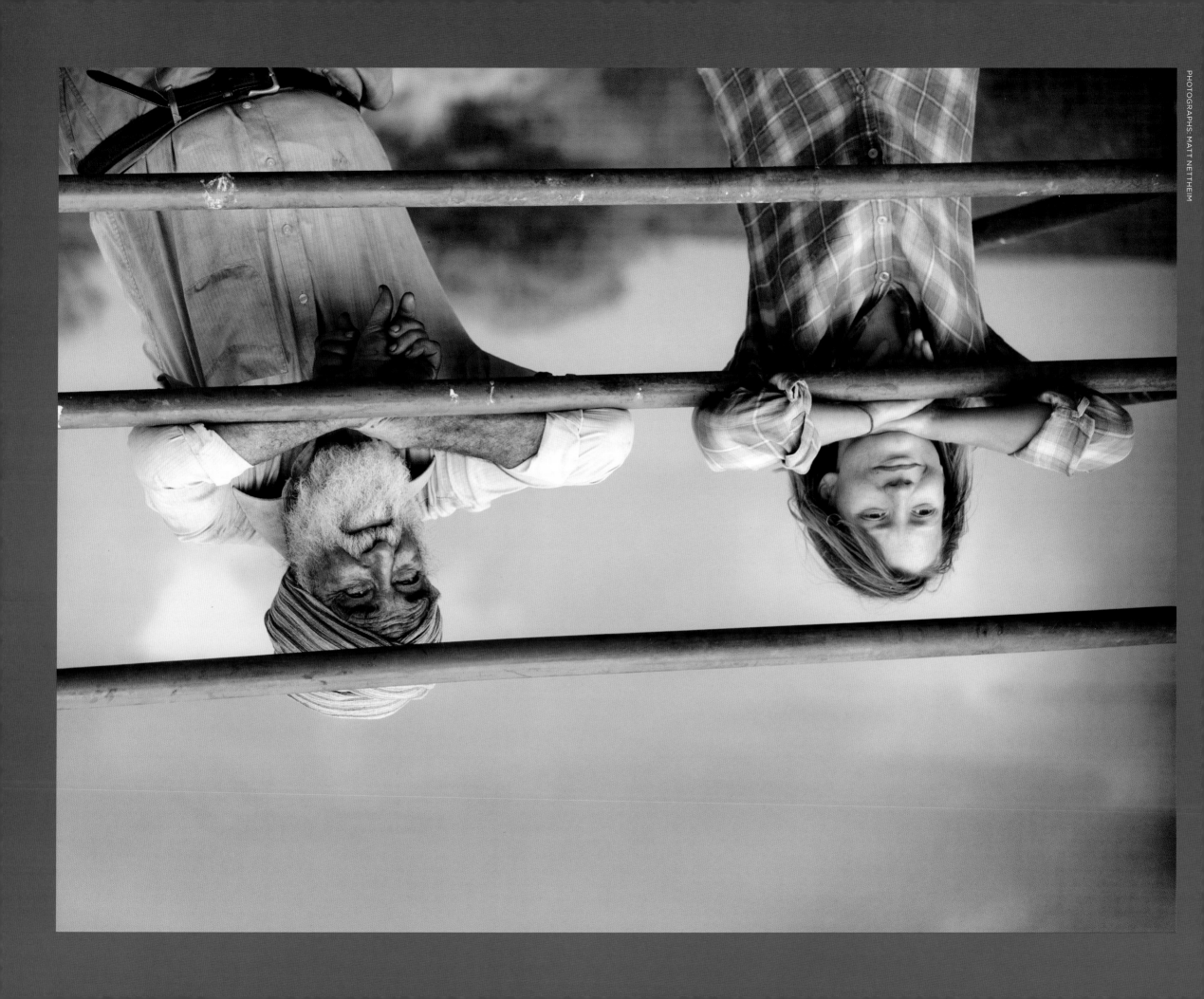

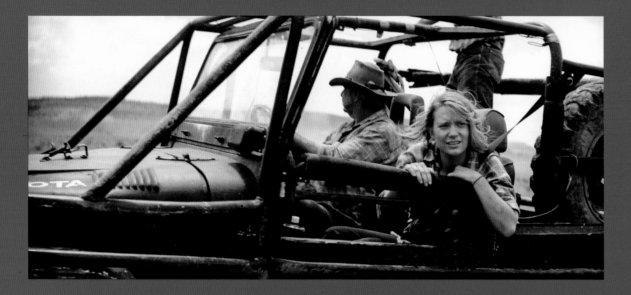

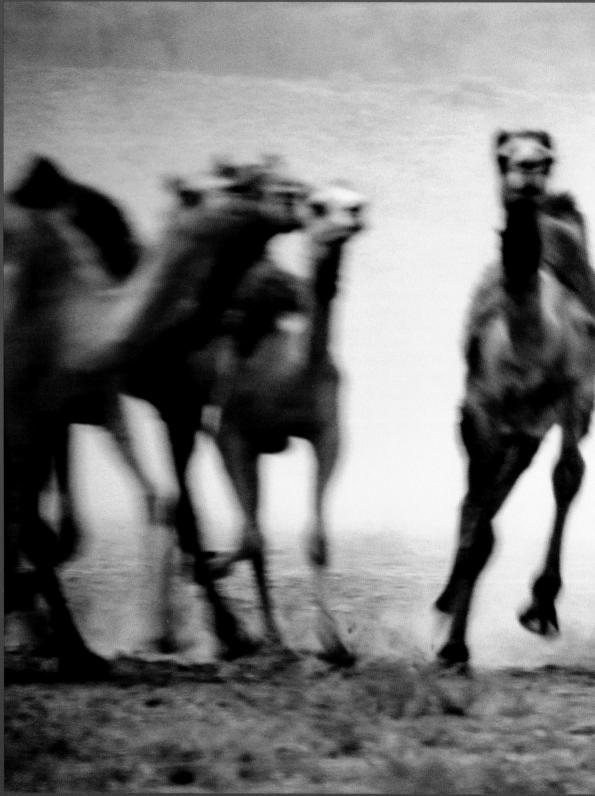

EXT. OPEN PLAIN - 3 MONTHS LATER

ROBYN bouncing violently in the passenger seat of an open UTE driven by SALLAY - racing across an open plain in pursuit of three sprinting camels.

Chilpi guns the engine. Evan stands in the tray of the ute swinging a lariat in one hand, somehow holding on with the other as the truck swerves and bounces in pursuit. They close the gap on the galloping cow and pull up alongside it. For a second the cow runs so close Robyn can see the fear in her eye - and in that moment Robyn's heart goes out of the chase.

EXT. OLD STONE COTTAGE

Sallay castrates Dookie. Robyn looks on. Bub is next in line. It's gory gruesome work.

> SALLAY
>
> *No choice. You've seen what happens when one of these bull camels gets his lovelies set on something. There's no stopping him. A bull in rut will do anything to get to a female camel. He'll bite, kick, kill anything that gets in his way... and that includes you.*

Sallay plops the bloody testicles into a bucket. Robyn grimaces.

> SALLAY
>
> *And when you're out there alone and you see a wild bull coming, you shoot it. Don't think. Shoot. You understand?*

> ROBYN (nods reluctantly)
>
> *Got it.*

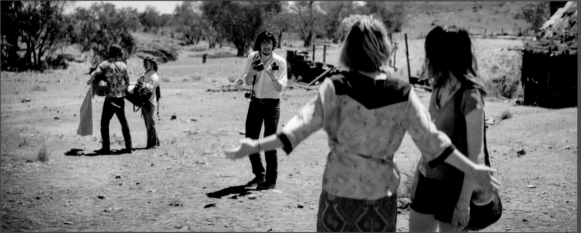

EXT. OLD STONE COTTAGE

Robyn hears loud raucous music approaching and stays out of sight behind the house, hoping whoever it is leaves. Her old friend Jenny approaches the house smiling with her boyfriend Toly and a group of friends in tow.

> JENNY
> *You can run but you can't hide.*

Jenny hugs Robyn.

> ROBYN (not thrilled by the intrusion)
> *How did you find me?*

> JENNY (a little hurt)
> *I asked around. Guess there's not many camel ladies in this town.*

> ROBYN (makes a face)
> *I hate that, it makes me sound like some old crazy woman.*

Jen gives her a look.

> JENNY
> *This is Peter, Bernard, Annie -*

Robyn glances at the others - long-haired urban types dressed for the inner city not the bush. They nod at her, she forces a polite hello. Rick wanders up, a self-conscious 27-year-old with long hair, beard, and round glasses.

> JENNY
> *- and Annie's photographer friend Rick. He's out from the States.*

> RICK (American accent)
> *Hi. I love your place. I didn't realise how big camels are.*
> *It's like a cow and a giraffe mixed together. They're beautiful.*

Given the dilapidated ruin behind her, Robyn thinks this an odd thing to say and shares a glance with Jenny.

> JENNY
> *You going to invite us in?*

> ROBYN (reluctantly)
> *Yeah - come in.*

EXT. OLD STONE COTTAGE - MORNING

The crew is packing to leave. Bernard and Peter each lug a swag into the station wagon. Robyn and Jenny walk away from the group arm in arm.

> RICK
> *Kangaroo!*

Robyn and Jenny quickly swing around and Rick snaps a POLAROID of them.

> ROBYN (very annoyed)
> *Hey, do you mind?*

> RICK (chagrined)
> *Sorry... bad habit!*

He retreats back into the house to help Toly pack. Robyn and Jenny stand in awkward silence. Jenny gives her a mixtape cassette and tears up a little — an unspoken appeal.

MOMENTS LATER
Robyn stands in the yard watching the van drive off down the road.

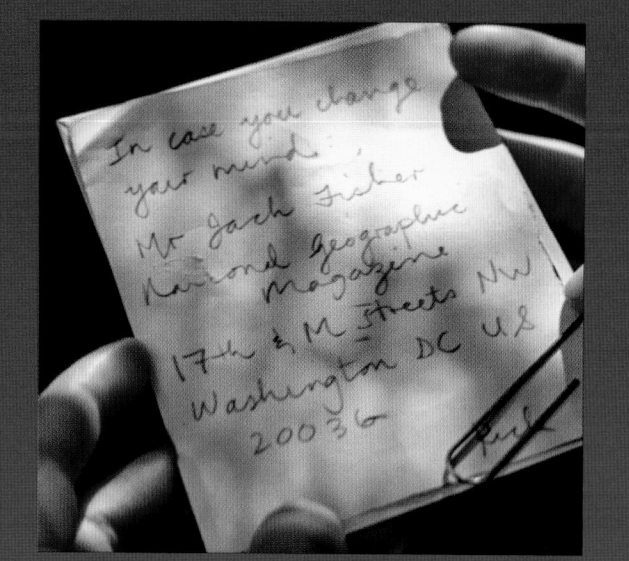

INT. OLD STONE COTTAGE

Robyn enters the empty house, takes in the silence. She digs out her cheap tape player and pops in JENNY'S CASSETTE. Mournful old music fills the air.

She finds Rick's POLAROID of her and Jenny purposefully placed in the centre of the table. She picks it up and studies it - notices a NOTE paper-clipped to the back: an address for *National Geographic*.

PHOTOGRAPH: MATT NETTHEIM

ROBYN GETS FUNDING FROM *NATIONAL GEOGRAPHIC*

ROBYN (WRITING TO NATIONAL GEOGRAPHIC IN A VOICEOVER)

...so I am writing in the hope that your magazine will sponsor my trip. I believe *National Geographic* to be of the highest international repute.

The trip will take me through some of the most beautiful and barren country the desert can show. I am enclosing a map of my proposed route, from Alice Springs to Ayers Rock, on through the Western Desert, and then to the Indian Ocean.

I have three camels and one small calf, trained and ready to go. They are perfectly reliable beasts. Their names are Dookie, Bub, Zeleika, and baby Goliath.

I am well aware of the hardship I will be facing; I am the first to admit I am remarkably under qualified for such a hazardous undertaking. But this is precisely the point of my journey; I'd like to think an ordinary person is capable of anything.

I look forward to hearing from you in the near future.

Yours faithfully,
Robyn Davidson

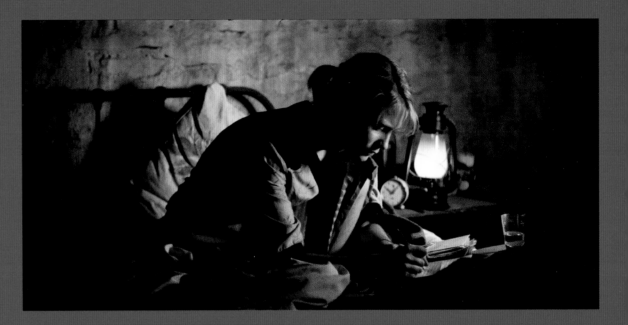

EXT. TRUCK

Robyn walks Sallay to his truck. He suddenly remembers something.

SALLAY
Oh, I almost forgot. These packages came for you.
There's a letter too...

He pulls a letter from his pocket. Robyn takes it: There's a logo of National Geographic on the envelope.

She walks away slowly tearing the envelope open and unfolding it — hesitates before daring to read.

ROBYN
I got the money!

National Geographic Society
1145 17th Street N.W., Washington, D.C. 20036-4688

Robyn Davidson
C/O - Sallay Mahomet
Finke Road, Alice Springs
N.T. AUSTRALIA 5750

Grinning, she reads the letter again to herself...
Her face suddenly drops as she scans the letter.

Camera pans across the letter as we see... 'an essential condition of our sponsorship is that we will be sending along a photographer to accompany you and document your journey to create a photo narrative along your journey to be featured in an upcoming issue of National Geographic. His name is Rick Smolan.'

Robyn's face falls and she begins anxiously tapping her fingers on the table...

ROBYN'S FAMILY ARRIVES

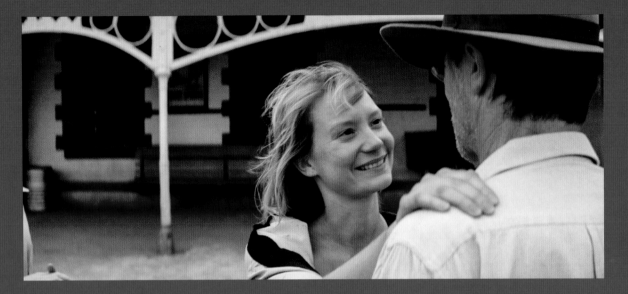

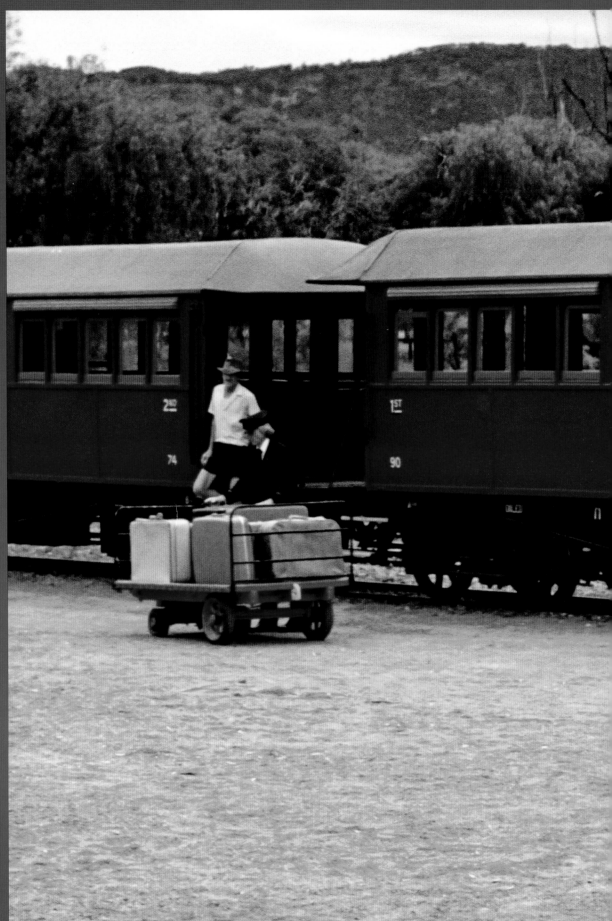

INT. ALICE SPRINGS TRAIN STATION - DAY

Robyn stands waiting on the Alice Springs train platform as FOUR YOUNG GIRLS disembark and run toward her.

> CHILDREN
> *Aunty Robbie! Aunty Rob! We came to say goodbye.*

Robyn is slightly awkward as her nieces jump all over her.
One carries a soft toy camel.

> ROBYN
> *How're you doing? Hey come here. Look at you!*

Robyn's sister MARG, early 30s, and her father, POP, soon follow.

> ROBYN
> *Hey, sis.*

Marg gives Robyn an awkward hug.

> MARG (masking her true feelings)
> *You look well.*

> ROBYN
> *Thanks for coming.*

Next Robyn moves to give her father a hug.

> ROBYN
> *Hey Pop.*

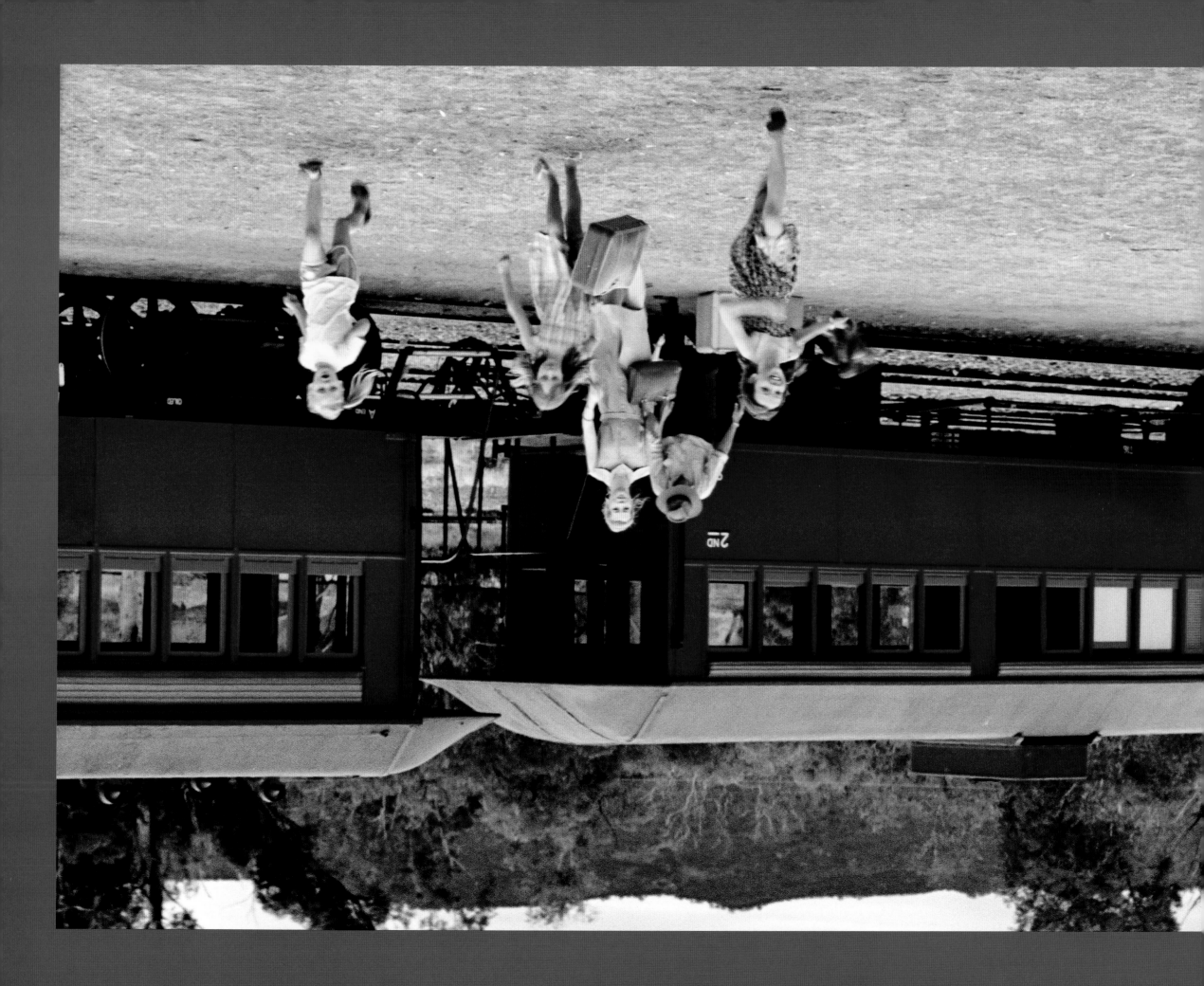

RICK'S ARRIVAL IS CLEARLY UNWELCOME

EXT. RICK'S TRUCK

Rick arrives, his car filled with every conceivable piece of new camping gear.

> RICK
> *An inflatable raft, for flash floods. And...*

He pulls out a pedal device and begins winding the handles to demonstrate.

> ROBYN
> *Um... Why would I need an exercise bike?*

> RICK
> *It's not an exercise bike. It's a generator for the radio, in case the batteries fail.*

> ROBYN
> *I'm not taking a radio.*

> MARG
> *Please Robyn, just take the radio.*

> RICK
> *What, you want to die out there or something?*

> SALLAY
> *Take the radio, just in case.*

> ROBYN
> *Okay, I'll take the radio but I am not taking the bike.*

> MARG
> *You know, it's really reassuring to know that my sister won't be alone out there.*

> RICK
> *Actually I'm only meeting up with her four or five times...*

Rick catches Robyn's look.

> ROBYN
> *Two or three times. Two or three.*

Rick smiles, beginning to understand that his presence isn't welcome.

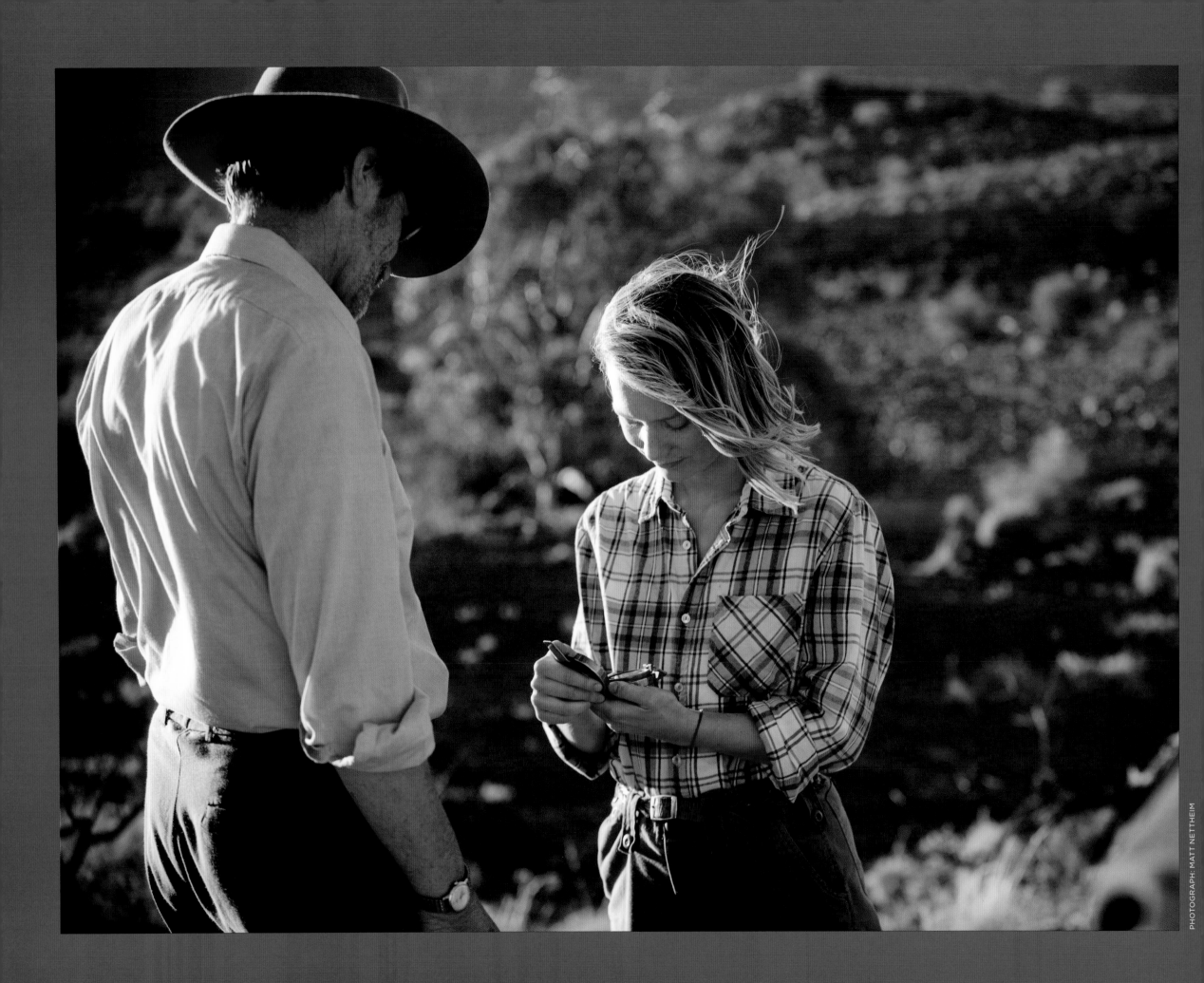

EXT. OLD STONE COTTAGE – MORNING

It's sunrise, and in a few hours Robyn will be setting off on the first day of her trip. She walks with her father in silence up the hill. Her father stops and pulls his old COMPASS from his pocket and gives it to her. Robyn is touched.

POP
Your mother gave me that.

She sees him choke up a little. Robyn smiles.

ROBYN
Thanks, Pop.

POP
You be sure you look after it.

ROBYN
I will.

EXT. OLD STONE COTTAGE – MORNING

The time to leave has come. Robyn says goodbye to her family and Sallay, anxious and excited, the compass around her neck, a knife strapped to her waist.

ROBYN
Take care, Pop.

Robyn turns to Sallay.

ROBYN
Thanks.

Robyn hugs Marg – who whispers in her ear:

MARG
If you get in trouble there's no shame in turning back, okay?

Robyn lifts her eyebrows as if to say 'Oh really'. She smiles. Robyn moves onto the children, sees her niece in tears.

She starts her walk up the hill. Diggity by her side.

POP
Bye darling!

NIECES
Bye Aunty Rob! Bye Aunty Robbie!

ROBYN (doing a mock-royal wave to her family)
Diggity, come on!

PHOTOGRAPH: MATT NETTHEIM

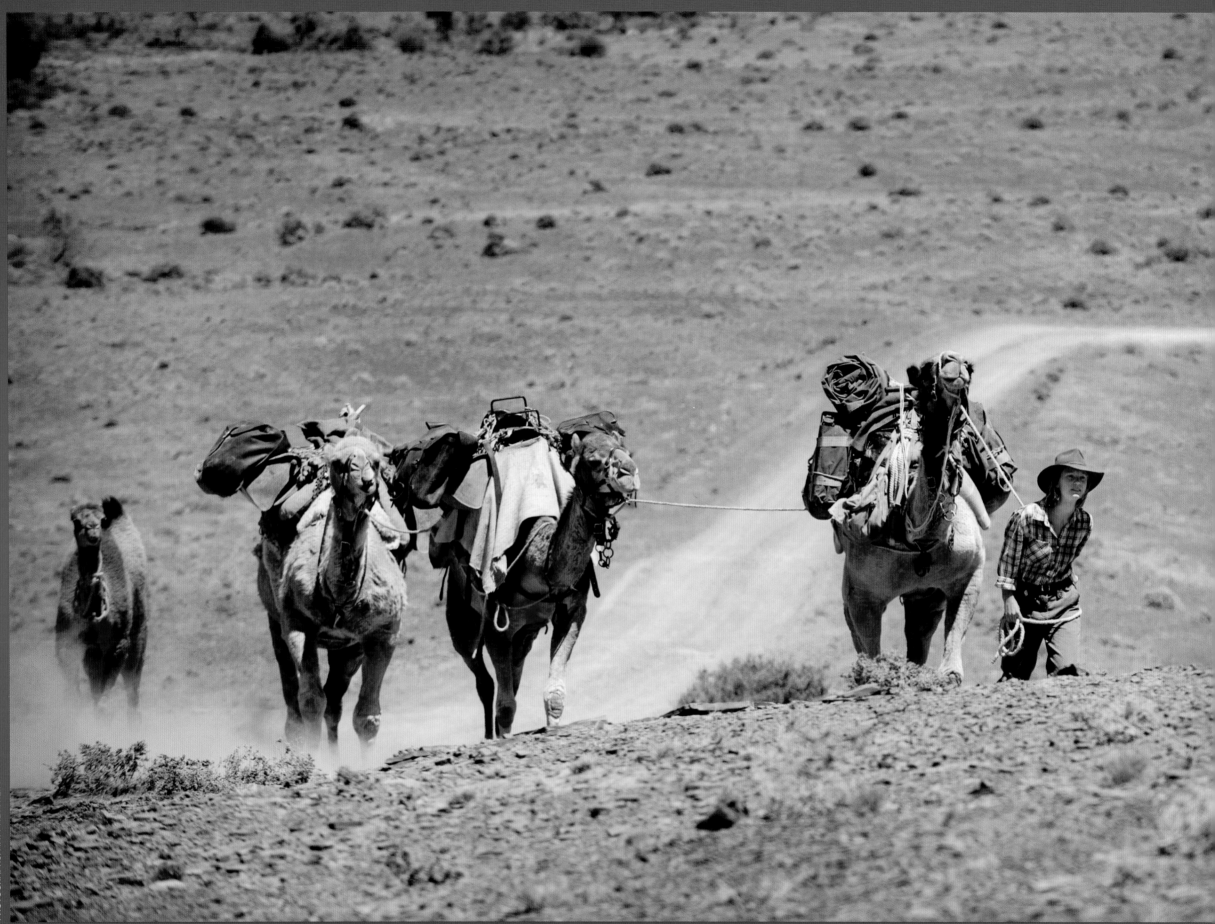

ROBYN IS FINALLY ON HER WAY

EXT. RIDGE NEAR COTTAGE - LATER

Robyn nears the crest of the hill, singing to herself. But when she crests the hill the sound of POP MUSIC rudely crashes in. In the near distance RICK is blasting music from his truck, waiting for Robyn to show. He waves in friendly greeting.

Robyn rides stiffly atop BUB looking glum. Rick scurries close by, snapping hundreds of photographs. Click-click-click. Robyn is visibly uncomfortable and self conscious.

RICK
Everybody I keep telling about this really can't believe it. 2000 miles. Is she crazy or something? Face this way a little... That's great... Everybody smile!

Satisfied, Rick lowers his camera for the first time.

RICK
How do you feel?

ROBYN (irritated)
Are we done?

RICK
Yeah, I think we're... I think it's good.

RICK (smiling)
OK. See you in a month!

Rick climbs into his truck. She watches him drive off, relieved, finally on her own.

ROBYN IS REFUSED ENTRANCE TO AYERS ROCK

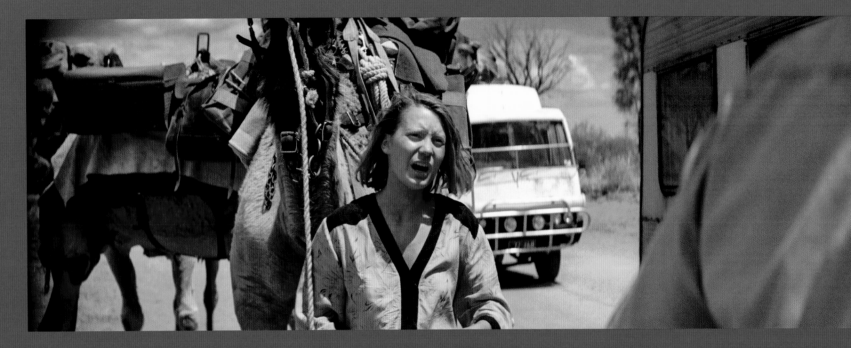

EXT. ULURU DUNES

Cresting the top of a hill, Robyn glimpses an enormous blue form shimmering and floating on the horizon. Robyn is thunderstruck. Ayers Rock (Uluru) is weirdly, primevally beautiful.

Uluru is looming closer now. Robyn leads the camels along a sand TRACK through desert oaks.

A 4WD ZOOMS past honking its horn, kicking up dust, startling the animals. Robyn leads them to a nearby rock and sits for a break. She watches a few more trucks pass, honking and waving.

She approaches the gated entrance to Uluru and is stopped by an unfriendly park ranger

> RANGER
> *Sorry, campground's full.*

> ROBYN (unsure)
> *It would only be for one night.*

> RANGER
> *Besides, camels aren't allowed inside park ground.*

> ROBYN (surprised)
> *Why?*

> RANGER (oblivious to the irony of the music-blaring camper vans streaming in through the gate)
> *Because it's a sacred sight.*

> CHILD'S VOICE
> *Hey, Camel Lady!*

PHOTOGRAPH: MATT NETTHEIM

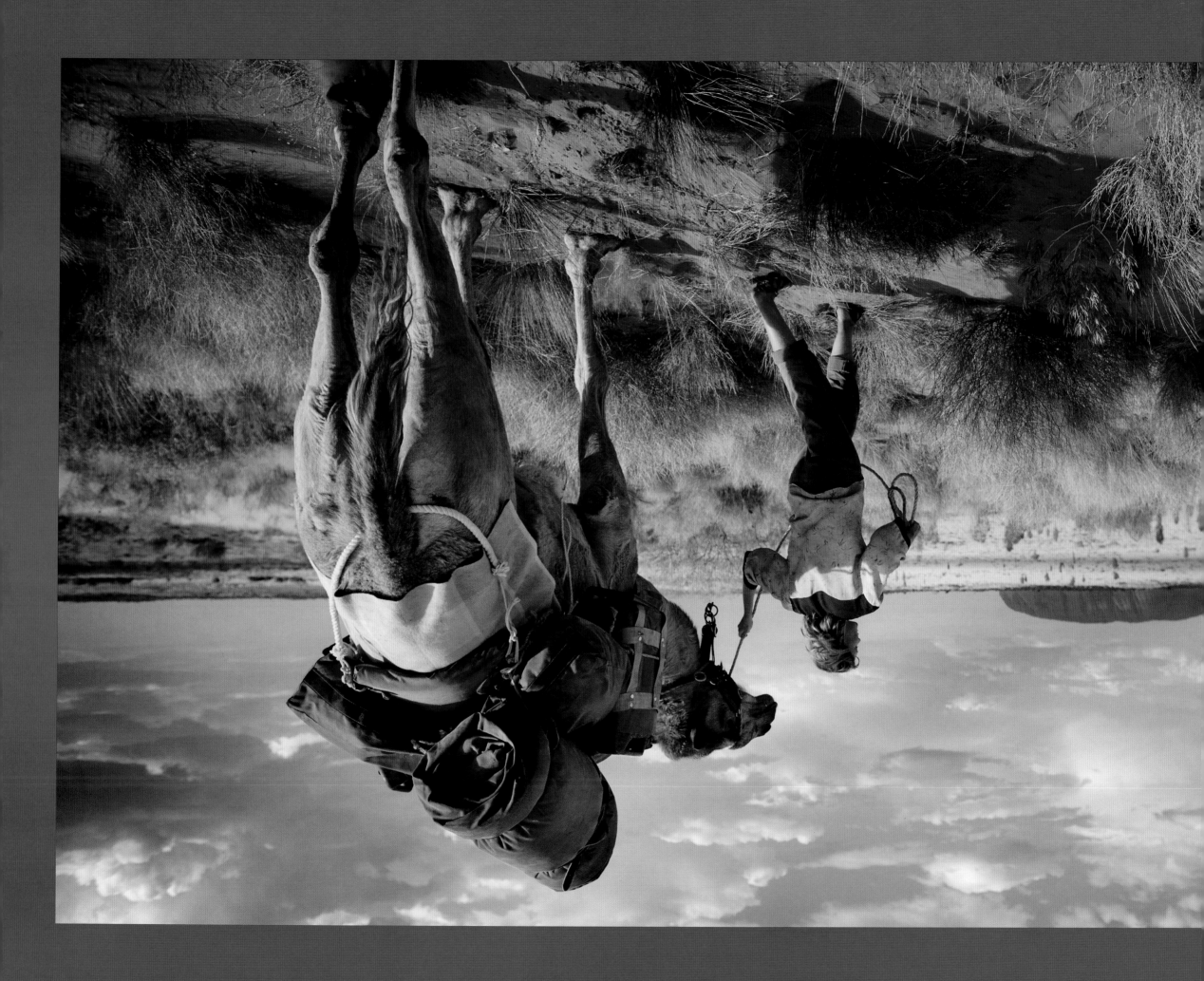

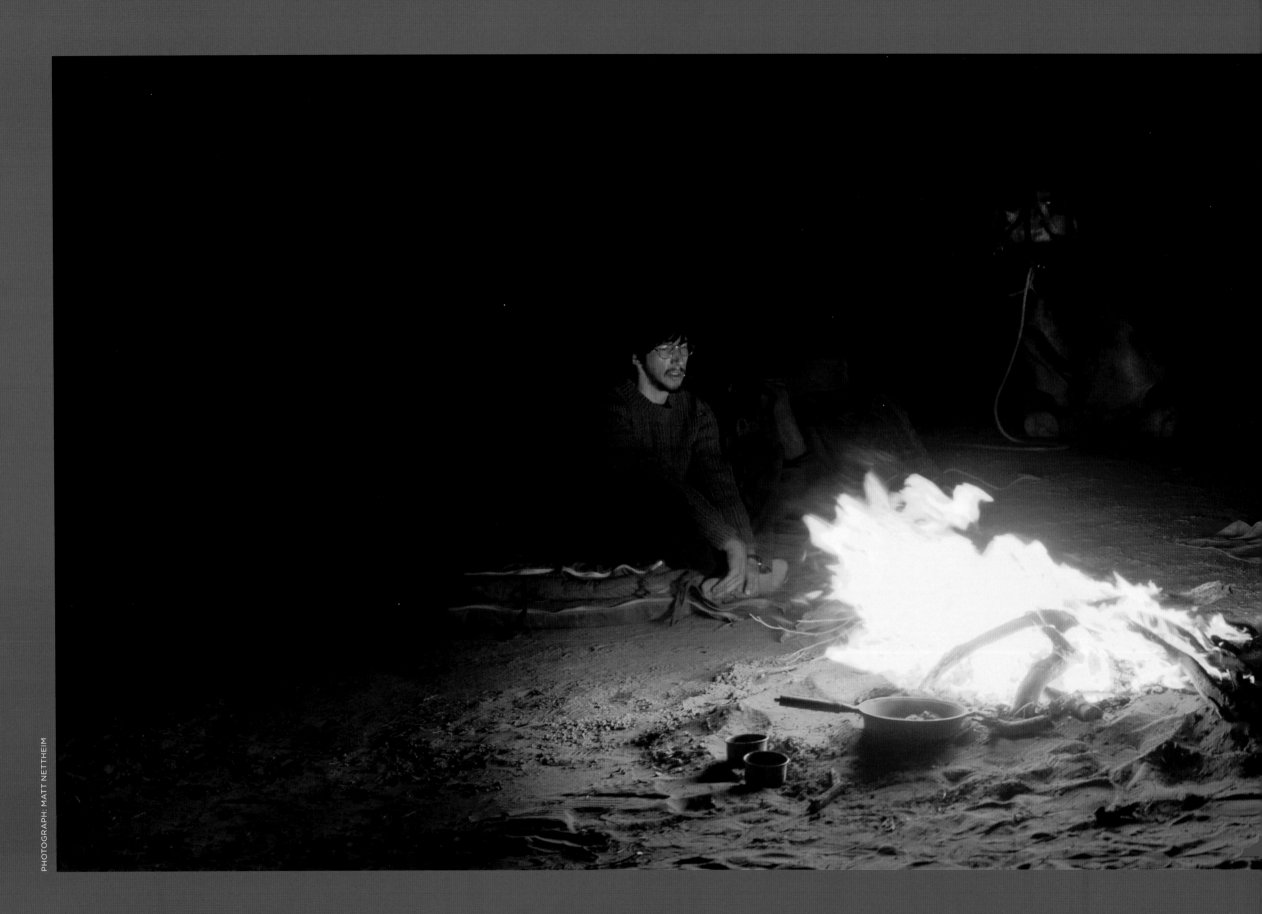

EXT. COVERED DUNES CAMPSITE - NIGHT

Robyn lies in her swag gazing up at the mysterious Olgas outlined against a star-filled sky. On the opposite side of the fire, Rick fumbles with his swag, knocking over gear. Breaking the spell. He settles into his swag.

Silence.

 RICK
 So. Your father was an explorer huh?

 ROBYN
 Not really.

 RICK
 Oh. I thought you said he was.

 ROBYN
 *I said he walked around East Africa harpooning crocodiles
 and looking for gold.*

Silence.

 RICK
 What about your mom?

 ROBYN
 I don't really remember her.

 RICK
 Oh, What happened to her?

 ROBYN
 She hanged herself.

Robyn rolls over and closes her eyes.

ROBYN BATTLES A SAND STORM AND IS FURIOUS AT RICK

EXT. WASHOUT HILL PLAIN / CAMPSITE - DUST STORM

A HOWLING WIND whips up a thick dust storm. ROBYN is chasing a skittish GOLIATH in wide circles, shouting and cursing. She falls blinded by dust, gets up and continues her pursuit. Weeping in frustration.

At the campsite RICK is struggling to gather their gear and load it into the truck. Stuff is blowing everywhere. ROBYN struggles through the blowing dust, dragging a reluctant GOLIATH back by his lead.

Rick opens the door of his ute. Pulls out his cameras and begins shooting Robyn as she struggles with her camels in the storm.

<div align="center">

RICK
(shouts to get her to look his way through the dust storm)
Robyn!

ROBYN (furious)
F#@! Off...

</div>

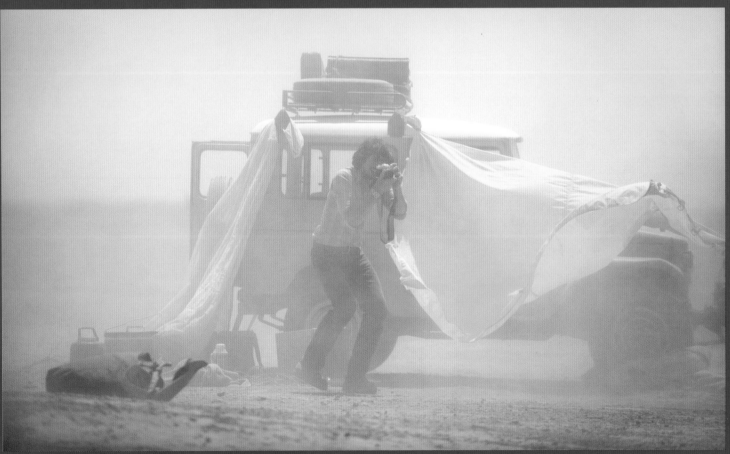

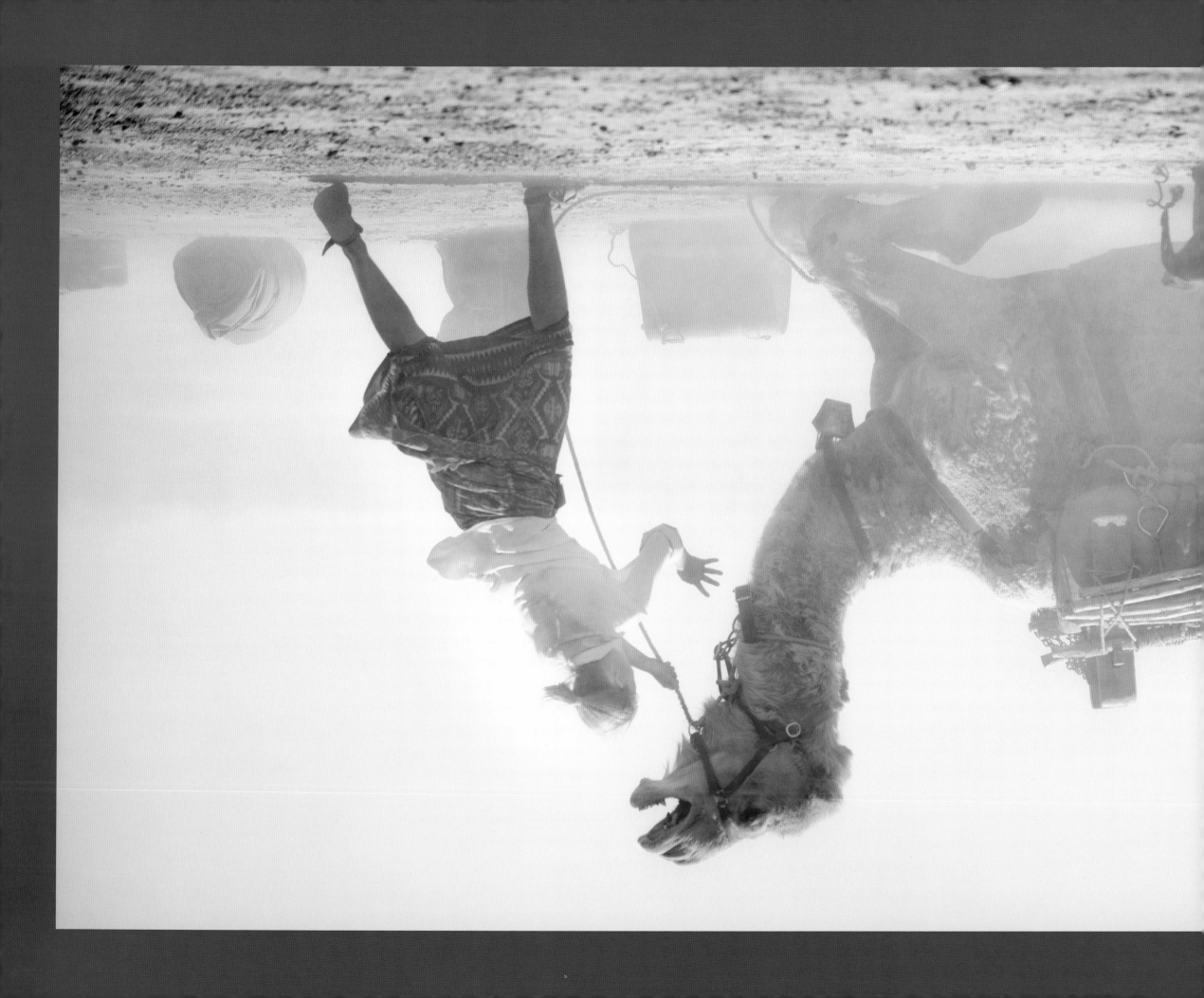

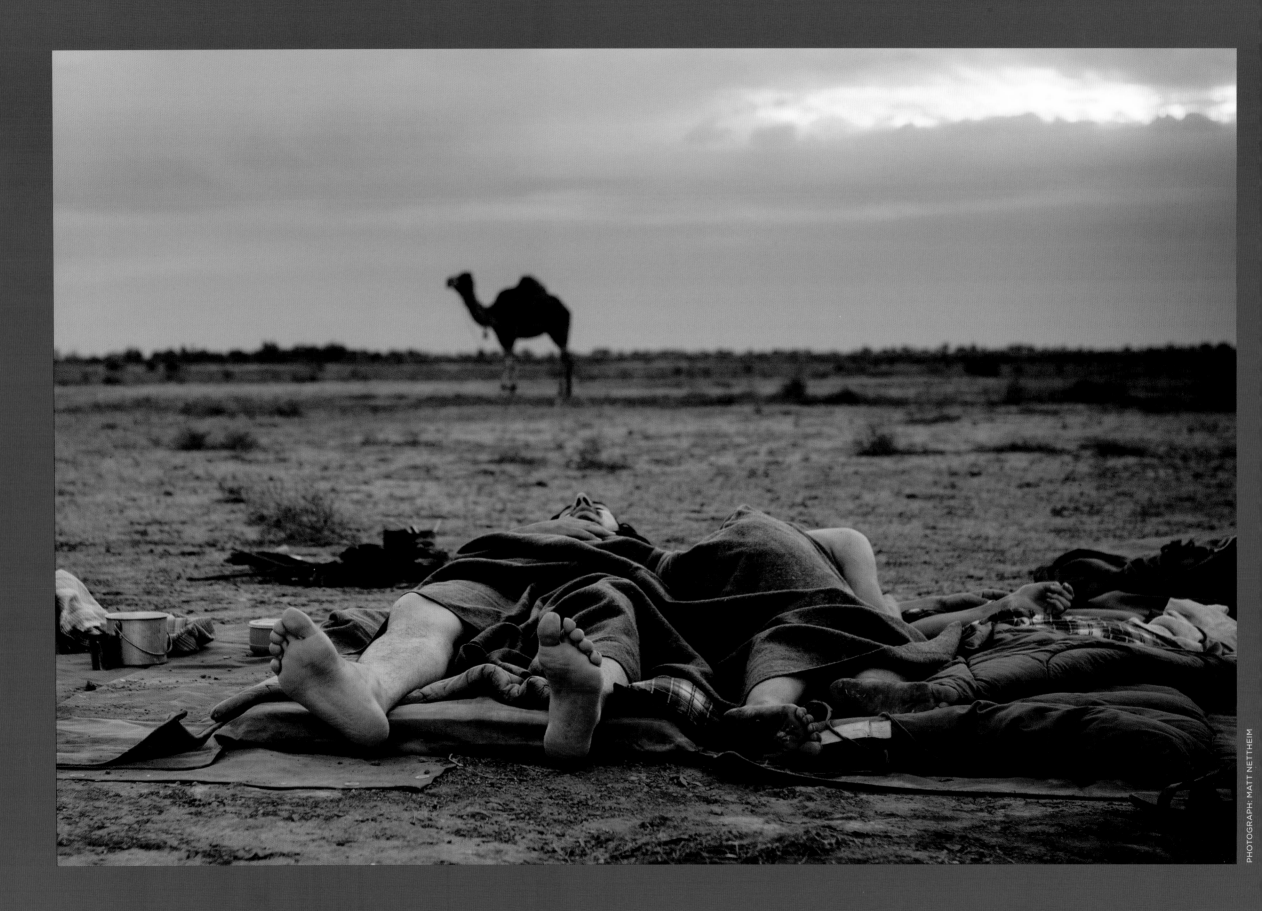

EXT. WASHOUT HILL PLAIN / CAMPSITE - POST STORM

Complete silence. Rick is wiping dust off his camera lenses. Robyn is wiping dust off her gear.

RICK (trying to make small talk to break the tension)
Well... it could have been worse. We could have been in a small plane flying through a typhoon. That's something you don't want to experience. I was in Irian Jaya covering the riots for Time. David Burnett was there, he won the Capa Medal in '73, he's a good friend of mine. And we're trying to land this plane on a narrow strip on the side of a mountain and the wings are just blowing back and forth...

ROBYN (interrupts, her voice quavering with fury)
I just can't stand this anymore. This whole thing is just some ludicrous pointless farce. Every day I load a pile of junk, I walk 20 miles, I unload a pile of junk. And you just stand around like some idiot taking pictures of me. I can't do it any more.

Rick reaches out to comfort her, begins to touch her back then hesitates, then touches her. She suddenly turns towards Rick and kisses him aggressively.

EXT. WASHOUT RAVINE CAMP - MORNING

Robyn is getting her camels saddled up. Rick pours a cup of coffee from a billy and brings it over to her in a gesture of affection.

RICK (warmly)
Morning.

ROBYN (coolly)
Morning.

He goes to kiss her on the mouth. But she slightly turns her face so that he has to kiss her on the cheek. He's hurt by the subtle gesture but doesn't say anything.

Robyn is loading up one of the heavy water cans and Rick tries to help her but she makes it clear she doesn't want his help.

ROBYN (instinctively retreating into herself)
You don't have to do that.

RICK
So... I was thinking of staying on for a few days.

ROBYN (dismissive)
Why?

Pause. The air is thick with tension.

RICK (defeated)
Well... I guess I'll see you in five weeks.

ROBYN (barely acknowledging his presence)
OK.

Rick turns around to walk back to his car and jumps back as Bub growls and lunges at him, just missing.

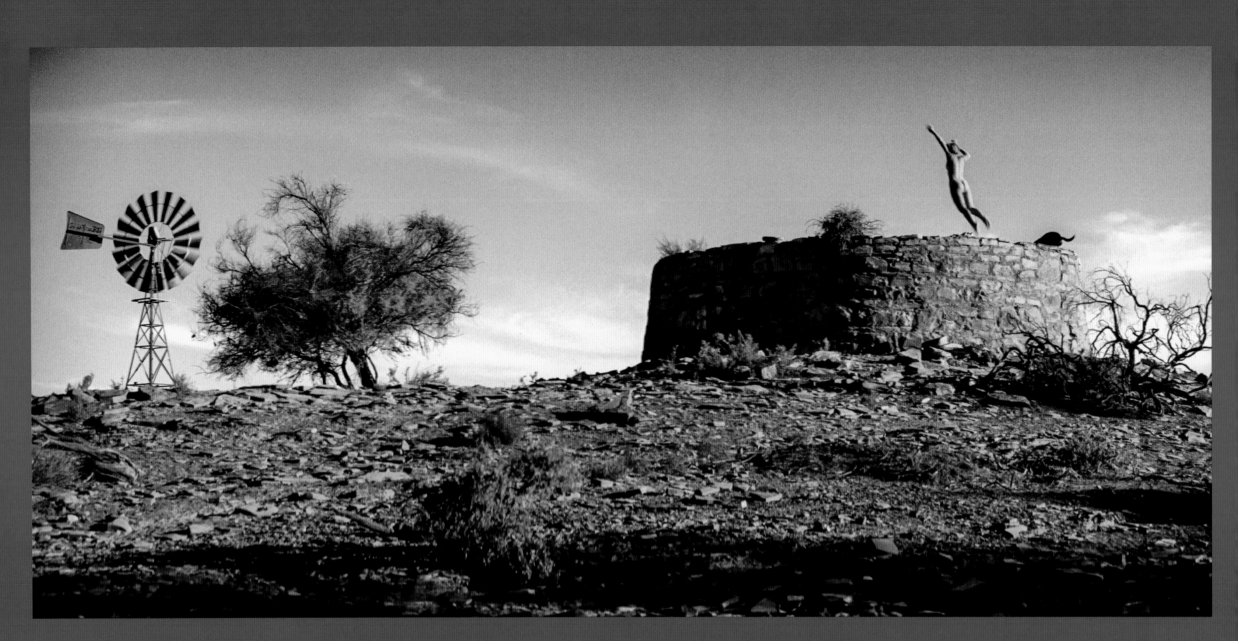

EXT. CATTLE BORE - DUSK

Robyn is alone at last. We see the camels drinking from a trough. As the camera pans up we see a windmill spinning lazily. Robyn, naked, is perched on the edge of a round cattle bore, joyfully jumps into the cool water, with a war whoop.

The light tells us it's late afternoon, the sun low, casting warm shadows. Robyn and Diggity swim.

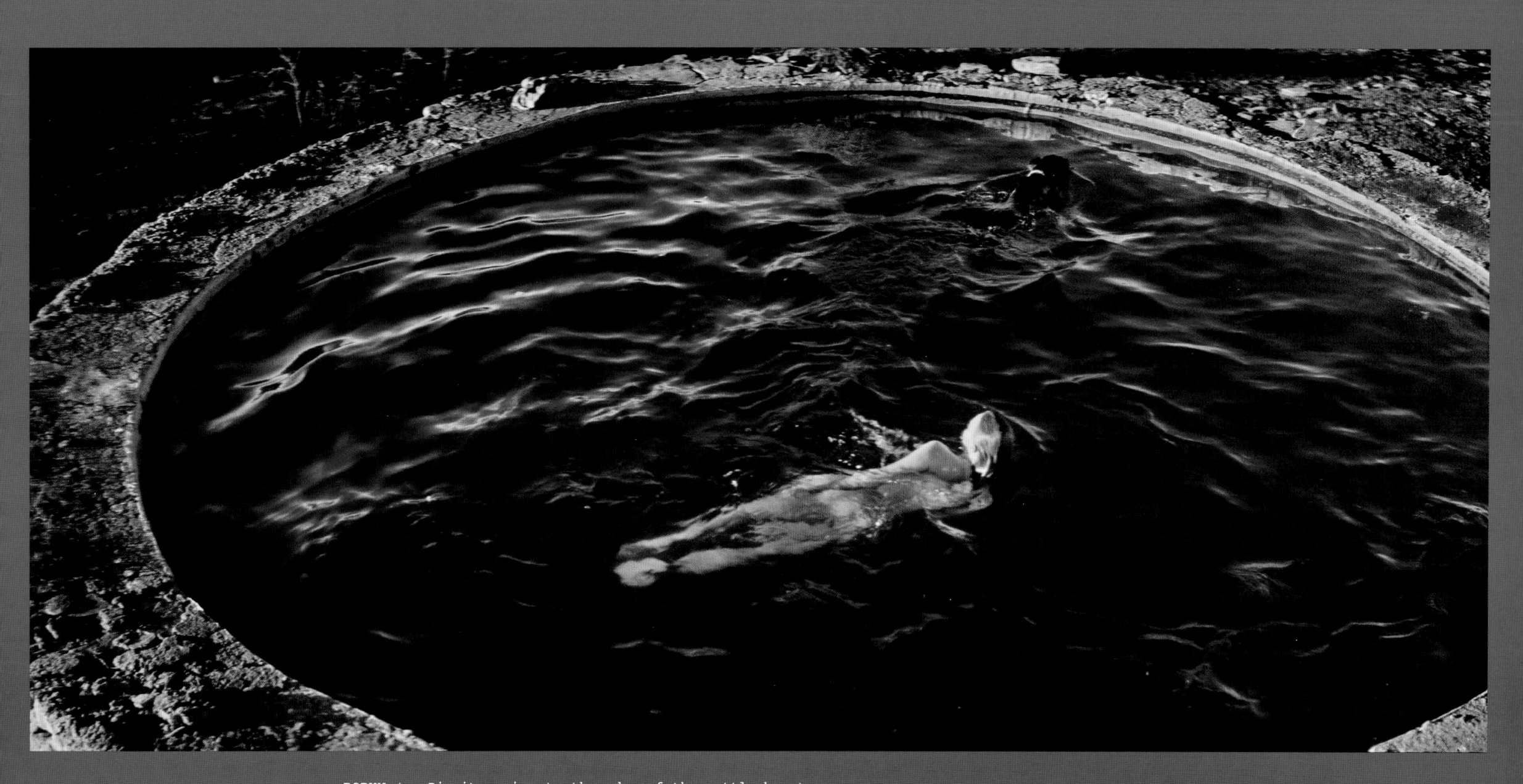

ROBYN (as Diggity swims to the edge of the cattle bore)
Don't get out...

Diggity runs circles around the lip of the cattle bore.

ROBYN
Come on girl!

Robyn swims, slowly and languorously, and then drifts over to the side of the bore
facing the setting sun. Pressing herself against the cool stone wall of the pool,
she watches the sun set and is, finally, at peace.

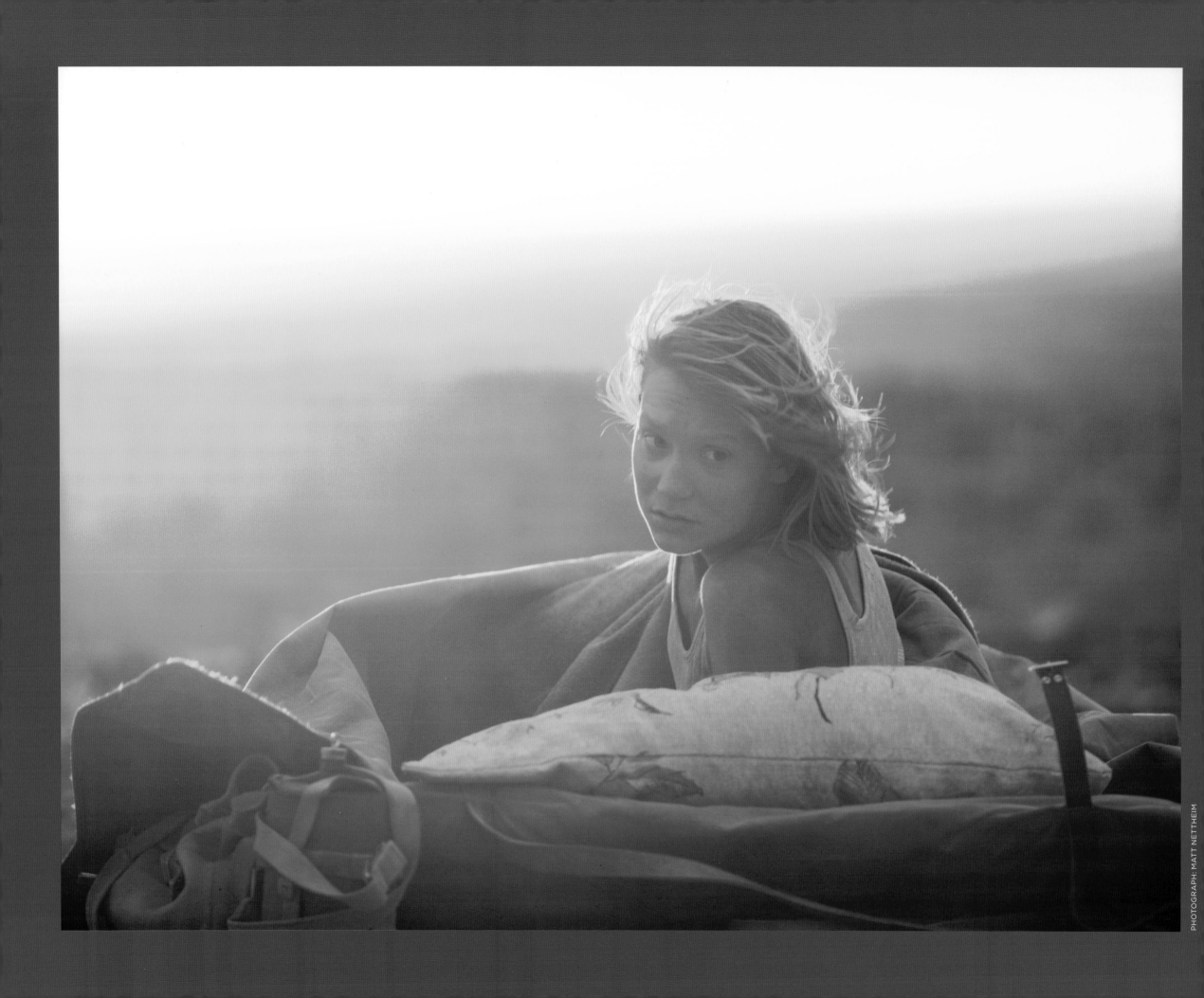

ROBYN AWAKES TO FIND THE CAMELS MISSING

EXT. KATA TJUTA DUNES — EARLY MORNING

The alarm goes off loudly waking Robyn from a deep sleep. She slaps the clock to silence it, sleepily kisses and then hugs Diggity. Sitting up and stretching, Robyn suddenly notices that it's quiet. Too quiet. She glances around, turns in a full circle shielding her eyes from the early morning sun, scans in every direction. There is no sign of her camels. They are gone.

ROBYN
Where are they Dig?

ROBYN
(her voice distant and echoing through the hills)
Dookie? Zelly? Bub?

We see Robyn climbing a hill, it's getting hotter. Diggity, panting, lags behind, her tongue hanging out in thirst, and sits under a few bare branches which offer no shade. Robyn, walking back to her, removes her skirt and drapes it over the branches to form a makeshift tent, protecting Diggity from the fierce sun.

ROBYN
Hey, you, stay here OK?

Diggity whines but follows orders, and remains panting under the tent, watching Robyn walk over the crest of the hill. Robyn is beginning to panic, exhausted, frightened. Then, despairing, she suddenly spots Dookie's head over a hill. She is hysterical, relieved and furious. As she approaches her errant camels she picks up a mulga branch from the ground and thrashes Dookie over and over, screaming.

ROBYN
Don't you ever leave me again! Don't you ever leave me!

She hits him until her anger is spent. Then she throws down the branch, sinks onto the ground. The camels burble and she catches her breath, regretting her outburst and leans her head against Dookie's thick hair, trembling, deeply ashamed.

ROBYN
(very quiet)
I'm sorry.

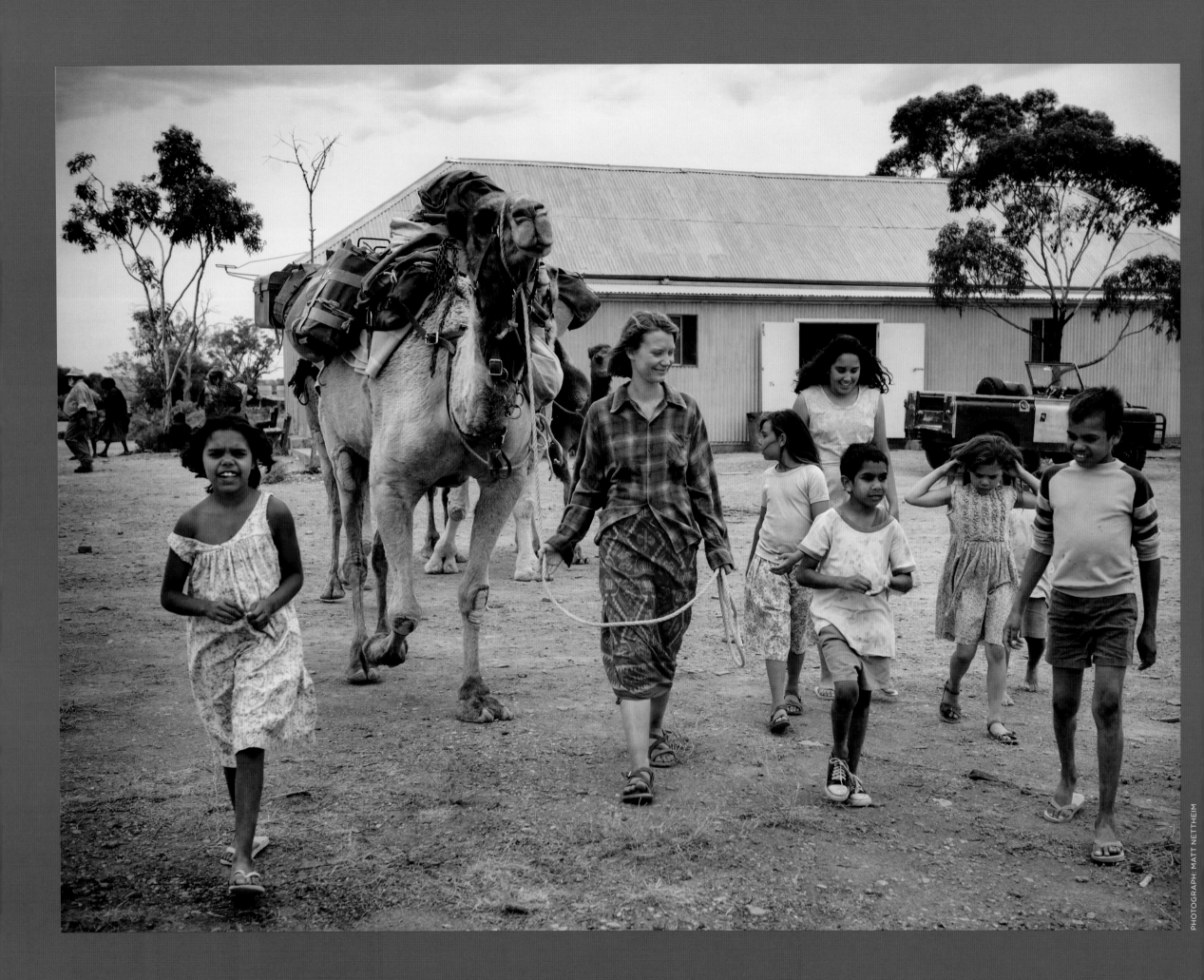

EXT. DOCKER RIVER – DUSK

Robyn and the camels enter the Docker River community. A few camp KIDS run up to the camels, but the general atmosphere is more circumspect than the last settlement. Rick, full of energy and happy to see her, greets her with a warm hug. She returns it stiffly.

The white community adviser, GEOFF, approaches them.

GEOFF (bland bureaucrat)
I take it you're the camel lady?

Robyn winces. Hates the expression. Rick circles them taking pictures of their meeting. Geoff glances awkwardly at the camera. Robyn tries to smile.

RICK
Sorry, can I get you guys to shake hands again?

Geoff and Robyn awkwardly repeat the action.

Rick approaches a group of older Aboriginal MEN who sit like sphinxes in the shade of a tin-roofed humpy. Click-click-click.

RICK
Hello there.

The older people recoil from Rick's camera. Sensitive to their discomfort, he puts it away.

GEOFF (to Robyn)
The old fellas can be a bit stand-offish with strangers.
Takes a while for them to warm up...

EXT. DOCKER – LATER

A group of women lead Robyn to a clearing away from the camp. The oldest women squat down at the front while the younger women and girls gather behind them. Robyn is motioned to the front. She doesn't understand what is being said, but there is much touching and laughing and reassurance. Robyn sits there stiffly, nervous, smiling.

The chanting begins, led by the old ladies. Sticks are tapped against each other and on the red earth. The music drones, meditative, transporting. Rising from the ground, an old woman gestures to Robyn.

WOMAN
Come.

ROBYN (shrinking back)
No, I can't.

The woman takes her by the hand and dances like a rock wallaby, making Robyn copy her. She tries her best. The young women hoot with laughter. Robyn freezes, then starts to laugh at herself. She tries again. Tears of laughter roll down cheeks, sides are clenched in delight. The old teacher hugs Robyn, then shows her how to do the body tremor at the end of each cadence. At last Robyn gets it right and she starts hopping and shuffling in grooves in the dust, shaking and turning and slowly skipping in a circle.

Time melts for her into a spiritual timeless trance. The music finally trails away and the dance group dissolves. Robyn finds herself standing there, in a daze.

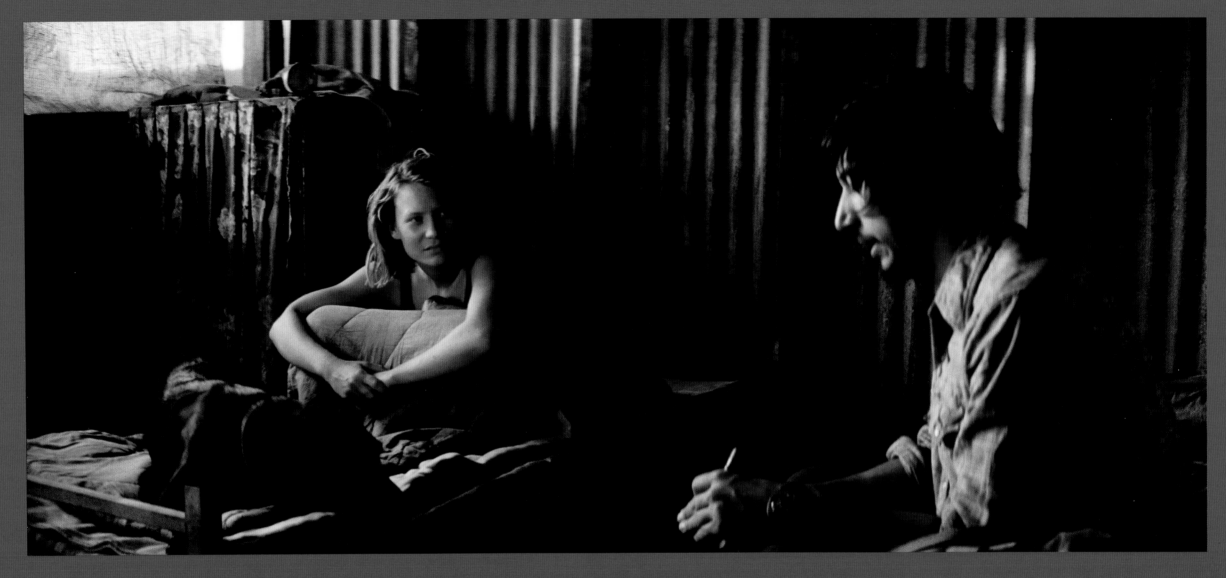

INT. HUT - PREDAWN

Robyn wakes to the sound of eerie wailing coming from the Aboriginal camp. Rolling over she sees Rick's empty bed. Rick steals back to the hut with his camera gear.

 ROBYN
 You didn't, did you??

 RICK
 No one saw me. Great images. Some kind of grieving ceremony.

Robyn sits heavily on the bed. She stares at him in disbelief.

 ROBYN
 That was secret business. Secret. Get it?

 RICK
 Nobody saw me. Man has to do his job.

 ROBYN
 *That's exactly the reason blacks were dumped in missions...
 men just doing their job.*

 RICK
 Eleven million readers will see these photographs.

 ROBYN
 *Couple of pictures in a magazine. You really think that's going to make a
 difference?*

 RICK
 I do. I think of what I'm doing as a service.

EXT. DOCKER RIVER- MOMENTS LATER

Robyn wanders over to join the same group of Aboriginal WOMEN who had invited her to dance with them as they prepare food. Robyn shyly asks permission to sit down, through gesture. Yes, it's OK. One of the old woman speaks, eyes on her work:

WOMAN
Husband no good.

ROBYN
He's not my husband.

INT. COMMUNITY ADVISOR'S HUT

Robyn and Geoff lean over a map showing the next leg of her journey from Docker River into the Great Victoria Desert.

GEOFF
That's the most direct route to Pipalyatjara, but it's dotted with sacred sites. It's forbidden to women I'm afraid. You'd need an old fella to guide you through.

ROBYN (hoping for some sympathy)
But the other way means 160 miles out of my way.

GEOFF
If you like I can ask around. See if there's an elder who would travel with you.

EXT. DOCKER RIVER - MORNING

Loaded up and ready to go, Robyn paces anxiously. Geoff comes out. Robyn looks to him, eager for news.

GEOFF (radiating anger)
Seems your boyfriend was seen taking photos of secret business.

ROBYN
He's not my boyfriend.

GEOFF (jaw clenched)
Sorry, can't help you. Their answer is NO.

ROBYN
Please... Just tell them I'm sorry.

Geoff turns around dismissively and disappears into his office. Robyn looks around and notices that no one has come out to see her off.

ROBYN (Looking at her camels)
Looks like we're taking the long way, Bub.

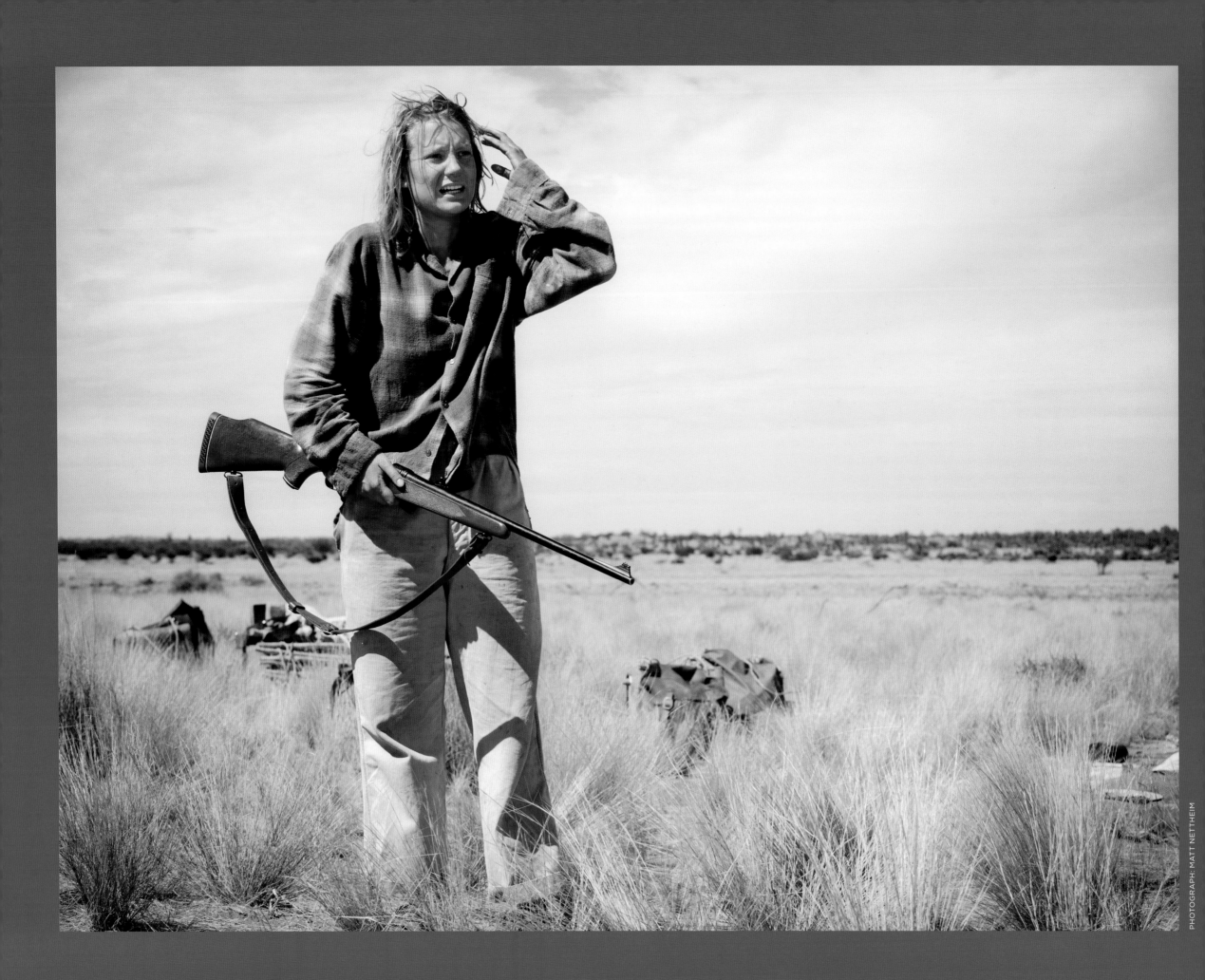

WILD CAMEL ATTACK

EXT. GYPSUM FLATS TRACK

Robyn trekking along an endless dirt track - utterly dispirited. Interminable walking. The country feels alien to Robyn. The silence is hostile.

Robyn squints into the distance. Out of the heat-haze stride three large bull camels in rut, tossing their heads and roaring. Robyn stops in dread. Terrified, her ears thump; her vision is distorted by fear.

SALLAY (in a flashback)
When you're out there alone and you see a wild bull coming – you shoot it. Don't think. Shoot.
You understand?

Grabbing her rifle, she ties up Bub and whooshes him down. Ties off Zelly to a small tree. Whooshes Dookie. Scrabbling for her ammunition, she loads the rifle with trembling hands. The powerful bulls are less than 50 metres away when she takes aim and fires. One camel spurts an arc of red blood. But they keep coming.

She fires again. And again. Missing. Finally she hits the lead bull and it slumps down, dead. The other two slow to a walk, but continue to move closer. Robyn reloads and fires repeatedly, distraught and frightened. She drops a second bull with a shot to the head. The last BULL ambles off into the distance.

Shaking with adrenaline, Robyn breaks into tears.

A TRIBAL ELDER COMES TO ROBYN'S RESCUE

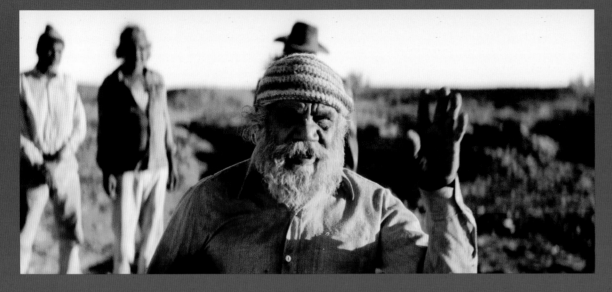

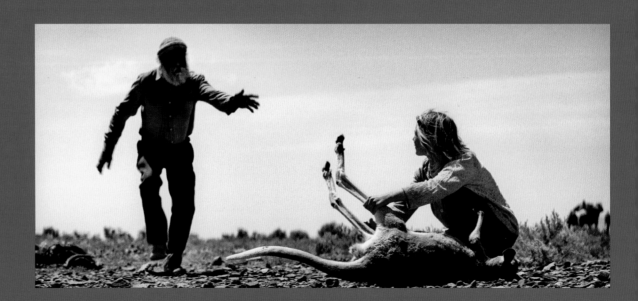

EXT MT FANNY CAMPSITE - DUSK

Robyn by the campfire hears the sound of a car in the distance. Four OLD FELLAS pile out with friendly grins. One of the old fellas brandishes a pair of freshly killed rabbits. Robyn serves tea from her billy. The old fellas cook the rabbits over the fire.

> VINCENT
> *Where you go?*

> ROBYN
> *West. To the ocean.*

> VINCENT (in disbelief)
> *Uru Pulka? Big lake?*

> ROBYN
> *Yeah, Uru Pulka.*

> VINCENT (shaking his head)
> *Too long way. Too long way for you.*

Robyn shrugs. Her gaze is drawn to another smaller, quiet man with dancing hands and a straight back. They share a quick smile. The quiet fella kindly hands her the best bit of his part-cooked rabbit, dripping with grease and blood, fur singed and stinking. She eats it gratefully.

> OLD FELLA
> *You go Pipalyatjara? Which way?*

Robyn nods at the dirt track stretching into the distance. He shakes his head.

> OLD FELLA
> *Too long that way. Too many sleeps, too far. Little bit long, that way.*

> ROBYN (respectful)
> *Miil-miil. Sacred country.*

> OLD FELLA (nods)
> *Need old fella...*

The old fellas talk among themselves in their own language. Deciding something. The smaller man who gave her the rabbit steps forward, introduces himself, hand on chest.

> MR EDDIE
> *Mr Eddie.*

Robyn puts her hand on her chest.

> ROBYN
> *Ngayulu ini Robyn-nya.*

He nods, glances at the endless road and motions for her to follow him.

EXT. PLAINS COUNTRY - DAY 148

Eddie walks along with Robyn's rifle slung over his shoulder, singing to himself. Robyn and the camels follow. Robyn wanders through the tall grass in a meditative peace following Eddie as he finds the plant he's looking for.

> EDDIE
> *Mingkulpa.*

He chews a leaf - and hands one to her to try. It tastes foul. She pulls a face. Eddie suddenly motions for her to be still. Twenty metres away - a red kangaroo, oblivious to their presence. Eddie fires, the kangaroo drops to the ground. Robyn takes out her knife and, just as she is about to skin the kangaroo, Eddie frantically gestures her to stop.

> EDDIE
> *Hey! Wiya, wiya mulapa wiya!*

He fervently signals that tribal law forbids women to cut the animal. Only men are allowed.

> ROBYN
> *I don't understand.*

> EDDIE (mimicking a throat being slit)
> *Woman never break the law. Woman never break this law.*

> ROBYN (chastened)
> *Ok I won't, I won't, I understand... only men do the cutting, I understand.*

He sighs and takes her knife. He makes a small incision in the stomach, and begins to gut the insides.

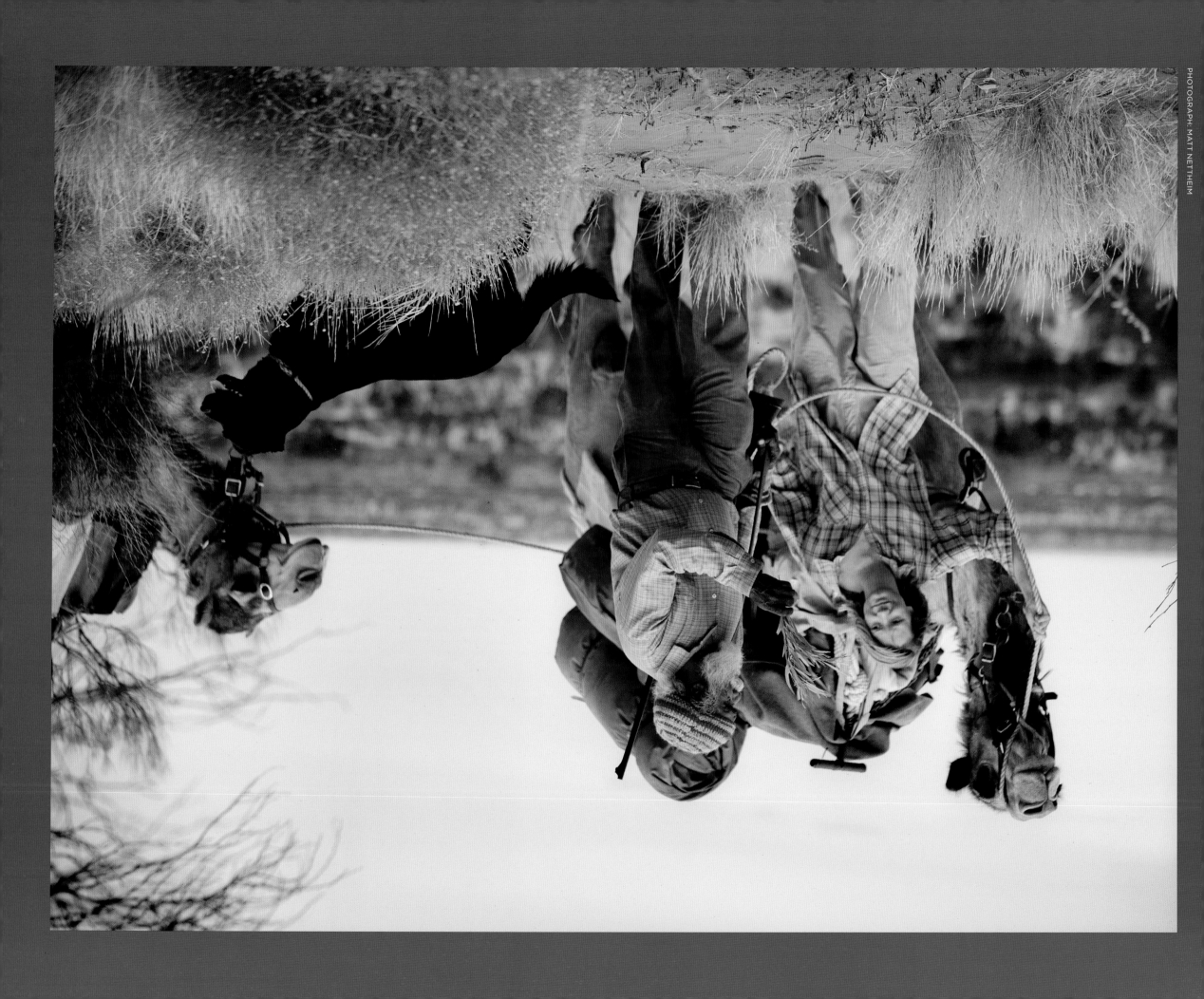

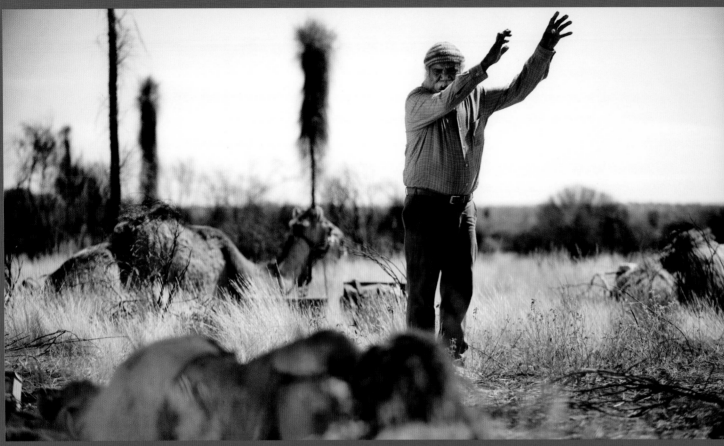

MR EDDIE AND THE TOURISTS

EXT. SPINIFEX COUNTRY CAMPSITE – Afternoon

EDDIE is telling a story, pantomiming the action. ROBYN reclines on her swag with Diggity listening, both deeply engrossed in his tale, neither understanding a word.

EXT. OPEN COUNTRY – TWO WEEKS LATER

Blazing sun. Robyn, filthy, sun-bleached hair in tangles, leads the camels in happy silence. Eddie sits atop the lead camel clearly in pain.

She whooshes Bub down.

> ROBYN (CONT'D)
> *How was it?*

Eddie hops off, groaning, rubbing his backside. Robyn smiles.

> EDDIE (suddenly cocks his head)
> *White fellas!*

Robyn stops — hears and sees nothing. Robyn shoots a dubious glance at him: how can he tell? Then a distant hum. Sees a red plume of dust growing on the horizon.

> ROBYN (struggling to get her camels moving)
> *Bub get up. Up Bub, come on, come on Bub... GET UP!*

Three car loads of TOURISTS have pulled up on the road and are badgering Robyn, Eddie and the camels. They snap photo after photo. Eddie shields his face.

> MALE AND FEMALE TOURIST VOICES (to Robyn)
> *Can we take some photos? Hold up there love, so we can get some photos... Get some photos? Take your photo? Yeah can we take your photo? Please stop so we can take your photo.*

Robyn reluctantly gestures for the tourists to wait as she brings her camels to a halt.

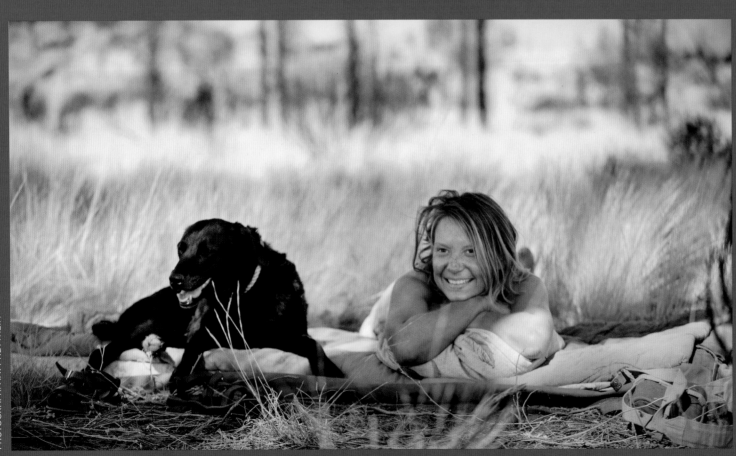

FEMALE TOURIST (to Robyn)
Where ya heading?

ROBYN (matter of factly)
To the ocean.

FEMALE TOURIST (incredulous)
To the ocean? You're dreaming.

MALE TOURIST (to Robyn)
How about a smile?

A big male TOURIST takes hold of Eddie's arm, brings him to a halt.

MALE TOURIST
Hey Jacky-Jacky. You stand here alonga camel, boy.

Robyn cracks. She grabs the burly tourist and pushes him HARD in the chest.

ROBYN
Hey Jack – you're a prick.

She guides Eddie away and then shouts over her shoulder at the frozen group of tourists.

ROBYN (seething)
Bloody swine!

Eddie turns and raises his arms, moving suddenly towards the tourists and begins to shout, pretending he is a raving savage.

EDDIE
Hey hey! Give me money, give me money!

He struts over to one woman, gets close to her face as he shouts and gestures wildly. The woman recoils in terror and starts handing him money.

MALE TOURIST
Don't give him too much...

Eddie walks demurely back to Robyn, turns his back to the tourists, and shows her the bills in his hands. They burst out laughing.

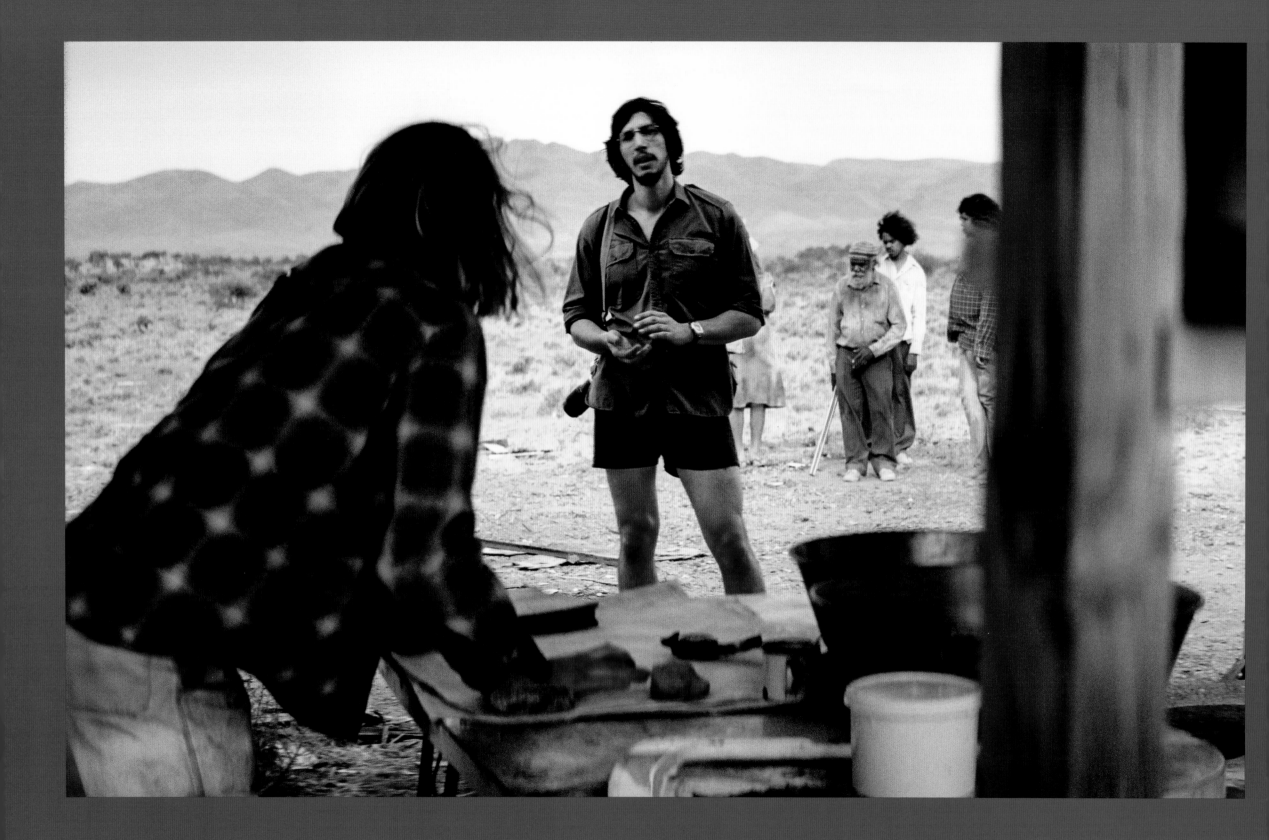

ROBYN (derisive)
What do you think?

RICK (angry)
I think you have a problem with people.

Robyn ignores him. Rick begins to walk back to Mr Eddie and friends then suddenly swings around back to Robyn. He's made a decision. Robyn looks up.

RICK (firm)
You know, I'm sorry but I'm driving ahead to Wiluna and dropping water drums along the track.

ROBYN (taken aback)
That's almost a thousand miles out of your way.

RICK
Yeah. Yeah... I know how far it is.

ROBYN (incredulous)
Are you sure?

RICK
One hundred per cent. I'll marked the drop points on your map.

Robyn thinks about it.

ROBYN
Ok. (Nods, gives a small begrudged smile.) Thanks.

EXT. WARBURTON

The place is a hole: every tree has been knocked down for firewood; a rusty car wreck; dust rises in suffocating clouds. A small cluster of buildings fortified by barbed wire. Robyn and Eddie lead the camels into the community. Rick stands speaking with weathered Aboriginals listening to Mr Eddie. Rick wanders over to Robyn, who is studying a map spread out on a dirty dusty folding table.

RICK
So... Eddie's very insistent you take along an elder.

ROBYN
Yeah... I prefer to do this stretch on my own.

RICK
Yeah, but it's better if you do this stretch with company.

ROBYN
Nah, I'll be fine.

A stand off. Robyn turns back to the map.

RICK
You won't find a drop of water. It'll be two months' travel on a dead straight track through empty desert. It's lucky to get six cars a year along it.

ROBYN (dismissive)
I'll be fine.

RICK
Would it make any difference if I told you that I don't want you to go alone?

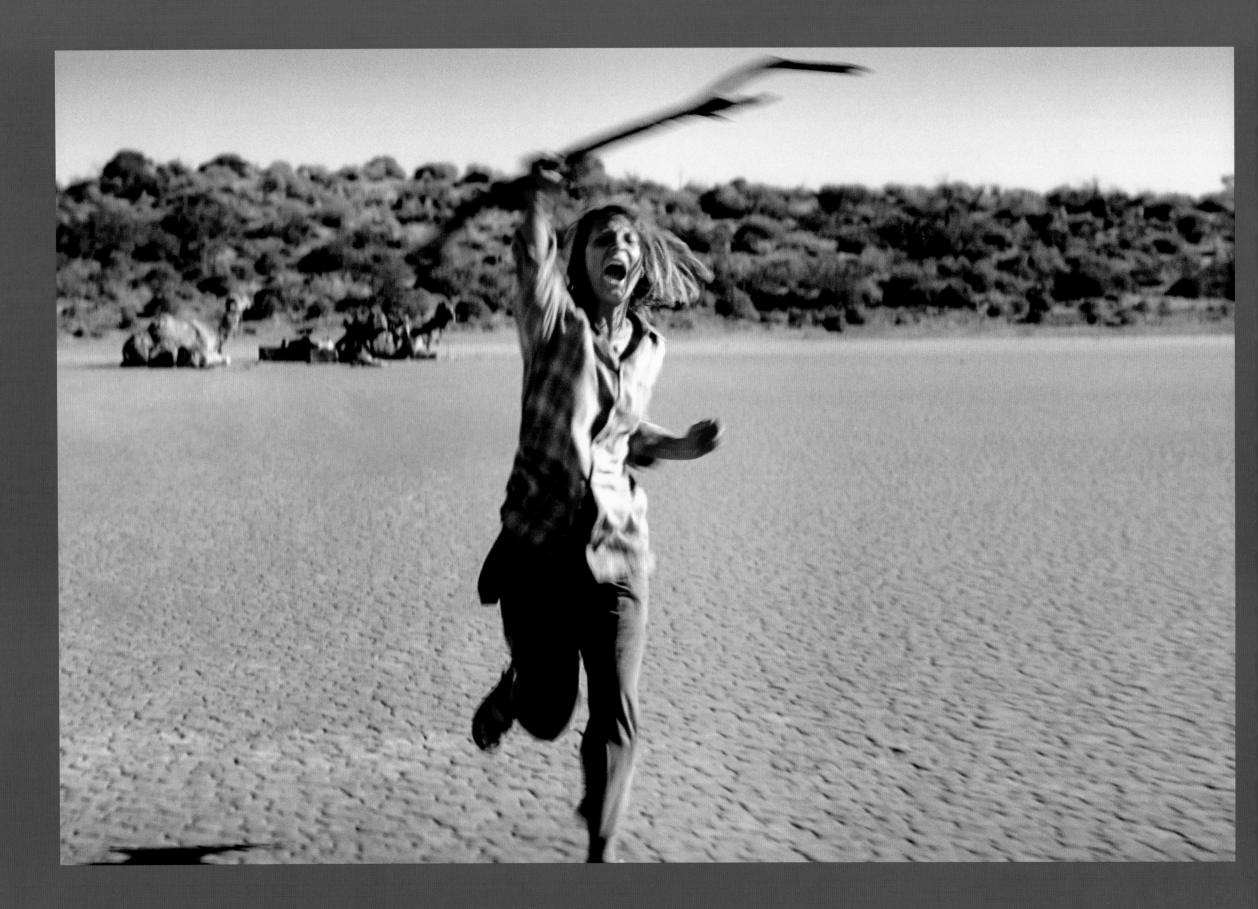

EXT. CLAYPAN CAMPSITE - LATE AFTERNOON

DIGGITY comes bounding into camp, barking loudly. The camels chew at their cud. Robyn scoops up Diggity and spins her around, hugging and kissing her. Sweating, she pours water from a drum onto a small towel to wipe off.

The camels are bobbing their heads unconcerned. All at once Robyn senses something in the distance behind her and swings around squinting in disbelief.

A floating spectre rises towards her on the horizon out of the shimmering heat as a lone bull camel appears to be trotting toward her.

Robyn, ignoring the rifle, grabs a large stick and begins running angrily towards the shape on the horizon, shrieking in fury.

ROBYN (a madwoman, howling)
Go away! Go away!

She suddenly stops and the shimmering image is no longer a bull camel but a just a swirling shimmering funnel, a dust devil.

ROBYN IS TAKEN IN BY A KINDLY OUTBACK COUPLE

EXT. GLENAYLE HOMESTEAD – NOON

A neatly kept stone and timber COTTAGE shimmers like a dreamy
mirage. MRS WARD, a grey-haired genteel old woman, sweeps
the stone verandah. She looks up from her broom, stops and
squints through the glare at the silhouette of Robyn and her
camels.

> MRS WARD
> *Hello dear, how nice to see you.*

ROBYN, tattered clothes falling off her bony frame, hat pulled
low over dust-matted hair, stares at her, unaccustomed to
conversation.

> MRS WARD
> *Won't you come in for tea?*

INT. GLENAYLE HOMESTEAD – LATE AFTERNOON

MRS WARD and MR WARD, two weathered and somewhat sun-addled
salts-of-the-earth, eat without speaking.

> MR WARD
> *Where you from?*

> ROBYN (quietly)
> *I was born on a cattle station. Near Dowling Downs.*

> MR WARD
> *Oh, a Queenslander eh? Whatya run?*

> ROBYN
> *Hereford.*

> MR WARD
> *Hard country that. Reckon she copped 'er share of drought, eh?*

> ROBYN
> *Seven years.*

> MR WARD
> *Muster through it did ya?*

> ROBYN (matter of fact)
> *We went broke.*

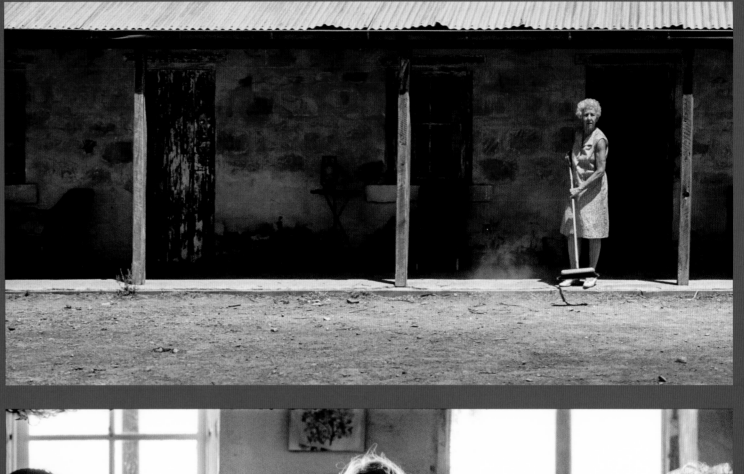

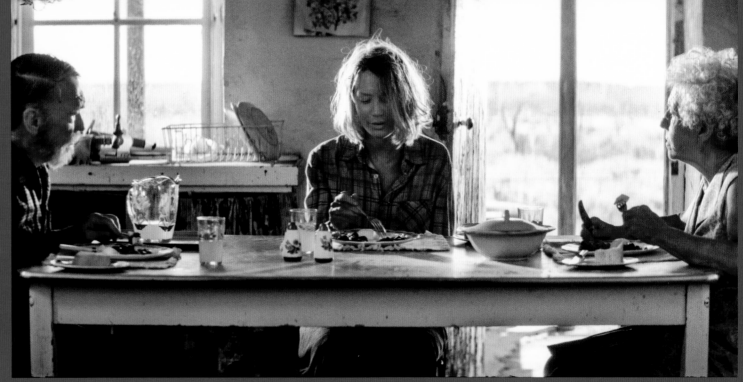

EXT. GLENAYLE HOMESTEAD - VERANDAH - EVENING

Robyn relaxes into Mrs Ward's touch, sitting in a metal tub as the motherly figure pours water over her hair, scrubbing her clean with a cloth.

INT. GLENAYLE HOMESTEAD - MAIN ROOM - NIGHT

Mrs Ward is doing the dishes. Mr Ward listens to an old song on the radio. ROBYN comes out of her room dressed in one of Mrs Ward's nightgowns, looking like a little girl. She finds an old record player and brushes the dust off an old LP. Scratchy music plays as a man sings 'Daisy have you seen the new dances come along?' Robyn wanders over to gaze at the old family photos scattered around the home, framed on the wall, sitting on the piano. She runs her fingers over the keys, playing a few notes. The three of them play Parcheesi as if they're a family.

EXT. GLENAYLE HOMESTEAD - MORNING

Robyn, looking bathed and refreshed, studies her MAP with Mr Ward.

MR WARD
...join up with the Canning at well ten, follow this track here. Reckon you're three weeks or so out of Wiluna.

Mrs Ward hands her a BOX OF FOOD.

ROBYN
Thank you for everything.

Robyn gives each of them a long hug. The couple watch her with concern as she heads away with the animals. They wave at her and she waves back.

DIGGITY EATS POISONED MEAT

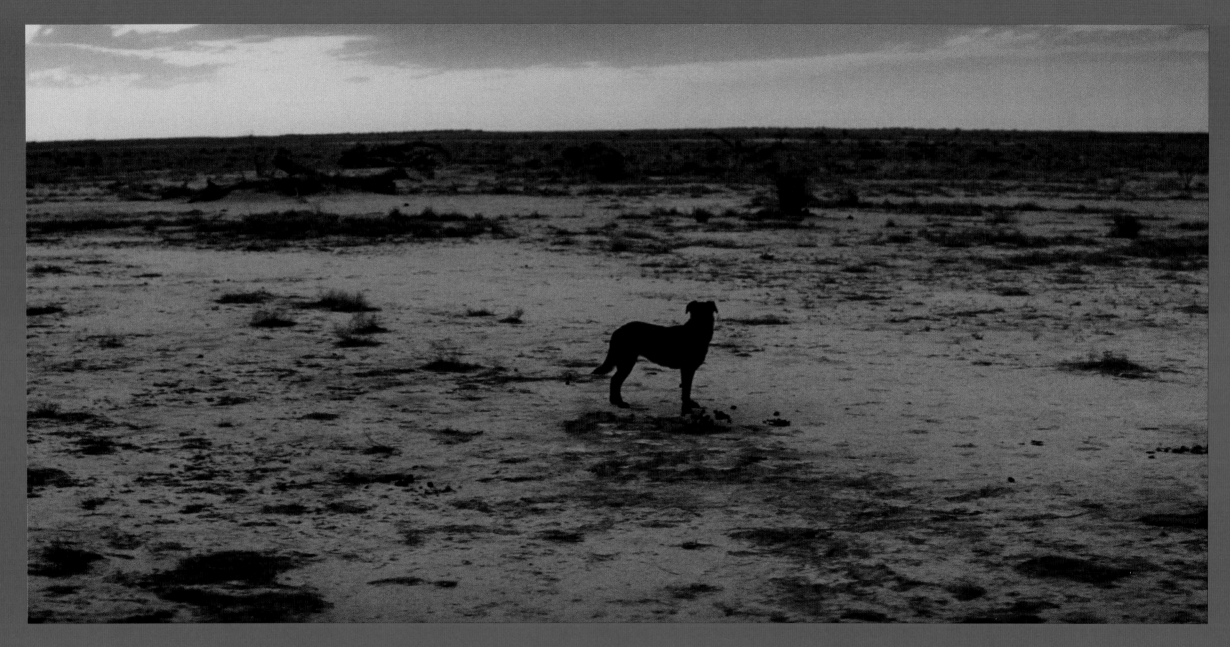

EXT. PLAINS COUNTRY - DAWN.

New country. Flat and barren. The sun is just coming up. Robyn is leading the animals across a scrubby plain away from the mountains. Diggity, panting, lags behind. Robyn stops, startled by the sight of a SILHOUETTED CORPSE hanging by a rope from a lone, distant tree. She grabs Diggity's collar.

EXT. LONE TREE CAMP - Dusk

The ground is bare, the camels look hungry. Robyn sits by the fire with a few fragments of food on a plate, nuzzling Diggity and feeding her their last scraps of food. Diggity whines.

> ROBYN
> *Last one girl.. That's all there is, no more...*

ROBYN lies in her swag cuddling Diggity, falls asleep listening to the mixtape.

'Sometimes I wonder why I spend the lonely nights dreaming of a song, the melody haunts my reverie and once again I'm all alone.'

We see Diggity running off into the twilight. A ghostly big fat full moon rises on the horizon, completely filling the frame.

Robyn wakes in pitch blackness to Diggity sneaking back into her swag.

ROBYN (groggy)
Hey Dig

Diggity licks her face profusely. Robyn cuddles her close and Diggity suddenly whines in pain, slinking back out and runs off, barking wildly. Robyn sits up and grabs her torch.

ROBYN (sitting up)
Dig? Dig? Dig!

Robyn chases after Diggity.

ROBYN
Come here, girl. Diggity!

Robyn's torchlight shines down on an empty bottle on the ground. Label reads:

STRYCHNINE. The torchlight shines over a dead animal.

ROBYN (frantic)
Dig. Diggity!

Diggity is foaming at the mouth, whimpering. Robyn scoops her up, hugs her close, and spins in circles. She sticks her fingers down Diggity's throat to induce vomiting...

ROBYN (hysterical)
Spit it out. Come on, girl. Come on.

Diggity leaps from her arms and races through the undergrowth madly, crashing into trees. She runs off into the distance and stares at Robyn. Eyes rolling. Growling. She falls, gets up. Growls at nothing. Hallucinating.

ROBYN
No no no... Come on, come on, come on... Diggity, Diggity, hey come on. Hey.

The first hint of THE SUN peaking over a distant range.

CUT TO:

ROBYN'S HANDS, shaking, load the rifle.

DIGGITY lies at a distance, tortured breathing. Twitching. Robyn walks across the desert towards her dying dog. She arrives at DIGGITY, near death, fighting for every breath.

She lifts the gun and FIRES. Then gasps and turns away from the body. For a long moment she remains frozen in place.

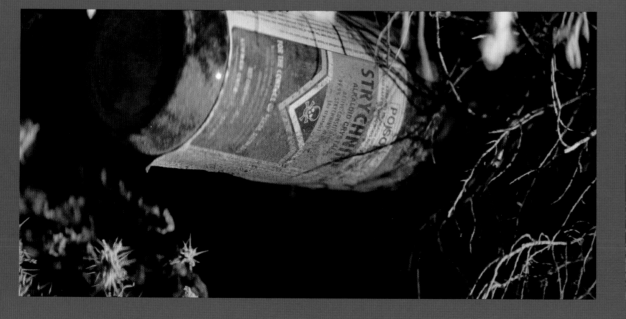

NOW COMPLETELY ALONE, ROBYN DESPAIRS

EXT. LONE TREE CAMP - DAWN

Robyn lies in her swag, in a state of shock. She's
trembling with uncontrollable spasms. Sweating. Numb.

The middle of the day. Robyn is asleep in her swag.

We see a deadly snake slither over her body, across her
neck. Robyn is unconscious with grief. She doesn't wake up.

Bub wanders over, bells tinkling. By now the camels are
hungry and thirsty. They bellow and are skittish. Dookie
knocks over a water drum. Robyn stares at her rifle, numb.

The afternoon shadows lengthen. It takes every ounce of
Robyn's strength to unpack the heavy radio. She sets up
the radio. A labour. She tries to use it but hears nothing
but static.

> ROBYN (very quiet)
> *Hello?*

No response. Just more crackle: the radio isn't working.
Even though she knows the radio is broken she keeps
talking.

> ROBYN
> *Is anybody there?*

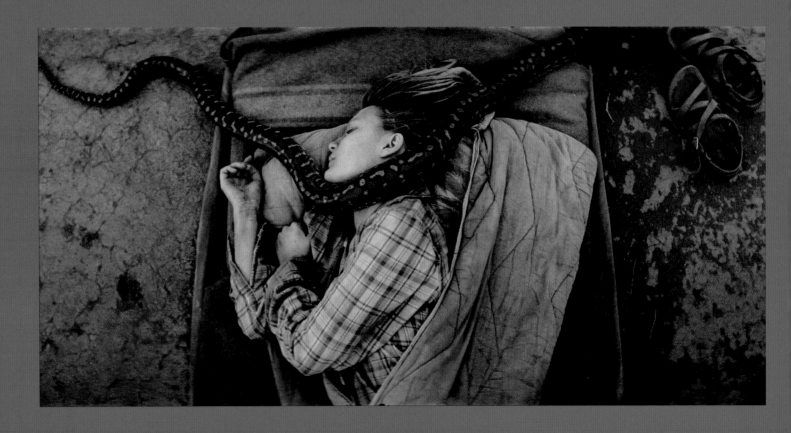

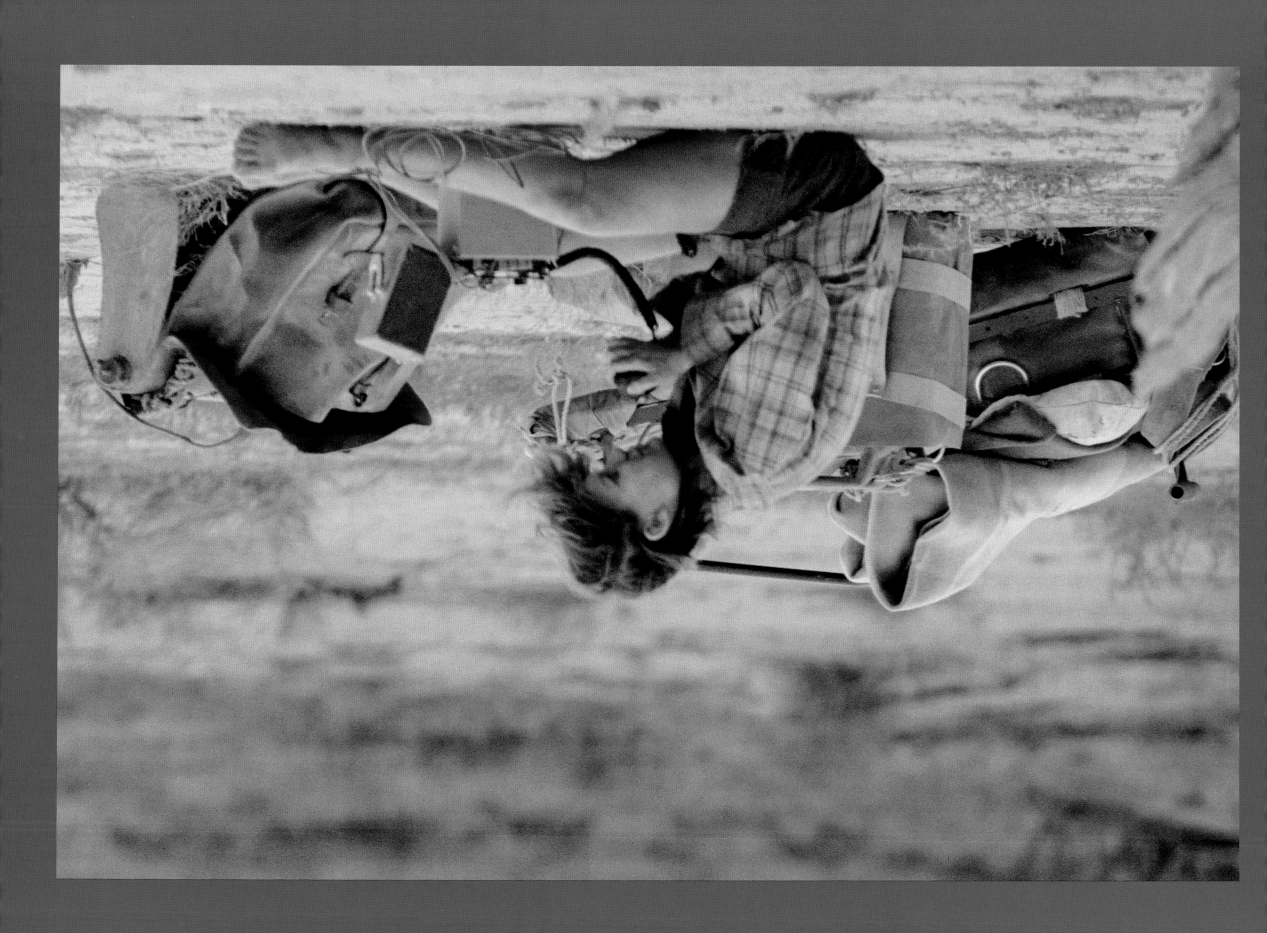

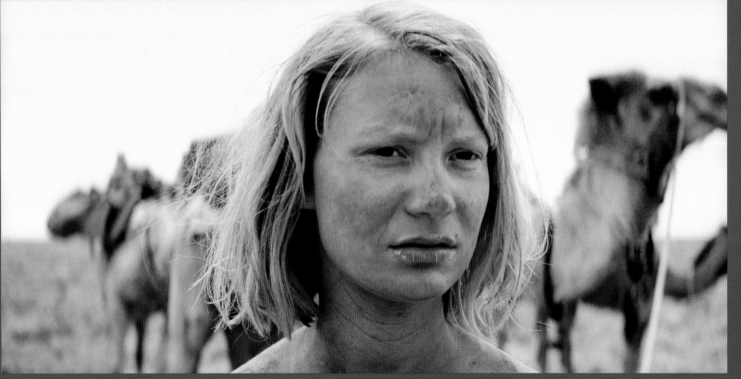

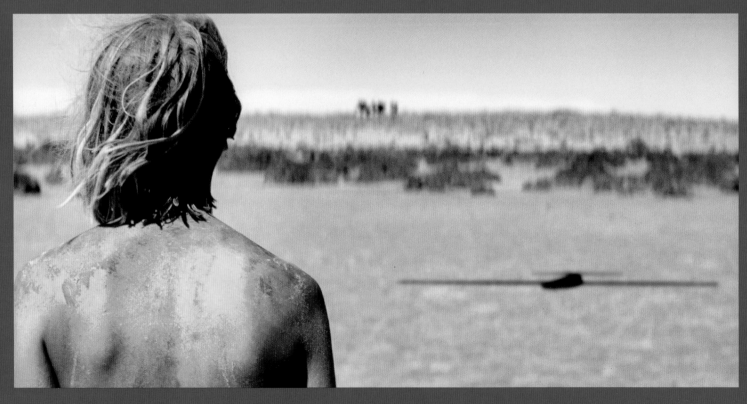

EXT. SALT FLAT - DAY
Flat and featureless hard-baked surface in every
direction. Not a pebble or blade of grass in sight.
In the far distance tiny figures enter the frame,
moving slowly.

EXT. SALT FLAT - CONTINUOUS
ROBYN, naked and covered in a thick layer of white
dust, shuffles along. Her eyes are puffed to slits,
and matted hair sticks out in all angles from under
a rag tied to her head. She lifts her sunburnt
face skyward.

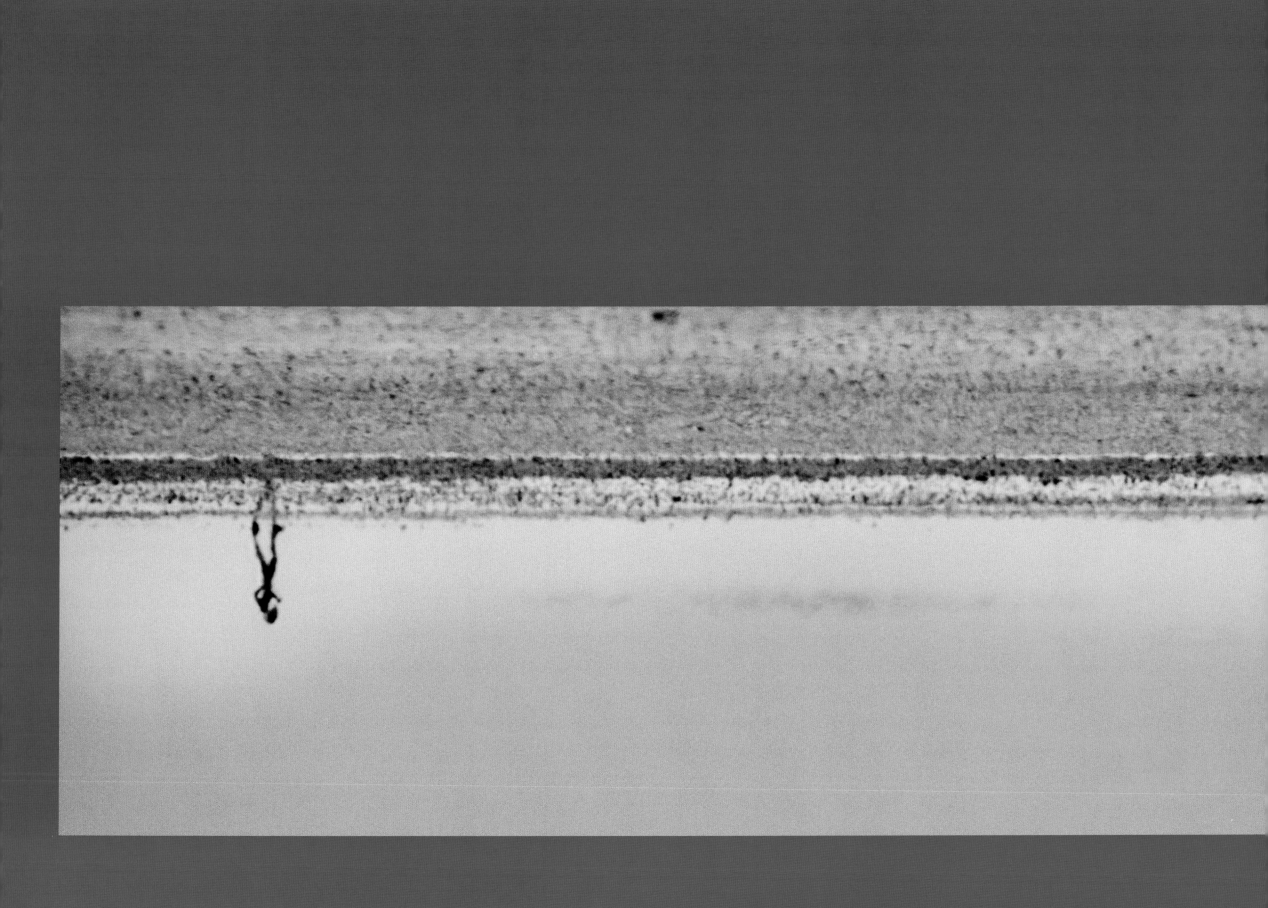

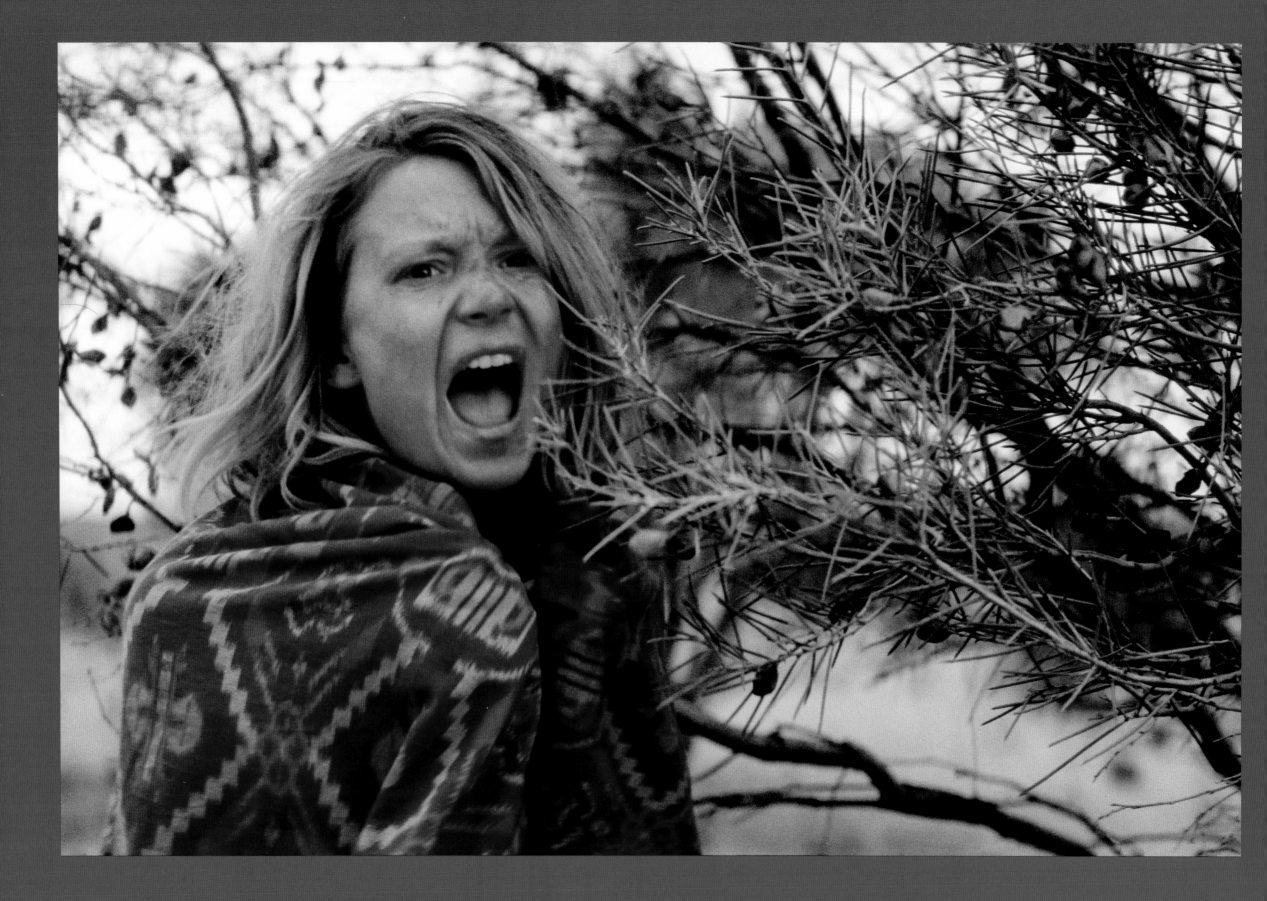

ROBYN hides in a thicket of dense brush. The CAMELS are hobbled and grazing a few hundred metres away. A LARGE CONVOY, a dozen vehicles, appears over a rise and heads towards her. Seeing the camels the cars pull over. A swarm of JOURNALISTS pile out, searching for her.

They circle the camels, snapping photos. A BLACK TRACKER studies the ground searching for her tracks.

Robyn's attention turns to RICK'S JEEP racing to a stop. RICK CLIMBS OUT.

Instinctively Robyn moves out towards him and the pack of journalists begin to run towards her.

RICK arrives a beat before them.

RICK
(panicked)
You okay? Hey, you okay? You alright?
I've been trying to find you for over a week.

Robyn stares at him, confused. The journalists descend on her with cameras and microphones. Reporters from various countries fire questions at her.

ROBYN
(screams out)
Leave me alone! Go away!

They snap her picture. Frazzled and weather worn, she looks like a mad woman.

Rick fends them off, pleading for privacy...

MOMENTS LATER
The pack of REPORTERS stand at a distance muttering amongst themselves - watching Rick huddling with Robyn. Rick is alarmed by her ragged appearance and fragile state. He looks around.

RICK
Where's Dig?

ROBYN
She's gone. Poison.

He understands the enormity of this.

Robyn, quiet and still in shock.

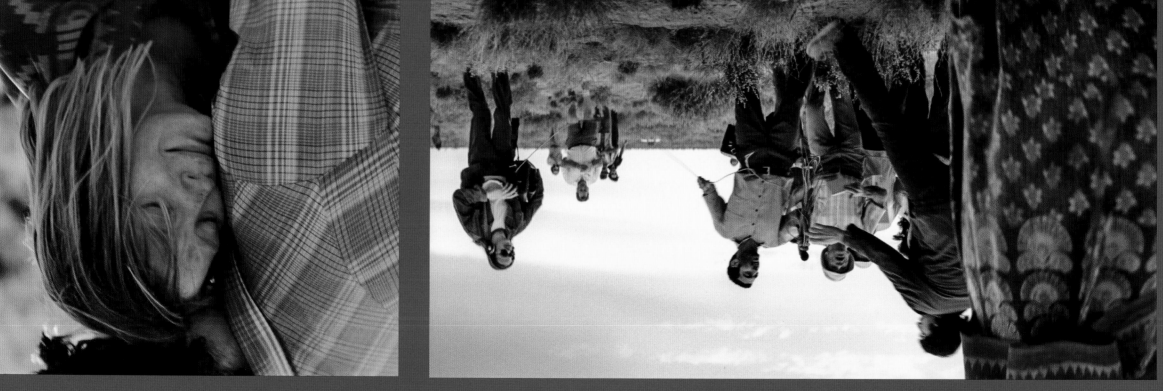

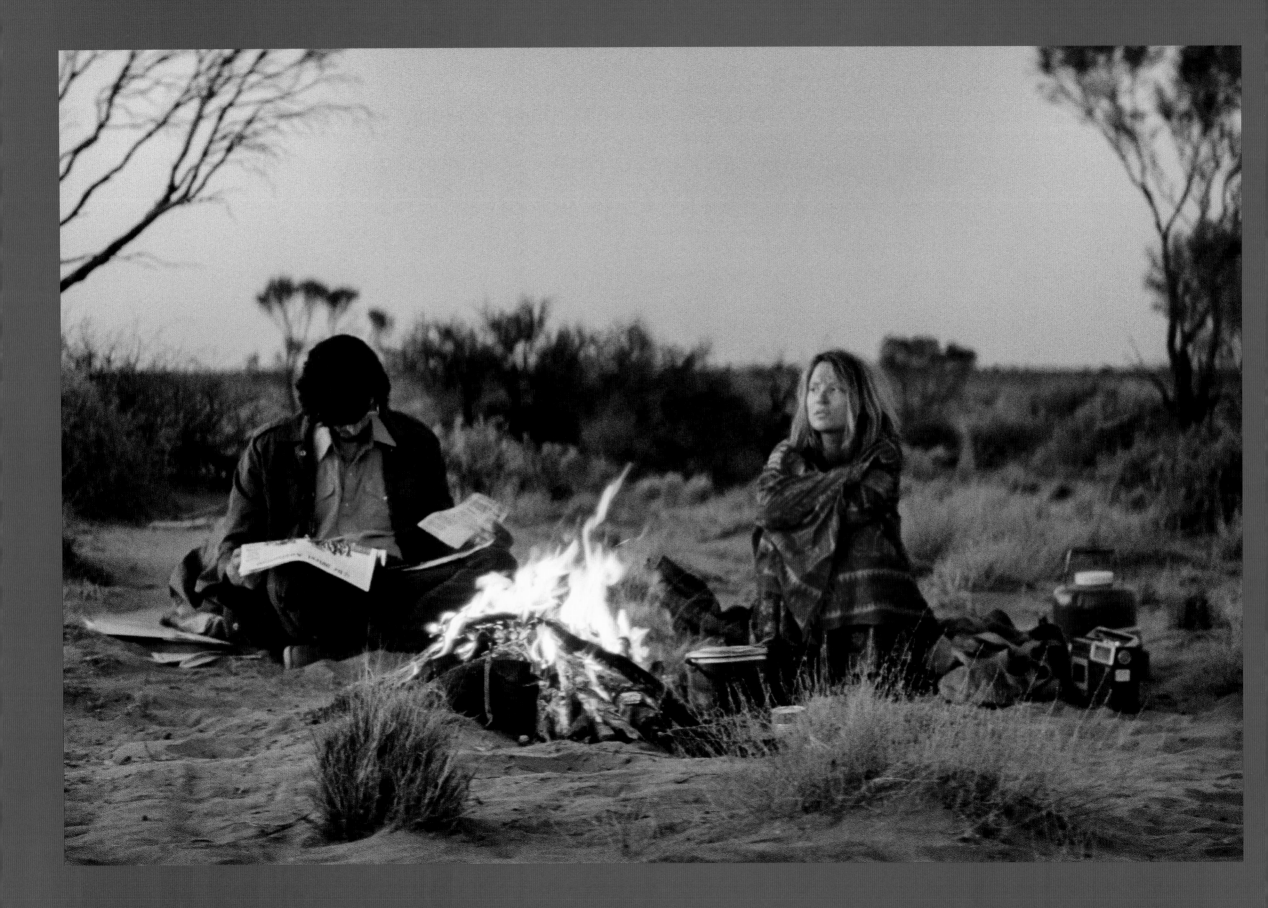

EXT. ROLLING PLAINS CAMPSITE – DUSK

In the distance the journalists sit around cars and campfires drinking and talking loudly. Rick sits with Robyn by a fire, flicking through clippings of newspaper articles.

RICK
You have one from London, another from New York. Paris, Saigon, Singapore. Wow, I can't even read where that's from.

She is far away.

ROBYN
Doesn't matter anyway.

Rick looks up.

RICK
What doesn't matter?

ROBYN
This trip. I never should have started it.

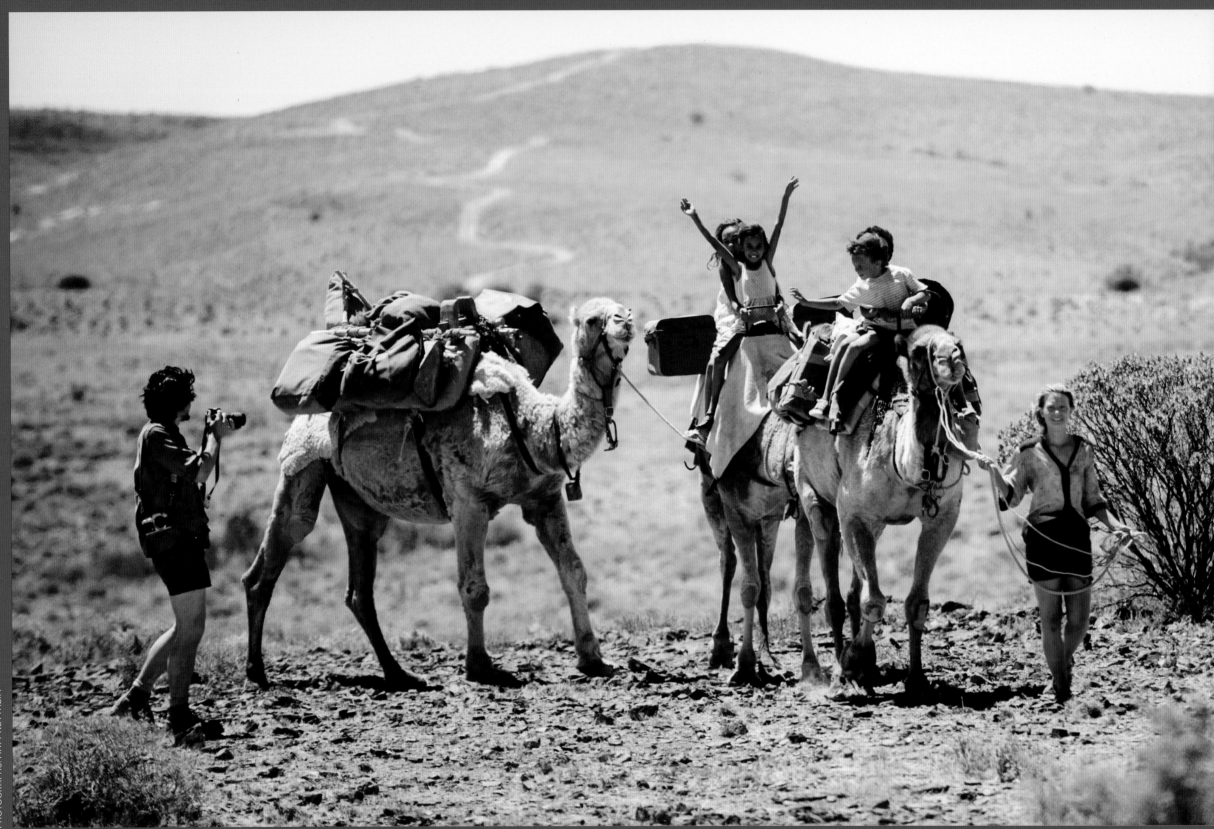

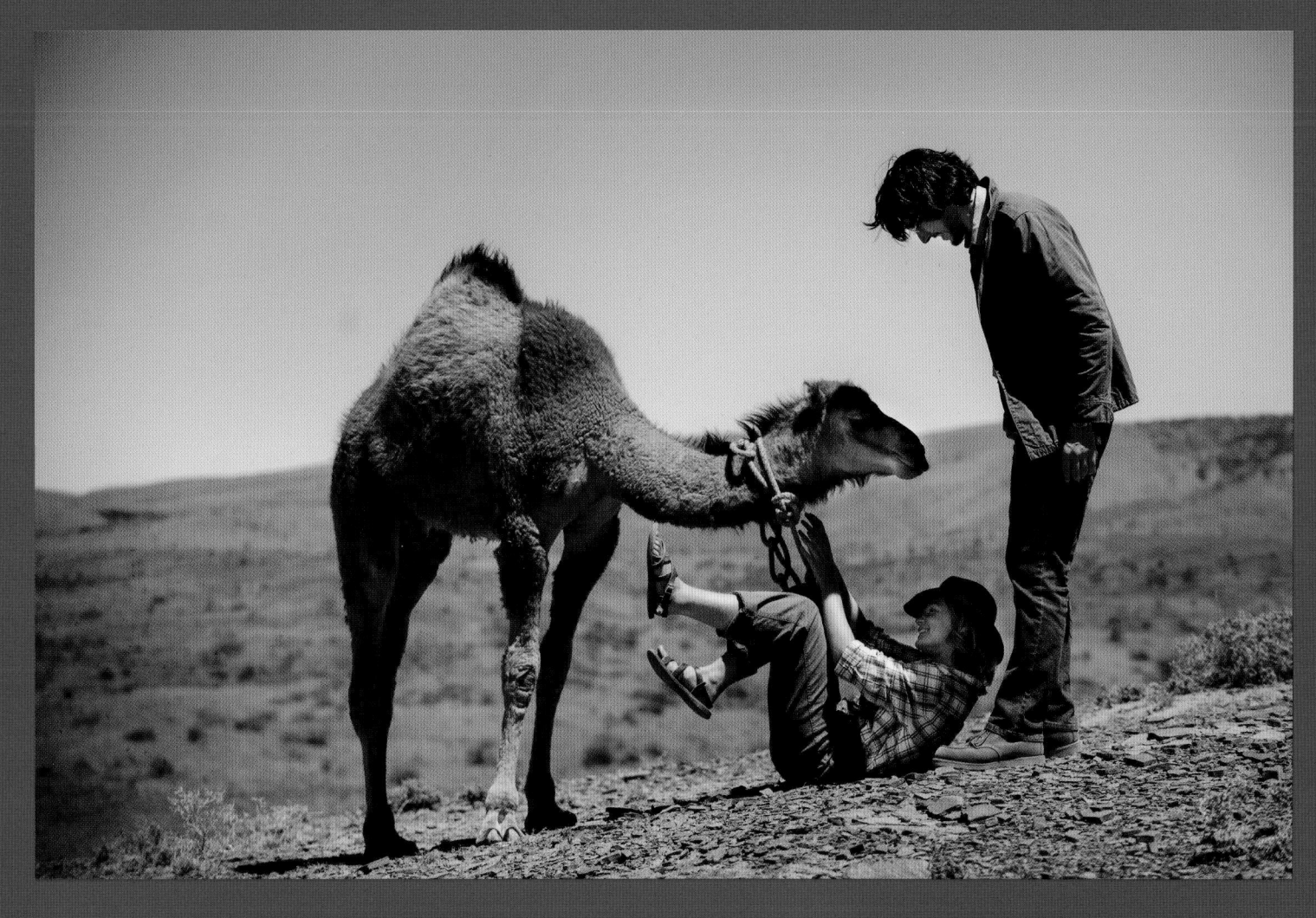

EXT. WILUNA PLAINS

Robyn is leading the camels along a track towards a small Aboriginal camp. A gang of delighted KIDS run out to meet them.

Robyn leads Dookie and Bub with three smiling kids riding on top. A group of their friends follow in the camels' wake. Rick takes photos of the kids enjoying their bumpy ride.

Two of the kids lead Rick by the hand.

The Aboriginal YOUNG WOMEN love seeing their kids having a good time and talk in low voices amongst themselves about the spectacle.

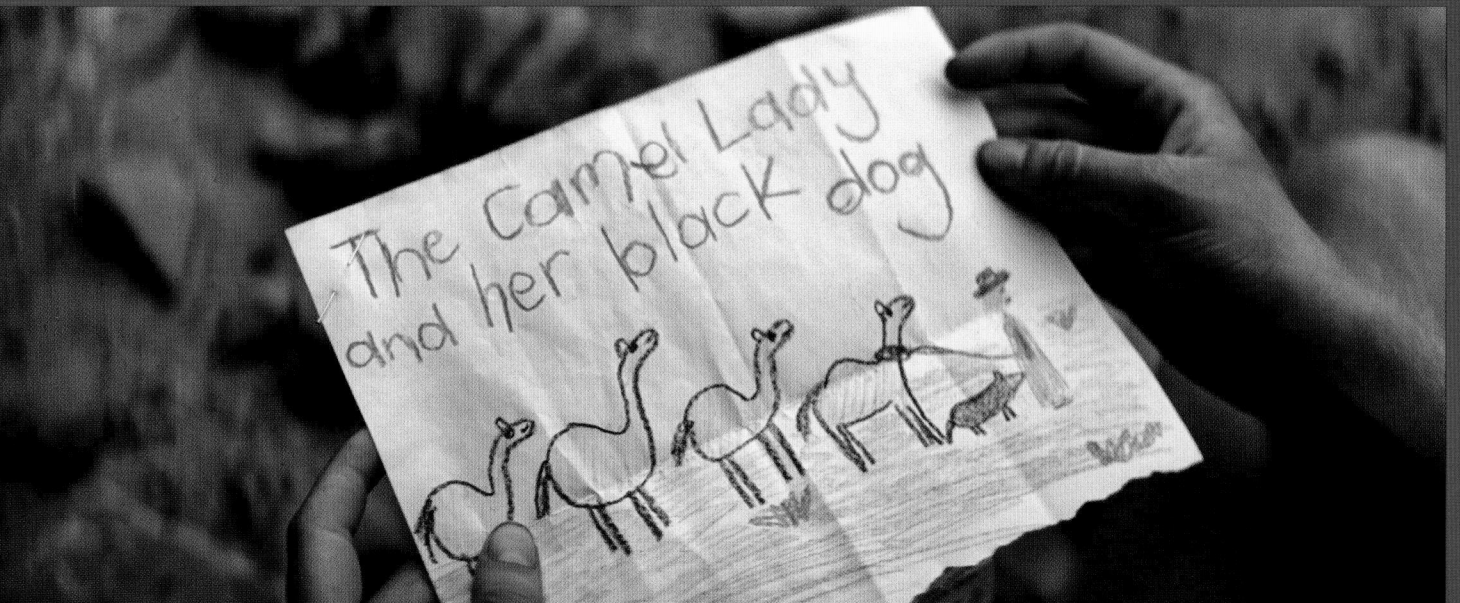

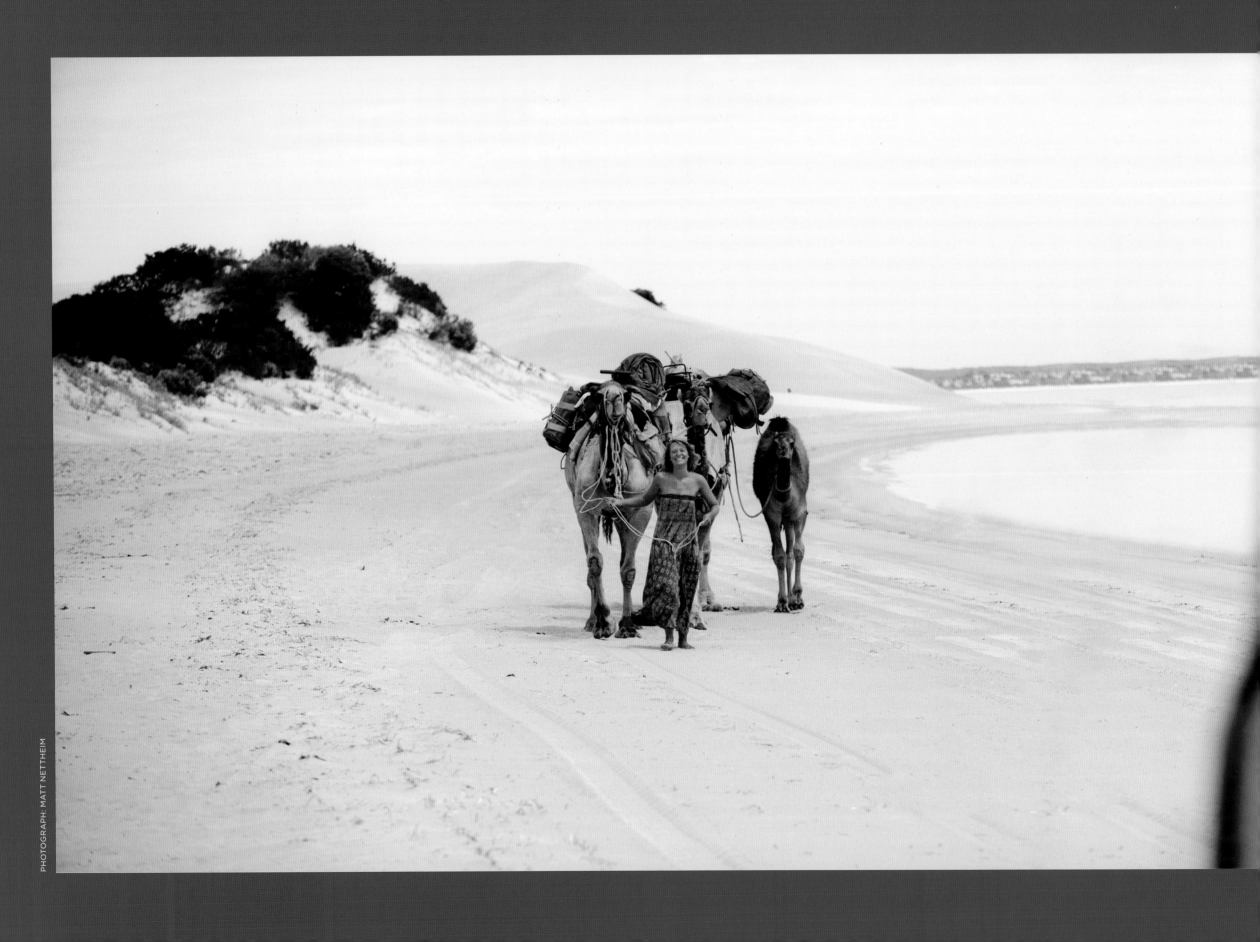

Robyn leads her camels up the dunes towards the sound of distant waves. She's brimming with a deep sense of personal accomplishment.

At the crest she sees before her the magnificent Indian Ocean.

Rick is sitting inside his 4WD on the shore reading a paperback novel, *Tunnel in the Sky* by Robert Heinlein. He hears the sound of her approaching and grins as he climbs out of the car. She raises her hand in acknowledgement. He warmly raises his hand in return.

Robyn and Rick share an intense jubilant hug.

Robyn is almost in disbelief - tearing up - but incredibly happy.

She laughs as she leads the camels into the ocean. Robyn dives into the clear blue water, submerging herself completely.

At last - she has made it.

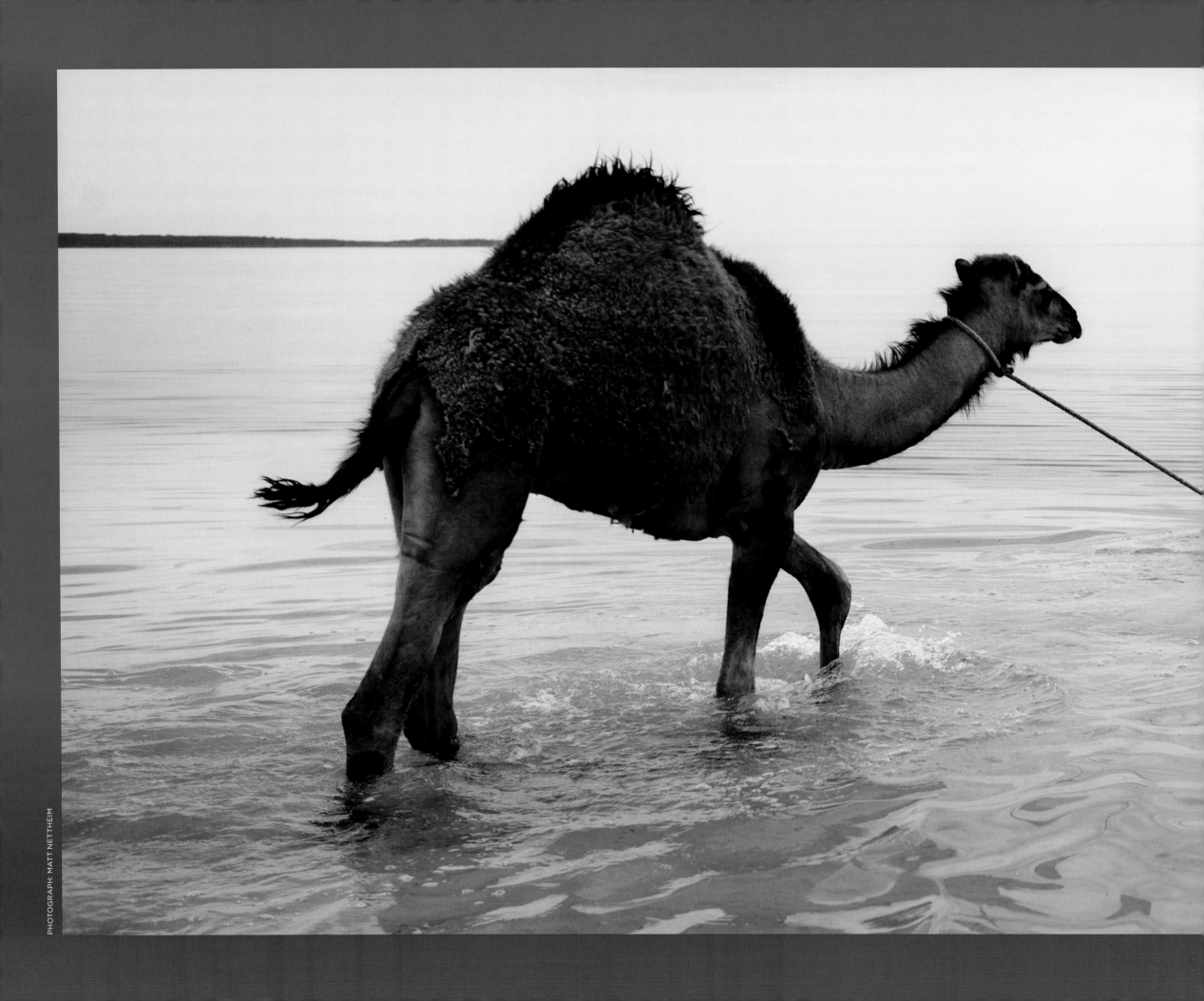

ff As with any journey, it's not what you carry,
but what you leave behind. **JJ**

BEHIND THE SCENES

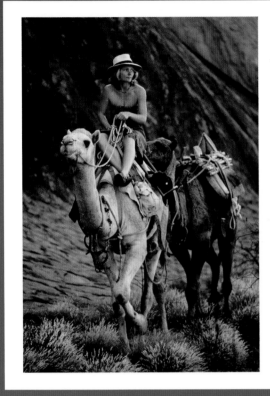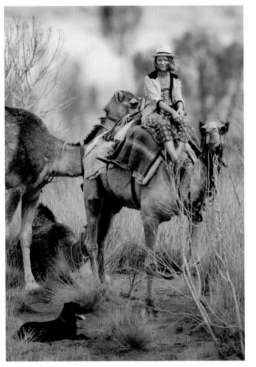

Robyn Davidson (left) on her original journey, Mia Wasikowska (right) in the film.

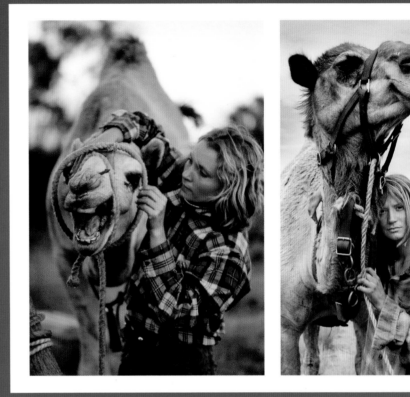

Robyn Davidson (left) on her original journey, Mia Wasikowska (right) in the film.

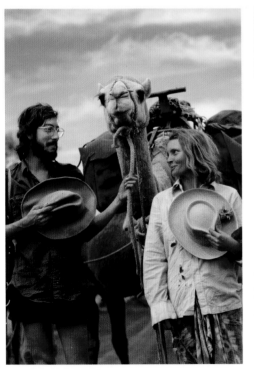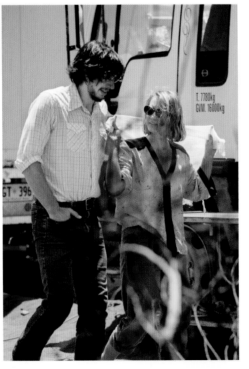

Rick Smolan and Robyn Davidson on the original journey.

Adam Driver and Mia Wasikowska during a break on the set of *Tracks*.

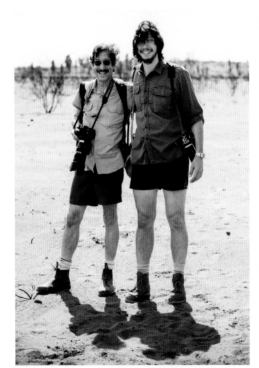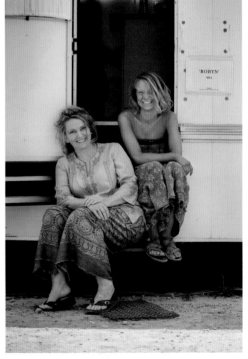

Rick Smolan and Adam Driver on the set of *Tracks* at Ayers Rock.

Robyn Davidson and Mia Wasikowska on the set of *Tracks* at Ayers Rock.

The departure scene close up.

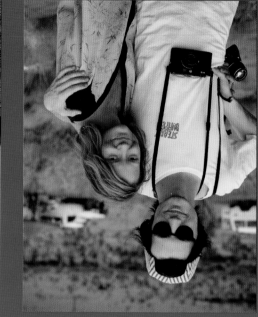
Mia and her brother, Kai, on set at Ayers Rock.

Shooting the departure scene with a long lens from a nearby hill.

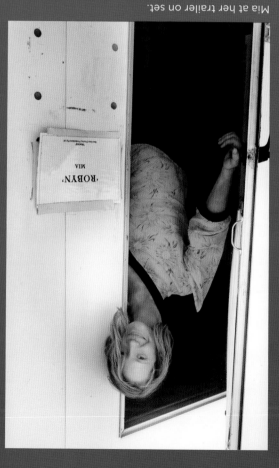
Mia at her trailer on set.

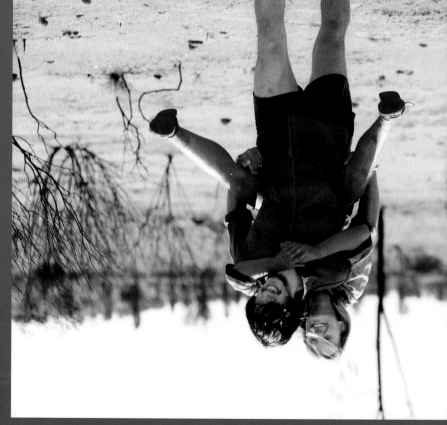
Mia and Adam goof around between takes.

Flies are a constant source of irritation in the outback and camera operators had to make sure none of them got inside the delicate cameras.

When the Oscar® winning team behind *The King's Speech* set out to bring Robyn Davidson's best-selling book *Tracks* to the silver screen, they were obsessive about every detail. They not only cast Mia Wasikowska, an extraordinary actress, to bring Robyn's story to life, they also wanted Mia to look like Robyn. For complete verisimilitude, the film-makers poured over photographs from Robyn's original epic journey and recreated them down to the blouses, skirts and worn flannel shirts. Likewise, in creating the film's sets, the art director took great care to craft scenes which would reflect the colour and light and unique look and feel of the outback.

The *Tracks* cast and crew spent two arduous months in remote areas of South and Central Australia bringing Robyn's story to life. The following pages are a scrapbook of moments shot by set photographer Matt Nettheim and Rick Smolan.

BEHIND THE SCENES

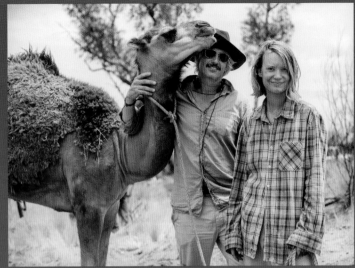

Mia and *Tracks* Director, John Curran.

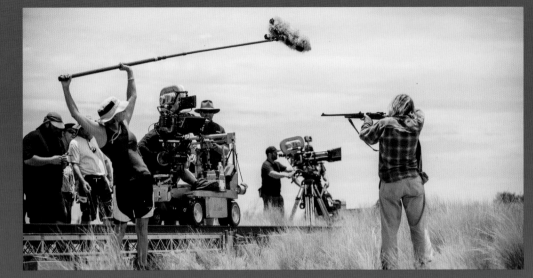

Shooting the scene when Robyn is attacked by wild bull camels.

Lily Pearl, who plays the young Robyn in the movie, holding the cover of *Tracks*.

Adam helps out between takes.

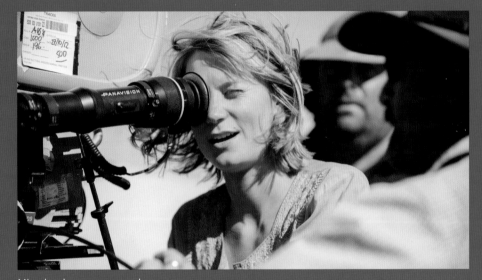

Mia checks camera angle.

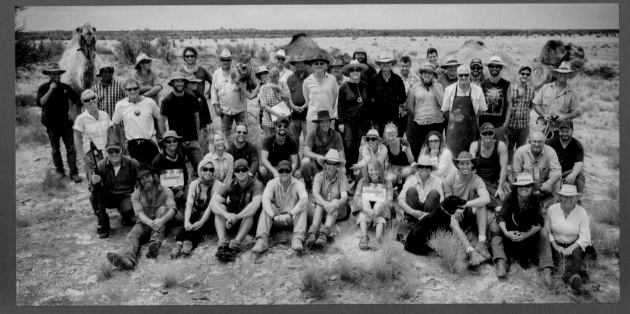

The *Tracks* crew.

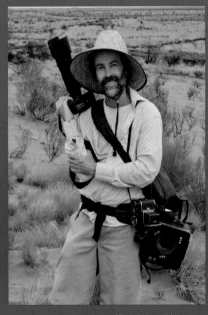

Matt Nettheim, the official Set Photographer whose spectacular photos appear in this section of the book.

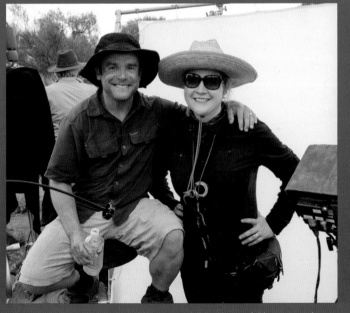

Camera Operator, Jason Ellson, and Director of Photography, Mandy Walker.

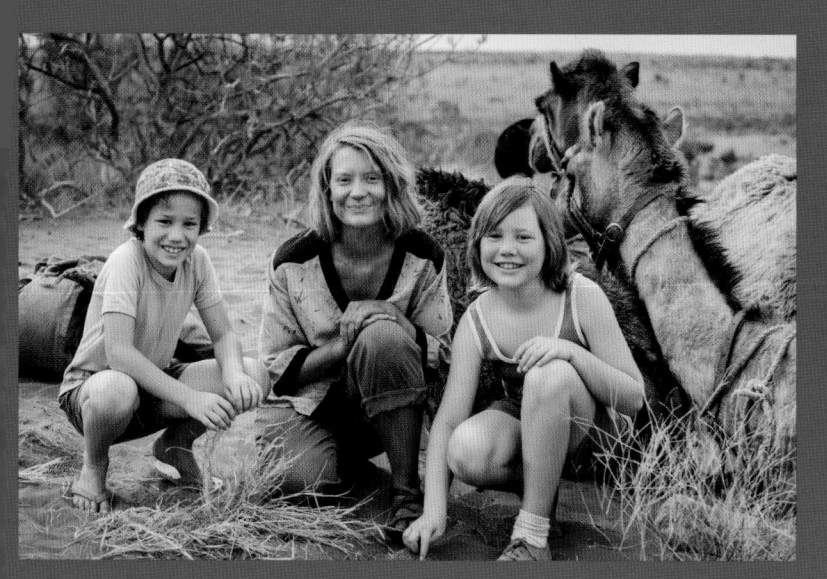
Mia at Ayers Rock with fellow actors Jed and Leo Payten.

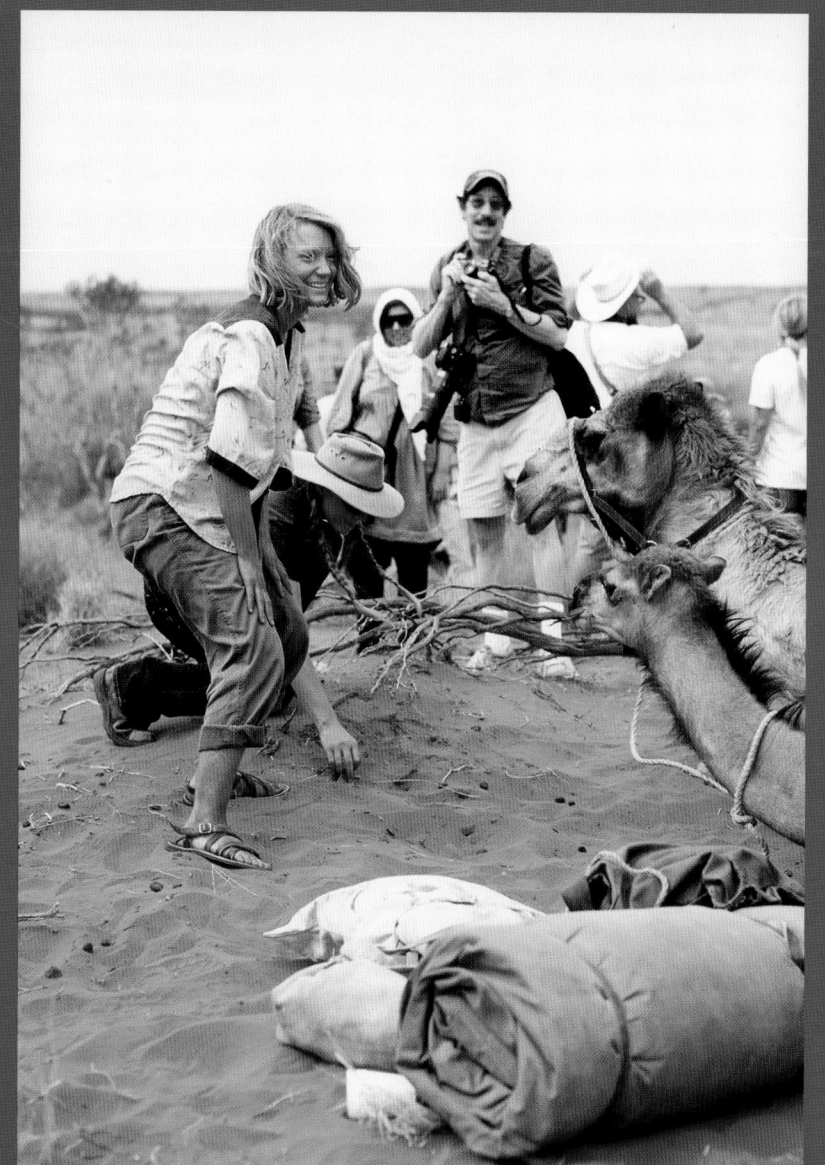
Rick, Mia, Robyn and Natasha Pruss looking at photos of the original journey on set.

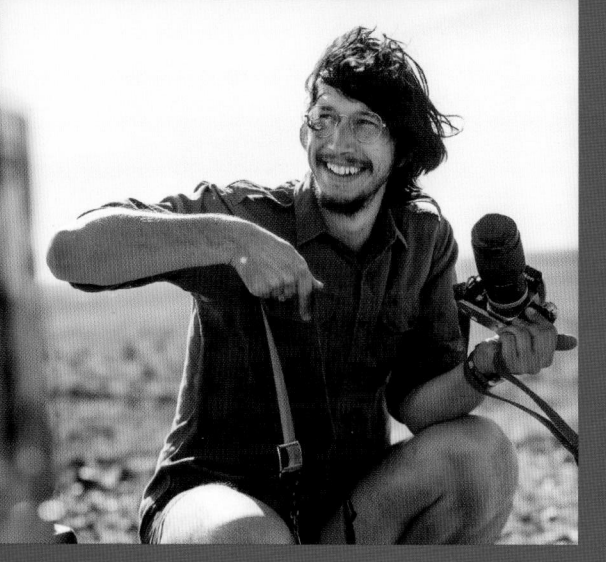
Adam Driver taking a break between scenes.

Rick and Robyn on set.

Rick photographs Mia at Uluru.

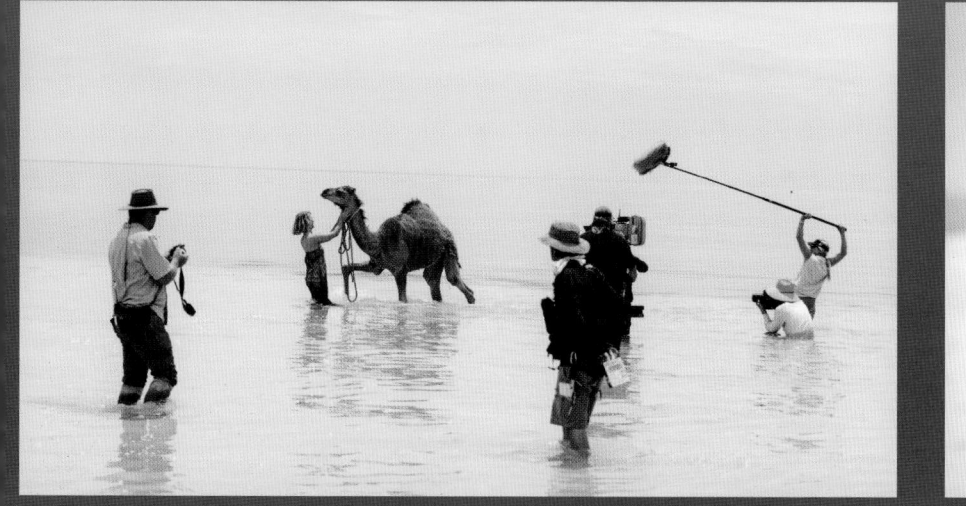
Shooting the beach scene.

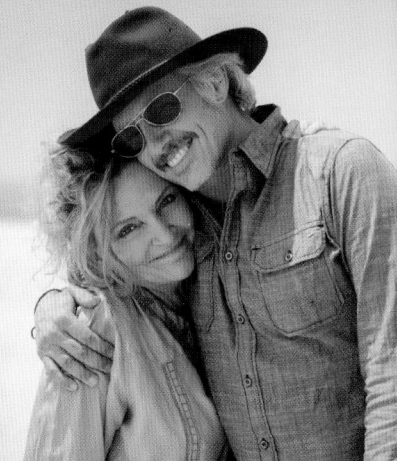
Director John Curran with Robyn.

Executive Producer Andrew Mackie, Mia Wasikowska, Executive Producer Richard Payten and Producer Emile Sherman on set.

INSIDE TRACKS STAFF AND ACKNOWLEDGEMENTS

Rick Smolan, Director

Jennifer Erwitt, Director

Katya Able,
Chief Operating Officer

Diane Dempsey Murray,
Design Director

IMAGES
Michael Marquand,
Photoshop Guru

Peter Truskier,
Image Management

PICTURE EDITING
Robert Pledge
Guy Cooper
Karen Mullarkey

CREATIVE CONSULTANT
Michael Rylander

BUSINESS DEVELOPMENT
Barry Reder

PUBLICITY
Holly Jacobus

LITERARY AGENT
Carol Mann

PROOFREADER
Jane Price

NATIONAL GEOGRAPHIC
Bob Attardi
Bob Gilka
Howard Hull
Chris Johns
Coburn Dukeheart
Sarah Leen
Elizabeth Krist
Vince Musi
Katherine Thompson

PRE-PRESS
Gary Hawkey, iocolor
John Bailey, iocolor

ON-PRESS COLOUR
Brad Zucroff

STERLING PUBLISHING
Adria Dougherty
Sari Lampert
Jennie Jewett
Joshua Mrvos
Nicole Vines Verlin

HARDIE GRANT BOOKS
Sandy Grant
Julie Pinkham
Jane Grant
Lucy Heaver
Todd Rechner
John O'Brien

AURASMA IMPLEMENTATION
Laura Kopf, HP
Lauren Offers
Nastassya Saad, HP
David Stone, HP

PRODUCTION SUPPORT
Alexandra Able
Zachary Able
Max Worrin

PERSONAL ASSISTANT
Olivia Huffman

ACCOUNTING AND FINANCE
Denise Courtney, Accountant
Ally Merkley, Bookkeeper
Jim Carlin
Matthew Diesenbruch,
Holthouse Carlin Accountants
Arthur Langhaus
Joseph Callaway, KLS Associates
Eugene Blumberg

LEGAL COUNSEL
Michael Donaldson,
Donaldson + Callif, LLP
F. Richard Pappas

FILM AGENT
Stephen Durbridge

SENIOR ADVISORS
Jeff Bezos, Amazon.com
Jeff Bleich, former US
Ambassador to Australia
Stuart Braxton,
Apple Computer
David Droga, Droga5
Rt. Honorable Malcom Frasier
Drew Herdner, Amazon.com
Tony Hsieh, Zappos
Marissa Mayer, Yahoo
Phillip Moffitt,
Life Balance Institute
Rob Small, Apple Computer

FRIENDS AND ADVISORS
James Able
Josh Baran
Brandee Barker
Brown Bartholomew
Sunny Bates
Zack Bogue
Andrew Bolwell
Russell Brown
David Burnett
The Carmichael Family
Satjiv Chahill
Rachel Chau
Sandy Climan
David E Cohen

Katie Cotton
Ray DeMoulin
Carlos Dominguez
Debbie Donnelly Robinson
Gene Driskell
Gayle Driskell
Amy Erwitt
CJ Erwitt
David and Sherry Erwitt
Ellen Erwitt
Elliott Erwitt
Erik Erwitt
Misha Erwitt
Sasha Erwitt
Tim Ferris
Jane Friedman
The Hancock Family
Michael Hawley
Marc Hodosh
A.J. Jacobs
James and Zem Joaquin
Yasmine and Matt Johnson
Kamil Kaluza
The Kasowitz Family
Donald Katz
The Lester Family
Serafina Maiorano
Richard Matthews
Doug and Tereza Menuez
Matt Murray
David Nobay

Jacqueline Novogratz
Georgia McCabe
Roger McNamee
Jon O'Hara
Dean and Anne Ornish
Andy Park
The Peyser Family
Tina Pohlman
Natasha and Jeff Pruss
Pamela Reed
Tom Reilly
Patti Richards
Kathy Savitt
Doug Scott
John Sculley
Megan Smith
Savannah Smith
Leslie Smolan
Lily Smolan
Reed Smolan
Sandy Smolan
Joy Solomon

Brian Storm
Amy Tan
Michael Tchao
Maria Valero
Jay Walker
Tom Walker
The Warezak Family
Lauren Wendle
Sam Worrin
Richard Saul Wurman
Randi Zuckerberg

JUNIOR ADVISORS
Sophia Able
Greta Kaluza
Violet O'Hara
Boris O'Hara
Sydney Pruss
Evan Pruss
Jed Payten
Leo Payten
Phoebe Smolan
Jesse Smolan

TRACKS THE MOVIE

MOVIE DIRECTED BY
John Curran

PRODUCED BY
Emile Sherman and Iain Canning

SCREENPLAY BY
Marion Nelson

BASED ON THE BOOK "TRACKS" BY
Robyn Davidson

ROBYN DAVIDSON PLAYED BY
Mia Wasikowska

RICK SMOLAN PLAYED BY
Adam Driver

KURT POSEL PLAYED BY
Rainer Bock

MR EDDIE PLAYED BY
Rolley Mintuma

SALLAY MAHOMET PLAYED BY
John Flaus

POP PLAYED BY
Robert Coleby

EXECUTIVE PRODUCERS
Andrew Mackie
Richard Payten
Xavier Marchand

CO-PRODUCERS
Antonia Barnard
Julie Ryan

DIRECTOR OF PHOTOGRAPHY
Mandy Walker ASC ACS

SET PHOTOGRAPHER
Matt Nettheim

PRODUCTION DESIGNER
Melinda Doring

EDITOR
Alexandre De Franceschi ASE

MUSIC COMPOSER
Garth Stevenson

COSTUME DESIGNER
Mariot Kerr

CASTING
Nikki Barrett

ASSOCIATE PRODUCER
Charles Dorfman

PRODUCTION MANAGER
Fiona Lanyon

FIRST ASSISTANT DIRECTOR
Phil Jones

SECOND ASSISTANT DIRECTOR
Renata Blaich

ART DIRECTOR
Janie Parker

HAIR AND MAKE-UP DESIGNER
Zeljka Stanin

SOUND RECORDIST
David Lee

US CASTING
Laura Rosenthal

POST PRODUCTION SUPERVISOR
Colleen Clarke

VISUAL EFFECTS SUPERVISOR
James Rogers

ASSEMBLY EDITOR
Mat Evans

SUPERVISING SOUND EDITORS
Andrew Plain
Yulia Akerholt

MUSIC SUPERVISOR
Norman Parkhill

THE WEINSTEIN COMPANY
Harvey Weinstein
Bob Weinstein
David Glasser
Stephen Bruno
Dani Weinstein
Bladimiar Norman
Anjulee Alvares-Cinque
Pam Pearlman
James Della Femina
Jennifer Stott

TRANSMISSION FILMS
Richard Payten
Andrew Mackie
Rowen Smith
Alicia Brescianini
Megan Young
Renee Melbourne
Matt Soulos

CAST (in order of appearance)
Young Robyn.....................Lily Pearl
Robyn.............................Mia Wasikowska
Publican...........................Philip Dodd
Publican's Wife..................Fiona Press
AdaDaisy Walkabout
KurtRainer Bock
Gladdy..............................Felicity Steel
Sallay...............................John Flaus
Chilpi...............................Ian Conway
Evan.................................Evan Casey
David................................David Pearce
Jenny...............................Jessica Tovey
Toly.................................Darcy Crouch
Peter...............................Brendan Maclean
Bernard............................Jamie Timony
Annie...............................Melanie Zanetti
Rick.................................Adam Driver
Bob..................................Ryan McMillan
Niece...............................Leah Michele
Marg................................Emma Booth
Pop..................................Robert Coleby
Young Boys........................Leo Payten
..Jed Payten

Pete.................................Steven Parker
Geoff...............................Bryan Probets
VincentVincent Forrester
Mr Eddie...........................Rolley Mintuma
Singing WomanYvonne Yiparti
Dancing WomanElsie Wanatjura
Dancing WomanRene Kulitja
Dancing WomanHappy Reid
Dancing WomanLydia Angus
Glendle.............................Tim Rogers
Tourist OneChelsea Haywood
Tourist Two.......................Andrew Harper
Suzuki Man........................Tom Budge
Mr Ward............................Edwin Hodgeman
Mrs Ward...........................Carol Burns
TV Reporters.....................Chris Duncan
..Ricardo Anasco

Robyn Stunt DoubleJackie Murray
Dookie..............................Morgan
Zeleika..............................Mona
Bub..................................Istan
Goliath..............................Mindie
DiggitySpecial Agent Gibbs Ziva

For speaking enquiries regarding *Tracks* or to book Robyn Davidson or Rick Smolan please contact Holly Goulet, American Program Bureau, (617) 614-1636 or email hgoulet@apbspeakers.com

To license images from this book please contact Elodie Mailliet, Contour by Getty Images, elodie.mailliet@gettyimages.com

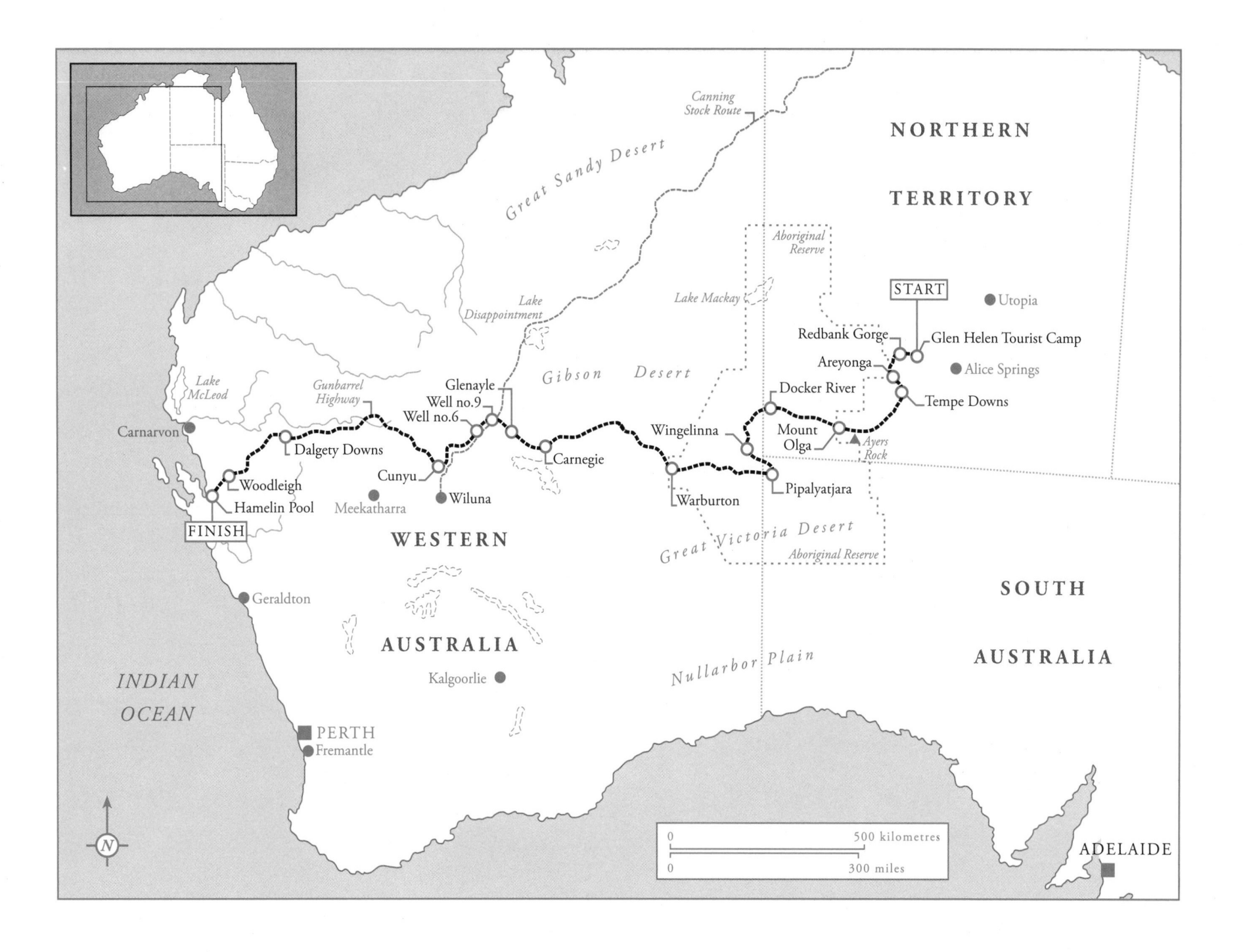